The Patron's Payoff ∿

CONSPICUOUS COMMISSIONS IN ITALIAN RENAISSANCE ART

Jonathan K. Nelson and Richard J. Zeckhauser

Principal Authors and Editors

PRINCETON UNIVERSITY PRESS · PRINCETON AND OXFORD

Published by Princeton University Press, 41 William Street,
Princeton, New Jersey 08540

In the United Kingdom: Princeton University Press, 6 Oxford Street,
Woodstock, Oxfordshire OX20 1TW

Library of Congress Cataloging-in-Publication Data

Nelson, Jonathan Katz.
The patron's payoff : conspicuous commissions in Italian Renaissance art / Jonathan K. Nelson and
Richard J. Zeckhauser, principal authors and editors.
p. cm.
Includes index.
ISBN 978-0-691-12541-1 (hardcover : alk. paper) 1. Art patronage—Italy. 2. Artists and patrons—
Italy. 3. Art, Renaissance—Italy. 4. Social status in art. I. Zeckhauser, Richard. II. Title.
N5273.N45 2008
707.9ʹ45—dc22 2008000584

British Library Cataloging-in-Publication Data is available

On title page: Michelangelo, *Guiliano de' Medici*, New Sacristy, San Lorenzo, Florence (Archivi
Alinari/Bridegman, Florence), detail.

This book has been composed in Minion Typeface
Printed on acid-free paper. ∞
press.princeton.edu

Printed in the United States of America

10 9 8 7 6 5 4 3 2 1

To Sally and Silvia

Were we patrons, you would be our artists.

Were we artists, you would be our muses.

But we are authors,

and you are our most prized readers.

CONTENTS

Michael Spence

SINCE the economic basis of much of the analysis in this wonderful book lies in game theory and signaling, and since I had something to do with the creation of the theory of signaling in market and social settings,[1] it might sound suspicious if I were to begin by saying that the theoretical underpinnings of the volume on the economic side are sound. Coming from me, this might sound like a father observing that his child is charming. Such a statement is not an effective signal, since it would cost the parent of an uncharming child little to utter. The fundamental requirement for a credible signal is that it be much cheaper to make for those who possess the underlying attribute that the sender wants to communicate. That assures that the signal is not easily imitated when the attribute is absent. For example, those lacking in academic capabilities do not try for a college education. To secure one would simply be too expensive in time, and probably money.

Fortunately, in penning this foreword there is a second signaling mechanism at work. I have an academic reputation to protect. Reputations, and the ways to build them through the commissioning of great (and expensive) art, are what this book is all about. The theories it presents are broad and insightful. Trust me—it would cost me a lot not to tell you truthfully.

In the spirit of full disclosure, I should also report that one of the authors, Richard Zeckhauser, is a longtime friend and was (many years ago) my doctoral thesis adviser and mentor, along with Thomas Schelling, whom you will meet in the text when the subject of game theory turns up. Richard is the only economist I have ever met who can do economic theory by reaching the conclusion (correctly) prior to actually doing the analysis. It is a rare gift.

I read this book in one sitting (almost); it would have been one in my academic youth. It is engaging in many different ways, and it is hard to put down. For those like me—who have for most of our lives been fascinated by the Italian Renaissance, but whose knowledge of the history of art, architecture, sculpture, and music and of the economics that underlay the burst of creativity that surrounded them was limited to a few courses in college, followed by numerous visits to galleries and cities over the years—reading these chapters was like meeting the people. Fortunately, my lack of relevant historical knowledge was reduced in the area of economics by a Ph.D. requirement at Harvard requiring an in-depth study of the concomitant burst of creativity

in commerce, accounting, finance, trade, and wealth accumulation during these centuries. And we know that science and engineering flourished then as well. The question that has always fascinated people is: "Why then in these three centuries, and why there in Florence, Rome, Milan, Venice, Mantua, and other centers of religion, commerce, and art in Italy?"

You won't find a complete answer to this very general question within these pages, but you will find a satisfyingly nuanced account of the linkages and interactions that sustained the production not only of great art but of the system of incentives that led to disciplined experimentation and risk taking, and ultimately to an amazing amount of innovation.

A key to understanding the system of patronage so clearly analyzed in these pages is mobility. During the Renaissance, economic and social mobility were possible. In addition, reputations were based on multiple dimensions of human endeavor: religious piety, commitment, and insight; wealth and economic performance; artistic and engineering creativity, to name a few. No single institution dominated the social landscape: not the church, nor a monarchy, nor the notables of banking and finance.

In this complex and fluid setting, elites felt the need to communicate their status to others in their own elite group, to other elites, and to ordinary citizens. And for multiple purposes: good old-fashioned ego was one, to advance or consolidate their power, and to transmit the status and power to successive generations in a family, to name just a few. To accomplish this, they engaged in highly public investments in art and architecture through the commissioning of works from renowned artists. These multiple acts of patronage accomplished their various objectives because the results were highly visible (a critical characteristic of any signal) and because those of high status, through a combination of wealth and access, could commission projects that were either inaccessible to or too expensive for those of lower status.

In the course of this, some elite individuals and families took the opportunity to be selective in signaling the attributes they wanted to project and, where possible, to exaggerate claims to accomplishments that commanded respect and admiration. The analyses of what the authors call signposting (flatteringly selective versions of history) and stretching (simple exaggeration within the constraints imposed by the recipient's knowledge) are entertaining and enlightening. They enrich the basic elements of the patronage-signaling model and illustrate the complexity of the multiperson game that included prominently the audience.

When in Rome, I try to catch a glimpse of the two great paintings by Caravaggio in the church of Santa Maria del Popolo. On these outings, as I peer over a gate and around a corner, I have often wondered why the paintings are tucked away in a little chapel in the left transept. Not far into the book I had a pretty good idea how that happened, and by the end it was clear. Chapels in

churches were paid for and decorated by patrons: a fund-raising device for the church or order, and a highly visible signal in a place of worship, accessible to the masses and elites alike. Art, altarpieces, tombs, masses, and much more figured into the mix. The "private" chapel became a central signaling device of the era.

Let me return to the question of the burst of creativity. In a certain sense, many things came together in the Italian Renaissance that might not have, and when that happens there is an element of accident or serendipity that runs counter to our deterministic science and social science instincts. The power and wealth of the Church were complemented by the growing power and influence of the Italian architects of what we would now call global trade and finance. Church and financier needed each other for financial and political reasons. The Church and the political structures controlled the public places, crucial for signaling, and the elites wanted to distinguish themselves and solidify their positions in society and for posterity. Income statements and balance sheets did not do the trick. They lacked visibility, comprehensibility to the majority of citizens, and any sign of religious or civic virtue. Art, public and religious, served the purpose admirably.

The burgeoning wealth and power of the families of commerce in search of status and respect found the most sought-after artists. They not only found them; they encouraged them within subtle but understood limits to be creative and innovative, in short to be different. They searched for masters in the making, and encouraged them. The search for the truly distinctive by the patrons (a more complex and sophisticated strategy than just bidding up the price of the services of Michelangelo and Raphael) created an environment in which innovation within a well-ordered structure was valued and encouraged.

That constellation of forces does not entirely explain (in terms of causation) the level of artistic genius that pervaded the period, but it does point to a fertile environment that was very far from discouraging the unconventional and the new. With fewer potential patrons (if you like, less competition in the signaling domain), the incentives for artistic innovation would have likely shifted in the conservative direction. One never knows about a counterfactual, but it seems a good guess.

Fortunately for the artists, sculptors, and architects (not to mention the scientists, engineers, and leaders of learning in other fields) that was not the case. The competition for recognition and immortality was intense. The learning effect was cumulative, and the beneficiaries are all of us who came after.

If the idea appeals to you of going back in time to the extraordinary period of the Renaissance in Italy with the patrons and the artists (the "principals" and "agents," in the language of economics) and the authors, to understand the incentives and the constraints, the opportunities and the missteps, then

you must give this book a try. For me reading the book felt similar to visiting a great art museum in the company of a knowledgeable, insightful, and engaging curator: a thoroughly rewarding experience.

Note

1. Michael Spence was awarded the Nobel Prize—2001 Prize in Economics in Memory of Alfred Nobel—for developing and formalizing the concept of signaling. (Eds.)

IN 2000 an economist, Richard Zeckhauser, and an art historian, Jonathan Nelson, ventured into the magnificent church of Santa Maria Novella in Florence. The plethora of private chapels there inspired the questions that launched this book. Why did patrons in Renaissance Florence spend so much to obtain and decorate chapels they rarely visited, and why did churches sell off the rights to these spaces? In both cases, the answer was "payoffs." By creating their chapels, patrons gained status, displayed both magnificence and piety, and hoped to shave some time off their stay in Purgatory. Churches generally sold the chapels for much more than their construction cost, and sold other profitable services, most notably masses, as tie-ins.

We addressed the churches' motivations in our first collaboration, the paper "A Renaissance Instrument to Support Nonprofits: The Sale of Private Chapels in Florentine Churches," which was presented at a National Bureau of Economic Research (NBER) conference in 2002, "The Economics of Not-for-Profit Organizations," and appeared in a book of the same title, edited by Edward Glaeser. Also in 2002, we organized a session at the College Art Association (CAA) Annual Conference titled "Conspicuous Commissions: Signaling Status Through Art in Renaissance Italy."

The excitement from the CAA session spurred us to produce this book-length analysis of Renaissance Italian art patronage viewed through the lens of the economics of information. We coauthored part I of the book. The CAA presentations by Thomas Loughman, Kelley Helmstutler Di Dio, and Molly Bourne, and a new essay by us, evolved into the chapters in part II. We felt it important to show that our methodology applies to other places and times. Fortunately, Larry Silver agreed to provide a wide-ranging essay demonstrating precisely this point.

We worked closely with our collaborators to refine their essays and our methodology, and thus produced a volume in which the examples exemplify the theory. For the hard work by all our colleagues, and for their spirit of collaboration, we are most grateful. We also wish to thank the many scholars who read an early draft of part I. They made invaluable suggestions, offered useful examples, and caught embarrassing errors, but most important they forced us to rethink our formulations. Alan Berger, Martin Gaier, Richard Goldthwaite, Dale Kent, Michelle O'Malley, Guido Rebecchini, Pat Rubin, Louis Waldman, and Evelyn Welch each provided extensive comments. Many colleagues gave

suggestions more informally; for these we thank Alison Brown, Caroline Elam, Edward Glaeser, Guido Guerzoni, Sheryl Reiss, Michael Rocke, and Sharon Strocchia. Marta Alvarez, our photo editor, ably assembled all the images in the volume and obtained their publication rights. Miriam Avins, our editor, wisely wielded her pen. Wendy Wyatt, our assistant, masterfully kept us on course. Nils Wernerfelt and Sanne Wellen were effective research assistants; Sanne also compiled the index. At Princeton University Press, we thank Nancy Grubb, who commissioned our book; Hanne Winarsky, who nursed it to completion; and our conscientious and discerning but anonymous reviewers. We are extremely grateful to the libraries that enabled us to carry out our research, especially those at the Harvard University Center for Italian Renaissance Studies ("Villa I Tatti," the institution where we first met), the Kunsthistorisches Institut in Florenz, and the Widener Library at Harvard University. We thank our home universities—Harvard's Kennedy School of Government and Syracuse University in Florence—for facilitating our research. The Herrnstein Fund at the Kennedy School and the National Science Foundation grant IIS-0428868, "Axioms and Algorithms for Reputation Systems," provided research support. Finally, we thank our families for putting up with the nutty hours of a transoceanic partnership.

<div align="right">

J.K.N., R.J.Z.
Le Meurice, Paris
July 2007

</div>

The Patron's Payoff ❧

Themes and Aims

IN A MEMOIR dated 1473, the Florentine merchant and patron Giovanni Rucellai stated that he had "spent a great deal of money" on his house, the façade of the church of Santa Maria Novella, the chapel and tomb in the church of San Pancrazio, and other projects. He observed that these commissions brought him "the greatest contentment and the greatest pleasure because they serve the glory of God, the honor of the city, and the commemoration of myself."[1] Our study, although recognizing the importance of the first two benefits mentioned by Rucellai, focuses primarily on patron's payoffs of the third kind: the celebration of individuals and their families. A clear-cut example is Rucellai's name emblazoned in Latin across the façade of the church of Santa Maria Novella [fig. 0.1]. Personal promotion through art was highly effective, largely accepted, and extremely widespread in Renaissance Italy, as in many other locales and eras. The ways in which artists met their patrons' needs for self-promotion dramatically affected the nature, appearance, and content of paintings, sculptures, and buildings. Consciously or intuitively, they worked in alliance with patrons to produce value for patrons as well as themselves.

Commissioned art always conveys information about the patron. Crucial decisions inherent in the creation of a specific work tell a great deal about the person who ordered it. The selection of the artist, materials, size, location, and subject help to indicate the benefits that a commission was expected to bring, as well as its intended audience. The choices made by a patron take on even more significance when considered with both costs and limiting factors, or "constraints," such as the availability of desirable artists, materials, and display locations. Analytical tools and models recently developed in economics address the sending and receiving of information. They comprise an important and recent subfield called the "economics of information." We employ and develop some of its central concepts to create a general framework for the study of commissioned art.

This volume aims to foster a lasting dialogue between two fields that rarely communicate, art history and economic theory. It offers a rare instance of the economics of information applied to historical settings, specifically the Italian Renaissance. Part 1 sets forth economic frameworks to promote sophisticated analyses of art patronage. Part 2 presents illustrative cases, developed by several other authors as well as ourselves, that focus on painting, sculpture, and architecture commissioned and executed in central and northern Italy between the early 1300s and the late 1500s. The final, extended essay presents examples

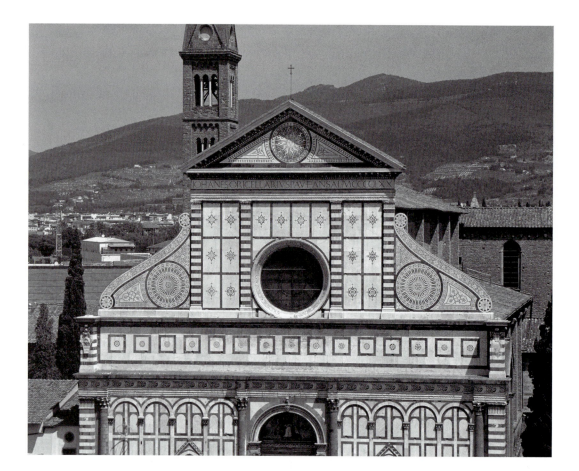

from other locales and other time frames to illustrate the broad applicability of our framework.

For students and historians of art and society, the economic theories and models we describe and develop offer four primary benefits. First, they establish a broad conceptual framework that delineates the relationships among patrons, artists, and audiences, and identifies the benefits that commissions brought to each. For example, a significant stimulus for patrons was the desire to signal status, as has long been recognized and discussed by art historians. Our framework draws on recently developed and new theories in the economics of information to isolate critical elements of art commissions that enable them to transmit meaningful information. This conceptual framework allows us to discuss the impact of individual works in a more precise manner than was possible previously.

Second, the theories and models offered here point to important, previously unexplored areas, and thereby encourage art historians to ask new questions. For example, why did many churches sell some private chapels for high prices and other chapels at extremely low ones? (That question is answered in chapter 5.) Our methods provide a means for art historians to incorporate findings

from economics well beyond such traditional concepts as supply and demand. For example, to answer the type of question just raised, Renaissance scholars might consider some new ideas from economics, such as insights coming from decisions to purchase education or engage in philanthropy to indicate status.

Third, our models facilitate comparisons between art commissions in Renaissance Italy and those made in different periods and geographic areas. Fourth, our approach helps scholars teach basic principles of art patronage, applicable for virtually any place or time. While developing our theories of patronage, we found it essential to describe mechanisms often taken for granted, and to illustrate them with concrete examples. This will assist those with little experience in art history, be they university students or scholars working in other disciplines.

Though we address the broad realm of "art," we concentrate on commissioned works that the patron expected an intended audience to see, appreciate for their aesthetic merit, and identify as made-to-order for a certain individual or group. Equally important, these viewers were expected to recognize the challenges or difficulties that the patron faced in creating the work, notably the cost, but also in securing the artist, materials, and locale. In short, the book focuses on what we label "conspicuous commissions." This phrase seeks to capture the central elements of "conspicuous consumption," Thorstein Veblen's famed term for spending behavior intended to convey the consumer's status. More than a century ago, he observed that the "gentleman of leisure" consumes "beyond the minimum required for subsistence and physical efficiency. . . . He consumes freely and of the best, in food, drink, narcotics, shelter, services, ornaments, apparel, weapons and accoutrements. . . . Since the consumption of these more excellent goods is an evidence of wealth, it becomes honorific; and conversely, the failure to consume in due quantity and quality becomes a mark of inferiority and demerit."[2] Veblen found "conspicuous consumption" irrational and wasteful, even despicable. More recent scholars have focused on the practical use of such behavior to signal status. For example, the social historian Peter Burke adapted Veblen's approach in his nuanced essay on "conspicuous consumption in seventeenth-century Italy." Focusing on palaces and coaches, Burke demonstrated the importance of this ostentation and "the informal rule of consumption which individuals and families ignored at their peril."[3] To distinguish themselves from those of lesser status, they felt the need to demonstrate "magnificence," a central concept discussed in chapter 3.

These intertwined objectives of signaling status and demonstrating magnificence, both attributes of crucial importance to the present volume, were articulated elegantly in a treatise written by Alessandro Piccolomini in 1552. The Sienese nobleman explained that

the munificent should make every effort so that his works cannot be easily imitated, and should always seek to outdo what has already been done by others on

similar occasions. His country houses must be magnificent and splendid, the gardens sumptuous, the town house grand and splendid and furnished in accordance with his degree and something over.[4]

The economic historian Guido Guerzoni employed this passage to help document his convincing argument that in the Italian Renaissance, the type of expenditure noted by Veblen "seems to be more the result of a conscientious, effective and rational calculation, than unconscious or ostentatious consumerist impulse."[5] In his pathbreaking study *Wealth and the Demand for Art in Italy, 1300–1600*, Richard Goldthwaite concluded that, for affluent patrons in Italy, commissions "expressed their sense of what constituted noble status; their spending habits arose from what is perhaps the universal desire of the rich to utilize wealth to set themselves off from ordinary people."[6] Goldthwaite demonstrated the particular importance of art in late medieval and Renaissance Italy. Though the urbanized elites had consolidated their exalted social position, they felt the need "to formulate an ideological confirmation of a class that . . . did not have the tangible evidence of status that the northern feudal nobility could take for granted—familial estates, seigniorial jurisdiction, privileges, titles."[7] In short, these Italian patrons used art to communicate essential but difficult-to-convey information—their elevated station in society. Whereas Goldthwaite focused on art patrons and collectors as a group, countless Renaissance sources indicate that individuals thought about commissions in terms of the distinction they could communicate. This comes across not only in grand treatises, such as Piccolomini's, but also in informal letters. In 1491, Isabella d'Este ordered some "black cloth for a mantle, such as shall be without a rival in the world. . . . If it is only as good as those which others wear, I had rather be without it!"[8] Thus, the Marchioness of Mantua wanted her clothing to express not only the highest quality but something that set her apart from others.

This desire for distinction, analyzed in a fundamental sociological study by Pierre Bourdieu, is perfect material for the economics of information, which explores how information is consciously transmitted and deciphered.[9] In traditional economics, the most powerful results arise in perfect markets, where decision makers are well informed—they have adequate information about any "product" they buy, and about workers or managers they hire. In such markets, consumers know all they need to know to accurately identify, say, the quality of ancient Roman sculpture. Prices reflect only quality and availability. Such ideal markets are rare; more often, markets are plagued with limited information. For example, a dealer selling antiquities is more aware than the potential buyer about the gray zones in the provenance or conservation of a work; the scholar knows better than nonspecialist readers if a new study stands on sturdy or shaky ground.

The economics of information explores how such imperfect information is transmitted and digested. It addresses, for example, how manufacturers or retailers communicate information about their products, how individuals convey their capabilities to potential employers, and how firms convey their prospects to financial markets. People daily take advantage of the economics of information without fully understanding its conceptual models, distilling truthful information from messages that are conveyed, actions that are taken, and records that are tallied.

The theory of signaling, one of the prime concepts in the economics of information, was developed by Michael Spence, who was awarded the Nobel Prize in Economics in 2001, along with two others who pioneered the economics of information.[10] Spence's classic book, *Market Signaling*, showed that capable individuals who could not directly demonstrate their skills to an anonymous job market might beneficially acquire a "costly" signal—a college degree—to do so. This signal can be secured at high but affordable cost by a motivated and talented person, but both getting into and getting through college would be extremely expensive to a less capable individual. This significant differential in costs makes the signal a reliable indicator of quality, and makes securing a college education worthwhile, even though the information learned in the process might be irrelevant to a prospective employer.

Most economic analyses focus on benefits that translate easily into dollars and cents. Even studies of economic history usually concentrate on questions of prices, compensation, salaries, and markets. The economics of information, however, applies readily to historical situations, such as art commissions, where benefits are not readily tallied in monetary terms. Such commissions rarely bring direct financial gain to patrons. Patrons accept the costs of commissions, together with the burden of their constraints, to obtain rewards or benefits that vary depending on the time, place, and individuals concerned.

What are those benefits? In Renaissance Italy, many patrons employed both words and actions to communicate self-serving messages. This constituted an important part of how the elite conducted themselves in behavior that Stephen Greenblatt called "self-fashioning."[11] They created an image of themselves that corresponded to, and in turn helped define, the norms of behavior and appearance in their society. For the affluent and noble, a key aspect of that image was the display of magnificence. In his short treatise *The Virtue of Magnificence* (1498), Giovanni Pontano explained that noble people are particularly intent "to realize the long lasting of their name and reputation, for which man's desire is infinite; moreover, especially for public buildings, the longer they last, the greater the glory they bring the person who built them."[12]

Pontano's text provides a useful guide to the "theory of magnificence," perhaps the most useful concept developed in modern patronage studies. This theory explores, as we do, the motivations behind expensive art commissions.

Outline of This Volume

In the first part of the book, we examine conspicuous commissions through the lens of game theory. This theory focuses on how people behave in interactive situations, in which one person's payoff depends on the behavior of another individual or group. The term "game" may sound frivolous to some, but in recent decades economists, political scientists, and sociologists have used it to describe situations as varied as war, competition in markets, political campaigns, and relations within the family. Game theory lays bare the underpinnings of these interactive situations and has won a highly prominent place in modern economics.[13] The Nobel Memorial Prize in Economics went to game theorists in both 1994 and 2005, and their work was employed by the 2001 winners, who developed the economics of information.[14] To understand any game, the first step is to identify the players. In the game represented by art commissions, the patron and artist are naturally the most important players, but the intended audience is also an indispensable participant.

In chapter 1, we describe the roles of patrons, artists, and audiences within principal and agent relationships, a central concept from the economics of information. Throughout societies worldwide and across time, the division of labor often leads to situations in which one person works on behalf of another. The first is called an agent; the second is the principal, the person who delineates the task and for whom the agent works. We expect the agent to serve the interests of the principal. The agent, who often has distinctive knowledge and capabilities, has considerable discretion in conducting the task.

We address the patron-to-artist relationship as one of principal to agent. Specifically, during the Italian Renaissance, the patron selected the artist and paid the bill; the artist acted as the agent charged to carry out the work with skill and aesthetic sensibilities. The approval process, of both the preliminary drawing or model and the final work, helped to ensure that the message conveyed by art reflected the patron's interests. Commissions usually led to a symbiotic collaboration between patrons and the artists. Both members of this "creative duo" aimed to favorably impress the audience, which consisted of contemporaries drawn from various classes, future viewers, and viewers in Heaven, mainly God and the holy intercessors, Mary and the saints. Thus, we could say that in working to impress viewers, both the patrons and the artists were working in tandem as agents for these principals, their audience. The members of each audience would view, learn from, and appreciate works of art, or so patrons and artists hoped. Similarly, the readers of a scholarly book can be thought of as its principals; they expect to learn, and they hope the material will be presented in an appealing style. The author-agents must assess how one or more types of readers will interpret and react to a planned book. If these agents fail to provide valuable and accessible information, the principals will neither read, nor recommend, nor cite the work.

After the players and their relationships are identified, game theory calls for scholars to establish the task at hand, and the rules of behavior. In this book, the patron's main task is to assert or increase his (or less frequently her) reputation through commissioned art. Chapter 2 examines the three major factors that patrons, as well as their artist agents, had to consider. They were the projected benefits (the reasons for commissioning a given work); the projected costs (financial and important other costs as well); and the applicable constraints, such as restrictions on extravagant displays, or the availability of distinguished locations.

These three elements, benefits, costs, and constraints, provide a framework for analyzing commissions. The patron's goal was to commission a work that would maximize benefits less costs, while working within the applicable constraints. The relevant benefits and costs do not lend themselves to a common metric—for example, enhanced status and financial cost are not readily comparable—so the patron had to weigh the tradeoffs between them subjectively. The artist was charged with producing a work that met the goals of the patron. The second chapter provides several questions—what were the benefits to patrons? what type of financial and social costs did they face? what constraints applied? who were the intended audiences?—that can be applied to commissions in any period.

The last two chapters in part I explore the strategies used by players in the commissioning game to obtain the desired benefits, while limiting costs and working within established constraints. Chapter 3 presents the two economic theories already mentioned: the Renaissance notion of magnificence, and the modern one of signaling. Like higher education, used to signal one's overall quality to an anonymous job market, works of art were employed to convey broad favorable characteristics. The most common attributes conveyed were wealth, status, and—especially for religious commissions—piety. The financial expenditure alone required to create most commissioned paintings, sculptures, and especially buildings in Renaissance Italy signaled the patron's wealth, since only the wealthy could afford such outlays.

Chapter 4 introduces two new models for examining commissions: "signposting" and "stretching." The first is little known in economics; the second is newly developed for this study. Together, they introduce the element of providing information that is selective, misleading, or exaggerated. Patrons used these mechanisms to communicate information about themselves through the art they commissioned.

The second part of the book consists of five illustrative cases that follow our methodology. We discuss them briefly here to introduce the concepts of signaling, signposting, and stretching. Chapters 5 and 6 show signaling in action in late medieval and Renaissance Florence. In chapter 5, we focus on the general phenomenon of private chapels. Though patrons rarely visited or prayed in these spaces, they spent vast sums to purchase, decorate, and staff

them. In return, these efforts offered patrons extraordinary opportunities to communicate information. Moreover, the artistic commissions that furnished these chapels represented a considerable percentage of the work carried out by painters and sculptors throughout our period of study.

Some commissions were available to patrons both rich and exalted but were difficult or impossible for others to make. Such projects effectively separated the potential patrons of art into two groups. The more complete the separation, the greater the value of the commission as a signal. Wealth without status was often not enough for gaining access to some rare commissions, such as building a chapel in a major church, and families whose wealth and power stretched across many generations had particular advantages. As Thomas Loughman explores in chapter 6, members of an elite lineage can set themselves apart from others through numerous purchases over many decades.

Through "signposting" an actor indicates specific, truthful, and important characteristics while simultaneously omitting other significant information. What distinguishes signposting from signaling is the selective revelation of information. To illustrate, the strategy of not indicating the source of one's wealth proved popular with most nonaristocratic patrons, especially when the intended audience included nobles. As Kelley Helmstutler Di Dio explains in chapter 7, the sculptor Leone Leoni included many references to his learning and his ties with the emperor in the façade he designed for his home in Milan in the 1550s. Nowhere, however, did he reveal that he had made his name and fortune as an artist, then considered a less than exalted occupation.

"Stretching" is the exaggeration or misrepresentation of important characteristics to convey an image intended to bathe the patron in a favorable light. In the Italian Renaissance, patrons and their audiences expected to see embellishments in art, but even by their standards there were limits to the degree of idealization permitted. Throughout the ages, artists have shown their skill in stretching claims about patrons; artist and patron must work together to determine where and how far to stretch. In chapter 8, Molly Bourne recounts how Francesco Gonzaga employed stretching. He used art to portray a major battle against the French as a significant victory, although many of his contemporaries considered the actual results mixed at best. The paintings, medals, and celebrations he commissioned, most notably Mantegna's *Madonna of Victory*, never assert that Gonzaga's troops trounced the army of King Charles VIII. However, the images give a clear impression that the Italians won the day. These splendid signposts accomplished their goal: the works of art greatly enhanced the ruler's reputation. A variety of surrounding elements, such as celebrations and coinage, complemented this picture.

These chapters by Loughman, Bourne, and Helmstutler Di Dio focus on three different centuries (fourteenth, fifteenth, sixteenth); cities (Florence, Mantua, Milan); media (architecture, painting, sculpture); types of patrons (patrician family, noble ruler, artist); and communication strategies (signaling,

stretching, and signposting). Since the principles underlying our study are general, they should apply to other realms and time periods as well. In chapter 9, Larry Silver shows that our methodology can inform art historians who work on other genres, periods, and locales. This is the standard and expected approach to validate a theory in economics: test it on one set of extensive data, and then establish that it applies to other sets of data. Silver selects many of the issues discussed in part 1 and applies them to examples from Europe in the 1600s and the United States in the early 1900s.

Parameters and Terms

Burke observed that, in Italy, "the shift toward more conspicuous forms of consumption took place in different cities at different times," though "it is not difficult to find contemporaries who declare that a fatal trend toward greater magnificence could be noticed around the year 1600."[15] His analysis focused on the "baroque" extravagances of the seventeenth century; our study begins with the early 1300s, which witnessed the rebirth of the ancient idea of magnificence. Display strategies were developed and established during the following three centuries, particularly in the realm of art and architecture, that later flourished in the baroque era.

This volume uses the geographic and temporal parameters used by Goldthwaite in his study of "the demand for art": Italy between about 1300 and 1600. The period is the first in Western history for which we have considerable primary literature on patrons and on commissions, including prices and, often, contemporary reactions to works. These sources have generated a vast secondary literature, especially for the Tuscan city-state of Florence, which enjoys a slightly disproportionate degree of attention in the first part of our volume. In all Italy, monumental buildings were always made on commission, as were the vast majority of the expensive and famous paintings and sculptures. The intended audiences could usually identify the patrons, or at least their families. For the sake of convenience we can distinguish between "corporate" patrons, such as city governments, religious orders, and brotherhoods or "confraternities," and "private" ones, the focus of our study. These private patrons ranged from merchants and humanists to aristocrats and rulers, and even included a few artists. Naturally, corporate and private categories overlapped, especially since individuals inevitably represented the interests of the groups, such as their clan, to which they belonged.

During the late medieval and Renaissance periods, the most powerful states on the Italian peninsula—politically, economically, and culturally—were the Duchy of Milan, the Kingdom of Naples, the Papal States, and the Republics of Venice and Florence. All these states are addressed in this volume, as is the smaller Duchy of Mantua. Florence, in particular, had a loosely defined stan-

dard of elite status, which allowed for social mobility, especially in comparison with northern Europe. This mobility, however, came with a price: while some ascended, others fell. Many leading families across Italy faced the periodic risk of exile or financial ruin. The Papal States presented a special case: the head of state—the pope—was rarely succeeded by a member of his clan. The election of a new pope had dramatic implications for the "Princes of the Church," the cardinals in all Christendom and especially in Rome. This dynamic situation in Italy provided a special incentive for those with disposable wealth to enhance their reputation through artistic commissions. This enhancement would be the patron's payoff.

Our focus on specific topics within one geographic area during a single time period enables us to hold other explanatory factors relatively fixed. This approach, well established in the social and natural sciences, makes our results more robust. In comparison to scholarly works by economic, political, and social historians of early modern Europe, those by Italian Renaissance art historians tend to focus on narrower periods and locations, and often on an individual artist, patron, or monument. While these monographic studies have produced an abundance of reliable data, this format can lead authors to emphasize characteristics that are unique, and miss those that explain works across multiple contexts. Though the trees stand clear, the forest gets lost. Studies on patronage patterns provide a welcome exception of the propensity to overspecialize, and our book follows in this tradition of taking a broad view.

Our period saw the birth or reappearance of many genres well suited to convey information about patrons, and many have remained popular in the Western world for centuries. They range from country villas to portraits of merchants, and within churches they include private chapels, frescoes, altarpieces, and tombs. We cite all these, as well as churches and palaces, as examples of what we now call art and architecture. More specifically, we concentrate on unique and custom-made paintings, sculptures, and structures that were expected to exhibit aesthetic beauty, among other qualities, and we confine ourselves to items that were expensive within their category, because those were the ones that effectively conveyed information.

Though the definition of art we use is a modern one, it designates a body of works that largely corresponds to those discussed by Giorgio Vasari in his monumental *Lives of the Artists* (1550, 1568). Many of the categories we ignore, such as gardens, tapestries, and works in precious materials, also communicated information about patrons, and could be used to illustrate our theories. Moreover, patrons spent vast amounts on these and other examples of "conspicuous consumption," which we barely discuss, such as antiquities and dress, not to mention the even costlier banquets, processions, and spectacles. Recent calculations on the Este courts in the sixteenth century establish that a mere 0.4 percent of the ducal expenses were devoted to painting and sculpture.[16] These surprising figures serve to underline the effectiveness of art

for signaling. For a substantial cost, but one quite low relative to other areas of expenditure, patrons communicated significant amounts of information through the visual arts.

Three additional reasons, beyond limitations of space and expertise, led us to focus on paintings (on walls, panels, and canvas), sculptures (in stone and metal), and architecture (churches, town houses, and villas). First, many of the examples most respected in the period have survived relatively intact, at least as compared with other genres. Second, these types of art and architecture are the best documented in regard to both their production and their reception. Third, the intended audience for these works could usually associate them with specific patrons or families, and many of their names have come down to us.

In this volume prices and fees are often provided in florins, the internationally recognized gold coin minted in Florence.[17] Unfortunately, magnitudes in florins are difficult to compare over time, given the changing, ever-appreciating value of these coins. These figures are even harder to relate to values in our own times. Following Goldthwaite's example, we compare prices in Florence with the contemporaneous rate of pay for unskilled construction workers in *lire*, a silver coin. This wage rate remained extremely stable, at roughly one-half *lira* (or 10 *soldi*) per day between 1350 and 1527, though during this period the value of the lira relative to the florin fell by half, from 3.5:1 to 7:1.[18] A full-time laborer could hope to work at most about 260 days a year, given the large number of religious holidays; thus one "man-year" of unskilled labor cost about 130 lire.[19] We use this figure for our calculations when lire values are available.[20] To illustrate, in 1429 Cosimo and Lorenzo de' Medici reportedly spent 3,000 florins for the funeral of their father, Giovanni; this corresponded to 12,450 lire or 96 man-years.[21]

These calculations of the prices of commissions in terms of workingmen's wages will be the limit of our mathematical complexity; we eschew the mystifying mathematical formulas that are so much a part of contemporary economic analyses. (Excess use of mathematics allows economists to signal their level of sophistication to their colleagues.) While developing ideas for this book, and participating together in art history and economic conferences, the principal authors often had to provide each other with definitions of basic principles from their respective fields. Now that we understand each other, we feel equipped to convey our models and our methodology in direct language that should be accessible to all motivated readers.

We turn now to our discussion of economic frameworks, frameworks that lay bare the underpinnings of sophisticated structures that were consciously employed and intuitively understood by patrons, artists, and audiences. We begin by discussing the roles of the three types of players in the "commissioning game."

Notes

1. Michael Baxandall, *Painting and Experience in Fifteenth Century Italy: A Primer in the Social History Of Pictorial Style*, 2nd rev. ed. (Oxford: Oxford University Press, 1988), 2. To make part I of this book and its references accessible to a broad audience, we generally limit our notes to recent and easily accessible sources in English.

2. Thorstein Veblen, *The Theory of the Leisure Class: An Economic Study of Institutions* (New York: Macmillan, 1899), 75.

3. Peter Burke, *The Historical Anthropology of Early Modern Italy: Essays on Perception and Communication* (Cambridge: Cambridge University Press, 1987), 132.

4. Guido Guerzoni, "Liberalitas, Magnificentia, Splendor: The Classic Origins of Italian Renaissance Lifestyles," in *Economic Engagements and the Arts*, ed. Neil De Marchi and Craufurd D. W. Goodwin (Durham and London: Duke University Press, 1999), 339; Guido Guerzoni, *Apollo e Vulcano. I mercati artistici in Italia 1400–1700* (Venice: Marsilio, 2006), 111.

5. Guerzoni, "Liberalitas," 371.

6. Richard Goldthwaite, *Wealth and the Demand for Art in Italy, 1300–1600* (Baltimore and London: Johns Hopkins University Press, 1993), 203.

7. Ibid., 200.

8. Evelyn Welch, *Shopping in the Renaissance: Consumer Cultures in Italy, 1400–1600* (New Haven and London: Yale University Press, 2005), 250.

9. On Pierre Bourdieu, *Distinction: A Social Critique of the Judgement of Taste*, trans. Richard Nice (Cambridge, MA: Harvard University Press, 1984), see discussion in chapter 3.

10. A. Michael Spence, *Market Signaling: Informational Transfer in Hiring and Related Screening Processes* (Cambridge, MA: Harvard University Press, 1974). Both Spence and the second laureate in 2001, George Akerlof, are discussed in chapter 3. For the official citations for all three laureates, see http://nobelprize.org/nobel_prizes/economics/laureates.

11. Stephen Greenblatt, *Renaissance Self-Fashioning: From More to Shakespeare* (Chicago: University of Chicago Press, 1980).

12. Giovanni Pontano, *I libri delle virtù sociali*, ed. Francesco Tateo (Rome: Bulzoni, 1999), 180.

13. Avinash Dixit and Susan Skeath, *Games of Strategy* (New York: W. W. Norton, 2004).

14. For the Nobel prizes, see http://nobelprize.org/nobel_prizes/economics/laureates.

15. Burke, *Historical Anthropology*, 147, 145.

16. Guerzoni, *Apollo e Vulcano*, 135.

17. Some prices are given in other gold coins minted in Italy, such as the ducat or scudo; at any given time, these all had roughly the same value. For useful introductions to the complex monetary systems used in Italy, see Michelle O'Malley, *The Business of Art: Contracts and the Commissioning Process in Renaissance Italy* (New Haven and London: Yale University Press, 2005), 13–16, and Welch, *Shopping*, 81–85, both with references to further literature. For Florence, see Mario Bernocchi, *Le monete della Repubblica fiorentina, III* (Florence: L. S. Olschki, 1976), and Richard

A. Goldthwaite, *The Building of Renaissance Florence: An Economic and Social History* (Baltimore and London: Johns Hopkins University Press, 1980).

18. Goldthwaite, *Building*, 429–30, 436, app. 1 and 3.

19. Goldthwaite, *Building*, 347–48, estimated that the total yearly cost to provide one adult with essentials (food, rent, and clothing) was 55 to 75 lire, which left at least half of a worker's earnings to support his family. He noted that the Florentine tax officials in 1427 considered the cost of living for a single adult to be 14 florins (or 56 lire).

20. Man-year figures are always approximate, and we round off all figures.

21. Sharon T. Strocchia, *Death and Ritual in Renaissance Florence* (Baltimore and London: Johns Hopkins University Press, 1992), 122.

Part I ∾ *The Commissioning Game*

PATRONS, ARTISTS, AND AUDIENCES

Introduction: Game Theory

THE INTERACTION between patron and artist, leading to the creation of a conspicuous work of art, can be compared to a game in which the payoff for each player depends on the behavior of the other. The presentation of commissioned art to an audience, together with its response, is a crucial second component of the game; thus the audience also constitutes an important player. There is usually a strong cooperative element among the players in this game. As the citation for the 2005 Nobel Memorial Prize in Economics puts it: "almost all multi-person decision problems contain a mixture of common and conflicting interests, and . . . the interplay between the two concerns could be effectively analyzed by means of non-cooperative game theory."[1] We find both common and conflicting interests between patrons and artists, and also between that "creative duo" and its audience.

Game theory analyzes interactive situations in which players usually try to influence the behavior of one another, much as patrons strive to affect the behavior of artists and vice versa. To do this, players need to assess how others will behave. Similarly, the artist and patron need to predict how the audience—often comprising multiple groups—will react to a commissioned work. The importance of this conjectured reaction makes the patron-artist game worth playing. In this chapter, we focus first on the relationship between patrons and artists, and then turn our attention to their audiences.

The Principal-Agent Relationship

In a study that was fundamental to the development of art history, focusing on fifteenth-century portraits of the Florentine "bourgeoisie," Aby Warburg employed business terms to describe how "works of art owed their making to the mutual understanding between patrons and artists. The works were, from the outset, the results of a negotiation between client and executant."[2] The structure of the relationship between these players can be described more accurately today by using a concept that is central in both game theory and the economics of information: the principal-agent relationship. In the standard formulation, the principal pays another individual for work and defines the main outlines of the task; the agent fulfills his responsibilities to the prin-

cipal and gets paid. For example, we find the principal-agent relationship in the world of modern medicine, between patient and doctor. The patient knows what symptoms need to be alleviated, the doctor which examinations to take and treatments to administer.

This model, in which "agents typically know more about their tasks than principals do, though principals may know more about what they want accomplished," applies neatly to the relationship between patron and artist in Renaissance Italy.[3] A patron might have wanted a palace to signal his (or less frequently her) status, or an image to highlight a battle victory.[4] The architect, sculptor, or painter, acting as agent, might have proposed solutions that the principal literally could not have imagined. In the art-commissioning game, the principal knew what he wanted to accomplish with the commission, but the artist had the skills required to produce the art and achieve the goals.

In many Renaissance commissions, intermediary agents played an extremely important role as liaison between patrons and artists.[5] Though Mantegna's *Madonna of Victory*, the subject of chapter 8, was made for Francesco Gonzaga, the marchese himself left most details of the project to members of his family and court. Intermediaries also played a well-documented role in the creation of the Laurentian Library in Florence, discussed below, designed by Michelangelo for Pope Clement VII. In our analysis, however, the term "agent" generally refers to the artist, working for the "principal" or patron.

An individual patron sometimes acted as the representative of his family, brotherhood, or guild, who played the role of off-the-scene principals in the commission. This was probably the case of some Alberti projects in the Florentine church of Santa Croce, discussed in chapter 6. Even when the patron was acting "on his own," he often represented and respected the traditions and needs of groups. The desire for honor and status, to mention only the most obvious benefits, was common to nearly all families and institutions. As a result, a private chapel in a church ordered by a single merchant still reveals the "social identity" of a group. In addition, as principal, the commissioner might have needed to negotiate with the religious order that had jurisdiction over the church, and with the *opera* or board of works responsible for the building. But, at the same time, the patron also played prime roles as *agent* in a series of separate relationships: he was the agent for his multiple audiences, including the heavenly one, his clan, and his fellow citizens.

This web of relationships imposed requirements—discussed in the next chapter as constraints—on both principals and agents, limiting their actions in the commissioning game. Thus, many individuals and groups influenced the strategies of the patron and artist, and their relation to their audiences.[6] Nevertheless, Renaissance sources recognized that the individual patron usually had a unique and leading role. Writing in the midfifteenth century, the architect Filarete explained that the patron "generated" the original idea or the seed for a building. The architect, like a mother, then "gestated" the seed

for seven to nine months while he produced various designs for the project.[7] To follow this biological metaphor, commissions usually led to a symbiotic collaboration between patrons and artists. Each benefited from the presence of the other; both were critical to the creation of the work.

In her book on the patronage of Cosimo de' Medici the Elder, the historian Dale Kent offered a new theoretical approach to the topic of patronage.[8] Building in part on several fifteenth-century texts that explicitly refer to a patron as the "author" or creator of individual monuments, she argued that the entire body of works purchased or commissioned by an individual can be considered, to cite her pithy subtitle, the "patron's *oeuvre*." This approach helps us understand, for example, the artistic commissions of Pope Clement VII, Cosimo de' Medici's illegitimate grandson. These works not only signaled Clement's status as a wealthy, cultured patron but also highlighted his membership in the Medici family.[9] To have made this claim convincing by means of one or a few works would have been difficult at best, blatant at worst. But when looking at Clement's entire oeuvre, the favorable message about the principal's central role comes across loud and clear. Subtle signals can proclaim loudly. When used in combination, these two complementary models—the commissioned works of a major patron as his oeuvre, and the patron as principal—enable scholars to secure a broad picture of how individuals used art to convey messages about themselves. We turn now to the instruments used by principals to fashion their intended messages, and to control their artist agents.

Contracts and the Role of Patrons

Contracts provide a starting point for understanding the role played by patrons in the commissioning game. A controversial and often-cited article of 1998 by Creighton Gilbert describes these documents as "disappointing," and notes that contracts rarely extend "beyond specifying pigments, sizes, and delivery dates. . . . The one variant in each contract is the subject matter . . . limited to a standard formula," such as the representation of a major saint or a well-known biblical story. On occasion, patrons provided "special descriptive texts" for unfamiliar subjects. At other times, however, they gave artists considerable freedom, especially in selecting subsidiary figures and scenes. Indeed, in several documented cases the artists proposed the main subjects. "The one further specification found fairly often is the relative placing of such elements, to the right or left of others or the like." Though allowing for this minor exception, Gilbert concludes that artists made most of the important decisions regarding the works they created, and criticizes "the widespread opinion that Renaissance patrons usually kept creative control over works they commissioned."[10] Gilbert shares this position with Charles Hope, another well-known art historian, who even finds it "difficult to substantiate the idea that early Renaissance pa-

trons were knowledgeable about the art they commissioned."[11] Both authors indicate that patrons relinquished a desirable degree of control. Game theory would regard such behavior as anomalous. This suggests that the lack of documentation about patrons' knowledge says more about the paucity of surviving evidence than it does about the prevalence of the phenomenon.

More important, perhaps, a nuanced reading of these records does indicate some patrons' "hands-on" approach to commissions. All scholars agree that the patron specified the materials, dimensions, basic subject, general organization of the composition, budget, compensation, and deadline. The patron also established the intended location for works, and thus the audience. For a religious painting, the location might range from a private chapel or bedroom to a high altar, street tabernacle, or civic building. In unusual cases, such as the Laurentian Library, the patron was involved deeply in deciding aspects of a work's appearance. And when Leone Leoni commissioned an ornate façade for his own palace in Milan, a project discussed in chapter 7, the patron-sculptor provided the plan, though he did not execute it personally. Here the principal understood the task better than his handpicked agent.

Patrons usually had a major impact on the viewing conditions for a work. They commissioned, for example, frames and pedestals in a wide range of sizes, materials, and shapes. They also transformed lighting effects by purchasing curtains and candles, and sometimes even adding new windows to a church. Taken together, these decisions strongly suggest that patrons maintained a significant degree of direct "creative control over works they commissioned," and were indeed "knowledgeable about the art they commissioned."

A recent major study of contracts by Michelle O'Malley now provides more concrete support for the widespread assumption that patrons played a central role in commissions, and allows us to better understand the nature of their interaction.[12] These documents regularly refer to previous works of art and, for large works, sometimes stipulate that figures be life-size. In several instances, we even discover that patrons, before selecting the most appropriate artist for a commission, carried out research on his previous works. Principals thus made many of the key decisions that limited and shaped their agents' solutions, and thereby influenced the final appearance of commissioned works.

Detailed drawings set the stage for the dialogue between the main players in the art-commissioning game, and gave each of them an instrument to influence the choices made by the other. More than a quarter of the painting contracts after 1450 studied by O'Malley called for drawings.[13] In commissions for sculptures and buildings, three-dimensional models were often used. The drawing or model helped the agent secure the appointment and clarify how he intended to carry out his brief; it also gave him an opportunity to justify a deviation from the patron's requirements—a requirement to show, for example, an unreasonably large number of figures, or to represent all of them life-size. Such "previews" of the final work allowed the principal to approve

and, if necessary, modify the proposal. Some contract drawings even suggested colors; other drawings and models offered more than one solution to a given problem.

In a composition drawing made for Cardinal Oliviero Carafa, Filippino Lippi included two possibilities for the lower part of the fresco depicting the triumph of Saint Thomas Aquinas over the heretics, which is painted on the side wall of the patron's chapel in Santa Maria sopra Minerva, Rome (figs. 1.1 and 1.2).[14] A balustrade appears on the lower left side of the drawing, a series of simple engaged piers on the lower right; in the center, a dramatic flight of steps leads up to a platform where the main action takes place. Perhaps Carafa found these ingenious plans too distracting. In the end, Filippino left out the stairs and brought the actors closer to the viewer.

Several other differences between the drawing and fresco also reflect a move toward clarity and simplicity. Only the former, for example, shows two dogs examining each other and includes a few figures sitting casually in the center. Though either the principal or the agent might have proposed these stylistic changes, other modifications are surely attributable to Carafa himself. He certainly asked Filippino to remove the portrait of the cardinal found in the drawing, in order to include those of several other figures, and to add the plethora of explanatory inscriptions in Latin found in the fresco. Carafa must have also given the artist specific indications about the use of personal and familial devices. These features, together with portraits and texts, nearly always indicate the direct intervention of the principal or his adviser. When they appear in a final work of art but not in preliminary drawings, the probability rises that there was patronal intervention. The inclusion of identifiable contemporary figures and easily legible inscriptions often reflects a strong desire to influence the reaction of the audience.

Unfortunately, we rarely have widespread documentation on the patron's involvement. Moreover, for the early modern period as well as our own, we hardly expect legal and financial records to include many important aspects of agreements between parties. The patron of a portrait might ask the artist to show the sitter as dignified or relaxed; an architectural patron might request a building that fits harmoniously within its neighborhood, or one that stands out and makes a statement. Such indications would rarely appear in a modern contract, and never in one drawn centuries ago.

We can compare the relationship between the Renaissance patron and artist with that between a modern company executive and an advertising agency. The CEO, as principal, stipulates the medium, budget, and timing of the ad campaign to the agency, which acts as the agent. In meetings between them, the executive probably also discusses the target audience, general message, and the qualities to be signaled. But the executive may take a further step, into what we call signposting, and identify qualities to be highlighted and issues to be omitted or glossed over, or may indeed even propose stretching, whereby

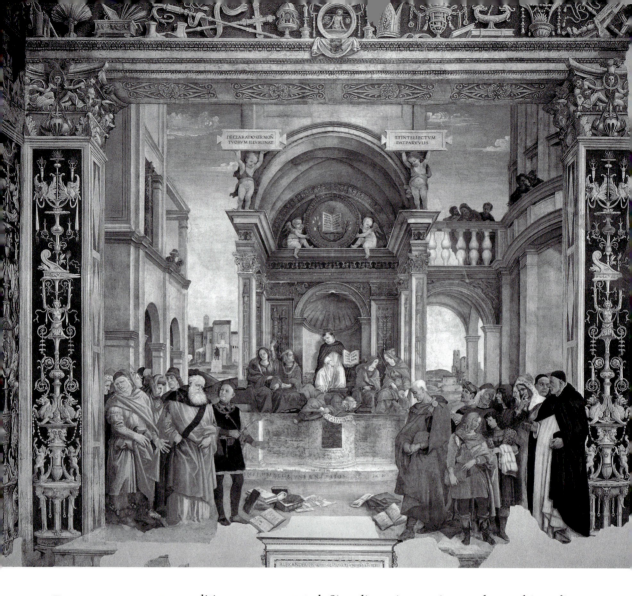

FIG. 1.1.
Filippino Lippi,
*Triumph of St.
Thomas*, Carafa
Chapel, Santa
Maria sopra
Minerva, Rome
(Photoservice
Electa, Milan)

some qualities are exaggerated. Signaling, signposting, and stretching, discussed in chapters 3 and 4, are primary strategies for using art to convey favorable information about the patron. The less straightforward the message to be conveyed, the more we would expect the executive today or the patron in Renaissance times to be involved. Often such involvement comes through conversations with the agent, at times through a wink and a nod. At other times, the principal exercises control simply by hiring an agent who understands his needs, or whose usual tendencies reflect his desired approach. In response to explicit and implicit requests, the agent provides the creative input to produce an image that meets the needs of the company (or art patron). The company reviews the proposed product and may provide input, but does not make suggestions so stringent as to stifle the agency's creative energies. Most of this crucial interaction would leave no paper trail.

The different types of messages conveyed by Renaissance commissions sug-

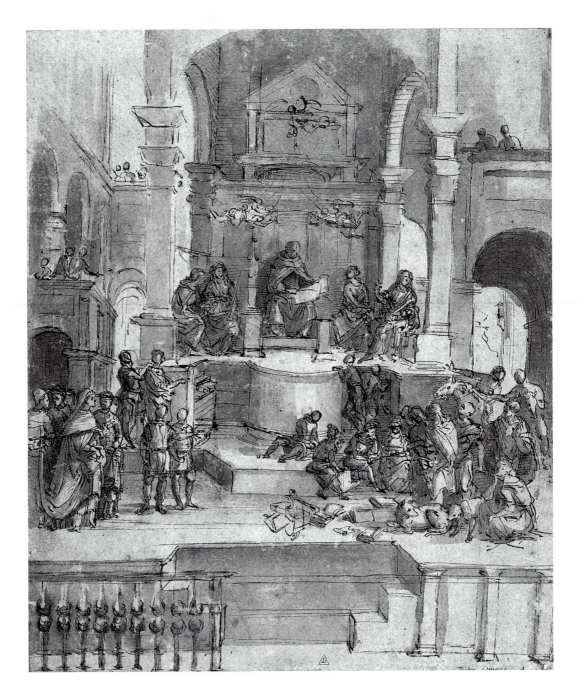

Fig. 1.2. Filippino Lippi, drawing for *Triumph of St. Thomas*, British Museum, London (British Museum, London). © Copyright the Trustees of the British Museum

gest alternative types of collaboration between principals and agents. Most often, the patron wanted his commissions to signal wealth or status; in these cases, he could leave most stylistic decisions to the expert in such matters, namely the artist. In these cases, our study supports two of Gilbert's main

conclusions. First, what Renaissance "patrons wanted to buy from artists . . . was enhancement of their honor and splendor."[15] Second, artists, not patrons, knew best how to signal these qualities. Sometimes, the agent knew better than the principal how much should be spent on a project and, in one extreme case, even misled him in order to achieve a mutually satisfying, better outcome. This was recognized by Pope Pius II in a letter to Bernardo Rossellino, whom he praised for "telling me falsehoods about the cost of the work. Indeed, if you had told the truth, you would have never convinced me to undertake a similar expense . . . and this noble palace and this cathedral, as splendid as there are in Italy, would not exist. Because of your trickery, these illustrious buildings were constructed."[16] Even in this example, however, the principal authorized the additional payments for the buildings in Pienza. He thus played an active role in determining the final appearance of a work by establishing the practical parameters for the artist's activity.

In contrast to many art historians, both Gilbert and Hope maintain that few patrons considered works of art as appropriate venues for expressing complex philosophical, theological, or political views. We concur, but that hardly implies that patrons used art to promote only the general characteristics of honor and splendor. For works employing signposting and stretching, we expect a far greater incidence of patronal intervention. If a painting or sculpture signposted some specific pieces of critical information while omitting others, such as selecting which ancestors or events in the family history to represent in a fresco cycle, the principal probably had a better feel than the agent both for what historical events and accomplishments were available and for what images would be most appropriate. Consider a fresco cycle painted from 1571 to 1573 at the Palazzo Vitelli, in Città di Castello, that depicted members of a noble clan. The patron, Paolo Vitelli, asked the painter *not* to show an order of knighthood given to a family member, since such titles had become too common and thus laughable.[17] If a painting or sculpture "stretched" the truth through misrepresentation or exaggeration—for example, the invention of family histories or coats of arms, both of which grew more frequent in the sixteenth century—the principal was best equipped to evaluate the potential risk and reward associated with any degree of stretch. It "is difficult to infer direct connections between aspects of the lives of illustrious patrons and particular works they commissioned," as Kent rightly observed.[18] Nevertheless, examples of signposting and stretching provide particularly fertile terrain for finding such links, and identifying the consequent degree of interaction between patrons and artists.

The Principal's Use of Carrots and Sticks

Principals often cannot monitor the agent's actions with any precision. This inability proves important across an array of principal-agent relationships. The need to control hard-to-monitor agents has led economists to study methods of inducement and enforcement. In modern society, principals often employ a carrot-and-stick strategy. In the example of the modern executive and his advertising firm, the principal might offer financial bonuses for unusually good observable outcomes, such as big sales increases, and terminate relationships, impose penalties, and even launch lawsuits after bad ones. The agent has the motivation to secure future commissions from the same firm, and to establish its reputation so as to win business from other firms.

Renaissance contracts between patrons and artists reveal parallel strategies. Some contracts mention a range within which the fee would be paid, which implies more money for better work.[19] Though very few surviving contracts specify additional payment for superior products, O'Malley's research firmly establishes that value was a flexible concept. Especially for works by respected artists, one cannot simply measure the work and count the figures portrayed in order to estimate the price. O'Malley has found firm evidence that the artist's reputation and place of instruction contributed significantly to the value of his works. Among "commissions for which the painters received the very high price of 200 florins or more . . . almost half of these high fees were paid to men trained in highly renowned artistic centers who undertook commissions in provincial towns."[20] These painters reaped benefits from having studied in cities famous for artistic production, and probably they also profited from the good reputations of their masters.

The major force assuring that the unmonitored artist would produce high-quality work was his desire to enhance his reputation, both for professional success and artistic satisfaction, and to bolster future income. In information economics, reputation plays a major role in guaranteeing quality output from hard-to-monitor agents.[21] At the upper end of the market, a high-status reputation will both boost prices and increase commissions. Hence, it was valuable for Renaissance Italian artists, not merely their patrons, to have commissioned works on display. The reasons, though, were substantially different: patrons sought secure status and success; artists sought a reputation for artistic skill, which would ultimately lead to material reward.

Fifteenth-century Florence provides an instructive case. It saw little change in payment for most professions, including the vast majority of painters who produced simple devotional works at standard prices. If an artist reached an elite status, however, he could ask for and expect much higher compensation.[22] The preface to the third book of Vasari's *Lives*, introducing what we now consider the "High Renaissance," mentions the "extraordinary rewards" enjoyed by some artists, surely a reference to Michelangelo and perhaps to Raphael as

well.[23] In a fascinating passage, Vasari states that higher prices provided incentives for higher quality: "if, in this our age, there were a due need of remuneration, there would be without a doubt works greater and much better than were ever wrought by the ancients."[24] The author, himself an artist, provides the patrons among his readers with a clear message: they can develop talent and obtain better works if they pay higher compensation.

A very large carrot for agents was the hope of future work, from both the same principal and others. Though not specified in contracts, Renaissance artists assuredly understood this in the same way that plumbers and professors understand it today: a task done well stimulates solicitations for future tasks. Renaissance principals had the luxury of selecting the most appropriate agent, and that made artists strive for excellence as they competed for commissions. A famous letter written to the Duke of Milan, probably in 1493, describes the four major artists then working in Florence; the anonymous agent specifically mentions the work done for the pope and Lorenzo de' Medici, indicating that such illustrious patrons provided some assurance of quality.[25] Especially in major cultural centers, artists developed reputations, which we can still often trace in great detail centuries later. An established Renaissance artist had a body of works that local patrons, in most cases, could see repeatedly and for many years. Principals had a range of opportunities to evaluate the agents they might employ.

The most secure way to learn about quality in a principal-agent relationship is through personal experience, a possibility offered by repeat transactions. Not only does repeat business enhance incentives to the current agent, who can hope for future work after doing a good job, it relieves the principal of the task of shopping around for a new agent, and reduces the time and effort required to inform the agent about what he desires. Across Italy, many Renaissance patrons chose the same artist for many different projects over a period of years. Courts provide the clearest examples, as seen in the careers of Leoni and Mantegna. In such continuing relationships, artists created works in a style and with an iconography that they hoped and expected would not only continue to satisfy the patron but would lead to new commissions from others as well.

As for sticks—that is, punishing an agent for falling short—surely the most feared was rejection of a finished work. Beyond the artist's loss of reputation, a rejected painting or sculpture would have little or no value. Artists nearly always made major works to be site-specific and with details selected by the patron. Often they had to assume the considerable costs of the materials as the project progressed. The possibility of rejection, documented in numerous examples, added a significant instrument to artist-patron relationships. Principals could also wield the "stick" of humiliation against their agents. In 1515, the friars at the Florentine church of the SS. Annunziata were so unhappy with Rosso Fiorentino's recently completed fresco, the *Assumption of the*

Virgin, that they asked Andrea del Sarto to repaint it.[26] Just three years later, the disgruntled patron of Rosso's *Uffizi Altarpiece* did not place the work in its intended location, on the altar of a prestigious chapel in the Florentine church of Ognissanti, but rather exiled it to a small church in the countryside, and then commissioned a new painting for the Ognissanti. Moreover, he paid Rosso less that the contracted amount, after getting an appraisal that valued the disputed altarpiece at a modest amount.[27]

Other dissatisfied patrons also clubbed with this financial "stick." As we shall see in chapter 4, Elisabetta Aldovrandini refused to pay the full amount she had contracted with Domenico Ghirlandaio for an altarpiece. After Ghirlandaio's death, the painting was completed by his workshop, and in 1496 a court ruling established that the substandard quality and lack of verisimilitude of the portraits lowered its value.[28] Across Renaissance Italy, many documents stipulated that the established compensation for an artist could be decreased after his work was appraised.[29] The combined threats of rejection, humiliation, and reduced compensation discouraged artists from skimping on effort, and from turning out work of low or unacceptable quality. Moreover, these threats also encouraged artists to create works that would meet the ambitions of patrons. After his inauspicious beginnings in Florence, and partly in reaction to them, Rosso first sought work outside the city and then radically changed his style. He eventually became extremely popular and even worked for the king of France.

The agency relationship worked enormously well for commissioned art in Renaissance Italy. Quality was generally considered to be very high, and patrons were most often satisfied. Beyond carrots and sticks, a major element that kept artists faithful to their patron-principals was their own professional pride, the desire to produce outstanding works and achieve high status. This motivation was apart from and in addition to the material rewards that a fine reputation would bring. Artists were as concerned about their reputations as their patrons were concerned about the quality of the works that they commissioned. On this point, then, the interests of principal and agent were relatively well aligned. To be sure, the effort costs that went into the commission were overwhelmingly borne by the artist. Some of the benefits to him from a high-quality work, mainly future commissions, were also disproportionately his, whereas others, such as lasting fame, would be enjoyed by both principal and agent. Given that the benefits were great, artists had a strong incentive to turn out their best work.

While patrons and artists both sought high quality, they were more likely to diverge on the need to convey the ideal message. Presumably, artists wanted to produce the best possible works from the standpoint of aesthetics; making sure that a patron was presented in the most favorable light was surely a secondary consideration. We assume, however, that painters, sculptors, and architects tried to discern the interests and needs of their patrons, sometimes

through direct discussion, at other times by distilling indirect comments and evidence. In some instances, we can reconstruct such dialogues. When Pope Clement VII needed to communicate with Michelangelo about plans for the addition of the Laurentian Library at San Lorenzo, the patron, residing in Rome, and the artist, living in Florence, exchanged a large number of letters. This unusual circumstance allows us to "overhear" the pope's numerous and remarkably specific requests and questions.[30] Loosely translated, they include: Choose a location for the new library that destroys the least number of priests' rooms. Create one staircase that occupies the entire *ricetto* (vestibule.) How many books can fit at a desk? How is the lighting? The remarkable survival of these letters allows us to appreciate the library, perhaps the most famous example of Renaissance secular architecture, as more than the expression of the artist's aesthetic vision. Instead, "the form of the *ricetto* must be seen as the complex product of three exceptional factors: Michelangelo's creativity, Clement's ambition, and the restraints imposed by the preexisting structure on whose foundation the library was built."[31] Only further research and fortunate archival finds will let us know what kinds of explicit demands and inquiries were normal fare for major commissions.

The Roles and Reactions of Audiences

Clement sought to impress visitors to the Laurentian Library. Indeed, works of art often powerfully affected viewers. Thus, as argued by Alfred Gell in his 1998 book *Art and Agency: An Anthropological Theory*, these objects operate as inanimate agents for patrons, agents, and audiences.[32] The returns to a commission (i.e., its benefits) depend strongly on the reaction of audience members. They will view, learn from, and value works of art, or so patrons and artists hope. In that sense, the patron and artist "work" for their common principal, the audience. In a noble court, for example, even when a courtier ordered decorations for his private residence, his primary interest, and that of the artist, might be to please the duke or prince. If the courtier commissioned works for the royal palace, then he acted as principal in relation to the artist, but as agent in relation to the head of state.

Every patron-artist pair must consider its audiences, assessing how different types of viewers will react to the work produced, including the negative possibility that they will ignore it or, worse, scorn it. We can classify the main types of audience as contemporary, future, and heavenly; the first two, in particular, have numerous subdivisions of crucial importance to principals and artists alike. Many works have multiple audiences, and different aspects of a commission might be targeted at different groups. The patron's first law of commissions is to attend to one's audiences, starting with what their members know about you and proceeding to what you want them to know. If the three

prime elements of real estate are location, location, location, those for patronage are audience, audience, audience.

For all patrons of religious works during the Italian Renaissance, one primary audience was in Heaven. As discussed in chapter 5 (on private chapels), patrons wanted God and the saints to see their devotion, and hoped that their commissions would help them reduce their time in Purgatory. Naturally, patrons knew it was a good deed to commission objects that inspired or aided worship, and expected that such actions would help them in the afterlife. In the early 1500s, Paolo Cortesi explained that "the more erudite are the paintings in a cardinal's chapel, the more easily the soul can be excited by the admonishment of the eyes to the imitation of acts, by looking at [painted representations of] them."[33] As examples, he gave two painting cycles in Rome, the one in "Cardinal Oliviero Carafa's Chapel in S. Maria sopra Minerva," mentioned above, and that "in the votive chapel built by the most illustrious Sixtus IV in the Vatican." The patrons of the Carafa and Sistine chapels surely hoped their works would achieve exalted results, and they did.

Those who commissioned religious works presumably also believed in an omniscient God, one who could read the hearts and minds of all. That is, celestial beings hardly needed to see the coats of arms on the frame of an altarpiece or the inscription on the wall of the church to identify the donors. The frequent and prominent displays of personal emblems thus indicate that patrons had a second audience in mind, namely viewers here on earth. Naturally, within this audience only a few were influential, most were not affluent, and many were not male. Several recent studies have directed attention to the young, the poor, and especially to women as viewers of art.[34] Patrons wished to communicate with those elites, especially those in their own city or region, who could identify the banners, plaques, and symbols that accompanied so many commissions.

This point was not lost on Fra Girolamo Savonarola, who in the late 1490s raged in Florence against the self-promotion of patrons: "you know why they put their [coats of] arms on the back of vestments, because when the priest stands at the altar, the arms can be seen well by all the people."[35] For patrons seeking to affirm or increase their status, the local audience thus played a crucial role. Viewers came into a church, piazza, or bedroom; they saw the impressive altarpiece, palazzo, or portrait; and they perceived magnificence. For this quality, desired by the wealthy and influential across Italy, there was no absolute standard; it existed only as beheld by an audience. Practical experience and historical insight make it clear that the same signals can produce a wide range of reactions in different individuals and groups within the viewing audience.

Academic studies on the economics of information too often ignore the question of heterogeneity among those who receive the information.[36] In contemporary society, however, the most professional signalers—advertisers, mar-

keters, and public relations firms—have studied this question with intensity, making market research a science. In Renaissance Italy, many artists, architects, and patrons were good intuitive market researchers: they understood how different audiences would receive their signals. They were aware that audiences differed in sophistication, and in their sense of decorum. Many commissions, including those visible to the general public, targeted elite viewers. In the passage about chapels quoted above, Cortesi mentioned two examples in Rome. Andrea Mantegna, in a letter of 1489 to Francesco Gonzaga, discussed another in the same city, the chapel he decorated for Pope Innocent VIII. The patron for and size of that commission brought the artist honor, and "most of all in Rome where there are so many worthy judges."[37] In 1546, the gentleman and knight Sabba di Castiglione wrote about the proper decoration of a noble palazzo, and observed that some prefer the works of Piero della Francesca or of Melozzo da Forlì, "who for perspectives and their artistic secrets are perhaps more agreeable for the intellectuals than they are appealing to the eyes of those who understand less."[38]

Agents often put their greatest efforts into major commissions, such as those for important principals. Even works out of view of the general public, such as those just discussed by Sabba di Castiglione, found in the private residences of prominent individuals, might be seen by the audience that counted most, the elite. This group included, among others, potential future patrons for the artist. Nevertheless, we encounter exceptions to this pattern: strong efforts were sometimes made for modest audiences. For example, Vasari recounts how Perino del Vaga accepted a fresco commission in Florence "although the place was out of the way, and the price was small," for reasons of art: "he was attracted by the possibilities of invention in the story and by the size of the wall."[39] But still this work offered the possibility of marketing. Perino's friends hoped it "would establish him in that reputation which his talent deserved among the citizens, who did not know him."

Sometimes, though more rarely, commissions were pitched to "ordinary" members of society. In his architectural treatise published in Venice in 1537, Sebastiano Serlio noted that painters adapted their works for less sophisticated patrons. He discussed the importance of perspectival adjustments or foreshortening for figures painted on ceilings, but noted that "skillful workmen in our time have shunned such shortening for that (in truth) it is not so pleasing to the eyes of the common sort of people."[40] Major artists and patrons knew how to adapt commissions for the portions of their audiences considered most important.

As noted by Wolfgang Kemp, researchers must recognize that viewers' reactions will vary. They will reflect not only their diverse backgrounds and expectations but also the varied "conditions of access" to a given work. This concept, which Kemp helped develop within the theory of German reception aesthetics, refers to "circumstances in which the work of art appears, from

the communicative characteristics of the medium used; through positioning, format, and contextualization; to the encompassing institutions."[41] Studies addressing audience reactions to art need to bear in mind which groups saw the works, and under what circumstances.

We should expect a range of reactions to the same work, for example Donatello's *David*, from different viewers (such as the patron, female members of his family, government officials), and in different settings and circumstances. Surely the sculpture had a different impact when seen in the courtyard of a private palace during a wedding than when seen in the town hall, where it was moved after the revolution of 1494.[42] To be sure, we often cannot state with confidence how different audiences, especially those many centuries ago, reacted to a given work of art. But it would surely be surprising if there were not significant variations, and if Renaissance artists and patrons did not anticipate that.

In addition to their contemporary audiences in Heaven and on earth, many patrons had a concern for future viewers. Consideration of this additional audience allows us to identify a major benefit that distinguishes works of art and architecture from other forms of conspicuous consumption. Banquets, clothing, and funerals are transient. Paintings, sculptures, and buildings often endure for many generations. In the late 1400s, Agnolo di Bernardo Bardi declared in his will that his donation to obtain a chapel in the Florentine church Cestello should serve as "an example to other benefactors."[43] Clearly, he intended the space and its decorations to both enhance his own status and inspire commissions by other patrons. As we should expect from a commission stipulated in his last testament, Bardi considered the reaction of viewers after his death. The Venetian humanist Ermolao Barbaro made this point explicit in a letter of 1489, when he wrote to a friend that stone tombs were made not for the dead but for the future.[44] Similarly, donors of buildings to universities today, particularly those who are quite elderly or who leave monies in their wills, are also playing to the future.

Just as Renaissance patrons had to speculate about the reactions of their intended audiences, art historians must speculate as well when seeking to determine the intent of those who commissioned art, or how varying types of people reacted to a work. But speculate we must if we are to understand the patronage process. Doing so, we must recognize that any conclusions we reach will derive from an amalgam of evidence, theory, and inference, and that findings about some commissions must be extended to yield insights into other, similar commissions. Although ironclad documentation will never be available, we strive here to understand the motivations and strategies of the players in the commissioning game. The players' expected benefits, and the reactions from their audiences, constitute two of the key elements in our analytical framework, the subject of our next chapter.

Notes

1. The citation also stated that Thomas Schelling's work offered "a unifying framework for the social sciences"; see <http://nobelprize.org/nobel_prizes/economics/laureates>.

2. Aby Warburg, "The Art of Portraiture and the Florentine Bourgeoisie: Domenico Ghirlandaio in Santa Trinita; The Portraits of Lorenzo de' Medici and His Household" [1902], in *The Renewal of Pagan Antiquity: Contributions to the Cultural History of the European Renaissance*, trans. David Britt (Los Angeles: Getty Research Institute for the History of Art and the Humanities, 1999), 187.

3. John W. Pratt and Richard J. Zeckhauser, preface in *Principals and Agents: The Structure of Business*, ed. John W. Pratt and Richard J. Zeckhauser (Boston: Harvard Business School Press, 1985), 3.

4. Though women regularly commissioned and produced art in Renaissance Italy, the vast majority of individual patrons and artists were men; therefore we often employ the male pronoun for patrons in this volume. For more on female patrons see Catherine King, *Renaissance Women Patrons: Wives and Widows in Italy, c. 1300–1500* (Manchester and New York: Manchester University Press, 1998); Sheryl E. Reiss and David G. Wilkins, eds., *Beyond Isabella: Secular Women Patrons of Art in Renaissance Italy* (Kirksville, MO: Truman State University Press, 2001); and the discussion of Elisabetta Aldovrandini in chapter 3. For women patrons in the seventeenth and nineteenth centuries, see chapter 9.

5. On intermediary agents see Sheryl E. Reiss, "Raphael and His Patrons: From the Court of Urbino to the Curia and Rome," in *The Cambridge Companion to Raphael*, ed. Marcia B. Hall (Cambridge: Cambridge University Press, 2005), 36–55 and esp. 52–53, 319 note 12.

6. For a subtle analysis of this dynamic see Jill Burke, *Changing Patrons: Social Identity and the Visual Arts in Renaissance Florence* (University Park: Pennsylvania State University Press, 2004), and Patricia Lee Rubin, *Images and Identity in Fifteenth-Century Florence* (New Haven and London: Yale University Press, 2007).

7. Martin Kemp, "From 'Mimesis' to 'Fantasia': The Quattrocento Vocabulary of Creation, Inspiration and Genesis in the Visual Arts," *Viator* 8 (1977): 358–61. For the Renaissance notion of "generating" a work of art, also see Dale Kent, *Cosimo de' Medici and the Florentine Renaissance: The Patron's Oeuvre* (New Haven and London: Yale University Press, 2000), 5–6.

8. Kent, *Cosimo de' Medici.*

9. Sheryl Reiss presented this research in her lecture "To Be a Medici: Proclaiming Status, Identity, and Legitimacy in the Art Patronage of Giulio de' Medici (Pope Clement VII)" at the 2002 annual conference of the College Art Association, in the session chaired by Nelson and Zeckhauser. Unfortunately, external circumstances did not allow her to submit her study to this volume. For Clement VII, see *The Pontificate of Clement VII: History, Politics, Culture*, ed. Kenneth Gouwens and Sheryl E. Reiss (Aldershot, UK, and Burlington, VT: Ashgate, 2005). In "Raphael," 319 note 11, Reiss observed that Kent's thesis applies to "major, elite patrons with many commissions to examine. It is more problematic for less active patrons who might have commissioned a single work or works of modest ambition."

10. Creighton E. Gilbert, "What Did the Renaissance Patron Buy?" *Renaissance Quarterly* 51 (1998): 392.

11. Charles Hope, "The Myth of Florence" (review of Michael Levey, *Florence: A Portrait*, Cambridge, MA: Harvard University Press, 1996), *New York Review of Books*, 31 October 1996, 55.

12. Michelle O'Malley, *The Business of Art: Contracts and the Commissioning Process in Renaissance Italy* (New Haven and London: Yale University Press, 2005). For litigation between patrons and artists, also see Mareile Büscher, *Künstlerverträge in der Florentiner Renaissance* (Frankfurt am Main: Klostermann, 2002).

13. O'Malley, *Business*, 197.

14. For the drawing (British Museum, inv. n. 1860-6-16-75) and fresco, see Jonathan K. Nelson, "I cicli di affreschi nelle Cappelle Carafa e Strozzi," in *Filippino Lippi*, ed. Patrizia Zambrano and Jonathan K. Nelson (Milan: Electa, 2004), esp. 541–46, 579–83 cat. no. 39.

15. Gilbert, "What Did the Renaissance Patron Buy?" 446.

16. Christof Thoenes, "'L'incarico imposto dall'economia.' Appunti su committenza ed economia dai trattati d'architettura," in *Arte, committenza ed economia a Roma e nelle corti del Rinascimento (1420–1530)*, ed. Arnold Esch and Christoph Luitpold Frommel (Turin: Einaudi, 1995), 57–58.

17. Julian Kliemann, *Gesta dipinte. La grande decorazione nelle dimore italiane dal Quattrocento al Seicento* (Milan: Silvana, 1993), 85.

18. Kent, *Cosimo de' Medici*, 3.

19. O'Malley, *Business*, 122–25.

20. Ibid., 154.

21. See, for example, George J. Mailath and Larry Samuelson, "Who Wants a Good Reputation?" *Review of Economic Studies* 68, no. 2 (April 2001): 415–41, and Paul Resnick and Richard Zeckhauser, "Trust among Strangers in Internet Transactions: Empirical Analysis of eBay's Reputation System," in *The Economics of the Internet and E-Commerce*, ed. Michael R. Baye (Amsterdam: Elsevier Science, 2002), 127–57.

22. Susanne Kubersky-Piredda, "Immagini devozionali nel Rinascimento fiorentino: produzione, commercio, prezzi," in *The Art Market in Italy, 15th–17th Centuries*, ed. Marcello Fantoni, Louisa C. Matthew, and Sara F. Matthews-Grieco (Modena: Franco Cosimo Panini, 2003), 115. For the price of art, and the great difficulty in comparing different forms of compensation, see Guido Guerzoni, *Apollo e Vulcano. I mercati artistici in Italia 1400–1700* (Venice: Marsilio, 2006), 231–64.

23. On Michelangelo's income, see Rab Hatfield, *The Wealth of Michelangelo* (Rome: Edizioni di storia e letteratura, 2002).

24. Giorgio Vasari, *Lives of the Painters, Sculptors and Architects*, trans. Gaston du C. de Vere, ed. David Ekserdijan (London: Everyman's Library, 1996), 1:633 (preface to part 3).

25. O'Malley, *Business*, 148; Nelson, "Gli stili nelle opere tarde: interpretazioni rinascimentali e moderne," in Zambrano and Nelson, *Filippino*, esp. 392–93.

26. The *Assumption* was not repainted, however, perhaps because Del Sarto would not work at the same low rates as Rosso. See David Franklin, *Rosso in Italy: The Italian Career of Rosso Fiorentino* (New Haven and London: Yale University Press, 1994), 20. We will address the question of rejected works in our paper "Quality Control for

Commissions: the Potential for Rejection or Replacement," to be given at the annual meeting of the Renaissance Society of America (Chicago, 2008) in the session we organized titled "Unacceptable Art: Rejected Commissions in Renaissance Italy."

27. Ibid., 35–42. The patron, Leonardo Buonafé, acted as executor to the estate of the Catalan widow Francesca Ripoli. Thus, Buonafé served as principal to Rosso but as agent to Ripoli.

28. Jean K. Cadogan, *Domenico Ghirlandaio: Artist and Artisan* (New Haven and London: Yale University Press, 2000), 270–73, 377–78.

29. O'Malley, *Business,* 122.

30. See Caroline Elam, "Michelangelo and the Clementine Architectural Style," in *Pontificate of Clement VII,* 199–225. In most of the letters, the pope's opinions and requests were expressed via an intermediary.

31. Silvia Catitti, "Michelangelo e la monumentalità nel ricetto: progetto, esecuzione e interpretazione," in *Michelangelo architetto a San Lorenzo. Quattro problemi aperti,* ed. Pietro Ruschi (Florence: Mandragora, 2007), 94.

32. For the application of Gell's notions to Italian Renaissance art, see Michelle O'Malley, "Altarpieces and Agency: The Altarpiece of the Society of the Purification and Its 'Invisible Skein of Relations,'" *Art History* 28, no. 4 (2005): 417–41.

33. Kathleen Weil Garris and John F. D'Amico, "The Renaissance Cardinal's Ideal Palace: A Chapter from Cortesi's *De Cardinalatu,*" in *Studies in Italian Art and Architecture, 15th through 18th Centuries,* ed. Henry A. Millon (Rome: American Academy in Rome, 1980), 92; for discussion see Nelson, "Cicli," in Zambrano and Nelson, *Filippino,* 548, 576 note 173.

34. See, for example, Rubin, *Images and Identity,* 98–112, 180–81, 333, and Adrian Randolph, "Regarding Women in Sacred Space," in *Picturing Women in Renaissance and Baroque Italy,* ed. Geraldine A. Johnson and Sara F. Matthews Grieco (Cambridge and New York: Cambridge University Press, 1997), 17–41, both with further bibliography.

35. Girolamo Savonarola, *Prediche sopra Amos e Zaccaria,* ed. Paolo Ghigheri (Rome: A. Belardetti, 1971–72), 2:26.

36. See the classic text by David M. Kreps, "Topics in Information Economics," in *A Course in Microeconomic Theory, Part IV* (Princeton: Princeton University Press, 1990), 575–719.

37. Creighton E. Gilbert, *Italian Art, 1400–1500: Sources and Documents,* 2nd rev. ed. (Evanston, IL: Northwestern University Press, 1992), 13.

38. Robert Klein and Henri Zerner, *Italian Art, 1500–1600: Sources and Documents* (1966; reprint, Evanston, IL: Northwestern University Press, 1989), 23.

39. Vasari, *Lives,* 2:166.

40. Sebastiano Serlio, *The Five Books of Architecture: An Unabridged Reprint of the English Edition of 1611* (New York: Dover Publications, 1982), 66.

41. Wolfgang Kemp, review of John Shearman, *Only Connect . . . Art and the Spectator in the Italian Renaissance* (Princeton: Princeton University Press, 1992), *Art Bulletin* 76, no. 2 (1994): 366. See Rubin, *Images and Identity,* on the importance of considering how and why observers engage in different types of seeing.

42. For two quite disparate approaches to the different audience reactions to the work, see Francesco Caglioti, *Donatello e i Medici: storia del David e della Giuditta*

(Florence: L. S. Olschki, 2000), esp. 101–52, 182–218, 291–319, and Adrian W. B. Randolph, *Engaging Symbols: Gender, Politics, and Public Art in Fifteenth-Century Florence* (New Haven and London: Yale University Press, 2002), 139–92.

43. Alison Luchs, *Cestello: A Cistercian Church of the Florentine Renaissance* (New York: Garland, 1977), 40.

44. Martin Gaier, *Facciate sacre a scopo profano: Venezia e la politica dei monumenti dal Quattrocento al Settecento*, trans. Benedetta Heinemann Campana (Venice: Istituto veneto di scienze, lettere ed arti, 2002), 93.

BENEFITS, COSTS, AND CONSTRAINTS

Introduction: Benefit-Cost Analysis

TO UNDERSTAND a game, we first identify the players. We then assess the range of actions each can take and the payoffs each can receive depending on the actions of the other players. For the art-commissioning game, in evaluating a patron's payoff, we should ask: what benefits did he seek to obtain when he engaged an artist, and what costs did he face? The latter include not only the financial outlay for a work but also the risk that a work might receive a negative reception. An understanding of these benefits and costs helps explain the choices made by the two featured players, the patron and the artist, or in the game-theoretic terminology presented in the previous chapter, the principal and the agent.

The benefit-cost framework provides significant insights into the appearance of commissioned art. While published research on patrons and monuments provides invaluable information about benefits (mainly social) and costs (mainly financial), the data are often scattered across studies whose main focus lies elsewhere. When art historians investigate these benefits and costs, they often use an anecdotal approach, without a systematic methodology. Benefit-cost analysis gives us a useful framework for systemic research on these payoffs, appropriate even when principals and agents acted intuitively.[1] Such analysis underlies the study of choice processes in economics and is particularly helpful when studies need to bring together a variety of elements that cannot be measured in financial terms.

The financial cost of a commission brought its own benefit. For a work of art to successfully convey certain desirable features, the production of the signal must have a high cost, at least sufficiently high to deter those who choose not to send it. For example, if a signal is to convey great wealth and power, the merely affluent and only important must find that signal very expensive to send. If all patrons could construct personal palaces or present themselves as heroes in bronze statues, the resulting architecture and art would convey little useful information. Unless the required expenditures are large enough to seriously dent the finances of patrons who choose instead to make smaller commissions, many others will make similar commissions. Beyond the financial cost of producing a signal, there is the potential of a negative reception cost. Few of us, even if we could afford to do so, would have ourselves portrayed

in a life-size bronze sculpture as a heroic ruler or champion athlete. Any patron, even the most affluent, will seek to avoid ridicule. A central lesson from signaling, discussed in the next chapter, is that high costs, be they financial or social, actual or potential, are necessary to obtain signaling benefits. In Renaissance Italy, patrons wanted value, but they were not hunting for bargains.

Benefit-cost analysis posits, quite simply, that a patron decides to commission a work when he expects—thanks to instinct or calculation, societal norms or past experience—that benefits will exceed costs. But another significant factor enters the calculation: constraints that operate on both the patron and the artist. These constraints came in many forms in Renaissance Italy and, for the most part, they were problems that could not be solved with money. In most churches, for example, even great riches would not allow a private patron to obtain the rights to the main altar. (If he did acquire this honor, that is, were he not subject to this constraint, that in itself would convincingly signal unusually high status.) Scholars regularly consider the practical limits on architectural projects, such as the physical conditions of the site or the availability of certain materials. This approach can be extended to include all commissions and a wide range of limitations. It provides a useful way to begin research on a commission, to clarify the options that were available.

In the Renaissance, the often unspoken rules of decorum imposed many of the most important constraints. These rules were subtle and complex; hence knowledge of them allowed viewers to differentiate between savvy patrons and inexpert ones who clumsily followed in their footsteps. Today, it is a challenge to reconstruct these norms, but we can note the social cost that patrons faced when they violated social conventions. Given that most patrons followed the rules of decorum, an awareness of those constraints can help us identify who commissioned undocumented works of art. A recent study, for example, convincingly argues that a set of twelve marble heads depicting Roman emperors, made by Desiderio da Settignano for someone in Naples, must have been intended for the king. The sculptures would have been inappropriate for anyone except the ruler, even for the wealthy few who had the financial means to make such a purchase.[2]

A different type of constraint, one we all confront when we go shopping, is that of total financial resources. Even if a patron concludes that a given project is worth the money, that is, the expected benefits exceed projected costs, it still may be forgone if he considers his available funds alongside the costs of other potential commissions that may prove more valuable. A patron with one thousand florins to decorate his bedroom or chapel will select the commissions that give the biggest bang for his buck, subject to the limitation that he cannot blow his overall budget. Economists refer to such a process as maximization subject to constraint.[3]

Constraints, together with benefits and costs, constitute the three basic elements of our analytical framework. That framework reminds researchers to ask

a series of key questions, and to focus attention on important though often overlooked points. The systematic consideration of these three main elements facilitates the study of the choices made by both principals and agents, and thus the evaluation and comparison of artistic commissions.

Unfortunately, historical studies rarely allow us to ascertain all the benefits, costs, and constraints of any given project with any precision. Not only has most documentation been lost, at least of the Renaissance era, but many of the intangible benefits and costs never found their way into the written records. Fortunately, significant evidence does survive for a large number of commissions. When we consider the evidence provided by them collectively, strong conclusions emerge.

Before discussing benefits, costs, and constraints in depth, we illustrate how these elements can deepen our understanding of a major commission from the late fifteenth century (fig. 2.1): the chapel of the powerful Neapolitan cardinal Oliviero Carafa in the prominent Roman church Santa Maria sopra Minerva, decorated by the leading Florentine painter Filippino Lippi, and by Lombard sculptors.[4]

The Carafa Chapel in Rome

When Carafa sought a chapel for himself in the Dominican church of the Minerva, he presumably wanted the most prestigious one possible. Across Italy, patrons and viewers would agree that the most impressive chapel was the one behind the main altar. This certainly held true for the Minerva, given that the altar block contained the relics of one of the most important Dominican saints, Catherine of Siena. In this church, as was typical in the period, the religious order maintained, and was intent on keeping, control of this space.[5] Thus the most prestigious chapel in the Minerva was not available to Carafa, though he was one of the most powerful cardinals in Rome at the time, and the cardinal protector of the Dominican Order. Had Carafa sought the rights to this chapel, he would have encountered a powerful constraint. (Significantly, a few decades later the first two Medici popes—Leo X and Clement VII—had their tombs erected in this very space. The difficulty of obtaining a burial place there signaled the extremely exalted status of the patrons.)

Carafa found a different way to demonstrate his exalted status. He used size and design to make a grand statement. In 1485 he purchased a small structure adjacent to the right transept, then had a large chapel constructed there; he thus replaced an existing altar, or perhaps a small chapel, dedicated to the Virgin Annunciate. Spatial constraints also led Carafa to a more daring decision: next to his main chapel he had a smaller one carved out of the wide buttress to create a vaulted burial chamber. In this way the patron obtained a prominent and honorable space for both burial and worship. To set the new

chapel off from the main body of the medieval church, Carafa commissioned an accomplished architect, perhaps Donato Bramante, to design a magnificent marble arch in an innovative style.[6] The arch bears an inscription with the name of the patron, and the double dedication of the chapel. Carafa, evidently unsatisfied with the original dedication to the Virgin Annunciate, used his authority to add, unusually, a second. His chapel also honors Thomas of Aquinas, the patron's own ancestor and one of the major Dominican saints.

The cardinal's position also allowed him to overcome a constraint that most patrons would have faced; he secured the services of a leading artist who was already engaged. Shortly before he met Carafa, Filippino Lippi had agreed to paint the fresco for the chapel of Filippo Strozzi, the wealthiest man in Florence, in the Florentine church of Santa Maria Novella. Fortunately for Carafa, Strozzi needed to remain on good terms with Lorenzo de' Medici, the political leader of Florence, who in turn needed the support of Carafa. Lorenzo wanted his thirteen-year-old son, Giovanni, to be named cardinal at that very time, but the powerful Carafa could have blocked this decision. Thus Lorenzo arranged for Filippino to work for Carafa in 1488, and Strozzi agreed to wait. Carafa incurred an obligation by thus obtaining the artist he wanted, as we learn from a fascinating letter of 1490. In reporting on progress in the painting of the Carafa Chapel, an associate of Lorenzo added: "I am certain that the Cardinal [Carafa] will remain indebted to you [Lorenzo] and content with him [Filippino]."[7] Indeed, young Giovanni de' Medici had recently obtained his cardinal's hat, and he later became the first Medici pope, Leo X. Naturally the Carafa Chapel also brought the cardinal financial costs, conveniently spelled out in another Renaissance source. Vasari wrote that it was valued at two thousand ducats, an extraordinary sum that probably included both materials and labor.[8] The fabulously wealthy Strozzi family, by contrast, spent about half that amount for all the decorations of the Strozzi Chapel frescoed by Filippino.[9]

Documents do not itemize other types of costs Carafa incurred for obtaining and decorating his chapel, much less the benefits he sought. These we must infer from contemporary norms, and from the nature of the commission itself. No doubt Carafa hoped for divine intervention to help him achieve salvation. The *Annunciation* of Filippino's frescoed altarpiece expresses this aspiration in visual terms: the kneeling cardinal is presented by Saint Thomas to the Virgin, who seems to turn and acknowledge the patron. Carafa's magnificent commission honored these two holy figures, and a papal bull of 1493 immediately transformed his recently completed chapel into a focal point for the cults of both. This decree—whose issuance was yet another reflection of Carafa's status—granted indulgences to worshippers visiting the chapel for the feasts of the Birth of the Virgin and of Saint Thomas. On the former event, the Brotherhood of the Most Holy Annunciation visited the Carafa Chapel as part of its annual procession. On the latter holiday, the pope himself conducted mass at the high altar, in the presence of the College of Cardinals. The annual

sermon was often given by scholars whose research on Thomas had been sponsored by Carafa himself. As the cardinals listened to these speeches, they could have admired the stories of Thomas depicted in Carafa's chapel. One of these, the *Miracle of the Speaking Crucifix*, is arranged to look best when seen from the high altar.[10] After the mass, the cardinals visited the chapel itself.

Carafa must have hoped that Saint Thomas and the Virgin would appreciate how Filippino's paintings of them inspired good deeds. According to Paolo Cortesi, as we observed in the previous chapter, the chapel frescoes did have this impact on the erudite. The group naturally included the cardinals and learned Dominicans. They could read the Latin inscriptions, surely provided by the patron or one of the scholars he supported, and could recognize their sources in Thomas's writing. Learned Dominicans would also have appreciated how Carafa revealed his support of one interpretation of Thomas through the details in Filippino's *Triumph of St. Thomas*. The cardinal endeavored to impress, influence, and inspire these erudite viewers while he promoted the cult of Thomas.

Carafa also entertained hopes that the College of Cardinals would elect him as pope; he nearly achieved this goal in 1492, and again in 1503. Though the cardinals obviously would not base their decisions primarily on art patronage, Carafa used his commissions to help create an image of himself as worthy of the Seat of Peter. Thus, the decorations of his chapel recall those in the Sistine Chapel, the recently completed chapel of Pope Sixtus IV, in a range of specific features, from the representation of the kneeling donor in the altarpiece and the inscriptions, to the pavement and balustrade.

In many of his commissions the cardinal expressed "the virtue of magnificence," to borrow the title from a 1498 treatise by Giovanni Pontano. The author, a humanist and statesman known to Carafa, succinctly identified another fundamental benefit sought by the cardinal in his art patronage. Noble people are particularly intent "to realize the long lasting of their name and reputation, for which man's desire is infinite."[11] As discussed in the next chapter, the display of magnificence requires grand expenditures; for Pontano, "magnificence is the fruit of money."[12] Though Carafa paid two thousand ducats for the Carafa Chapel, this did not represent a major sacrifice, since we can infer that his fortune was vast. Just a few years later, he is said to have spent fifteen thousand ducats for the construction and extensive marble decoration of a chapel in the Cathedral of Naples.[13] Renaissance cardinals earned enormous amounts, and Carafa could have spent much more on his chapel in Rome. For example, he could have included a marble statue of himself, as he did in his chapel in Naples (fig. 2.2). Carafa also commissioned a marble relief, including a portrait, on a tomb for a family member in another church in Naples. Why did he forgo this in Rome?

Carafa's Roman chapel, however magnificent in some contexts, was strategically restrained in others; that is because he worked within the constraint

FIG. 2.2. Tommaso Malvito, *Portrait of Oliviero Carafa*, Succorpo Chapel, Duomo, Naples (Luciano Pedicini Archivio dell'Arte, Naples, Curia Arcivescovile, Naples)

of maintaining decorum. Because of the risk of incurring stiff social costs, he decided not to commission certain works in his Roman chapel, such as a large marble portrait. In the Sistine Chapel the patron appeared only once, as kneel-

ing in Perugino's frescoed altarpiece (now replaced by Michelangelo's *Last Judgment*). Perhaps Cardinal Carafa, who aspired to the same position as Sixtus IV, thought it would be inappropriate if he tried to "outdo" the pope. In Filippino's frescoes Carafa also appears only once, as kneeling in the altarpiece; the patron rejected the idea, reflected in the preparatory drawing for the *Triumph over the Heretics*, of including a second portrait. Most probably Carafa wanted to cultivate a reputation for modesty and frugality, qualities praised by his contemporaries. This might also explain why he only rented a palace in Rome, though it would have been less costly to purchase his own.[14] In these ways Carafa avoided offending other cardinals. He presented himself as interested only in the glory of God, and not in personal vanities, a strategy to foster his (ultimately unsuccessful) candidacy to become pope. Nevertheless, he did this in such a way as to impress both contemporary and future visitors to the chapel with his importance and that of his family. The commission thus helped to realize one of the primary benefits of commissions in Renaissance Italy.

Social Benefits

The benefits Carafa expected from his commission were hardly desired only by patrons of his exalted status. This aristocratic cardinal from Naples manifestly shared the goals expressed by Giovanni Tornabuoni, a Florentine merchant, in his contract of 1485 with Davide and Domenico Ghirlandaio. Tornabuoni specified that the frescoes in his chapel in Santa Maria Novella were commissioned "as an act of piety and love of God, to the exaltation of his house and family and the enhancement of the said church and chapel"[15] (fig. 2.3). And in a now famous quote from a dozen years earlier, another Florentine patron and merchant, Giovanni Rucellai, explained in a memorandum for his descendants that his commissions brought him "the greatest contentment and the greatest pleasure because they serve the glory of God, the honor of the city, and the commemoration of myself."[16]

When discussing Rucellai's quote in *Painting and Experience in Fifteenth Century Italy* (1972), one of the most influential modern studies on Renaissance art, Michael Baxandall, argued that "it is not very profitable to speculate about individual clients' motives in commissioning pictures." We believe, however, that by identifying the desired benefits we can better understand the choices made by principals and agents (or clients and artists, in Baxandall's terminology). The desire to honor the city, for example, naturally resonated with civic patrons. In 1406, the governors of Siena deliberated that frescoes by Taddeo Bartoli in the town hall were intended "to decorate the chapel and honor our Commune."[17] Private patrons, the primary focus of this volume, sought important benefits from their audiences in Heaven as well as those here on earth, the group to whom we now turn our attention.

Countless treatises, letters, and wills—here we provide but one example of each—reveal the role of art in establishing and burnishing an honorable reputation. In his treatise *On the Art of Building*, the humanist Leon Battista Alberti wrote that "we build great works so as to appear great in the eyes of our descendants; equally we decorate our property as much to distinguish family and country as for any personal display."[18] These words aptly apply to the commissions made by his own ancestors in the Florentine church of Santa Croce, as discussed in chapter 6. The Alberti family ordered, among other works, highly visible tombs in the church. Perhaps they were motivated by the rather surprising reasoning expressed by the merchant Filippo Strozzi, in a private missive about plans for the tomb of a deceased relation: "the honor gets assigned to us and not to the dead, and in making it beautiful we honor ourselves."[19] No doubt, these patrons also made their "artistic" decisions for religious reasons. In a similar vein Giovanni Grimani, the Venetian patrician and prelate, used his first will, of 1592, to order the sale of his antiquities. He was concerned that he had "offended God by collecting . . . and having spent on such vanities a great amount of money which could have been applied to works of charity."[20] Nevertheless, the great collector had a change of heart six months later, and requested that the cameos and medals be given to his nephew "for the honor of our house of the Grimani." Architectural monuments, marble tombs, and collections allowed patrons to obtain the high—for some the supreme—benefits of honor and distinction.

Writing in Naples, Pontano mentioned the aesthetic pleasure derived from "ornamental objects," such as statues, paintings, and tapestries, but hardly emphasized this as a motivation for patrons. "Their appearance delights, and they bring prestige to the Lord [i.e., owner], because they are seen by many who fill the house."[21] Pontano explained how magnificent commissions trumpet the status of patrons, and how those notes echo: "such buildings, when made in this way, attract visitors from the most distant parts to admire them, and invite poets and writers to praise them."[22] Indeed, a vast body of poems–and, beginning in the sixteenth century, published letters, travel journals, and treatises as well—refer to specific works of art. Often, especially for portraits, tombs, and palaces, the patrons themselves are mentioned. Their fame traveled widely, thanks to the written word.

Already in the Renaissance we find the now familiar concept that a patron's name is linked to that of a famous artist. In a letter of about 1569 to Bartolomeo Ammanati, a fellow sculptor-architect, Guglielmo della Porta, described his plans for a treatise:

There will be a short discussion about some of the illustrious princes who, with their great generosity, brought many of our profession to true excellence, such as the Magnificent Giuliano, the great Michelangelo; Duke [Ludovico il] Moro, Leonardo da Vinci; Pope Leo [X], Raphael of Urbino; [Pope] Julius II, Bramante;

[Pope] Paul III, Antonio da Sangallo; Signor Jeromino Morone, Amadeo; the Prince of Oria [Andrea Doria], Perino del Vago; . . . the most illustrious [Cardinal Antoine Perrenot de] Granvela, Lione [Leoni] Aretino . . . and others.[23]

Given their interest in future audiences, these patrons would have appreciated that their prestige has spread not only far but long. Visitors today crowd museums and palaces to see magnificent Renaissance works whose patrons are often identified. These viewers can still discern, centuries later, the wealth and status of the people who spent so expansively on their artistic commissions.

The prestige brought by art was particularly important to patrons in late medieval and Renaissance Italy. As Goldthwaite has demonstrated, the powerful and wealthy Italian families lacked some valuable elements that were available elsewhere for impressing each other and the general citizenry.[24] Staged jousts were helpful, but these sporting events were pale imitations of the real battle victories that characterized the grandeur of nobles in northern Europe. The merchants had respectful servants but lacked both the vassals and huge retinues of the elites in England, France, and the Germanic states.

The status-claiming situation in Florence was especially complex because power and nobility had been severed. In the late thirteenth century the newly formed communal government excluded the old noble families, the magnates, from the most powerful political offices.[25] Over time, a new class of Florentine patricians arose that mimicked the behavior of the politically disenfranchised former nobles, much as wealthy New Yorkers in the late nineteenth century took on the habits and appearance of English gentlemen and ladies. The affluent merchants in Renaissance Florence, and to a lesser degree the elites across Italy, needed mechanisms to establish and validate their new status. Art provided a perfect opportunity for individuals to signal their status and to solidify their identity.

In Florence, several of the most important patrons of art and architecture came from families that suffered periods of banishment, as did the Alberti, Medici, and Strozzi. In the 1430s, after the Alberti had been exiled, the humanist Leon Battista Alberti wrote his his widely read book *The Family*. Significantly, when discussing expenditures that contribute to honor and status, he referred to the works described as commissioned by "our fathers."[26] His words helped trumpet the fame of these monuments, but the works carried their own message: they were decorated with the family arms and symbols, which were visible to all. Commissioning art and architecture thus provided a long-term publicity benefit not available through other forms of conspicuous consumption. Even when families fell into disgrace, their arms were rarely removed from buildings.[27]

The frequent shifts in power in virtually all major cities made the concern for one's political status particularly important. The most powerful clan in Florence, the Medici, were exiled no less than three times in less than a cen-

tury. Would the banishments have been even more frequent, or for longer periods, if the lofty status of the Medici had not been widely proclaimed? Niccolò Machiavelli believed that the prudence, wealth, and lifestyle of Cosimo the Elder "caused him to be respected and loved by citizens in Florence, and held in wonderful consideration by the princes not only of Italy, but of all Europe."[28]

Significantly, Cosimo constructed his massive town house just after returning to Florence from a brief exile. Given his recent absence, the Medici leader particularly needed to signal the solidity and importance of his family locally. Writing in the early sixteenth century, Francesco Guicciardini rightly predicted that the works Cosimo commissioned would last and keep his fame alive.[29] Art and architecture even helped the banker and merchant earn the respect of the landed gentry in northern Europe. The international status and renown of the Medici continued to grow and spread over the next century. It also allowed them to achieve success in the "marriage market," the golden ladder of social climbing in Renaissance Europe. In 1565, Francesco I de' Medici married Johanna of Austria, sister of Holy Roman Emperor Charles V and a member of the prestigious Hapsburg family.

That grand public buildings help to ensure political stability had already been noted by Aristotle, and Galvano Fiamma, in a text dating to the early 1330s about the Milanese leader Azzo Visconti, elaborated this notion. "The people seeing wonderful residences, stand rapt in fervent admiration. . . . On account of this, they are convinced that the prince is so powerful that it would be impossible to attack him."[30] A century later, Alberti expressed a closely related idea: the special effect that beauty has on the public protects buildings against destruction.[31] And in his book written for cardinals in the early 1500s, Cortesi stated that sumptuous architecture "easily restrains the admiring multitude from doing harm," and mentioned instances when mobs had destroyed buildings lacking architectural value. He recommended that his reader live in a building "which will dazzle the eyes of the people by its dignified splendor."[32]

Another "political" benefit to patronage, as described by an ancient source, caught the attention of Giovanni Rucellai. The Florentine architectural patron noted in his private memorandum that Gnaeus Octavius "was made consul of Rome, the first one of his family, on account of his building a very beautiful palace . . . a palace imbued with great dignity and renown because it embodied good order and measure, and he understood that it was the reason for his acquiring the greatest goodwill and favor with the people."[33] Rucellai believed that magnificent commissions would also lead to a more general "goodwill." Surely the Florentine merchant and his contemporaries took this lesson to heart as they attempted to polish their reputations though patronage. Another Florentine author, writing a few years later in the 1460s, assessed a group of influential and anti-Medici Florentines who met at the new home of Luca Pitti:

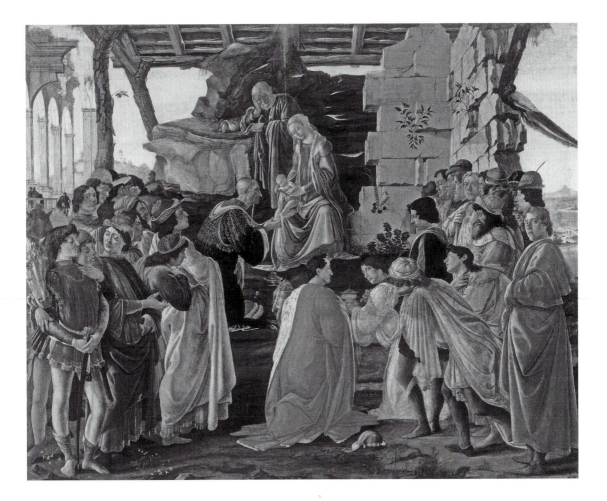

"they consented to his having such prestige, and to increase it they too visited his house. And they did this to block Piero [di Cosimo] de' Medici, to whom previously everyone was accustomed to going to consult on public affairs as well as private."[34] Then, as today, certain visitors can both add to the status and flag the political affiliation of a host.

Botticelli's *Adoration of the Magi* in Florence illustrates how a patron used art in his attempt to obtain goodwill from the local rulers (fig. 2.4).[35] The painting includes several prominent portraits, including those of Cosimo de' Medici, his son Piero, and grandsons Lorenzo and Giuliano. For most viewers, then and now, these effigies suggest that the patron, Gasparre Del Lama, a minor broker, had close ties with the family. In reality, Del Lama had no significant connections with the Medici, and he evidently used the altarpiece to flatter them. Lorenzo was the effective ruler of Florence, and his brother Giuliano belonged to the same guild as the patron. Authors generally assume that Botticelli carried out this work before Del Lama was tried and condemned for fraud in 1476.[36] In the end, no one raised a finger to help Del Lama, and perhaps the Medici, though open to pandering, found it unwelcome from frauds.

FIG. 2.4. Botticelli, *Adoration of the Magi,* Galleria degli Uffizi, Florence (Archivi Alinari/Bridgeman, Florence)

If the patron had had something special to offer the political leader, he might have fared better. In 1621, for example, when Nicolò Avellani was on trial in Mantua, he obtained a pardon from Duke Ferdinando in exchange for the "gift" of several prestigious paintings in his collection.[37] The Gonzaga dukes, in turn, like the rulers of other artistic centers, used their unique position to commission paintings and sculptures they could give as gifts to more powerful leaders. These works, such as Correggio's *Loves of Jupiter*, donated from Duke Federico II Gonzaga to Emperor Charles V, or Bronzino's *Allegory of Love*, given by Duke Cosimo de' Medici to the French king Francis I, not only communicated the sophistication of the patron but also brought him political benefits. In a similar way, as we have seen, Lorenzo de' Medici arranged for Carafa to obtain the services of Filippino, and thus the cardinal remained in debt to the Florentine leader.

Financial Benefits

Commissions did more than allow patrons to consolidate and improve their status. They helped signal political connections, which often led to economic benefits: a scholar might get a lucrative public appointment, a merchant a significant tax break. In the sixteenth century, we find several patrons across Italy who proclaimed their allegiance to rulers through inscriptions or symbols on the façades of their homes. Both the Lanfredini and the Pandolfini did this in Florence, for example, as did Leone Leoni in Milan.[38] In paintings, the most obvious way to curry favor was to embellish works with portraits of political leaders, as Del Lama attempted to do in Botticelli's *Adoration of the Magi*. The principals themselves probably made decisions of such delicacy, and certainly approved or rejected them if proposed by their agents.

Highly conspicuous commissions could yield economic benefits more directly. A letter discussed in chapter 7 demonstrates the impact of Leone Leoni's impressive home, servants, and horses. They convinced one of his contemporaries that the sculptor could be trusted with a large quantity of silver. Others surely felt the same way about conspicuous and costly commissions. Artistic investments conveyed success and financial stability, and sometimes were bread cast upon the waters effectively. These messages resonated particularly well in early modern Europe, whose economy depended on credit. Italy was far from an all-cash society; not only the most important banks and businesses, but also the small shops, employed a complex mixture of cash, barter, and loans. Though construction workers received regular wages, requiring patrons to have cash on hand, the wealthy enjoyed generous credit lines from merchants. "Personal appearances and household possessions were, therefore, not only signals about social standing and prestige," as Evelyn Welch recently demonstrated; "they were also key indicators of credit-worthiness."[39] Art and

architecture, we believe, served a similar function. A man who owned a grand town house in the center of town and had decorated a prominent family chapel would find traders, silk merchants, and fishmongers more willing to accept his promises of repayment, and those of his servants and family, in exchange for their goods. Similarly, a home that did not include shops on the ground floor clearly signaled the wealth of the owner. (As an added benefit, in Florence at least, architecture used only for domestic purposes was exempted from taxation, a Renaissance tax break for the affluent.)[40] "Luxury," as Karl Marx observed, became "a business necessity" as "an exhibition of wealth and consequently as a source of credit."[41]

The need to keep up appearances also discouraged a patron from selling off property. In her analysis of Francesco Castellani, a Florentine merchant in the 1400s, Welch revealed that he "was forced to maintain his stature by a high level of consumption . . . his political and social credit depended in the most literal sense on what he and his family wore, ate, and gave as gifts to friends and potential allies."[42] Whenever possible Castellani used his servants and friends to conceal actions, such as taking loans or pawning goods, that might reveal his precarious financial situation. The desire to conceal what he hoped would be a temporary shortage of funds might explain why Castellani did not sell off the prominent and valuable family chapel in Santa Croce, one of the city's most honored churches.[43] In 1486, Filippo Strozzi had paid the considerable sum of 300 florins (over fourteen years' pay for a laborer) to purchase a chapel in Santa Maria Novella from a family down on its luck.[44] Such a sale would immediately signal duress, and Castellani sacrificed to avoid sending such a message.

Financial Costs

The financial benefits of commissions were indirect, and hard to measure. Their financial costs were all too tangible. All art considered in this volume entailed high direct financial costs, though often not for reasons that a modern viewer would suspect. Until well into the sixteenth century, the materials for a large altarpiece often cost more than the labor, even for the efforts of famous artists. Gilded wooden frames were usually more expensive than the images they contained. Reflecting the cost of their materials, frescoes provided the cheapest solution for figurative mural decorations, and tapestries were the most expensive. In the Sistine Chapel, for example, Pope Julius II paid Michelangelo six thousand ducats for the labor and supplies needed for the vault frescoes; his successor, Pope Leo X, paid Raphael one thousand ducats for cartoons or full-scale drawings for the ten tapestries that hung on the side walls, but the total cost for the tapestry works, including weaving and the threads of gold and silver, was about fifteen thousand ducats.[45] When we turn

to building projects, in the Renaissance as today, payments to even major architects were but a small fraction of the total costs.

Reflecting the price of materials, Renaissance sculptures in marble and bronze cost far more than paintings of a similar or even much larger scale; this represents a neat reversal of current prices. For most Renaissance patrons, however, buildings constituted the most expensive genre discussed in this volume: a palazzo cost at least ten times more than an altarpiece but usually much more. Though exact prices are difficult to establish, we have considerable information about Renaissance Florence. In 1473 Bongianni Gianfigliazzi estimated the value of his recently completed palazzo—purchased partly built in 1460 for two thousand florins (83 man-years)—at five thousand florins (212 man-years).[46] Goldthwaite calculated that the Bardi-Busini remodeled their palazzo in 1487 for 155 man-years, the Da Gagliano spent 103 man-years in the 1520s for a new façade, the Bartolini paid 611 man-years between 1520 and 1533 for a major palace, and for one of the largest Renaissance homes, Filippo Strozzi and his heirs paid for 1,333 man-years by 1506.[47] These costs in man-year equivalents exceed those of even the most fabulous private mansions today.[48]

Often the original patrons never lived to see their buildings constructed. Such was the case of Luca Pitti, who complained of "a host of debts, hundreds and hundreds of florins," and of Filippo Strozzi, who in the view of one contemporary was "lorded over" by his own palazzo.[49] Some Florentines even went bankrupt building; Giovanni Boni, for example, had to sell off his recently completed home. These events illustrate the extraordinary costs patrons were willing to incur, that is, the risks they were willing to take, to signal their wealth and status.

Social Costs

Beyond the monetary costs of commissions, patrons had to bear "social costs." These were usually incurred when the message received from a work of art differed from the patron's expectation. At a minimum, an audience might miss the intended message of a commissioned work; at worst, an artwork might receive a negative reception. Consider four reasons why a work of art might fail to convey what the patron wished. First, commissions left incomplete for any reason often put patrons in a poor light. In Orvieto, the cathedral *opera* or board of works declared in a meeting that the group was "held in the lowest esteem" and suffered "disgrace" because a fresco cycle begun forty years earlier by Fra Angelico was still unfinished.[50] Though the views of their colleagues in Siena are not documented, the board members there must have felt even greater shame when the overly ambitious plans for the "new cathedral" were abandoned.

Second, a dramatic change in ownership, such as those resulting from the common afflictions of confiscation, political failures, or bankruptcy, inevitably changed the meaning of art. Often it delivered a blow to the status of the original patron beyond the mere loss of the opportunity to impress. Sometimes the new patron took credit for a work begun by others, as Pope Leo X did when he had his name prominently inscribed in Raphael's *Room of Heliodorus*; the fresco cycle had been commissioned by Julius II and was nearly completed in his lifetime.

Third, the iconography could be too abstruse or complex, confusing the intended audience. In 1475, for example, when the humanist Giovanni Aurelio Augurelli attended a joust in Florence, he did not understand the meaning of the painted banner carried by Giuliano de' Medici. Though he described this in a positive light—"Everyone has a different opinion and nobody agrees with anybody else. This is more delightful than the pictures themselves"—the patron may have considered such iconographic ambiguity a cost.[51] In a similar vein, a display of erudition might backfire, like a bon mot injudiciously placed or misunderstood. This fate befell Bartolomeo Valori at the very end of the sixteenth century. His decision to adorn the façade of his Florentine palace with portraits of famous Florentines as herms—stone posts with sculpted heads—stirred invectives from contemporary authors. One poet complained that these carvings insulted the very figures they were intended to honor by impaling them like criminals. He also found them ugly.[52]

Works of poor style or quality were the fourth and most important example of art messages missing their mark. In a letter to the building committee of the Piacenza Cathedral, Leonardo warned that if the members rushed to select an artist to make their bronze doors, "some man may be chosen who by reason of his inadequacy may cause your descendants to revile you."[53] Leonardo's caution, though self-serving, was on the mark. Indeed, a member of a civic council in Prato expressed virtually the same idea during a meeting about a new painting for the town hall: "if the said work is not excellent . . . it will bring more dishonor than honor, and, even if obtained with a low cost, it will be completely useless."[54] To avoid this fate, the principals sought out a famous agent for the commission, Filippino Lippi.

The high reception costs of poor art were memorialized in a poem by Strazzola from the 1490s titled "What Gentile Bellini's canvas said." The poem's telling line is: "Everybody who sees me so ill painted / Cannot restrain himself from laughing at me."[55] Such a reaction, the patron's worst nightmare, was just the price that Bartolomeo Valori paid for the façade of his palace. Especially in Florence, learned viewers wrote and even published attacks on prominent commissions they considered to be inappropriate or of low quality.[56] But even when a work incurred negative reception costs, there might be a silver lining. As decades or centuries passed, a patron's posthumous reputation often rose in the eyes of new audiences, sometimes because later audiences did not know

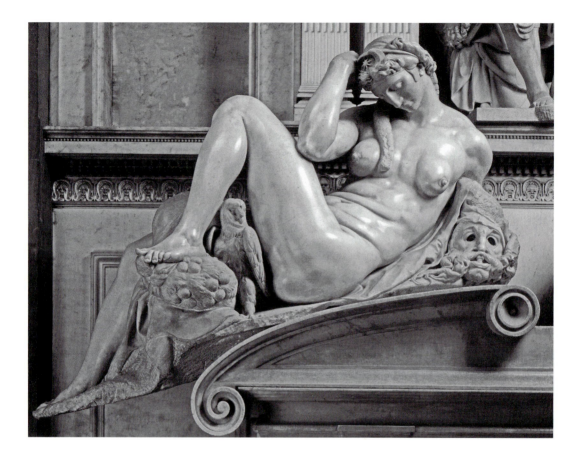

the sources of embarrassment, sometimes because they had more receptive tastes. Today, admirers of Renaissance art would be thrilled to own a painting by Bellini or Valori's palazzo.

The allegory of *Night* (fig. 2.5), one of Michelangelo's marble sculptures in the New Sacristy, provides a fascinating glimpse at the shifting social benefits and costs of art in sixteenth-century Florence. When the commission begins we find the expected alignment between the aims of the agent and principal. Michelangelo created a number of impressive works intended to glorify the Medici in their funerary chapel at San Lorenzo. In his draft for the inscription, intended to be placed on the tomb of Giuliano de' Medici, Michelangelo gives voice to *Night* and her companion *Day*. The sculptures themselves state that they were rightly punished by Giuliano for having caused his early death. The artist thus showed *Night* in a fitful sleep and gave her the physical signs of breast cancer.[57]

Before the sculpture was finished, however, Duke Cosimo de' Medici took over the city as a tyrant. Michelangelo turned against him, abandoned Florence, and left the New Sacristy sculptures incomplete. A few years later, he penned another poem about *Night*, published by Vasari in his 1550 *Life* of Michelangelo. In these verses, he exploited the ambiguous iconography of his own sculp-

ture, and reinterpreted it as a statement against Cosimo's rule. *Night* speaks again but asks not to be awakened, "as long as the hurt and shame endure." Michelangelo's friend Donato Giannotti was hardly alone when he recognized this passage as "very relevant to our times."[58] If many viewers had accepted Michelangelo's new explanation of *Night*'s unusual appearance, the sculpture would have created a high social cost for the Medici. Instead, the artistic quality of the work constituted a benefit, and trumped Michelangelo's attempt at revisionism. In the late 1500s, Francesco Bocchi listed *Night* as one of the four most perfect works of art in Florence, and the enlightened patronage of the Medici is still acknowledged by the many visitors to the New Sacristy.

Constraints

Social and financial costs were not the only factors that limited a patron's choice of commissions. Patrons also worked within a number of limitations that we label constraints, following the terminology of economics. Some constraints were absolute and universal: chapels had only one altarpiece. Some applied to some donors and not others; thus Carafa was able to entice Filippino away from his prior commitments. Some, such as sumptuary laws, could be relaxed for a price. And some constraints could be violated, but only by taking a risk. If they were financial constraints, the risk was a reduced standard of living or political bankruptcy. If they were societal norms or other social constraints, the risk was severe social costs. Below we shall see examples of patrons who took such risks, lost, and suffered the results.

For Renaissance art projects, some constraints applied to commissions individually (such as ecclesiastical, civic, and social constraints on content, or the availability of an artist). Other constraints, such as limited space or financial resources, forced a patron to select one among several potential commissions. Though all patrons faced some constraints, better-placed patrons faced fewer of them. Thus, a patron's ability to contract for commissions beyond the reach of others, such as a painting by Raphael or a tomb in the high chapel of a major church, was an effective signal of one's status, quite apart from the resulting art itself.

The artist played a vital role in the patron's attempt to maximize returns on his commission, and thus had to attend to the constraints the patron faced. When seeking the best solutions to a principal's needs, agents had to work within those constraints while attempting to bolster benefits, and at the same time controlling both financial and social costs. The artist also had to remain attentive to his (or occasionally her) own aesthetic concerns. When we can identify the various limitations impinging on a commission, we can better appreciate the artist's achievement.

Constraints on space, the availability of materials, or finances are relatively

straightforward. The most subtle constraints related to rules of decorum. The rewards from presenting oneself as above one's station might be great if one was not caught. Both ancient and Renaissance authors often stressed the importance of commissioning works commensurate with the patron's social condition; they evidently thought the temptation to violate this constraint was high. In his treatise on architecture, Filarete even included plans for houses suitable for certain ranks of society.[59] Pontano provided a useful example, derived from ancient texts, to illustrate how a commission could lead to derision. Licinus, a barber, became so wealthy and famous that he built himself a rich tomb, but all his contemporaries found such a noble setting inappropriate for someone of such low social condition. Thus the taunting epigram, "Licinus lies in a marble tomb, while Cato is in a small one, and Pompeius has none at all. Can we believe in the existence of the Gods?"[60]

A similar fate befell the Renaissance poet Bartolomeo Aragazzi, as recounted in an amusing letter by his contemporary Leonardo Bruni. Bruni saw the now celebrated sculptures carved by Michelozzo for Aragazzi's tomb (fig. 2.6) being transported with great effort by workmen. One of them cried out "May the gods damn all poets!" Why? Because "this poet who died recently, well known to be stupid and puffed up with conceit, ordered a marble tomb to be made for himself." [61] Bruni further argued that a man's fame should rest on his praiseworthy works, not a tomb, and he reserved special scorn for the lowborn patron who commissioned a grand monument: "I wonder, what actions, what deed will you have inscribed? That your father drove asses and goods around the fairs?" Even if such a patron could meet the production costs for such a commission, the work would be received poorly by his contemporaries. We can discern the motivations behind Bruni's attack from the notes to his translation of the *Economics*, then attributed to Aristotle: "Wealth will lend adornment and honor . . . if we make our outlays opportunely and gracefully."[62] Bruni evidently considered the grandeur of Aragazzi's tomb to be excessive. For many Renaissance viewers, the reputation, not the mere wealth, of the deceased constituted a significant differential cost for commissioning an honorable tomb. Many tombs, quite apart from money, would be too expensive in social costs for all but the true elite.

Even elites needed to be careful. The title of a short dialogue from the mid-1400s, "Against the Detractors of Cosimo de Medici's Magnificence," indicates that some people objected to the ambitious building campaign of the Florentine leader.[63] The author, Timoteo Maffei, defended Cosimo's magnificence from attacks made against his vast architectural expenditures. Maffei, a canon of the Augustinian order, was hardly a disinterested author. His unpublished text supported Cosimo's decision in 1456 to finance the rebuilding of the Badia at Fiesole, given to Maffei's order in 1439. Already in 1463, Pope Pius II wrote in praise of Cosimo's building projects, but noted the objection to these works from some who considered the patron a tyrant.[64] In 1525, Machiavelli observed

FIG. 2.6. Michelozzo, *Aragazzi Monument*, Cathedral, Montepulciano (Photo Scala, Florence). © 2002. Photo Scala, Florence

that Cosimo was always extremely prudent, because he knew that extraordinary works have the danger of attracting envy.[65] Vasari's *Life* of Brunelleschi, written a quarter century later, provides a concrete example. Here we learn that Cosimo rejected the initial plans for a large and sumptuous palace "more to avoid envy than by reason of the cost."[66] Thus the expected reception costs of the contemplated commission, not the monetary outlays they would require, were the prohibitive factor. As Cosimo realized, magnificent commissions can stir envy; works of art can even become the focus of public rage. After the Florentines banished Piero de' Medici, the son of Lorenzo the Magnificent, they confiscated the art collections in the Medici palace and melted down the silver votive images depicting Lorenzo and his mother in the church of the SS. Annunziata.[67] When the ruling Bentivoglio family was driven out of Bologna in 1507, their palace was destroyed by the townspeople.[68]

Patrons understood that they had to pay attention to the sensibilities of

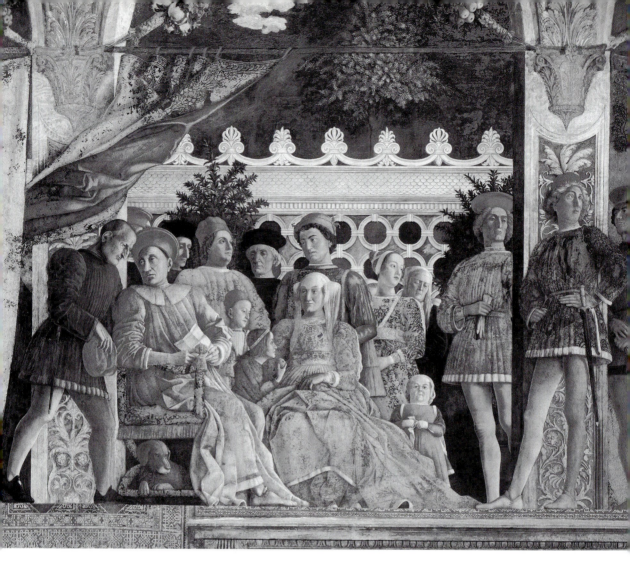

FIG. 2.7.
Mantegna,
*The Gonzaga
Court*, Camera
degli Sposi,
Ducal Palace,
Mantua

their audiences: their social equals, their inferiors, and especially their superiors. For example, when the bishop of Trent commissioned a fresco cycle from Dossi Dosso, he rejected the artist's suggestion to depict the sack of Rome. As the bishop wrote in 1531, the scene would be highly inappropriate should the pope ever decide to visit.[69] Soon after the Marquis of Mantua commissioned Mantegna's fresco cycle in the Camera degli Sposi (fig. 2.7), complete with portraits of his family, the emperor, and the king of Denmark, he received a worrying letter from his ambassador in Milan. The latter relayed that the Duke of Milan "is not a bit pleased that your lordship did not have his Excellency himself portrayed in it."[70] The marquis replied that the emperor was his superior and the king his brother-in-law, and he did not change the fresco. Might the reply have been different had the emperor himself requested that a portrait be added?

Church regulations often imposed constraints on principals and agents.[71] Chapel decorations, for example, had to identify and thus celebrate the holy

figure to whom the altar was dedicated. Especially after the Council of Trent, imagery deemed to be offensive could be transformed or destroyed. In Venice, Paolo Veronese had to face the Inquisition to defend the artistic choices he had made in a painting of the Last Supper, though rather than remove several details considered unacceptable, he merely changed the title.[72] In Rome, Michelangelo's student Daniele da Volterra had to add clothing to several figures in the *Last Judgment* that the master had represented as nude. These "indecorous" images inspired widespread criticism of the fresco, and nearly led to its destruction.[73]

Often, the authorities responsible for specific churches did not grant patronage rights for the most prestigious locations. In 1447, Castello Quartesi offered to pay the board of works of the church of Santa Croce, Florence, the remarkable sum of 100,000 florins (4,154 man-years), in order to build an honorable façade. When his request to adorn the structure with the symbol of his family was refused, Quartesi shifted the focus of his patronage: he paid for the construction of a new church outside the city walls, San Salvatore al Monte. This building bears his coat of arms on the façade, and within, the patron is buried at the crossing, in front of the high altar.[74] Giovanni Rucellai was able to obtain the right to adorn the façade of an old and highly prestigious church in the center of Florence, Santa Maria Novella, with his name and symbols.[75]

The patrons of private chapels—major sites for commissions and status signaling—tried to avoid the censure of the clergy, unless the expected benefits from the potential offending action exceeded the expected losses from punishment. As we shall see in chapter 5, these spaces displayed substantial and colorful indications of ownership: names, coats of arms, emblems, and banners, plus of course images of the owners. Fra Girolamo Savonarola and many likeminded churchmen had strong negative feelings about the family and personal symbols emblazoned on the frames and bases of religious paintings and statues. Several reformers attempted to combat what they saw as the vainglory of tombs in churches. A 1530 regulation in Venice sought to reduce the number of such tombs but made exceptions for saints, prelates, rulers, princes, and benefactors.[76] This last category included all patrons, rendering the norms little more than symbolic. In his 1542 regulations on church burials in sacred places, the bishop of Verona, Gian Matteo Giberti, condemned those who erected artful and expensive tombs in eminent places that "exceeded" the altars themselves.[77] Patricians paid lip service to his new directives but built tombs in churches much as before. In Milan, Archbishop Carlo Borromeo introduced strict new regulations in 1565 for future tombs. He even considered having Leone Leoni's elaborate bronze tomb of Gian Giacomo de' Medici removed from the Duomo in Milan, along with other "vain trophies" as a good example to the diocese, though this was never done.[78] Nevertheless, patrons surely realized the reception-cost threat implicit in such statements.

Some church and social conventions were less constraining than others; that is, they were enforced flexibly, with money frequently enhancing elasticity. Flexible conventions, even those for which exceptions must be purchased, are not constraints. A range of regulations could be lifted for a price. For example, across Italy the severely worded sumptuary laws, which prohibited such vanities as the ostentatious display of jewels or lace, in practice often merely required that wealthy wearers pay a fine. When Florence revised its laws, it allowed the sale of exemptions to constraints on consumption.[79] Such "paying for the pomp," to use the Venetian phrase, transformed the civic regulation from a constraint to a cost.[80] As we shall see in the next chapter, the differing abilities to pay such costs provided a further means to distinguish among wealthy Venetians.

Great demand for an artist often created an availability constraint; artists could and did turn down uninteresting offers, such as one from an undistinguished patron. The most successful and established figures, such as Michelangelo, Titian, or Raphael, worked almost exclusively for the most elite members of society. A run-of-the-mill patron could not engage a "superstar" for even a very well-paid commission.[81] Throughout history, commissions of a superstar have provided a very effective signal of status. The commission, though expensive, was often something money alone could not buy. Naturally, the very status of the famous artist generated interest in his works, thus providing patrons with attributes skill alone could not guarantee: increased visibility and implied status.[82] In some cases, as the letter to Ammanati reminds us, the fame of elite patrons remained bound to that of the artists they supported.

In the Renaissance, the availability of some materials also constituted a constraint. Today a wealthy patron can purchase virtually any building material, but in the period under discussion some stones, such as colored marbles or porphyry, were available only from distant countries or ancient monuments. Access to these materials indicated that the patron had connections or power, or both. In 1585, for example, Pope Sixtus V prohibited the excavation of porphyry in and around Rome.[83] This constraint forced most patrons to obtain imitation porphyry, or specimens of poor quality. Those who ignored the law not only obtained the finest product but signaled their high status by disregarding the pope.

Regulations on commissions imposed "permissibility constraints." On the streets of Florence, a private tower could be no higher than the town hall; at the church of Orsanmichele, only selected guilds obtained the right to adorn the external pillars with statues of their patron saints.[84] One practical constraint that limited all commissions was location. Though wealthy patrons could find a range of settings for a home, tomb, or chapel—and within a house many walls might be available for paintings in the bedrooms and antechambers— few of these spaces were considered prestigious, and prestige was always a prime consideration. The location constraint often did not impose on all equally,

creating just the type of differential costs that permit signaling. Such differential location costs applied frequently to commissions in public settings. For example, wealth alone could not buy a plot of land to develop on the most important street. As a result, the desirable setting signaled highly positive qualities about the patron, such as belonging to an old family, or enjoying the favor of churchmen or municipal authorities.

Within given locations, space itself constituted a significant constraint; a chapel had room for only one altarpiece, and only one sculpted portrait bust could sit above any given door in a private palace. By selecting or commissioning a work for these settings, the patron "used up" the opportunity; this had a cost, but not one that could be rendered in financial terms. Space also constituted a major constraint *within* works of art. A painting could contain only so much information, such as likenesses of specific people or scenes from the life of the patron. With its portraits, the painting could pay homage to some prominent citizens, but the honors had to be limited lest the story get lost, the honor be diminished, or aesthetic quality fall.

In theory, patrons would have liked to choose all commissions for which benefits exceeded costs. However, when constraints on the total were binding they made commissions that both met the constraints and maximized the difference between total benefits and total costs. For patrons of moderate means, financial costs would have been the major consideration. Such costs also influenced wealthy patrons, the group studied in this volume, but for them financial costs were less of a concern. They sought the status benefits that could come from commissions that were prestigious, not merely expensive. And thus, over centuries, bronze busts, painted altarpieces, and magnificent palaces were produced in great numbers. They served as effective signals of status, the subject to which we now turn.

Notes

1. Anthony Boardman et al., *Cost-Benefit Analysis: Concepts and Practice*, 2nd rev. ed. (Upper Saddle River, NJ: Prentice Hall, 2001).

2. Francesco Caglioti, "Fifteenth-Century Reliefs of Ancient Emperors and Empresses in Florence: Production and Collecting," in *Studies in the History of Art: Collecting Sculpture in Early Modern Europe*, ed. Nicholas Penny and Eike D. Schmidt (Washington, DC: National Gallery of Art, forthcoming), 66–109, esp. 68–70.

3. Edith Stokey and Richard J. Zeckhauser, *A Primer for Policy Analysis* (New York: W. W. Norton, 1978), 134–58.

4. On Carafa and his chapel, see Gail Louise Geiger, *Filippino Lippi's Carafa Chapel: Renaissance Art in Rome* (Kirksville, MO: Sixteenth Century Journal Publishers, 1986), and Jonathan K. Nelson, "I cicli di affreschi nelle Cappelle Carafa e Strozzi," in *Filippino Lippi*, ed. Patrizia Zambrano and Jonathan K. Nelson (Milan: Electa, 2004), 513–55, 579–83 cat. no. 39.

5. For central Italy, see Christa Gardner von Teuffel, "Clerics and Contracts: Fra Angelico, Neroccio, Ghirlandaio and Others: Legal Procedures and the Renaissance High Altarpiece in Central Italy," *Zeitschrift für Kunstgeschichte* 62, no. 2 (1999): 190–208. For Venice (where patricians did often obtain the right to burial in front of the high altar) and Florence, now see two essays in *Lo spazio e il culto: relazioni tra edificio ecclesiale e uso liturgico dal XV al XVI secolo*, ed. Jörg Stabenow (Venice: Marsilio, 2006): Riccardo Pacciani, "Il coro conteso: rituali civici, movimenti d'osservanza, privatizzazioni nell'area presbiteriale di chiese fiorentine del Quattrocento," 127–51, and Martin Gaier, "Il mausoleo nel presbiterio : patronati laici e liturgie private nelle chiese veneziane," 153–180.

6. Silvia Catitti, "L' architettura della Cappella Carafa in Santa Maria sopra Minerva in Roma," *Annali di architettura* 16 (2004): 25–43.

7. Melissa Meriam Bullard, "The Magnificent Lorenzo: Between Myth and History," in *Politics and Culture in Early Modern Europe: Essays in Honor of H. G. Königsberger*, ed. Phyllis Mack and Margaret C. Jacob (Cambridge and New York: Cambridge University Press, 1987), 49.

8. Giorgio Vasari, *Lives of the Painters, Sculptors and Architects*, trans. Gaston du C. de Vere, ed. David Ekserdijan (London: Everyman's Library, 1996), 1:568 (Life of Filippino). Vasari claimed, however, that the figure did not include the cost of assistants or of the expensive blue pigment. Ducats had roughly the same value as florins.

9. For the Strozzi Chapel, see Eve Borsook, "Documents for Filippo Strozzi's Chapel in Santa Maria Novella and Other Related Papers," *Burlington Magazine* 112, no. 813 (1970): 738 note 20; and see the discussion in chapter 5 of this volume.

10. The composition of the frescoed lunette above the *Triumph of Saint Thomas* appears oddly lopsided when viewed from within the chapel, but those looking at it from the high altar can see only the left-hand scene, the *Miracle of the Speaking Crucifix*. The miraculous painting itself is now in the Carafa Chapel in San Domenico, Naples, and may have been in the family's possession in the late 1400s.

11. Giovanni Pontano, *I libri delle virtù sociali*, trans. and ed. Franceso Tateo (Rome: Bulzoni, 1999), 180.

12. Ibid., 164.

13. Diana Norman, "The Succorpo in the Cathedral of Naples: 'Empress of All Chapels,'" *Zeitschrift für Kunstgeschichte* 49, no. 3 (1986): 355.

14. On the cost of housing, see D. S. Chambers, "The Housing Problems of Cardinal Francesco Gonzaga," *Journal of the Warburg and Courtauld Institutes* 39 (1976): 21–58.

15. D. S. Chambers, *Patrons and Artists in the Italian Renaissance* (Columbia: University of South Carolina Press, 1971), 173–75.

16. Michael Baxandall, *Painting and Experience in Fifteenth Century Italy: A Primer in the Social History of Pictorial Style*, 2nd rev. ed. (Oxford: Oxford University Press, 1988), 2.

17. Michelle O'Malley, *The Business of Art: Contracts and the Commissioning Process in Renaissance Italy* (New Haven and London: Yale University Press, 2005), 105.

18. Leon Battista Alberti, *On the Art of Building in Ten Books*, trans. Joseph Rykwert, Neil Leach, and Robert Tavernor (Cambridge, MA: MIT Press, 1988), 291.

19. Creighton E. Gilbert, *Italian Art 1400–1500: Sources and Documents*, 2nd rev. ed. (Evanston, IL: Northwestern University Press, 1992), 411–12. Similarly, Pontano, *I libri*, 192, wrote about twenty years later that patrons of tombs must consider how best to preserve the fame not only of the person to whom the tomb is dedicated but also of the person who dedicated it.

20. Evelyn Welch, *Shopping in the Renaissance: Consumer Cultures in Italy, 1400–1600* (New Haven and London: Yale University Press, 2005), 292.

21. Ibid., 232.

22. Pontano, *I libri,* 184.

23. Werner Gramberg, *Die Düsseldorfer Skizzenbücher des Guglielmo della Porta* (Berlin: Mann, 1964), 1:126. The name of Michelangelo's patron is presumably an error for Lorenzo the Magnificent, Giuliano's brother. For mention of Morone, in a very rich essay on literary references to art, see Giovanni Agosti, "Scrittori che parlano di artisti, in Quattro e Cinquecento in Lombardia," in Barbara Agosti et al., *Quattro pezzi lombardi (per Maria Teresa Binaghi)* (Brescia: Edizioni L'Obliquo, 1998), 89 note 146.

24. Richard Goldthwaite, *Wealth and the Demand for Art in Italy, 1300–1600* (Baltimore and London: Johns Hopkins University Press, 1993), 200.

25. John M. Najemy, "Florentine Politics and Urban Spaces," in *Renaissance Florence: A Social History,* ed. Roger J. Crum and John T. Paoletti (Cambridge and New York: Cambridge University Press, 2006), 25–26.

26. Patricia Lee Rubin, *Images and Identity in Fifteenth-Century Florence* (New Haven and London: Yale University Press, 2007), 19.

27. Ibid., 20. We find a parallel in modern-day philanthropy, given that donors' names usually remain on buildings even after they encounter severe legal difficulties.

28. Niccolò Machiavelli, *Istorie fiorentine*, ed. Franco Gaeta (Milan: Feltrinelli Editore, 1962), 462.

29. Patricia Lee Rubin, "Magnificence and the Medici," in *The Early Medici and Their Artists*, ed. Francis Ames-Lewis (London: Birkbeck College, 1995), 47. In a similar vein, Francesco Barbero encourged Cosimo to donate funds to a Venetian church because that would contribute to his fame in both Venice and Florence; A. D. Fraser Jenkins, "Cosimo de' Medici's Patronage and the Theory of Magnificence," *Journal of the Warburg and Courtauld Institutes* 33 (1970): 164. On magnificence, also see Rubin, *Images and Identity*, esp. 34–42.

30. Paula Spilner, "Giovanni di Lapo Ghini and a Magnificent New Addition to the Palazzo Vecchio," *Journal of the Society of Architectural Historians* 52 (1993): 458.

31. Goldthwaite, *Wealth*, 219.

32. Kathleen Weil Garris and John F. D'Amico, "The Renaissance Cardinal's Ideal Palace: A Chapter from Cortesi's *De Cardinalatu*," in *Studies in Italian Art and Architecture: 15th through 18th Centuries*, ed. Henry A. Millon (Rome: American Academy in Rome, 1980), 89.

33. Dale Kent, *Cosimo de' Medici and the Florentine Renaissance: The Patron's Oeuvre* (New Haven and London: Yale University Press, 2000), 220.

34. For citation and discussion, see Rubin, *Images and Identity*, 12.

35. Rab Hatfield, *Botticelli's Uffizi "Adoration": A Study in Pictorial Content* (Princeton: Princeton University Press, 1976).

36. Though this dating and reasoning remain plausible, we should also consider that Del Lama, immediately after his disgrace, would have had a good reason to ask Botticelli to include the Medici portraits.

37. For this and other examples of forced gifts in exchange for political favors, see Guido Rebecchini, "Il mercato del dono. Forme dello scambio artistico a Mantova tra Cinque e Seicento," in *Tra committenza e collezionismo: studi sul mercato dell'arte nell'Italia settentrionale durante l'età moderna*, ed. Enrico Maria dal Pozzolo and Leonida Tedoldi (Vicenza: Terra Ferma, 2003), 113–22, esp. 115–17.

38. For the Florentine examples, see Michael Lingohr, "Palace and Villa: Spaces of Patrician Self-Definition," in *Renaissance Florence,* 269. For Milan, with references to other examples in northern Italy, see chapter 7.

39. Welch, *Shopping,* 92.

40. Lingohr, "Palace," 253.

41. As quoted in Pierre Bourdieu, *Distinction: A Social Critique of the Judgement of Taste*, trans. Richard Nice (Cambridge, MA: Harvard University Press, 1984), 287 note 21.

42. Welch, *Shopping,* 226–27.

43. Though it is possible that Francesco Castellani did not have the authority to make this sale, the need to keep up appearances probably kept many impoverished chapel owners from ceding their patronage rights.

44. J. R. Sale, *The Strozzi Chapel by Filippino Lippi in Santa Maria Novella* (Ann Arbor and London: Garland, 1976), 104–8. We estimate a "man-year" of unskilled labor at about 130 lire; see discussion in the introduction.

45. Charles De Tolnay, *Michelangelo II: The Sistine Ceiling* (Princeton: Princeton University Press, 1949), 109–10, appendix no. 90, 248–49; John Shearman, *Raphael's Cartoons in the collection of Her Majesty the Queen, and the Tapestries for the Sistine Chapel* (London: Phaidon, 1972), 13.

46. Brenda Preyer, "Around and in the Gianfigliazzi Palace in Florence: Developments on Lungarno Corsini in the 15th and 16th Centuries," *Mitteilungen des Kunsthistorischen Institutes in Florenz* 48 (2004): 55–104, esp. 66.

47. Richard A. Goldthwaite, *The Building of Renaissance Florence: An Economic and Social History* (Baltimore and London: Johns Hopkins University Press, 1980), 399–400. For these buildings he evaluated a man-year of unskilled labor as 150 lire.

48. If an unskilled construction worker earned $40,000 per year, 155 man-years would be $6,200,000, and 1,333 would be $53,320,000.

49. For the quotes by Luca Pitti and Luca Landucci, see F. W. Kent, "Palaces, Politics and Society in Fifteenth-Century Florence," *I Tatti Studies* 2 (1987): 50.

50. O'Malley, *Business,* 107.

51. Salvatore Settis, *Giorgione's Tempest: Interpreting the Hidden Subject*, trans. Ellen Bianchini (Chicago: University of Chicago Press, 1990), 128.

52. Robert Williams, "The Façade of the *Palazzo dei 'Visascci,*'" *I Tatti Studies* 5 (1993): 225.

53. Leonardo da Vinci, *Leonardo on Painting: An Anthology of Writings*, ed. Martin Kemp, trans. Martin Kemp and Margaret Walker (New Haven and London: Yale University Press, 1989), 257 no. 617.

54. O'Malley, *Business,* 104.

55. Gilbert, *Italian Art*, 193; Norman E. Land, *The Viewer as Poet: The Renaissance Response to Art* (University Park: Pennsylvania State University Press, 1994), 95–97, with reference to other "poems of blame." For the many poems attacking the obsure painter Ombrone, see Agosti, "Scrittori," 88.

56. See, for example, Louis A. Waldman, *Baccio Bandinelli and Art at the Medici Court: A Corpus of Early Modern Sources* (Philadelphia: American Philosophical Society, 2004), for the many criticisms of Bandinelli's *Hercules*; and Michael Wayne Cole, "Grazzini, Allori and Judgment in the Montauti Chapel," *Mitteilungen des Kunsthistorischen Institutes in Florenz*, 45 (2001), 302–12.

57. On the *Night* and its reception, see Jonathan K. Nelson, "The Florentine *Venus and Cupid*: A Heroic Female Nude and the Power of Love," in *Venus and Cupid: Michelangelo and the New Ideal of Beauty*, ed. Franca Falletti and Jonathan K. Nelson (Florence: Giunti, 2002), 29–40, and Jonathan Nelson and James Stark, "The Breasts of *Night*: Michelangelo as Oncologist?" letter to the editor, *New England Journal of Medicine* 343, no. 21 (November 23, 2000): 1577–78.

58. For the poem (Girardi n. 247), with discussion, see *Michelangelo: Poesia e Scultura*, ed. Jonathan K. Nelson (Milan: Electa, 2003), 18, 168.

59. Fraser Jenkins, "Cosimo de' Medici's Patronage," 168.

60. Pontano, *I libri*, 182.

61. Gilbert, *Italian Art*, 166–67.

62. Quoted and discussed in Rubin, *Images and Identity*, 36.

63. Fraser Jenkins, "Cosimo de' Medici's Patronage," 165.

64. Enea Silvio Piccolomini, *I Commentarii*, ed. Luigi Totari (Milan: Adelphi Edizioni, 1984), 1:353–55, also mentioned in Fraser Jenkins, "Cosimo de' Medici's Patronage," 165.

65. Machiavelli, *Istorie*, 459, also mentioned in Fraser Jenkins, "Cosimo de' Medici's Patronage," 165.

66. Vasari, *Lives*, 1:353. For a similar comment see his *Life* of Michelozzo, 1:379.

67. K.J.P. Lowe, "Patronage and Territoriality in Early Sixteenth-Century Florence," *Renaissance Studies* 7, no. 3 (1993): 262. For other politically motivated attacks on art, see Richard C. Trexler, *Public Life in Renaissance Florence* (New York: Academic Press, 1980), 123–24.

68. William E. Wallace, "The Bentivoglio Palace: Lost and Reconstructed," *Sixteenth Century Journal* 10, no. 3 (Fall 1979): 97–114.

69. Creighton E. Gilbert, "What Did the Renaissance Patron Buy?" *Renaissance Quarterly* 51 (1998): 433, who rightly emphasizes that the artist, not the patron, proposed the subject.

70. Gilbert, *Italian Art*, 131.

71. See discussion in chapter 5.

72. Robert Klein and Henri Zerner, *Italian Art 1500–1600: Sources and Documents* (1966; reprint, Evanston, IL: Northwestern University Press, 1989), 129–132.

73. For this intervention, and sixteenth-century criticism of the fresco, see Bernadine Barnes, *Michelangelo's Last Judgment: the Renaissance Response* (Berkeley: University of California Press, 1998).

74. Giampaolo Trotta, "Le vicende della 'fabbrica,'" in *San Salvatore al Monte: Antiquae elegantiae per un' acropolis laurenziana* (Florence: Becocci Scala Editore, 1997), 11.

75. Rab Hatfield, "The Funding of the Façade of Santa Maria Novella," *Journal of the Warburg and Courtauld Institutes* 67 (2004): 81–127.

76. Martin Gaier, *Facciate sacre a scopo profano: Venezia e la politica dei monumenti dal Quattrocento al Settecento*, trans. Benedetta Heinemann Campana (Venice: Istituto veneto di scienze, lettere ed arti, 2002), 59.

77. Kathryn B. Hiesinger, "The Fregoso Monument: A Study in Sixteenth-Century Tomb Monuments and Catholic Reform," *Burlington Magazine* 118, no. 878 (1976): 283–84; Gaier, *Facciate,* 59.

78. Hiesinger, "Fregoso," 287; Gaier, *Facciate,* 61.

79. Sharon T. Strocchia, *Death and Ritual in Renaissance Florence* (Baltimore and London, Johns Hopkins University Press, 1992), 62, 212, about funerary regulations.

80. Catherine Kovesi Killerby, *Sumptuary Law in Italy, 1200–1500* (Oxford: Clarendon Press, 2002), 123.

81. Sometimes, of course, a patron of middling status ordered a work by an artist who later became a superstar, e.g., Del Lama's commission of Botticelli's *Adoration of the Magi.*

82. Rab Hatfield, "The High End: Michelangelo's Earnings," in *The Art Market in Italy, 15th–17th Centuries,* ed. Marcello Fantoni, Louisa C. Matthew, and Sara F. Matthews-Grieco (Modena: Franco Cosimo Panini, 2003), 1996.

83. Suzanne B. Butters, *The Triumph of Vulcan: Sculptors' Tools, Porphyry, and the Prince in Ducal Florence* (Florence: L. S. Olschki, 1996), 1:43.

84. Najemy, "Florentine Politics," 21–32.

Introduction: Distinction

MOST ITALIAN Renaissance patrons felt the need not merely to establish an elevated status but also to advertise it to contemporary and future audiences. More than a mere desire, this "advertising" often constituted a social obligation. As members of the elite, patrons had to distinguish themselves from those of lower status as well as act in a manner considered appropriate for their class. For both reasons, art patronage flourished. Any conspicuous commission was expensive, and thus out of the reach of but a sliver of the citizens. Still, some artworks had financial costs that were low relative to some other expenditures: most paintings cost far less than a fine horse or an elegant dress.[1] Nevertheless, the social costs, discussed in the previous chapter, usually limited conspicuous commissions to the wealthy and powerful. Distinction thus constituted a major benefit for players in the commissioning game; to achieve it, they employed a strategy that others would find prohibitively costly.

The drive for distinction encouraged the practice of "self-fashioning." In a celebrated study, literary theorist Stephen Greenblatt argued that individuals in Renaissance England—and his observations are valid for all Europe—devoted extraordinary efforts "to fashion a gentleman or noble person," as Edmund Spenser described his intention in *The Faerie Queen*.[2] The Renaissance period saw the publication of numerous handbooks designed to help readers "thread successfully through the labyrinth of social distinctions, to win at the game of rank."[3] Winning often entailed distinguishing oneself from actions and beliefs associated with individuals of lower status. In recent decades, many scholars have explored how patrons used commissions to fashion a persona and effectively communicate it to others.[4] The elite also found ways, in both art and society, to indicate—and thereby set off—those who had lower status.[5] In this chapter, we concentrate on how commissioned art served to distinguish patrons by elevating their status. In the next, we explore how art conveyed highly selective or exaggerated information about the patron, thereby incurring some risk to further enhance distinction.

In his study *Distinction: A Social Critique of the Judgement of Taste*, Pierre Bourdieu revealed how individuals express their status by exhibiting their discernment or "taste."[6] Bordieu's analysis of contemporary French society—

published originally in 1979 and recently named one of the ten most important sociology books of the twentieth century—argues that the ability to differentiate between culturally laden symbols increases one's "cultural" or "symbolic capital." This serves to distinguish the "distinguished" from the "vulgar." Bourdieu considered a range of "techniques designed to create and accumulate symbolic capital," from museum visits and furniture purchases to home entertaining.[7] Of all these activities, he found the purchase of works of art, which offer objectified evidence of "personal taste," to be the one that is closest to the most irreproachable and inimitable form of accumulation, that is, the internalization of distinctive signs and symbols of power in the form of natural "distinction," personal "authority," or "culture."[8]

Only some of Bourdieu's "techniques" apply to Renaissance Italy. Though we can consider the body of works commissioned by a great patron as his *oeuvre*, we have no evidence that his contemporaries considered this the expression of "personal taste." Nevertheless, as Patricia Rubin has recently observed, the possession of certain objects undoubtedly conveyed the owner's knowledge and sophistication to fifteenth-century viewers. "Discriminating was at once a model of knowledge . . . and, as now, a mechanism of class distinction."[9] Already in the early fifteenth century, the renowned scholar Poggio Bracciolini understood that his contemporaries saw antiquities as a means for collectors to "accumulate symbolic capital." In the essay *On Nobility*, one character notes: "Our host, having read that illustrious men of old used to ornament their homes . . . with statues, paintings, and busts of their ancestors, to glorify their own names and their lineage, wanted to render his own place noble, and himself too, but having no images of his own ancestors, he acquired these meager and broken pieces of sculpture, and hoped that the novelty of his collection would perpetuate his fame among his descendants."[10] Poggio took for granted the goal of self-glorification, and showed how even those lacking blue blood—what Bourdieu would call "natural distinction"—employed art to bolster their status. If viewers appreciate the criteria used to acquire or commission works of art, the owner's reputation for recognizing quality is enhanced. Giovanni Rucellai, Bracciolini's younger contemporary, boasted that he owned several works "by the hands of the best masters there have been, for some time past and up to now."[11] He had picked winners, was rightly proud, and received a reputational boost, at least from modern audiences. Surviving evidence documents that some patrons and collectors, such as Lorenzo de' Medici "the Magnificent," achieved this boost in the eyes of contemporaries as well.

To help explain how players in the commissioning game successfully obtained the desired benefits of social distinction, this chapter explores the theories of magnificence and signaling. Both attempt to explain why certain expenditures were made, and how those who made them were seen by the intended audience. The theories of magnificence and signaling, as first presented in the early 1970s, have become extraordinarily influential, respectively, in the study

of early modern Europe and in economics. Scholars have not, however, noted the fundamental similarities between these complementary theories of how information gets conveyed. In his treatise on magnificence, written in 1552, Sienese nobleman Alessandro Piccolomini explained that "only someone who makes great things while spending could be properly called 'magnificent.'"[12] He focused on public displays, such as the "building of temples, porticoes, and theaters," and the presentation of "public festivals and comedies." Nevertheless, Piccolomini observed that magnificence "could show itself on private occasions, which happen seldom, such as weddings, parties, banquets, receptions of distinguished guests, expenditures on town and country residences, domestic ornaments and furnishings, and other similar things where one can see sumptuousness and grandness."[13] By this criterion, a wide range of expensive and conspicuous commissions qualify as magnificent, but here we will focus on one genre—architecture—often discussed in both ancient and Renaissance texts on magnificence.

Today many consider these treatises on magnificence as little more than a justification for conspicuous consumption, but A. D. Fraser Jenkins, in his fundamental article of 1970, drew attention to the "distinctive" quality of magnificence. Starting with Aristotle, most sources emphasized that magnificent spending was an exclusive virtue of the rich and wellborn. A recent study by an economic historian, Guido Guerzoni, demonstrated how the theory of magnificence, especially as it developed in sixteenth-century Italy, carefully distinguished noble expenditures from merely big spending. We believe that magnificence bestows distinction through the principles laid bare centuries later by the highly influential theory of signaling. In the classic book on the topic, *Market Signaling* (1974), which helped earn Michael Spence the Nobel Prize for Economics, the chapter "Status, Income and Consumption" begins with this observation: "Veblen many years ago suggested that highly visible consumption is used by people as a signal of wealth and, by inference, power and status."[14] If Spence had looked back to authors writing many years before Veblen and across to those addressing the visual arts, he could have said that "magnificent" commissions signaled the same qualities. Economists have not, however, extended the theory of signaling to a historic period, nor considered art commissions. Even for Renaissance writers on magnificence, expenditures on grand public occasions held the greatest interest. In the last section of this chapter, we apply the theory of signaling to conspicuous commissions made by "distinctive" individuals.

Magnificence

Across medieval and Renaissance Italy, in areas with vastly different governments, the wealthy and powerful understood and exploited the theory of mag-

nificence. The term derived from Aristotle, who defined it as "a virtue concerned with wealth . . . [which] consists in suitable expenditure on a great scale."[15] In a key passage interpreted by many authors, most notably Thomas Aquinas, Aristotle recommended that a magnificent man construct two types of structures: public buildings dedicated to the gods, and a grand house commensurate with his wealth.[16] He also indicated the flip side of the coin: since magnificence represents a virtuous way to spend money and leads to public good, "all these things bring with them greatness and prestige" for the patron.

In 1498 these themes were developed into a short treatise on magnificence by Giovanni Pontano, a prominent scholar and statesman, who was active in Naples. His views are consonant with those expressed by many other fifteenth-century authors, including the Florentines Leon Battista Alberti and Matteo Palmieri, the Bolognese Giovanni Sabadino degli Arienti, and the Venetian Giovanni Caldiera. In one of his rare examples taken from contemporary Italy, Pontano noted that, in Florence, Cosimo de' Medici showed magnificence "in building temples and villas, then in making libraries . . . he was the first to take up the custom of devoting private riches to public good and to the beauty of the fatherland."[17] This passage echoes the sentiments expressed a half century earlier by Timoteo Maffei, who defended Cosimo's magnificence from attacks made against his vast architectural expenditures.[18] After listing the many buildings commissioned by Cosimo, his supporter declared that "all these things deserve extraordinary praise and should be recommended to posterity with the utmost enthusiasm, since from Cosimo's Magnificence in building monasteries and temples it will have had divine excellence before its eyes, and it will consider with how much piety and with how much thankfulness we are indebted to God." Maffei also noted that Cosimo used his magnificent commissions to fulfill the need to distinguish himself: "It was necessary that he should appear more fully equipped and more distinguished than the other people in town, in the same proportion as he received benefits from it greater than theirs." Unlike other Renaissance authors discussed in the previous chapter, Maffei did not mention the crucial role these magnificent buildings played in supporting Cosimo's political survival in Florence.

Not surprisingly, private citizens of elite status, not merely heads of state, adapted the practice of using magnificent commissions to distinguish themselves. In a biography of Filippo Strozzi, probably the most important architectural patron in late fifteenth-century Florence, his son Lorenzo wrote: "If magnificence is recognized and demonstrated by honorable and glorious projects, and especially in the construction of public and private buildings, one can say that Filippo not only acted in a magnificent way, but surpassed the magnificence of every other Florentine."[19] Lorenzo supported this claim with a long list of Filippo's commissions. Most notably, Filippo decided to build a magnificent palazzo that would "bring renown to himself and all his [kinsmen] in Italy and abroad."[20] We can determine that the patron achieved his

goal from several letters by various relatives of Filippo. Most importantly, Giovanni Strozzi in Ferrara quoted the opinion of the "Lord," presumably Duke Ercole d'Este. This authority compared the building under construction with that of the Medici leader in Florence, declaring that Filippo's palace "will be more splendid than Lorenzo's."[21]

Cynical readers should not conclude that Renaissance patrons commissioned grand public works merely to glorify themselves and their families. In a related context, it is misleading to view texts on magnificence as exalted justifications of greed and vanity, written by insincere humanists only to serve the interests of their wealthy patrons. Recent studies have demonstrated that in Florence—and the argument extends readily to other cities—the desire to spend virtuously for the common good neatly complemented a highly developed and broad-based appreciation for the beauty of the city.[22] In his discussion of magnificence in the book significantly titled *On Civil Life*, Palmieri explained how private commissions and actions contribute to beauty that benefited all citizens. Even luxury objects owned by private individuals, such as "magnificent dwellings" and "precious chattels," should be considered together with public goods because they are "highly suited to the general embellishment of the city and create civic beauty, from which there results civic grandeur, honor, and good."[23] In the preface of his monumental treatise *On the Art of Building*, Alberti stressed the universal value of fine architecture: "When you erect a wall or portico of great elegance and adorn it with a door, columns, or roof, good citizens approve and express joy . . . because they realize that you have used your wealth to increase greatly not only your own honor and glory, but also that of your family, your descendants, and the whole city."[24] Low-income and affluent residents alike, intensely proud of their city, shared a collective desire to burnish its reputation, to make it appear ever more stunning and prosperous. Such pride only enhanced patrons' abilities to signal their virtue.

Naturally, not all shared this collective vision. In Naples, Pontano's views contrasted with those of Tristano Caracciolo. Inspired partially by a concern about patrimonial stability, as well as ethical and religious motivations, he proposed strictness, parsimony, and austerity in behavior.[25] Similarly, as we shall see in chapter 5, many churchmen railed against the private citizens who were aggrandizing themselves through public magnificence.

Conveniently for Renaissance patrons and modern scholars, Pontano specified the qualities that lend a building magnificence. He felt that "those who strive for magnificence must consider the appearance above all."[26] Buildings must exhibit "above all sumptuousness, but with worthiness. For worthiness itself is principally comprised of these things: ornament, size, excellence of materials, and the perpetual duration of the work." Writing in the same years as Pontano, Arienti advocated virtually identical qualities for a magnificent building; he omitted durability but added the value of what we might call

"creature comforts."[27] A half century earlier, Caldiera explained that in Venice the value of the family is expressed in the size of the palazzo, in its materials and artistic quality, and in particulars such as a well-lit courtyard and the size and form of the entrance portals.[28] In accord with many writers prior and since, he found that magnificence called for both grand scale and noteworthy beauty.

There was an additional prime requirement: the building must "fit," and what fit one owner would not often be appropriate for another. All Renaissance authors agreed that for a magnificent house to communicate a favorable message about its patron, it must, as Alberti wrote, "be adapted to the dignity of the owner."[29] Similarly, for Arienti, the building must correspond to "to the condition and state of the man."[30] Magnificence could be overdone, especially in the wrong hands. Some authors presented the problem in ethical terms. In Florence, Palmieri observed that "he who would want . . . to build a house resembling the magnificent ones of noble citizens would deserve blame if first he has not reached or excelled their virtue."[31] In other words, the returns to mishandled magnificence could be small or even negative. Those who did not follow fundamental rules of decorum, as we saw in the previous chapter, faced negative reception costs. Pontano warned that the patron would appear ridiculous if the commissioned work did not "correspond precisely" to his social and economic status.[32] Here, once again, Pontano drew on the authority of Aristotle: "Great expenditure is becoming to those who have suitable means to start with acquired by their own efforts or from ancestors or connections, and to people of high birth or reputation, and so on: for all these things bring with them greatness and prestige" (*Nichomachean Ethics*, 1122b). Authors writing in cities ruled by nobles often used blue blood and wealth to evaluate the appropriateness of magnificence. Caldiera offered a fascinating insight into how commissions should be calibrated to status in Renaissance Venice: aristocrats who had inherited their wealth should show more magnificence than people who had accumulated their wealth by themselves.[33] (This dictum has persisted to hamper the nouveaux riches in subsequent eras.) On the other hand, both Francesco Patrizi, writing in Siena in the mid-1400s, and Domenico Morosini, in Venice shortly before 1500, "explicitly proposed that houses of patrician families in a republican state should resemble each other to convey the impression of a homogeneous ruling class."[34] Though they believed that such families should exhibit magnificence, it should be limited to members of this elite group.

The observations by Patrizi, Morosini, and other authors recognized the fierce competition inherent in status seeking. In a Renaissance rat race of "keeping up with the Strozzi," patrons had to spend vast, sometimes ruinous amounts to maintain social status. If other patrons were contracting for magnificence at the 100,000-florin level, it would do a prosperous merchant little good to reach 90,000 florins. To reach the top of the heap, he might decide to spend

110,000, which in turn would encourage others to push harder to 120,000.[35] Here the competition was about who could do more to beautify the city, glorify God, and enhance their own and their families' reputations. The importance of such striving in Italy, and the fruits it produced, was discussed in a 1588 by Giovanni Botero in *Three Books on the Causes of the Greatness of Cities*. "A gentleman spends more generously because of the competition, and in order to emulate others, in the city, where he can see and be seen by honorable people, than in the country, where he lives among the animals and talks with bumpkins. . . . In this way, the buildings necessarily increase and the arts multiply."[36] Whereas this would seem to be a purely positive development, some of Botero's contemporaries noted a great danger. Annibale Romei observed in 1591 that some less affluent nobles were "unable to bear the pomp and the arrogance of the richest in their lifestyle, clothing, and other external matters."[37] Though buildings increased and arts multiplied, they contributed to an excess degree of social climbing. As Silvio Antoniano lamented in 1584, "The artisan now wishes to be the equal of the citizen, the citizen the equal of the gentleman, the gentleman the equal of the noble, and the noble the equal of the prince, and these are intolerable things beyond reason and measure which displease God and lead to a thousand sins."[38]

One solution was to distinguish among different types of expenditures, making some more virtuous or appropriate than others. Piccolomini described the financial transactions of "everyday life, such as gifts and payments, alms and household expenses," as examples of "liberality." Magnificent actions, on the other hand, conveyed "sumptuousness and grandness," and for these "three aspects should be considered: who spends, how much is spent, and the matter of spending."[39] These expenditures thus served as signals that distinguished elite patrons from the rest. Magnificence, as Aristotle had said, was limited "to people of high birth or reputation."

Signaling

To create magnificence players must exercise both skill and subtlety. The Renaissance patrons and artists who were responsible for magnificent works had to carefully select expenditure levels and tailor commissions to convey the appropriate message. They also had to be sensitive to the ability of their audience to interpret any commission. Fortunately, elites—a patron's most important audience—were highly skilled in assessing the quality of works, the costs to create them, and their appropriateness for the patron who provided them. In this section we examine how signals are created and interpreted.

In a sermon given in Siena in 1427, Bernardino discussed how public signs contributed to effective signals. "By what do we know the shops, eh? By their signs . . . thus we know the shop of the wool merchant by his sign." And so too

with the moneylender, wine seller, hotelier, and tavern keeper.[40] Such signs were needed: at this time Florence had 1,540 shops.[41] But it was not sufficient merely to know what a merchant did. As Bernardino explained, many merchants tried to cheat with false weights and fraudulent goods.[42] During the same period, Leon Battista Alberti warned that "the world is filled with fraudulent, false, perfidious, bold, audacious, and rapacious men. Everything in the world is profoundly unsure. One has to be far-seeing, alert, and careful in the face of frauds, traps, and betrayals." As Rubin commented, "Appearances were deceptive. They were also instrumental."[43] What indicators existed to help shoppers, and how did they convey information that was essential but highly difficult to communicate, such as the purveyor's honesty and the quality of his goods? How, for example, did sellers of high-quality goods distinguish themselves from those whose products were inferior when some aspect of quality, such as durability, was not obvious on inspection?

The economic theory of signaling addresses the question of how to convey difficult information in modern markets where information is held asymmetrically. Traditional economics assumes that decision makers are well informed—that they have adequate information about anything they buy, be it a product for sale, a person offering a service, or an individual proclaiming her capabilities. Sometimes it is easy to gather the requisite information, for example when a product is purchased frequently, or when a professor's class is regularly offered and well attended. But even in developed economies, much valuable information is not transmitted to all interested parties. The need to instill trust leads merchants to conspicuous expenditures that do not improve the quality of their goods. In Renaissance Italy, for example, pharmacists invested relatively large amounts in the infrastructure of their shops. In Florence, Luca Landucci had been earning three hundred gold florins a year when working for another pharmacist, but when he opened his own establishment he lamented that "the cupboard alone cost fifty gold florins." Welch argued that such expenditures, and those for majolica jars to hold ingredients, proved "to both customers and the supervisory authorities . . . that these pharmacies had the appropriate effective ingredients."[44] This constitutes a perfect example of signaling: although fancy containers do not necessarily contain or properly preserve the required products any better, they convey a reassuring message about the pharmacist. Thus, the fancy packaging was essential; in the Renaissance, as today, clients needed to see signs of quality before making purchases. By the same logic, a magnificent, classically inspired palace probably functioned for merchants as a sleek corporate headquarters does today. It trumpeted abundance, and attracted clients lured to strong indicators of success. An unusually modest building, on the other hand, might create a social disaster for the Renaissance patron, and a business one for the modern company.

Sellers usually know more about their products than buyers, and this cre-

ates an informational imbalance. As a result, sellers need to produce signs or signals that convey some essential qualities about their products, such as durability, or themselves, such as honesty. At the most abstract level, assume that an individual has (or possesses a product with) a desirable characteristic we can call X. Assume that those lacking X will find it much more expensive than those having X to produce a particular signal, Y. This will discourage them from using Y. Hence, observing an individual with Y will tend to indicate that the individual possesses X.

This fundamental principle of drawing inferences from differential costs underlies a highly influential article, "The Market for 'Lemons,'" which garnered George Akerlof the Nobel Prize.[45] The owner of a used car knows whether or not the vehicle starts on cold mornings, something that cannot be determined by a potential purchaser. Owners of nonstarters would like to dispose of them; thus people who are shopping for a secondhand car should expect its quality to be below average for its vintage—that is, a lemon. This handicaps the owner of a perfectly fine car, since that information cannot be readily conveyed to nonexperts, but signaling comes to the rescue. A used-car dealer who can assess reliability can offer a generous warranty—one that is economically feasible only if the car is good—to signal the high quality of his product.

In Renaissance Italy, cities needed to address the shoppers' fear of deception, as voiced by Bernardino and many others. One popular solution was to provide certificates that authenticated goods.[46] The Silk Guild in Milan, for example, stipulated that all silk cloth be stamped in the guildhall, and buyers had to present their purchases within three days to be checked. If material was faulty or fraudulent, customers would receive their money back plus a 25 percent premium. The certificate or stamp thus signaled difficult-to-communicate information, mainly quality. It was costly to sell fraudulent goods, as it is costly to offer a generous warranty with a car that works poorly.

The concept of "differential costs" extends easily to nonmonetary matters. For example, today it is easy and inexpensive to make a text available on the Internet. When a generic search engine turns up an art historical study on an unknown website, potential readers know nothing about its quality. Specialists, suspicious that the author could not publish the article in a more established setting, view such a piece with extreme caution. In contrast, it is extremely difficult to publish a paper in an established academic journal unless one is a capable scholar. Hence, readers expect studies that get major publication to present new conclusions based on solid research. The difficulty that weak scholars face in placing articles in a respected journal constitutes a significant differential cost. Prominent publication thus signals quality. Scholars win respect for having published many major journal articles or having published books with prestigious presses, even from those who have not read the works.

The concept of signaling can help to resolve a number of real-world puzzles.

Consider three examples. Why did Renaissance apothecaries used majolica vessels and furniture to signal the quality of their products, and their professional seriousness, when a dishonest pharmacist could obtain the same vases and cupboards? Over time, as the poor quality of his product became known, the dishonest pharmacist's sales would slump, and the high investment would have been squandered. A much-studied contemporary puzzle is why companies with spare cash pay dividends rather than repurchase shares, especially when dividends are taxed much more heavily than capital gains.[47] Economists say that the costly action of paying a dividend signals a firm's rosy prospects, since cutting dividends would be very embarrassing. Hence, only firms with bright prospects will commit to dividends today. The most famous example of signaling was mentioned in the introduction to this book: Students, even those with limited intellectual interests, work hard to obtain a diploma from a prestigious liberal arts college. That is because securing the degree signals a range of positive qualities, including motivation and determination.

Spence showed rigorously, in mathematical terms, why conspicuous consumption expenditures work—namely, their costs are substantially lower to those who have more money. To use an example familiar to most readers, if a speaker at an academic conference appears in a designer dress, the audience will conclude that she is wealthy. Even an assistant professor of moderate means could scrape together five thousand dollars for such an outfit, but her sacrifice of everyday living standards would be much greater than that of her colleague with inherited wealth. Purchasing the signal of the expensive outfit is much cheaper for the rich person.

Economists refer to communications with very low differential costs as "cheap talk." More generally, words, actions, or instruments cheaply available to all tell nothing favorable about those who use them.[48] To quote a long passage from Homer in the original Greek is impressive. To toss an occasional Latin term into one's speech might merely convey an attempt to impress. Knowledgeable people, seeking to impress, are good at conveying that their talk is not cheap. Signaling elite status in Renaissance Italy involved high stakes; such "talk" was not cheap.

Signaling in Renaissance Art

A modern-day visitor to Italy who sees a grand altarpiece, statue, or palace from the Renaissance era will conclude that the patron had ample resources. But at the time it was made, something more was almost certainly conveyed, namely that the patron fit the criteria of magnificence. The high social costs to these commissions, if chosen in deviance from one's station, guaranteed that the works signaled status, not merely wealth.

The key to signaling was differential costs, which ensured that a work of art

or the specific attributes of it were not cheap talk. We saw in chapter 1 that Paolo Vitelli asked a painter *not* to depict an order of knighthood given to a family member, since by that date such titles had become abundant, and thus offered little distinction among the elite.[49] In a similar vein, the poet Aretino refused the offer of a nonstipendiary title (but accepted a beautiful gold chain) because "a knight without an income is like a wall without a cross, which is pissed on by everyone"[50] (fig. 3.1). In economic terms, these commentators recognized that cost differentials for certain knighthoods had fallen so low that membership in such orders no longer signaled status. They feared that viewers might interpret a reference to the order as cheap talk or, even worse, an attempt to claim status from a signal that revealed little. Such a claim, if recognized, would lower the claimant's status. Vitelli, our shrewd patron, requested that other noble titles be included; presumably, the intended audience would understand that those were more difficult to obtain. Similarly, a respected academic today might have a résumé that lists a lecture delivered at Princeton University but omits one given at an insignificant institution. Beyond wealth, culture and taste were often required for conspicuous commissions; thus, the art signaled the patron's culture and taste.

Since money alone often was not sufficient to commission various works, and certain works would be inappropriate for some patrons, many commissions also signaled status. As we have seen, one patron might be able to signal high status through a message whereas others trying to do the same would face the high reception cost of social disapproval. Triumphal entries into cities—consisting of ephemeral street decorations and permanent written records—provide a salient case. Very wealthy but common citizens might be able to afford such extravaganzas—much as a CEO today could hire a band to play "Hail to the Chief" at the beginning of board meetings—but if the audience felt that the protagonist did not deserve the honor, it would bring only ridicule.

Given these types of costs, even uninformed members of the throng witnessing a Renaissance triumphal entry could draw accurate conclusions about the importance of a celebrated leader. One probably typical example, unusual though for the abundant documentation that has survived, was the 1585 triumphal procession of Duke Carlo Emanuele I of Savoy and his bride Catherine of Austria.[51] Volumes of letters, between ducal representatives and the government officials responsible for realizing the project, detail the preparations for a series of entries into nine different cities. This correspondence indicates the high importance given to the identity, status, roles, and clothing of participants. The Savoy, not yet a major power at this date, wanted to show that they could carry off a triumphal entry comparable to those produced by major European dynasties. The procession was made at the very time the Savoy were mounting an extensive campaign to obtain a royal title. They demonstrated the capacity to express themselves in the visual language expected of royal houses: allegories, ancient-inspired decorations, and classical gods.

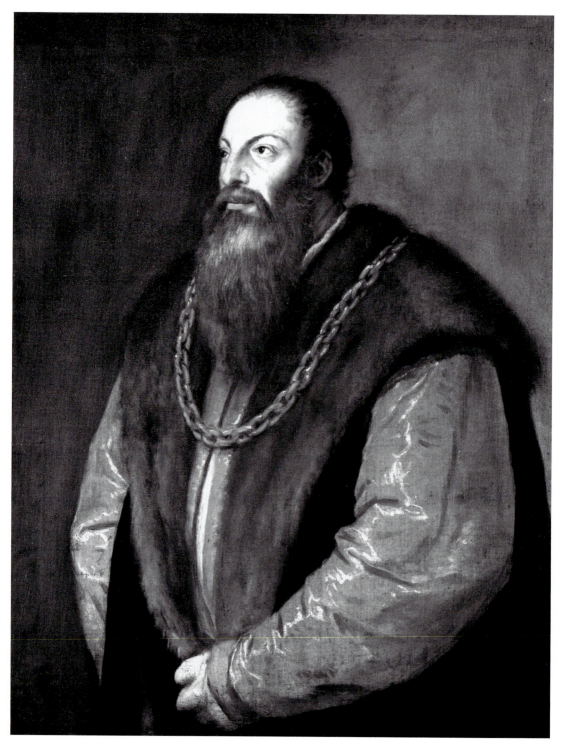

FIG. 3.1. Titian, *Portrait of Pietro Aretino*, Frick Collection, New York (Frick Collection, New York). © The Frick Collection, New York

The extensive literature on Renaissance processions focuses primarily on the learned iconographic programs conveyed by the costumes, statues, and painted arches. Scholars explain how the events promoted specific messages useful to the rulers, supplying examples of selective revelation of information, what we call signposting, a subject discussed in the next chapter. The analyses often fail to assess what the actual intended audiences perceived. Erwin Panofsky would be disappointed in accounts written by learned eyewitnesses to the Savoy processing, including ambassadors in attendance; they showed a surprising lack of interest in the iconography. The same is true of the patrons themselves, and most members of the audience probably felt the same way. But all grasped the grand pageantry and recognized that great wealth, skill, and power were required to produce it.

The triumphal entry signaled the general quality and high status of the Savoy family. The origins and marriage alliances of the Savoy permitted them to stage this panoply of events, and they had the sophistication to produce them in the proper style. Though skilled planners were necessary, to avoid the embarrassment of gaffes in symbolism or protocol, these details were not arranged by the Savoy themselves.

Most probably, we can interpret the vast majority of complex painted and sculpted iconographic programs in a similar fashion. Patrons wanted to show that they could "talk the talk" and impress viewers with an overall appearance, but expected few to appreciate the fine details of the message. The rarity of triumphal entries indicates that they were difficult for all but the most exalted to mount, and helped ensure their effectiveness as signs of elite status. With more familiar processions, such as those associated with funerals, patrons had to spend ever-increasing amounts to distinguish their families as exceptional. As a result, wealthy Florentine patrons regularly spent far more on funerals than on the altarpieces and frescoes for which they are now famous. In the 1400s, the cost of prominent funerals ranged from three hundred to seven hundred florins (about eight to twenty man-years), excluding the price of tombs or masses. A few exceptional funerals cost far more, with those for the Medici, Alberti, and Strozzi families reaching the cost of over sixty man-years each.[52]

Many elements of funerary rituals, such as canopies, candles, and the public display of the deceased, were incorporated into the designs for the most exclusive tombs. As with triumphal entries, however, money alone could not allow patrons to obtain such personal monuments. As a result, the type and placement of tomb markers provided a socially acceptable and widely used mechanism to allow individuals to differentiate themselves. Not surprisingly, the churches in Florence, as in other cities, developed a series of codes for tombs.[53] The simplest and most common type was the small floor marker, although larger, rectangular marble slabs also appeared frequently in the pavement of chapels. Freestanding monuments were almost unheard of, and wall

tombs were exceptional; the presence of a stone canopy or arch enriched the signal, providing additional evidence of high status.

Many casual viewers in the fifteenth century presumably understood what art historians have realized only recently: even very rich and powerful private patrons were rarely honored by wall monuments adorned with effigies. The frequent appearance of this tomb type, such as Bruni's, in modern art books obfuscates how exclusive such effigies were in the Renaissance. In Florence, as we now recognize, nearly all fifteenth-century monumental tombs with sculpted effigies commemorate high officials in the Church or local government. If we turn to nonmonumental tombs, nearly all portraits represent members of one of four elite groups: lawyers and physicians, higher ecclesiastics (and other important religious figures), "civil servants" buried at public expense, and knights and aristocrats. In short, if one can see the face of the departed, and especially if one can look up or out (but not down) at him, his status, like his burial place, was high.

The careful choice of materials for tomb monuments also helped Renaissance patrons across Italy signal status. Writing in 1539, Lilio Gregorio Giraldi from Ferrara opined that burials in the ground were vulgar and plebeian. He judged marble sepulchres more "civil," and porphyry and bronze coffins apt for "princes and potentates."[54] Following a similar line of thought, the Venetian Giovanni Priuli complained in 1575 about the planned tomb for two doges from his family. He argued that "nowadays the most illustrious men are no longer entombed in Istrian stone."[55] The use of this material for the tomb of a mere physician, Tommaso Rangone, made it no longer appropriate for those of higher class.

The greater the differential costs of signals, whether because of monetary cost, status constraints, or requirements of taste or erudition, the more a particular commission separated one from the others. Time could often be the partner of true elites, making their endeavors more costly to imitate. Bourdieu observed that "the objects endowed with the greatest distinctive power are those which most clearly attest . . . the quality of their owner, because their possession requires time and capacity which, requiring a long investment of time, like pictorial or musical culture, cannot be acquired in haste or by proxy."[56] In the competition to commission objects with such "distinctive power," families who retained money and influence over long periods had unique opportunities. As Loughman demonstrates in chapter 6, members of a long-prominent family can set themselves apart from others by obtaining a number of tombs in one location. This *oeuvre* gained value as time passed, because even if a nouveau riche merchant could obtain a tomb of the most exalted material and type, he could not place it near comparable monuments of his ancestors. In chapter 7, Helmstutler Di Dio demonstrates how Leone Leoni obtained an "object" with extraordinarily high distinctive power: the right to burial in the imperial church in Milan, Santa Maria della Scala. This

honor was reserved to the most illustrious men of the court of Charles V. In both cases, patrons obtained what money alone could not buy; one needed to have high status, and thus these two commissions signaled this difficult-to-convey quality. The most effective signals are those that are beyond the reach of others.

Notes

1. For a discussion of costs, prices, and markets, with references to further literature and databases, see Michelle O'Malley, *The Business of Art: Contracts and the Commissioning Process in Renaissance Italy,* (New Haven and London: Yale University Press, 2005); Evelyn Welch, *Shopping in the Renaissance: Consumer Cultures in Italy, 1400–1600* (New Haven and London: Yale University Press, 2005); and Guido Guerzoni, *Apollo e Vulcano. I mercati artistici in Italia 1400–1700* (Venice: Marsilio, 2006).

2. Stephen Greenblatt, *Renaissance Self-Fashioning: From More to Shakespeare* (Chicago: University of Chicago Press, 1980), 169.

3. Ibid., 163.

4. See, for example, Mary Rogers, ed., *Fashioning Identities in Renaissance Art* (Aldershot, UK, and Brookfield, VT: Ashgate, 2000), and Wim Blockmans and Anthenu Janse, eds., *Showing Status: Representation of Social Positions in the Late Middle Ages* (Turnhout: Brepols, 1999).

5. Diane Owens Hughes, "Earrings for Circumcision: Distinction and Purification in the Italian Renaissance City," in *Persons in Groups: Social Behavior as Identity Formation in Medieval and Renaissance Europe*, ed. Richard C. Trexler (Binghamton: Medieval & Renaissance Texts & Studies, 1985), 155–177 and Ruth Mellinkoff, *Outcasts: Signs of Otherness in Northern European Art of the Late Middle Ages* (Berkeley: University of California Press, 1993).

6. Pierre Bourdieu, *Distinction: A Social Critique of the Judgement of Taste*, trans. Richard Nice (Cambridge, MA: Harvard University Press, 1984).

7. For the "ten most important sociology books" honor, conferred by the International Sociological Association, see http://www.ucm.es/info/isa/books/books10.htm.

8. Bourdieu, *Distinction*, 282.

9. Patricia Lee Rubin, *Images and Identity in Fifteenth-Century Florence* (New Haven and London: Yale University Press, 2007), 17. For examples of how works of art, especially ancient pieces, signaled the knowledge of their owners, also see ibid., 165–168, and Paula Findlen, "Possessing the Past: The Material World of the Italian Renaissance," *American Historical Review* 103, no. 1 (1998): 83–114.

10. Dale Kent, *Cosimo de' Medici and the Florentine Renaissance: The Patron's Oeuvre* (New Haven and London: Yale University Press, 2000), 240. Poggio himself argued that nobility is found not in objects but in wisdom and virtue.

11. Creighton E. Gilbert, "What Did the Renaissance Patron Buy?" *Renaissance Quarterly* 51 (1998): 411.

12. Guido Guerzoni, "Liberalitas, Magnificentia, Splendor: The Classic Origins of Italian Renaissance Lifestyles," in *Economic Engagements and the Arts*, ed. Neil De Marchi and Craufurd D. W. Goodwin (Durham and London: Duke University Press, 1999), 337, and Guerzoni, *Apollo e Vulcano*, 109–110.

13. Guerzoni, "Liberalitas," 337, and Guerzoni, *Apollo e Vulcano*, 109–110.

14. A. Michael Spence, *Market Signaling: Informational Transfer in Hiring and Related Screening Processes* (Cambridge, MA: Harvard University Press, 1974), 62.

15. A. D. Fraser Jenkins, "Cosimo de' Medici's Patronage and the Theory of Magnificence," *Journal of the Warburg and Courtauld Institutes* 33 (1970): 162–170.

16. Paula Spilner, "Giovanni di Lapo Ghini and a Magnificent New Addition to the Palazzo Vecchio," *Journal of the Society of Architectural Historians* 52 (1993): 453–465, esp. 458.

17. Giovanni Pontano, *I libri delle virtù sociali*, trans. and ed. Francesco Tateo (Rome: Bulzoni, 1999), 188.

18. For this and the next two quotes, see the translation and discussion in Fraser Jenkins, "Cosimo de' Medici's Patronage," 165–66.

19. Lorenzo di Filippo Strozzi, *Le Vite degli uomini illustri della Casa Strozzi*, ed. Pietro Stromboli (Florence: Landi, 1892), 72.

20. F. W. Kent, "'Più superba de quella de Lorenzo': Courtly and Family Interest in the Building of Filippo Strozzi's Palace," *Renaissance Quarterly* 30 (1977): 311.

21. Ibid., 315.

22. Jill Burke, *Changing Patrons: Social Identity and the Visual Arts in Renaissance Florence* (University Park: Pennsylvania State University Press, 2004), esp. 35–37, and Rubin, *Images and Identity*, esp. 19–42.

23. Rubin, *Images and Identity*, 40.

24. Leon Battista Alberti, *On the Art of Building in Ten Books*, trans. Joseph Rykwert, Neil Leach, and Robert Tavernor (Cambridge, MA: MIT Press, 1988), 4.

25. Giuliana Vitale, "Modelli culturali nobiliari a Napoli fra Quattro e Cinquecento," *Archivio storico per le province napolitane* 105 (1987): 27–103.

26. Pontano, *I libri*, 178. Similarly, see Alberti, *On the Art of Building*, 291: "it is preferable to make the parts that are particularly public or are intended principally to welcome guests . . . as handsome as possible."

27. Rupert Shepherd, "Giovanni Sabadino degli Arienti and a Practical Definition of Magnificence in the Context of Renaissance Architecture," in *Concepts of Beauty in Renaissance Art*, ed. Francis Ames-Lewis and Mary Rogers (Aldershot, UK, and Brookfield, VT: Ashgate, 1998), 52–65.

28. Kornelia Imesch, *Magnificenza als architektonische Kategorie: individuelle Selbstdarstellung versus ästhetische Verwirklichung von Gemeinschaft in den venezianischen Villen Palladios und Scamozzis* (Oberhausen: Athena, 2003), 176.

29. Alberti, *On the Art of Building*, 291.

30. Shepherd, "Giovanni Sabadino," 53.

31. Richard A. Goldthwaite, "The Florentine Palace as Domestic Architecture," *American Historical Review* 77, no. 4 (October, 1972): 990.

32. Pontano, *I libri*, 182.

33. Imesch, *Magnificenza*, 176.

34. See discussion in Michael Lingohr, "Palace and Villa: Spaces of Patrician Self-Definition," in *Renaissance Florence: A Social History*, ed. Roger J. Crum and John T. Paoletti (Cambridge and New York: Cambridge University Press, 2006), 267.

35. Robert H. Frank and Philip J. Cook discuss, in *The Winner-Take-All Society: Why the Few at the Top Get So Much More Than the Rest of Us* (New York: Free Press, 1995), a more extreme version of this phenomenon. There are very high returns to the professional golfer or the topflight litigator who is just a little bit better than his or her competitors.

36. Quote taken from the 1598 edition of Giovanni Botero, *Della ragion di stato e delle cause della grandezza delle città*, ed. Luigi Firpo (Bologna: Forni, 1980), 350 (II.x).

37. Guerzoni, "Liberalitas," 363; Guerzoni, *Apollo e Vulcano*, 128.

38. Guerzoni, "Liberalitas," 339; Guerzoni, *Apollo e Vulcano*, 127.

39. Guerzoni, "Liberalitas," 337; Guerzoni, *Apollo e Vulcano*, 110.

40. Welch, *Shopping*, 137.

41. Ibid., 140. By 1561, the number of shops had increased to 2,172.

42. Ibid., 71–72.

43. For this comment and the Alberti citation, see Rubin, *Images and Identity*, 4.

44. Ibid., 158.

45. George Akerlof, "The Market for 'Lemons': Quality, Uncertainty and the Market Mechanism," *Quarterly Journal of Economics* 84, no. 3 (1970): 488–500.

46. Welch, *Shopping*, 73.

47. A higher tax rate on dividends generally applied in the United States until 2003. Once the two tax rates were equalized, many companies, such as Microsoft, began paying dividends.

48. Vincent P. Crawford and Joel Sobel, "Strategic Information Transmission," *Econometrica* 50, no. 6 (1982): 1431–51.

49. Julian Kliemann, *Gesta dipinte. La grande decorazione nelle dimore italiane dal Quattrocento al Seicento* (Milan: Silvana, 1993), 85.

50. Pietro Aretino, *Il primo libro delle lettere*, ed. Fausto Nicolini (Bari: Laterza, 1913), 25 (letter of 17 September 1530); with this line the poet quotes himself from *Il Marescalco* (act V, scene II); Pietro Aretino, *Teatro*, ed. Giorgio Petrocchi (Milan: Mondadori Editore, 1971), 71.

51. Marta Alvarez González, "Pageantry and the Projection of Status: The Triumphal Entries of Catherine of Austria (1585) and Christine of France (1620) in Turin," *Mélange de l'École française de Rome: Italie et Méditerranée* 115, no. 1 (2003): 29–50.

52. Sharon T. Strocchia, *Death and Ritual in Renaissance Florence* (Baltimore and London: Johns Hopkins University Press, 1992), 59, 77, 122, 292 note 55, provides details on several exceptional funerals: for the Acciaiuoli in 1353 (5,000 florins or 131 man-years); the Alberti in 1377 (3,000 florins or 84 man-years); the Medici in 1429 (3,000 florins or 96 man-years); the Tornabuoni in 1432 (1,056 florins or 32 man-years); and two ceremonies for the Strozzi in 1491 (1,222 florins or 61 man-years). We estimate a "man-year" of unskilled labor at about 130 lire; see discussion in the introduction.

53. Andrew Butterfield, "Monument and Memory in Early Renaissance Florence,"

in *Art, Memory, and Family in Renaissance Florence*, ed. Giovanni Ciappelli and Patricia Lee Rubin (Cambridge and New York: Cambridge University Press, 2000), 135–62.

54. Kathryn B. Hiesinger, "The Fregoso Monument: A Study in Sixteenth-Century Tomb Monuments and Catholic Reform," *Burlington Magazine* 118, no. 878 (1976): 284 note 9; and Martin Gaier, *Facciate sacre a scopo profano: Venezia e la politica dei monumenti dal Quattrocento al Settecento*, trans. Benedetta Heinemann Campana (Venice: Istituto veneto di scienze, lettere ed arti, 2002), 212.

55. Gaier, *Facciate*, 211–12.

56. Bourdieu, *Distinction*, 281.

SIGNPOSTING AND STRETCHING

Introduction: Signposting and Stretching

THE PREVIOUS chapter explored the strategies Italian Renaissance art patrons used to distinguish themselves in the eyes of their audiences. Those strategies usually employed broad strokes and grand gestures to communicate wealth and status. This chapter addresses situations in which principals felt a need to communicate more specific information, such as connections with a prominent leader or victory at a certain battle. But specificity does not require integrity, and the messages conveyed by many Renaissance Italian commissions were intended to inflate the patron's reputation. There were two strategies behind such self-fashioning: signposting and signaling. Signposting applies to messages that conveyed the truth, but not the whole truth. Stretching indicates that the commission overstated the patron's accomplishments or qualities.

Modern audiences expect artists to take liberties in their pursuit of beauty. In Renaissance Italy, principals and their audiences also accepted a high degree of "artistic license," albeit for a broader array of reasons. They often hoped and expected that works of art would go beyond mere pleasing aesthetics; commissioned works needed to be morally uplifting to viewers. A painted history, like a written one, they felt, should inspire viewers to carry out good deeds and avoid evil ones. A propagandistic role in service of a good deed—namely providing models for behavior—was accepted. The modern-day equivalent might be the eulogy of a public figure. No one expects to hear a careful balancing of pluses and minuses. Positives always get the bulk of the attention, with negatives slighted or omitted. This is signposting, rooted in the time-honored conventions of classical epideictic rhetoric. When those positives are exaggerated, this is stretching. The third section below, on stretching, focuses on such embellishments in art. The second, on signposting, assumes that the intended audience for paintings and sculptures accepted the validity of the information conveyed about the patron; say, that the general depicted in one portrait actually led his troops to an important victory, and the noblemen shown in another had ancestors with blue blood.

Signposting and stretching were almost always accompanied by signaling.

Given their expense, all prestigious commissions automatically served as signals, at a minimum for wealth but often for more. Differential costs drove the success of all three mechanisms. Such costs assured that the messages received would not be so common that they conveyed little information. If everyone could mount a campaign of medals and proclamations about their battlefield successes, without doubters coming to the fore, such campaigns would be worthless, even for legitimate victors. But fortunately for true heroes (and for the stretchers who mimicked them), credible distortions would have been far too costly for all but a few. So too for those who successfully signposted legitimate adulatory information. Few others had such information to put forward. That disparity represents the differential costs that enabled signposting to work.

Signposting

Through signposting a player indicates specific, truthful, and important characteristics while simultaneously ignoring other significant information.[1] Signposters thus differ from mere signalers in two main ways. First, they publicize definite and often detailed information, such as a close connection to a prominent family or having won a military victory. For example, as we shall see, Francesco Sassetti advertised his close connections with Lorenzo de' Medici, and Jacopo Pesaro reminded viewers that he had led a victorious battle against the Turks. In other words, they did not merely signal generic characteristics such as wealth or high status.

Second, signposters leave out noteworthy information that might detract from a favorable picture. For example, we would expect a lowborn but highly decorated general to commission a portrait including references to his profession but not his origins, but a nobleman whose title dwarfed his wealth and who was reduced to working for a living to choose the opposite. Domenico Ghirlandaio's fresco *Confirmation of the Rule of Saint Francis* (fig. 4.1) in the chapel of Francesco Sassetti (Florence, Santa Trinita, 1480–1485) shows how a patron drew attention to selected key characteristics but left out others.[2] In the foreground, three children and their tutors walk up a flight of stairs. The clothes and detailed features identify these figures as portraits, and the uninformed viewer might assume that the patron proudly put his sons on display. If that were the case, the painting would represent a standard example of signaling. In reality, however, the children are the sons of the political leader of Florence, Lorenzo de' Medici, who appears at the top of the stairs.

Lorenzo is flanked by two of his most trusted supporters. Closer to the viewer is Francesco Sassetti, the donor, who ran the Geneva branch of the Medici bank, seen together with his son. On Lorenzo's right is Antonio Pucci. Both of these allies stood symbolically at Lorenzo's side just a few years earlier when, in 1478, a rival faction in Florence murdered his brother Giuliano and

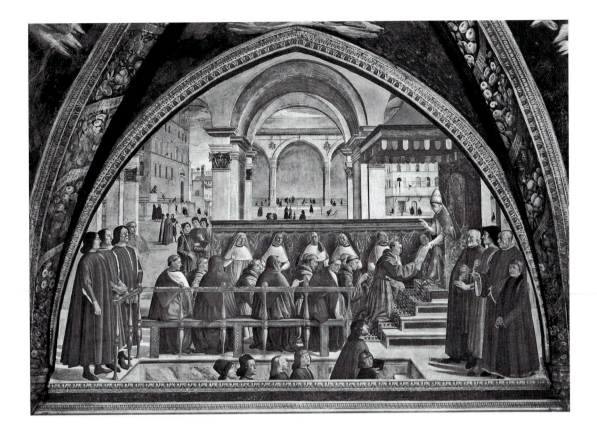

attempted to assassinate the Medici leader himself. Sassetti used his chapel fresco to signpost this risky feat of loyalty. The painting, however, conveniently omits a crucial fact about the patron's relationship with the Medici. By the time he commissioned the fresco, Sassetti had nearly run the Geneva branch of the Medici bank into bankruptcy. Naturally, neither Renaissance nor modern observers would expect a fresco cycle to illustrate an embarrassing event or situation. Moreover, Sassetti knew—and could have expected his contemporaries to know—that patrons rarely commissioned major chapel decorations when they faced a financial or social crisis. Thus, Sassetti could mix himself into the pool of patrons without stirring questions from unknowing viewers. In this commission, not surprisingly, the principal went to unusual lengths to have his agent signal the positive qualities of deference, respect, and loyalty to the effective head of state in Florence. This was a time when Sassetti desperately needed Medici support.

Also in the early 1480s, Antonio Pucci commissioned a series of paintings by Botticelli, *The Story of Nastagio degli Onesti,* to celebrate the wedding of his son. The son's union had been arranged by Lorenzo de' Medici, whose arms appear prominently in the scene portraying the wedding feast. As in the Sassetti Chapel, an unusual detail—the arms of the marriage broker—indicates the patron's desire to signpost. The selection of guests at the feast, as recorded

FIG. 4.1. Domenico Ghirlandaio, *Confirmation of the Rule of Saint Francis,* Sassetti Chapel, Santa Trinita, Florence (Archivi Alinari/ Bridgeman, Florence)

by Botticelli, reveals the political affiliation of Antonio Pucci. Once again he appears with Francesco Sassetti. This time they are physically close to Lorenzo's brother Giuliano, the murder victim of just a few years earlier. Thus the painting represents not a historic reality but, rather, a pictorial tribute to the Medici. Not surprisingly, the painting does not even hint that the Pucci, now major statesmen, had been minor guildsmen just a few decades earlier.[3]

Paintings and sculptures offer a prime opportunity to signpost, because the combination of available space, aesthetic considerations, and artistic traditions inevitably impose limits on the amount of information a commissioned work can convey about a patron. Thus, a Renaissance patron such as Sassetti could use art to signpost his important connections but leave aside references to significant embarrassments. The signposting model demands that there be some significant cost—in time, space, or money—to providing information. If there were not, viewers—like the readers of a thick autobiography that made no reference to the author's parents—would note with suspicion the absence of a certain well-known event or personal connection, and might conclude that the reference was omitted to conceal an associated misfortune or disgrace.

The modern advertising world provides a convenient example of information costs. An automobile ad on television raises no suspicions if it fails to identify horsepower or trunk size. To provide such detail would entail extraordinary costs in time, and thus financial outlay. But if the manufacturer's brochure at a dealership left out such facts, potential customers might well conclude that the horsepower was low and the trunk unusually small, since the cost of including that information would be modest.

Those sending a message and their audiences also put a premium on creative expression. The communications need to be well organized, engaging, and stimulating; thus the cost of providing artistic quality and unity often overpowers all other considerations. Were the automobile ad twice as long, for example, the "seller" would hardly include twice the information, lest quality or unity be lost. Similarly, in a Renaissance portrait, the principal might wish to include references to his learning, property holdings, military victories, and illustrious relations, but the agent could hardly include all while maintaining any sense of artistic unity. A fresco cycle could easily include several scenes celebrating past glories, but if there were too many, the images would become too small and cluttered. Thus artistic conventions and aesthetic considerations limited the information conveyed by any commission, thereby protecting those who wished to avoid any mention of important but inglorious information.

Signposting, though common, was hardly the norm in Renaissance art, primarily because most commissions did not convey specific information about the patron. Often the patron is merely identified, perhaps through a family crest adorning the frame of an altarpiece, or a portrait in an altarpiece. When a work shows unusual variations on signaling or progresses to signposting, the

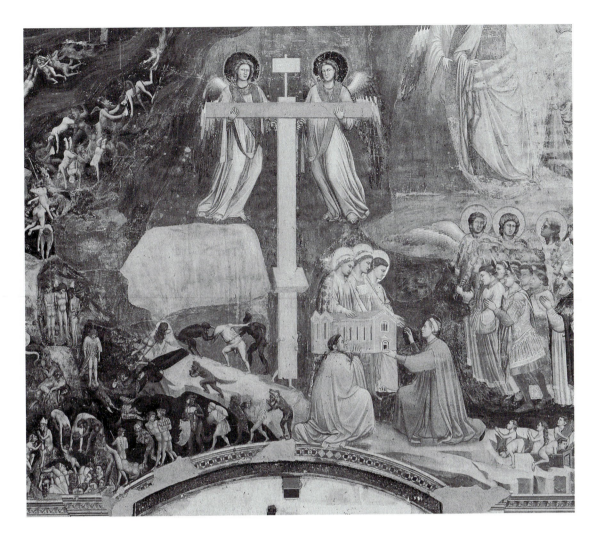

Fig. 4.2.
Giotto, *Last Judgment*,
Arena Chapel,
Padua, detail
(Archivi Alinari, Florence)

principal-agent relationship is of greater interest, because the patron probably gave the artist more detailed instructions. If modern viewers miss these deviations from the norm, they miss part of the message.

Patrons with "image problems," Sassetti being a prime example, often employed signposts in an attempt to improve their reputations. This motivation certainly applied to Enrico Scrovegni, best known today as the patron of Giotto's fresco cycle for his private chapel in Padua, the Arena Chapel.[4] Scrovegni found himself in a very disadvantageous position. Not only had a history of local families insulted his plebian origins, but Dante, in the *Divine Comedy*, had recorded Enrico's father among the usurers in Hell. To counter these defamations, the younger Scrovegni, who also prospered in the family business, commissioned no fewer than three portraits of himself for the chapel. In the most famous one, a detail of the *Last Judgment* (fig. 4.2), Giotto depicts the patron as he literally offers the chapel, in the form of a model of the building, to the Virgin. A magnificent tomb not far away shows the patron in the attire

of a knight, a title he held. For the façade of the building, seen even by those who never entered, Scrovegni commissioned a freestanding statue of himself as a knight and founder of the chapel.

In his chapel, Scrovegni avoided all indications about the source of his wealth, and went beyond period norms to advertise his most noteworthy qualities. To be sure, some of his fellow citizens might have objected to such portraits of a lowborn, second-generation usurer, especially where he appears in Paradise. But placing oneself amidst the angels is hardly an outright lie. If Scrovegni evaluated the risks of ridicule and exposure, he must have considered them worth taking, as his reputation was already tarnished. Thus, he used art to signpost the positive to both contemporary and future audiences. (Scrovegni would surely be pleased that today only a few academics care one whit about how he paid for his commissions.) The strategy of not indicating the source of one's wealth proved very popular among some nonaristocratic patrons, especially when their intended audiences included nobles. As Helmstutler Di Dio explains in chapter 7, the sculptor Leone Leoni included many references to his learning and his ties with the emperor in the façade he designed for his home in Milan in the 1550s, but nowhere do we discover that he made his name and fortune as a "mere" artist. This may reflect his alternative, more lofty status; he had recently been knighted. Other artists' homes, such as those of Giorgio Vasari in Arezzo, and of Federico Zuccari in Florence, proudly signpost symbols of the owner's profession.

Sophisticated patrons used subtle means to express favorable information about themselves. In the 1470s, the chancellor of Florence, Bartolomeo Scala, planned a city palace, itself a sign of significant wealth. Born outside Florence, and of most humble origins, Scala hardly wanted to indicate his background. Hence, he signposted a quality that set him apart from others: his great erudition and, more specifically, his writings. The architecture for his house draws on ancient prototypes, and the sculpted reliefs in the courtyard draw on allegorical fables Scala himself had penned in imitation of Aesop.[5] Most visitors, with the available prompting by Scala, would have recognized the culture and creativity of their host. Only the intellectual elite—presumably, the most important audience for the patron—would have appreciated the references to the writings of Stoic authors and of the patron himself. The complementary erudition of the intended audience and patron made Scala's elaborate and personally orchestrated effort worthwhile.

Portraits offer a wonderful opportunity to signpost, since they focus on the subject in a chosen setting. Thus political leaders could, and often did, portray their retinues as a way to indicate the grandeur of their court and the favors they had bestowed. Given their scale, fresco cycles offered leaders particularly rich opportunities to signpost. Some commissions, such as Andrea Mantegna's *Camera degli Sposi*, discussed in chapter 2, or Benozzo Gozzoli's *Procession of the Magi* in the Palazzo Medici, Florence, showed leaders' powerful allies and

relations. This announced the importance and authority of those depicted, not merely the signposter. All benefited from this welcome recognition.

Private citizens often signposted their personal accomplishments in portraits. The patronage of Tommaso Rangone in Venice shows signposting on a grand scale.[6] Born in Ravenna, Tommaso Giannotti became doctor to count Guido Rangone, who allowed his physician to use his noble name. Tommaso Rangone, who had taught philosophy, medicine, astronomy, and mathematics, also took to calling himself "Philologus" to call attention to his literary knowledge (philology). He paid the considerable sum of one thousand ducats to rebuild the façade of the church of S. Giuliano, which includes a bronze portrait by a famed artist, Alessandro Vittoria (fig. 4.3). The patron sits with a branch in one hand and a tablet on his knee, amidst learned inscriptions in Greek, Latin, and Hebrew. Though the precise meaning of the monument remains elusive, the work shows the sitter as "Thomas Philologus Ravennas," the words that appear prominently below his effigy. In this work, the patron brilliantly

FIG. 4.3. Alessandro Vittoria, *Portrait Bust of Tommaso Rangone*, S. Giuliano, Venice (Archivi Alinari, Florence)

exploited his peculiar status. His lack of political rights in Venice—he was neither local nor aristocratic—meant that the self-glorifying monuments he wanted to build would not threaten the powerful senators in Venice. Moreover, physicians were exempted from the sumptuary laws. Still, Rangone repeatedly pushed the limits, and did not always meet with success. In 1552 the Senate refused his request to rebuild the façade of S. Geminiano, then facing San Marco and now destroyed, probably because the donor wanted to include a portrait statue. Persistence and money paid off. The following year, a similar request was supported by the nearby church of S. Giuliano, but this highly conspicuous commission brought Rangone some negative attention, alongside its benefits. One author poked fun at the erudite title under the bronze bust; another argued that if a physician used Istrian stone for a façade, the tomb for a doge must be made in a more noble stone, presumably marble. Fortunately for Rangone, such an escalation in materials did not take place. Unlike Scrovegni and Leoni, Rangone included references to his profession in the portrait and inscriptions. This forms part of a long tradition of tombs for doctors, jurists, and lawyers. Though not a noble, Rangone had a highly respected profession that brought him honor and wealth; thus he signposted it.

In commissions, intriguing stories often lurk behind unexpected signposts about professional achievements. In Venice's Church of the Frari, Bishop Jacopo Pesaro kneels in the left foreground of the altarpiece (fig. 4.4) he commissioned from Titian, with other members of his family on the right side.[7] Nothing odd here. In Titian's *Pesaro Altarpiece* (1518), however, the figures behind Jacopo do strike an odd note: a soldier holds a large standard with the Pesaro and papal arms and turns to two men, one black and the other wearing a turban. This group alludes to Jacopo's role in 1503 when, as a captain named by Pope Alexander IV, he helped capture the island of Santa Maura from the Turks. Moreover, after the patron died in 1547, his tomb was installed next to the altarpiece with an inscription that begins: "Jacopo Pesaro, Bishop of Paphos, victorious in war against the Turks." The rivalry between Jacopo and his cousin Benedetto Pesaro for credit over the battle at Santa Maura illuminates unexpected details in both commissions. Jacopo knew that most Venetians who attended the church would see Benedetto's prominently placed tomb, which envelops the entrance from the nave to the sacristy. Here, inscriptions and images celebrate Benedetto's victory at Santa Maura. Both members of the Pesaro family used art to signpost their military triumph in the same battle. Presumably, they aimed to win the acclaim of their contemporaries and of future audiences, such as ourselves.

Biographical cycles in painting and sculpture bristled with opportunities for signposting. The 1330 monument to Bishop Guido Tarlati in the Cathedral of Arezzo, commissioned by his brother, presents sixteen narrative panels. These celebrate the good government enjoyed by the city of Arezzo under Tarlati's administration, and portray as well the evil rule of his predecessors.[8]

Fig. 4.4. Titian, *Pesaro Altarpiece*, Santa Maria Gloriosa dei Frari, Venice (Archivi Alinari, Florence)

We expect that when commissioned works include biographical scenes, patrons would have chosen or at least approved them. Alas, most evidence is lost, but Pintoricchio's 1502 contract for frescoes in the library of the Siena Cathedral survive. The frescoes recount the life of Pope Pius II, Cardinal Piccolomini's uncle. According to the terms of his agreement with the agent, the principal selected the scenes he wanted to portray about the pope.[9]

Signposting indicates that key information was left out, not only that selected details were included. Unfortunately, it is virtually impossible to document when a scene was omitted to improve the patron's reputation. But in chapter 9 Silver provides a convincing example of a conscious omission. Peter Paul Rubens made a series of frescoes for the dowager queen of France, Marie de' Medici, with the portrayed moments from Marie's life carefully selected to glorify her. An embarrassing event from the patron's life, depicted in *The Departure of the Queen from Paris*, was replaced in the final program with the *Felicity of the Regency*. The patron hoped that the paintings would legitimize her claim to power as she fought (in vain) against her own son, Louis XIII, for her position as ruler.

When elite players meet troubling circumstances, signposting offers an attractive strategy. Consider an unusual feature, the donor portraits in the *Malatesta Altarpiece* (fig. 4.5) by Domenico Ghirlandaio and his workshop.[10] In about 1493, Elisabetta Aldovrandini commissioned the painting when she found herself in a most unusual and precarious position. As the mistress of Roberto Malatesta, ruler of Rimini, she became the mother to his only sons, Pandolfo IV and Carlo. After Roberto's death in 1482, two of his brothers, Galeotto and Raimondo, became guardians of the young boys and regents of Rimini with Elisabetta. A July 1492 letter by Pandolfo tells us about the next dramatic development: "that traitor Galeotto and his sons made plans to cut me to pieces, with my mother and my wife, but that fate, thank God, became theirs."[11] Elisabetta, once the ruler's concubine, emerged from this year of murder and betrayal as the sole regent and guardian. That year she used art in an attempt to assert and consolidate her role in Rimini.

Renaissance viewers of the *Malatesta Altarpiece,* familiar with conventions of donor portraits, would have noticed some extremely odd features. In the foreground, Elisabetta appears much larger than the other three figures: Pandolfo, his wife, and his brother. Moreover, she holds the place of honor at the left (to the right of the central holy figure). In virtually all Renaissance altarpieces that include male and female donors, the former are taller and kneel on the left. The exceptions, as in this case, usually indicate that the pictured woman commissioned the work. In no other Renaissance work does the female patron literally tower over the other figures, but Elisabetta needed to signpost her prominent position in Rimini. Rather than appear alone, she choose to include her two sons, the justification for her power in the city.

Ironically, the portraits did not meet her expectations for quality. Elisabetta

FIG. 4.5. Domenico Ghirlandaio and workshop, *Malatesta Altarpiece*, Museo della
Città, Rimini (Paritani, Rimini). Museo della Città di Rimini / Photo Paritani, Rimini

refused to make the final payment of more than twenty-four florins, a sum equal to nearly 20 percent of the total compensation. The resulting litigation, settled in Florence in 1496, established that Elisabetta had to pay only ten florins given the low quality of the painting. The arbiter stated that though the portraits of the lords of Rimini should have been done from life, the images hardly corresponded to their person or appearance.[12] From Elisabetta's point of view, the altarpiece could not fulfill many of its intended functions if viewers could not easily identify the woman on the left. Elisabetta tried to use the altarpiece to signal one specific aspect of her status, her political power, an attribute that was all the more important given her unconventional path to having acquired it. The court decision, albeit financially helpful, did not promote the goal of legitimizing her power. In 1496 Elisabetta expressed her fear to the Venetian government that her son Pandolfo, who had come of age the previous year, wanted to murder both her and his brother Carlo. Later that year she was indeed dead, amidst rumors that Pandolfo had poisoned her.

Commissions that signpost hold attractions for an array of patrons with something to hide. Those who need to resurrect their reputation, as did Sassetti and Scrovegni in Florence and Padua, have to take some chances. Sassetti, the banker, was relatively modest, and just paid obeisance. Scrovegni, the usurer whose family had been so insulted, took more chances by glorifying himself in multiple contexts. This may have improved his position, but not sufficiently: he died in exile. Leoni and Rangone, in Milan and Venice, decided to direct attention to their erudition and to skip, respectively, their profession or family origin. Both did well. Elisabetta and Marie, respectively in Rimini and in Paris, played games in which the stakes were higher. Each sought to secure her tenuous claim on power, and commissioned paintings to help. Both lost.

Whether paying tribute to an employer after inadequate performance, appealing to an elite one hopes to join, or making claims to the public on one's right to rule, a well-crafted signpost is an excellent way to convey an intended message. It allows the patron to reveal positive information, conceal the rest, and expect that the odds of escaping undiscovered are favorable. Viewers often do not know what salient information is missing from a fresco or portrait. Today, when looking back to assess the context for any work with images that tell a story, it is important to determine not merely what was portrayed but also what of great consequence was left unsaid.

Stretching

Some people find it insufficient merely to signal general characteristics or to signpost selected ones. They want to cast a more favorable image than either of those strategies would permit, and so they stretch the truth. We find "stretch-

ing" when sellers communicate important and favorable characteristics in a misleading or highly exaggerated manner. Even in Italian Renaissance art—which by its very nature embellished and idealized the natural world—two major constraints kept stretchers in line: deterrence and credibility. If the audience discovers that claims are excessively exaggerated, sellers or patrons lose face; much or all is lost. As the sociologist Erving Goffman discussed in his pathbreaking study *The Presentation of Self in Everyday Life*, being caught with a false front can lead to "immediate humiliation and sometimes permanent loss of reputation"; this in turn decreases one's overall credibility.[13] Think about inflating a balloon, and getting paid in proportion to its volume; at some point the balloon bursts and its volume goes to zero.

Italian Renaissance art produced many examples of inflated claims that elevated the reputation of the patron, or the person represented in a portrait, as well as a small number of such claims that were punctured and led to the shame of a burst balloon. In the first category we find the tomb of a painter, Fra Filippo Lippi, in the Cathedral of Spoleto.[14] The inscription states that Lorenzo de' Medici the Magnificent paid the bill, and, not surprisingly, the monument includes the Medici coats of arms. The tomb also exhibits the Lippi arms, and everything seems to be in order. But, alas, the artist's family had no crest. It was invented for this occasion in about 1490 by his son Filippino Lippi. For these arms we can assume that Filippino took the initiative, though Lorenzo must have approved. Including the crest certainly inflated the status of both Filippo and Filippino Lippi, and probably of Lorenzo as well.

When a stretch was detected, the resulting loss of face could be expensive. This gave both patrons and artists an incentive to be cautious. One story, told by Franco Sacchetti in the late fourteenth century, recounts how Giotto nipped in the bud a potential case of excessive stretching.[15] The celebrated artist refused to accept a commission from a craftsman who wanted a painting with an invented coat of arms. As the potential patron had no right to such an honor, Giotto probably did him a favor. Such excessive stretching would likely have been exposed, turning the patron into a laughingstock.

This is exactly what took place in the sixteenth century, when the invention of illustrious family histories and coats of arms became far more common. This led several authors to lament or lampoon such exaggerations. Anton Francesco Doni, the son of a scissors maker, wrote a hilarious passage in *La Zucca* about his illustrious ancestors, including Popes Doni I and Doni II.[16] Also in mid-sixteenth-century Florence, the sculptor Benvenuto Cellini attacked his rival Baccio, who "added the surname Bandinelli on his own account, and . . . had neither family nor arms."[17] We find a similar spirit of exposure in Vasari's *Life* of Bandinelli. When discussing the artist's tomb, in the Florentine church of the SS. Annunziata, Vasari recorded the inscription "BACCIO BANDINELLI" under the sculpture of the *Pietà*; a few pages later, he archly concluded the biography with a discussion of the artist's family name "because it was not

always the same, but varied."[18] This negative reception from Vasari, amplified to the community, indicates the potential downside of stretching.

When it came to glorifying one's family, however, many decided that the potential benefits outweighed these risks. The Savoy used their triumphal entry into Turin, discussed in chapter 3, to successfully assert the false claim that their lineage descend from the House of Saxony. In 1585, they erected an arch in the city that even included Bertoldo of Saxony, the reputed founding father of the Savoyard lineage.[19] This stretch conveyed a powerful message, in part because others could not readily imitate. The ability to mount a grand display, combined with kernels of truth within a stretch, were qualities both critical and scarce.

For sellers or patrons, the value of communicated information increases the more it is stretched, assuming that it is believed. However, as stretching proceeds, sellers face an ever-increasing risk of exposure. If the intended audience knows that stretching is of little cost to the signaler, say because detection is almost impossible, then the information that is conveyed, even honest information, will be severely discounted. The public relations office of an American president usually describes even an unproductive summit meeting as fruitful. Eventually, audiences learn how to discount for this kind of inflation. When everyone inflates information and buyers automatically discount what they hear, sellers must engage in compensatory stretching. Consider a national leader putting spin on the results of a summit meeting. If the true productivity was 93 on a scale of 100, and the official news service released this figure, the public might conclude that it was worth only 88. A claim of 97 might lead to a public perception of 92. But if the claim were boosted to 99—as might happen in a totalitarian regime—shrewd members of the public might smell a fish and discount the value down to 70. Excessive exaggeration leads to diminished legitimacy.

This type of discounting was common to the Renaissance audiences for painted portraits. Viewers expected to find that portraits were idealized, figures slimmed, and skin smoothed, though authors regularly praised such a portrait with phrases like "so lifelike it lacks only a voice." For Pietro Aretino, Titian's portraits of Eleonora Gonzaga and Elisabetta Massola were so "true" that one could see the sitter's internal virtues.[20] Such comments, which reflect rhetorical rather than visual traditions, might lead the unwary modern reader astray.

Our general finding about stretching in Renaissance art is that it was expected, accepted, and widely practiced. Even when stretching was excessive by the standards of the intended audience, patrons were rarely caught and punished. This is hardly surprising, since many excess stretches capitalized on the ignorance of the audience and there was no clear line beyond which a stretch became offensive. We might compare Renaissance expectations to our own when we see a Hollywood movie "based on a true story." The director almost

always presents a handsome hero and exquisite leading lady in a simplified and sanitized story with an uplifting ending. Renaissance painters and sculptors made lords appear grander in portraits than in reality, and ladies more beautiful. Their contemporaries could appropriately discount this embellishment, and viewers today should attempt to do the same. Though many praise Ghirlandaio's *Portrait of an Old Man* (fig. 4.6) for its "realism," the bulbous growth on the patron's nose was even more prominent in the preparatory drawing.[21]

On occasion, the documentation surrounding a portrait allows us to identify the stretch. In a letter of 1617, Caterina de' Medici complained from Mantua to her brother, Grand Duke Cosimo II, that a local artist had depicted her with too large a nose. The Bolognese painter Alessandro Tiarini was a more successful agent with a subsequent portrait, a portrait that earned high praise from Caterina's husband Ferdinando, the Duke of Mantua: "You have depicted her better than any other, since you have improved and embellished her looks without diminishing her likeness."[22] A stretch was undertaken in a more celebrated portrait in the same city many years earlier. In 1534–36, around the time when Aretino condemned Isabella d'Este as ugly, and immediately after Titian had painted her portrait in her midfifties, the patron had the artist paint yet another image. In the latter work (fig. 4.7), however, the agent represented the principal as if in her youth. This led Isabella herself to unveil the stretch in a letter, by observing that she had not been so beautiful.[23] Not that she had expected an accurate image: it was based on an earlier portrait by Francia, itself derived from a portrait done from life by Costa, so the whole process was like a biased pictorial version of the game of "telephone." In short, Titian both reversed time and stretched the truth to serve a client. No doubt Isabella hoped that this attractive image would remain in the minds of viewers; centuries later, her goal has been achieved.

Renaissance patrons and viewers expected idealization in portraits, especially those of important individuals, so as to communicate a particular type of information. The goal was not merely to convey physical appearances but to create images of nobility, virtue, and moral stature. Since accurate depiction would achieve this for few people, the Renaissance sense of decorum demanded embellishments in portraits, devotional works, and narrative scenes, whoever commissioned the work. Images of the Virgin, for example, regularly show her in magnificent robes though the Bible unequivocally describes her as poor. A shabbily dressed Mary would be offensive; her clothes must be worthy of the queen of Heaven. In a similar vein, Giraldi Cinzio warned authors that it would be improper for his contemporaries to follow the example of Homer, who once wrote that a princess went with her maids to wash clothes in the river.[24] A secular, Christian, or ancient noblewoman must look the part, whether in art or literature.

A fascinating letter of 1544, by Niccolò Martelli, discusses the tradeoff be-

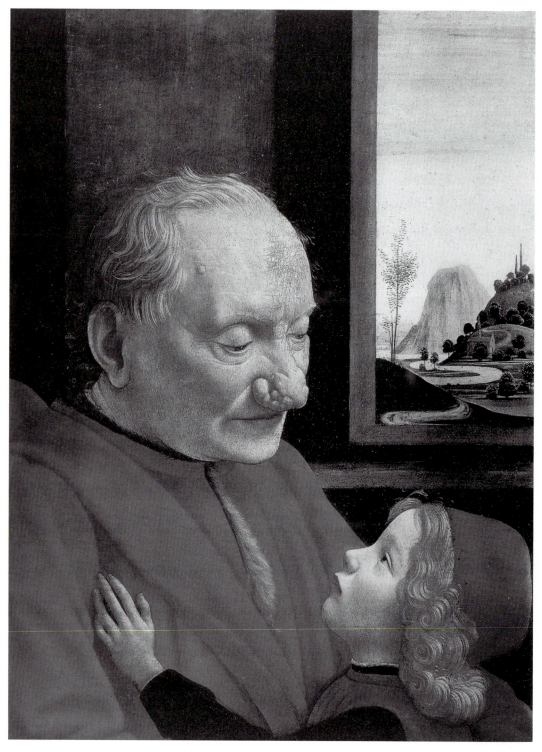

FIG. 4.6. Domenico Ghirlandaio, *Portrait of an Old Man,* Musée du Louvre, Paris
(Archivi Alinari, Florence)
Opposite page: FIG. 4.7. Titian, *Isabella d'Este*, Kunsthistorisches Museum, Vienna
(Archivi Alinari/Bridgeman, Florence)

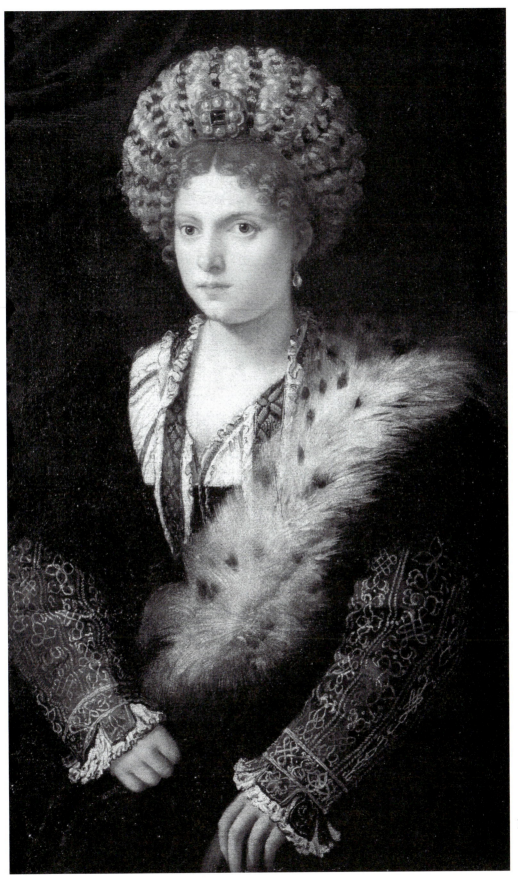

tween truth and image in relation to Michelangelo's sculptures of the Medici "Captains" in the New Sacristy of San Lorenzo in Florence (fig. 4.8). The often-cited passage, always quoted out of context, illustrates Martelli's views on appropriate stretching for commissioned artistic and literary works.

> They say that poets are adulators and liars, an idea which I . . . don't deny, but let's see why they do it. Michelangelo . . . having to sculpt there the illustrious lords of the most felicitous house of the Medici, did not use as his models Duke Lorenzo and Lord Giuliano as Nature had portrayed and composed them, but rather gave them a size, proportion, decorum, grace, and splendor which he thought would bring them more praise, in such a way that the people gazing at them would be amazed. Thus, if famous writers at times add something to the truth they do it to make them [the subjects] more wonderful for future centuries.[25]

Rather than condemn Michelangelo's deviations from Nature, Martelli indicates that the very goal of artists and writers was to bring praise to their patrons. Moreover, when they did so, the resulting work simultaneously embellished the artist's reputation as an effective agent. Viewers familiar with these portrait conventions presumably discounted the inflated information. They recognized that the works aimed not to accurately capture superficial appearances but to inspire viewers with "higher truths." And given that embellishment was the norm, an artist who presented patrons as they looked in life to the "naked eye" would have no patrons to worry about.

These portraits reflect a conception of art comparable to that of writing history, as expressed in the preface to the second part of Vasari's *Lives*: "To make known the . . . strategies of men: the causes, then, for fortunate or unfortunate actions. This is truly the soul of history, which teaches men how to live and makes them prudent."[26] This view derives from Cicero, who argued that history "sheds light upon reality, gives life to recollection and guidance to human existence."[27] By extension, paintings of historical events or personages must also provide lessons. And to make a point, or to overcome the natural discounting of any claim, it is often desirable or necessary to stretch the truth.

In formulating his ideas in the 1540s, Vasari received crucial advice and support from a professional historian, Paolo Giovio. In a letter of 1534–35, he had addressed the need to exaggerate within the bounds of acceptable accuracy: "You well know that history must be truthful, and one should not trifle with it at all except in a certain and limited latitude given to the writers by ancient privilege to exaggerate or minimize the vices in which persons err; and conversely . . . to heighten or underplay their virtues."[28] Though Giovio does allow for some stretching, he clearly does not welcome it. He put his words into practice by providing the program for a fresco cycle by Vasari, in the Room

Opposite page: FIG. 4.8. Michelangelo, *Giuliano de' Medici*, New Sacristy, San Lorenzo, Florence (Archivi Alinari/Bridgeman, Florence)

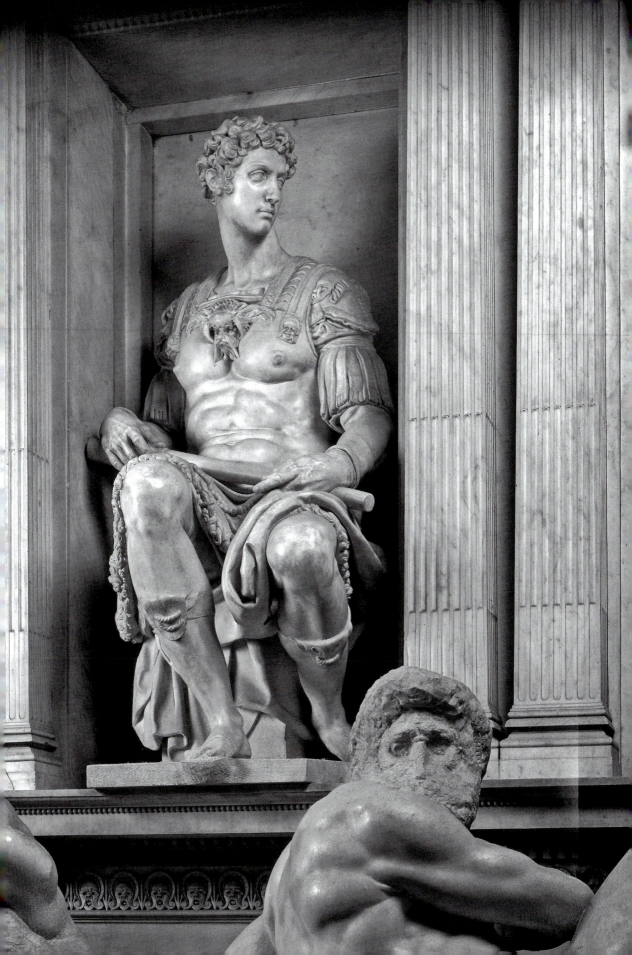

IN PACE
OPTIMÆ ARTES EXCOLUNTUR
INGENIA AD PACEM COALESCUNT
PUBLICÆ PRIVATÆQUE OPES AUGENTUR

FIG. 4.9.
Giorgio Vasari,
*Paul III as
Peacemaker*,
Room of the
100 Days,
Palazzo della
Cancelleria,
Rome (Archivi
Alinari/Archi-
vio Anderson,
Florence)

of the 100 Days of the Palazzo della Cancelleria in Rome, that celebrates Pope Paul III (fig. 4.9). Vasari wrote that one scene depicts "the universal peace made among Christians by the agency of Paul III, and particularly between the Emperor Charles V and Francis, who are portrayed there; wherefore there may be seen Peace burning arms."[29] Such mixing of allegorical figures and portraits indicated, for Renaissance viewers familiar with sophisticated visual codes, that the fresco did not re-create a fictive history. Giovio explained that, following the rules of rhetoric, praise is based on virtue; events from life only serve to exemplify the moral qualities. By focusing on virtues, one can "praise the man with banners waving, without any fear of falling into the mud of lies, and keeping all vices quiet."[30] This banner-waving approach allowed the painter to celebrate the patron, thus fulfilling one of the goals of history painting without explicitly having to stretch the truth.

If a principal or agent decides to employ stretching, four tactics keep the stretched balloon from bursting, and thus proving counterproductive. First, the magnitude of the stretch can be controlled directly. Second, the stretcher may employ media, such as artistic depictions, in which substantial embellishment is expected, even encouraged, and hence will go unpunished even if detected. Third, by steering clear of a knowledgeable audience a stretcher can

avoid being detected. Thus, patrons will not request a bold stretch in work that will be seen by those who can easily gauge the degree of exaggeration. Fourth, the stretch can make fuzzy rather than sharp claims. To illustrate the last, if a corporate CEO announces that there is fervent interest in a new product, that is a fuzzy claim, and hard to refute. In contrast, a sharp claim—say, that orders on hand for the new product exceeded a certain amount—can be verified. If false, the person who made the claim will suffer significant embarrassment. Quite possibly the claimant's principal—the corporate board in this instance—will suffer embarrassment as well. Sharp claims are like sharp instruments; they can make a point, but they can also puncture a stretched balloon. Vasari's fresco cycle for Paul III replaces a specific event with a generic depiction, thus making a "fuzzy" instead of "sharp" claim. In addition, as works of art, the frescoes naturally include embellishment; anything less would be unusual and inappropriate. But if all stretches were costless, that is, if any claim would be readily excused and if anyone could make such claims, they would no longer serve their purpose: the stretches would do little to convince discerning audiences that someone's accomplishments were greater than they really were. Such convincing is what makes for a successful stretch.

Francesco Gonzaga, the subject of Bourne's essay in chapter 8, was a stretcher both bold and successful. He used art to stretch the very mixed results of a major battle against the French into a significant victory. Fuzziness helped. The medals and paintings, most notably Mantegna's *Madonna of Victory*, never state that Gonzaga's troops trounced the army of King Charles VIII. However, these images give the distinct impression that Italians won the day. That was hardly the view of many contemporary witnesses, but few of them lived near Gonzaga's base in Mantua, and their words were never heard or soon forgotten. The images accomplished their goal: they greatly enhanced the ruler's reputation.

The tomb of the Venetian admiral Vincenzo Cappello, "Captain General of the Seas," makes a sharper claim than the images for Francesco Gonzaga, but one still fuzzy enough not to offend the Renaissance sense of decorum.[31] The most famous event in Cappello's life was a major military defeat at the hands of the Turks, the battle of Prevesa in 1538, two years before his death. In 1542 his son, also named Vincenzo, made plans to restore the admiral's reputation with a magnificent tomb, complete with a statue of his father over the door of the façade of a highly important and central church in Venice, S. Maria Formosa (fig. 4.10). The inscriptions compare him to the great admirals of antiquity and attribute his lack of complete success to "fate."[32] The son thus used art to successfully stretch the truth about his father's reputation, and to provide him with an acceptable justification for an unsatisfactory outcome.

Successful stretching is nowhere more deftly executed in the visual arts than in the fresco cycle commissioned in the 1570s by Pio Enea Obizzi from Giambattista Zelotti, following a program by Giuseppe Betussi.[33] The scenes

Fig. 4.10. Domenico Grazioli da Salò, *Portrait of Vincenzo Cappello*, S. Maria Formosa, Venice (Archivi Alinari, Florence)

illustrate grand events from the lives of the patron's ancestors; the inscriptions below, complete with references to written sources, were published by Betussi with a dedication to Pio Enea. These inscriptions, however, represent fantasy, not scholarly footnotes; thus we can read the entire cycle as a great painted fiction. Though the patron and his adviser stretched the truth with sharp signs, to a degree that modern viewers would surely find excessive, we have no evidence that the cycle proved counterproductive or was ridiculed in any way. The setting in a private villa allowed the Obizzi family to control its presentation. To those unfamiliar with the true origins of the clan, nothing need be said. To the knowledgeable, the cycle could be explained as a grand metaphor; moreover, the Obizzi surely realized that many families reinvented their past and that it was best for all to let sleeping dogs lie. Successful stretching—

much more than signaling or mere signposting—requires patrons and artists to remember a prime rule of patronage: know thy audience.

❧ ❧ ❧

In the second part of this book, we turn to several cases in which the strategies of signaling, signposting, and stretching were employed. Given its greater importance and broader applicability, signaling earns two chapters, and signposting and stretching receive one chapter each. These case studies put flesh on the bones of our analytic concepts; hence, the richness of their historical analysis cloaks their methodological underpinnings. Whether the art conveyed information by signaling, signposting, or stretching, differential costs constituted the driving force in the commissioning game. The patrons' relatively low costs allowed them to obtain benefits despite—or because of—the constraints they and others faced, thereby securing positive payoffs. These three elements—costs, benefits, and constraints—comprise the framework for analyzing the patron's payoff.

Notes

1. The concept was first presented in Richard J. Zeckhauser and David V. P. Marks, "Sign Posting: The Selective Revelation of Product Information," in *Wise Choices: Games, Decisions, and Negotiations*, ed. Richard J. Zeckhauser, Ralph L. Kenney, and James K. Sebenius (Boston: Harvard Business School Press: 1996), 22–41. Paltering, seeking to mislead but not lying outright, is frequently accomplished through the selection, revelation, and concealment of signposting. See Frederick Schauer and Richard Zeckhauser, "Paltering," in *Santa Fe Institute Workshop on Deception*, ed. Brooke Harrington (Stanford: Stanford University Press, forthcoming).

2. For the chapel and patron, see Eve Borsook and Johannes Offerhaus, *Francesco Sassetti and Ghirlandaio at Santa Trinita, Florence: History and Legend in a Renaissance Chapel* (Doornspijk: Davaco, 1981), and Jean K. Cadogan, *Domenico Ghirlandaio: Artist and Artisan* (New Haven and London: Yale University Press, 2000), 93–101, 230–31.

3. For the portraits, and the Pucci ties with the Medici, see Patricia Lee Rubin, *Images and Identity in Fifteenth-Century Florence* (New Haven and London: Yale University Press, 2007), 224–226, 247, 260–261.

4. Laura Jacobus, "A Knight in the Arena: Enrico Scrovegni and His 'True Image,'" in *Fashioning Identities in Renaissance Art*, ed. Mary Rogers (Aldershot, UK, and Brookfield, VT: Ashgate, 2000), 17–26.

5. Patrica Lee Rubin, "Patrons and Projects," in *Renaissance Florence: The Art of the 1470s*, ed. Patricia Lee Rubin and Alison Wright (London: National Gallery Publications, 1999), 70–71. She also argues that other contemporary palaces in Florence signal qualities of the patronal families, from the powerful Pitti to the discreet Boni.

6. Martin Gaier, *Facciate sacre a scopo profano: Venezia e la politica dei monumenti dal Quattrocento al Settecento*, trans. Benedetta Heinemann Campana (Venice: Istituto veneto di scienze, lettere ed arti, 2002), 207–38, 476–86.

7. Rona Goffen, *Piety and Patronage in Renaissance Venice: Bellini, Titian, and the Franciscans* (New Haven and London: Yale University Press, 1986), chapter 4.

8. John Pope-Hennessy, *An Introduction to Italian Sculpture*, 4th rev. ed. (London: Phaidon Press, 1996), 1:245. After the Tarlati were banished, some of these scenes were mutilated. Such defacement indicates the high risk of negative reception costs associated with highly propagandistic political monuments, particularly within a society in flux.

9. Michelle O'Malley, *The Business of Art: Contracts and the Commissioning Process in Renaissance Italy* (New Haven and London: Yale University Press, 2005), 182.

10. Cadogan, *Domenico Ghirlandaio*, 270–73; Jonathan K. Nelson, "Jockeying for Position: Donor Portraits in Ghirlandaio's *Malatesta Altarpiece*," forthcoming.

11. Antonio Cappelli, "Pandolfo Malatesta ultimo signore di Rimini," *Atti e memorie delle R.R. Deputazioni di Storia Patria per le provincie modenesi e parmensi*, 1 (1863), 427.

12. For the document, and a different interpretation, see Cadogan, *Domenico Ghirlandaio*, 272, 377–78.

13. Erving Goffman, *The Presentation of Self in Everyday Life* (Garden City: Doubleday, 1959), 59.

14. Jonathan K. Nelson, "Profilo biografico," in *Filippino Lippi*, ed. Patrizia Zambrano and Jonathan K. Nelson (Milan: Electa, 2004), 58–63.

15. Franco Sacchetti, *Il trecentonovelle*, ed. Valerio Marucci (Rome: Salerno Editrice, 1996), 181–83 (Novella LXIII).

16. See Louis A. Waldman, *Rewriting the Past: The* Memoriale *Attributed to Baccio Bandinelli and the Culture of Forgery in Early Modern Europe,* forthcoming. We thank Professor Waldman for sharing this material, and for his valuable suggestions to this chapter.

17. Benvenuto Cellini, *Due trattati* in *Opere*, ed. G. G. Ferrero (Turin: UTET, 1971), 596.

18. Giorgio Vasari, *Lives of the Painters, Sculptors and Architects*, trans. Gaston du C. de Vere, ed. David Ekserdjian (London: Everyman's Library, 1996), 2:309, 305. On p. 304, Vasari could not resist adding that the Pazzi family granted the use of their prestigious chapel to Bandinelli "without divesting themselves of the rights of ownership and of the devices of their house that were still there." On Bandinelli's self-fashioning, also see Waldman, *Rewriting*.

19. Marta Alvarez González, "Pageantry and the Projection of Status: The Triumphal Entries of Catherine of Austria (1585) and Christine of France (1620) in Turin," *Mélange de l'École française de Rome. Italie et Méditerranée* 115, no. 1 (2003): 46–48.

20. Norman E. Land, *The Viewer as Poet: the Renaissance Response to Art* (University Park: Pennsylvania State University Press, 1994), 89.

21. Cadogan, *Domenico Ghirlandaio*, 276–77.

22. Carlo Cesare Malvasia, *Felsina Pittrice: vite de' pittori Bolognese* (Bologna: Guidi all'Ancora, 1841), 2:130. For the letter of 1617, and discussion of the portrait, see Molly Bourne, "Medici Women at the Gonzaga Court, 1584–1627," in *Italian Art, Society,*

and Politics: A Festschrift for Rab Hatfield (Florence: Syracuse University Press, forthcoming).

23. Rona Goffen, *Titian's Women* (New Haven and London: Yale University Press, 1997), 91.

18.24 For a discussion of this passage, in Cinzio's *Discorso intorno al comporre de i romanzi* (1554), see Deanna Shemek, *Ladies Errant: Wayward Women and Social Order in Early Modern Italy* (Durham and London: Duke University Press, 1998), 83.

25. [Niccolò Martelli], *Il primo libro delle lettere di Nicolo Martelli* (Florence: Anton Francesco Doni, 1546), 48–49.

26. Cicero, *De Oratore* (II.ix.36), as quoted and discussed in Patricia Lee Rubin, *Giorgio Vasari: Art and History* (New Haven and London: Yale University Press, 1995), 152. For powerful arguments that Vasari himself did not write the second preface see Thomas Frangeberg, "Bartoli, Giambullari and the preface to Vasari's 'Lives' (1550)," *Journal of the Warburg and Courtauld Institutes* 65 (2002): 244–58, especially 257.

27. Rubin, *Vasari*, 151.

28. Ibid., 163.

29. Vasari, *Lives*, 2:1041–42.

30. Julian Kliemann, *Gesta dipinte. La grande decorazione nelle dimore italiane dal Quattrocento al Seicento* (Milan: Silvana, 1993), 46.

31. Gaier, *Facciate*, 178–206, 465–470.

32. According to the Venetians, their fleet had been betrayed by their supposed ally, Admiral Andrea Doria, who led the fleet of the Holy Roman Emperor.

33. Kliemann, *Gesta dipinte*, 116–18.

Part II ❧ *The Patron's Payoff*

A PARADISE FOR SIGNALERS

Jonathan K. Nelson and Richard J. Zeckhauser

Introduction

PROMINENT AND BEAUTIFULLY decorated private chapels in major churches provided patrons with an excellent mechanism to signal both their wealth and their membership in the ruling elite, and to distinguish themselves from their near peers.[1] The signal was effective because the ownership and embellishment of such chapels was extraordinarily expensive. Moreover, quite apart from the monies required, such chapels were likely impossible for lesser citizens to secure. Owners of chapels thus effectively separated themselves from other individuals as being higher in wealth, status, or both. As religious structures, the chapels did even more. Their decorations exemplified magnificence and piety. Chapel donors expected that generous expenditures would aid in their salvation, and thus one primary audience was celestial. But as these patrons believed in a God who could identify benefactors without any need for the coats of arms and identifying inscriptions that were prominently placed at the entrances and interiors of private chapels, such displays of personal and family signs indicate an earthbound audience, and the messages created for this group are the focus of this chapter.

Patrons wanted to communicate hard-to-convey information to their fellow citizens, namely to announce their personal status and that of their families. Status flowed mainly from wealth and social ties—attributes that often could not be demonstrated directly, particularly since religious leaders advocated humility and self-effacement. The desire to demonstrate status and wealth, to distinguish oneself from others who were outwardly similar, was urgent. Private chapels provided a prime signaling opportunity for the display of magnificence. Compared with other commissions that could serve these functions, such as grand banquets, palaces, and elaborate funerals, most chapels were substantially less expensive. Given that richly decorated chapels conveyed a great deal of information, they were available as a potential cost-efficient signal for many wealthy patrons, and not merely the richest members of society. At the local level, ordinary visitors to churches could recognize the names, arms, and symbols of chapel patrons. Members of the primary earthly audi-

ence, individuals of the same social and economic class as the patrons, constituted more sophisticated viewers. They well understood what we define as constraints: for example, the difficulty in obtaining a prestigious location in a high-status church, or the services of a celebrated artist. The elite could also appreciate the refinement and taste displayed in certain commissioned works, qualities that also resonate with modern audiences. The vast majority of Renaissance altarpieces and tomb sculptures that are now in museums once embellished private chapels. Compared with other examples of conspicuous consumption, chapels offered another advantage: the risk of negative reception costs was very low. Given the religious nature of the art and architecture in chapels, and for the most part their uncontroversial iconography, few patrons ran the risk of communicating an objectionable message. But patrons did not escape the criticism of churchmen, many of whom objected to the display of coats of arms and portraits as inappropriate, even offensive vanities. For most patrons, it appears, the potential for being subject to this "standard" attack was considered a low price to pay for the benefits to be secured from owning a conspicuous chapel. For a beautiful chapel in a prominent church, the financial costs—including not merely the price of patronage rights but also outfitting the chapel for religious functions, decorating it, and staffing the masses—were painfully high for all but the very wealthy. But financial pain had its advantages: chapels that were more expensive, or more prominently placed, sent stronger signals than did others. Patrons were able to distinguish themselves both through the chapel they bought and by how they decorated it. Viewers in turn could obtain an idea of the donor's status by considering the status of the church and the chapel's location within it. Also telling were its contents: the size and intricacy of the art, the cost of materials, and the distinction of the artists. Starting in the late Middle Ages, the increase in the desire for private chapels helped fuel a building explosion that led to a radical transformation in ecclesiastical architecture.

The Functions of Chapels

This chapter considers the motivations of donors and the costs and construction of chapels in Florence over a period of about 250 years. Our tale begins in the late 1200s, when construction began on the first two churches that included significant numbers of private chapels, Santa Croce and Santa Maria Novella.[2] It ends in the early 1530s, when Renaissance Florence became a duchy; at that time, the Medici family began to exercise much greater control over local churches, and specifically over the sale and decoration of their private chapels.

Rarely did individuals attend mass in these private chapels; most probably, the owners themselves entered infrequently. Instead, the chapels served pri-

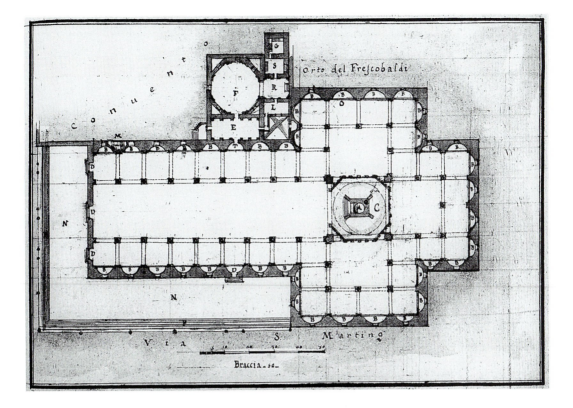

marily as a setting for memorial masses and as a visual attraction. In addition, these spaces often provided burial places for donors and their families.[3] The chapels discussed here were modest architectural spaces that formed a shallow niche, as in Santo Spirito (fig. 5.1), or more frequently a box.[4] The box was defined by three walls, with the fourth side closed off by a metal gate, the original format in Santa Maria Novella and Santa Croce (figs. 5.2 and 5.3). Most churches included chapels in both arms of the transept; in many, such as San Lorenzo and Santo Spirito, they also lined the side aisles.[5] In the late 1200s and early 1300s, the leading mendicant orders built the first churches in Florence containing significant numbers of private chapels. The Dominican church of Santa Maria Novella has four spatial box chapels in the transept (fig. 5.4), and the slightly later Franciscan church of Santa Croce has ten. In both churches, the chapels are part of the original construction. In the later Middle Ages, the new class of extremely wealthy and status-conscious merchants created a strong demand for private chapels. By the late 1300s, the popularity of such chapels had spread across Europe, especially in affluent commercial cities. Indeed, throughout southern Europe private chapels line the walls of most late medieval and Renaissance churches. Formally, at least, benefactors did not purchase the spaces outright but only obtained the patronage rights (*ius patronatus*). Rights to the high altar usually remained with the religious authority responsible for the church, such as a religious order.[6] For other chapels, churches

FIG. 5.1. Eighteenth century, drawing of plan of the church of Santo Spirito, Florence (Kunsthistorisches Institut, Florence)

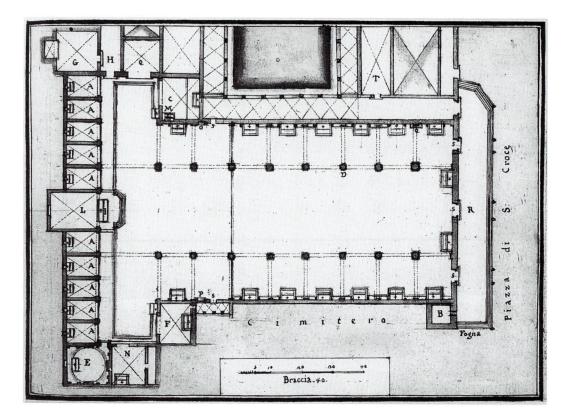

FIG. 5.2. Eighteenth century, drawing of plan of the church of Santa Croce, Florence (Kunsthistorisches Institut, Florence)

regularly transferred rights to individuals or families, including brothers and extended clans, but corporate groups such as brotherhoods or trade associa- tions also owned some. These rights allowed the patrons not only to arrange private masses and burials but even to select the officiating clergy.[7]

For most practical purposes, these spaces functioned as private property; chapels could be left to heirs, and the patronage rights were often resold. Pa- trons proclaimed their rights at the entrance to chapels with inscriptions, ban- ners, and coats of arms. Family arms, emblems, and mottoes were woven into the chapel decorations—such as on the wall frescoes, stained glass windows, marble tombs, and altarpiece frames—and into liturgical instruments includ- ing candlesticks, censers, and chalices. Portraits of donors frequently appeared in altarpieces, frescoes, and tombs. These highly conspicuous signs marked the chapels as "private territory."

Written records from the period, ranging from literature and letters to church documents, very rarely mention individuals visiting private chapels, aside from special occasions such as feast days. Certainly, in this period, people did not take communion frequently. We have no reason to believe that merchants

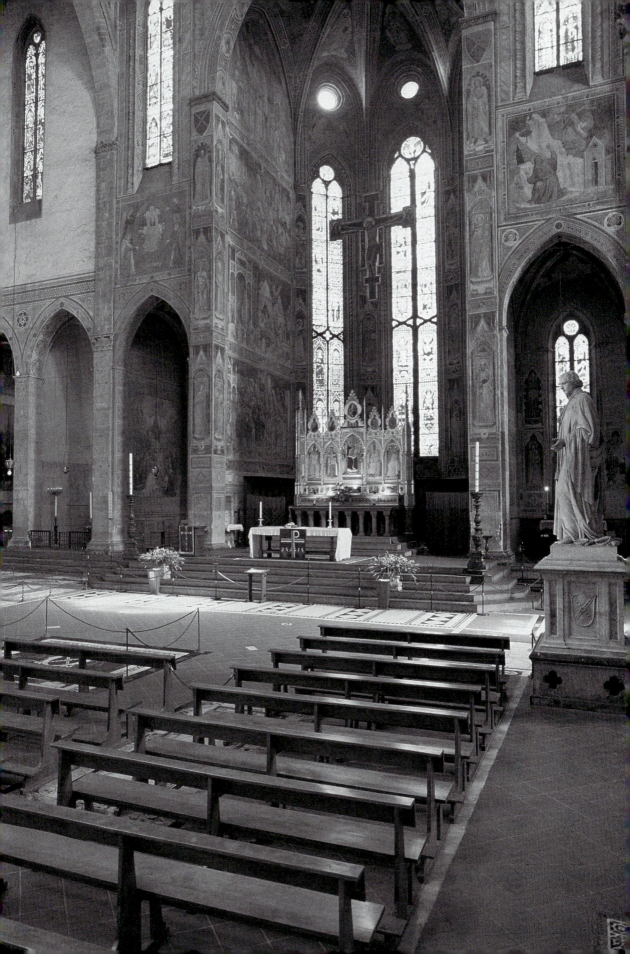

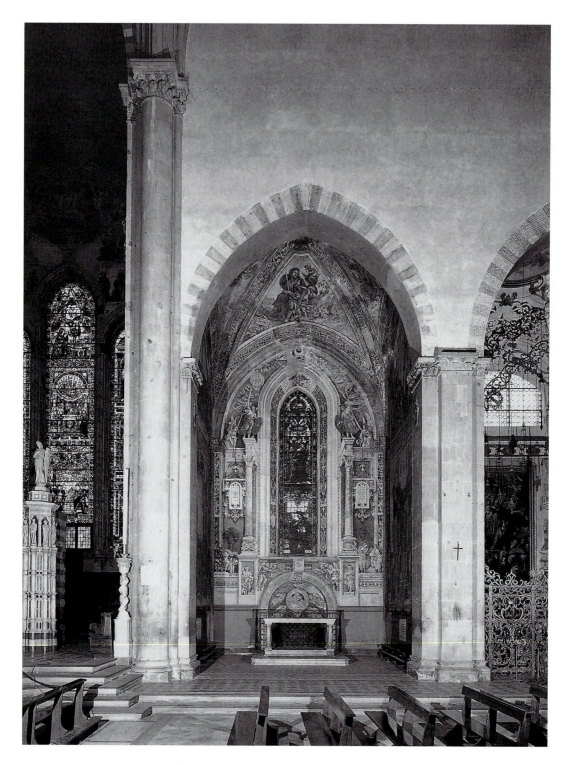

FIG. 5.4. Right transept with chapel of Filippo Strozzi, church of Santa Maria No-
vella, Florence (Paolo Bacherini, Florence)

dropped by their chapel on their way to work or attended mass there on Sundays, as the faithful might do today in their family pew. Since the spatial box chapels were located in the transept, beyond the rood screen, they were off-limits to women except as burial places, and men would have found them locked with gates.[8] Nevertheless, visitors could gaze above and through the barriers at the decorated spaces. They could easily appreciate the most expensive features—the size, location, and architecture of a chapel, and its larger decorations. And they could readily determine the prominently identified patron. Even from a distance, churchgoers could also see the tombs and altarpiece frames, though curtains or shutters often covered the main images.[9] The altarpiece paintings would be unveiled on holidays, or when masses were held at these altars. On ordinary days, however, tombs and altarpieces would signal only the general qualities of wealth and piety, via their size, materials, framing elements, and displays of arms.

Patrons had a particular interest in special events when strong incentives temporarily increased both church attendance and the visibility of chapel decorations. To cite but one example of attendance rewards, a papal bull of 1344 informed the faithful that they could reduce their punishment in Purgatory by 515 days by attending mass at Santa Maria Novella on the feast day of Saint Thomas. The masses that day took place in the splendid Strozzi Chapel, which was dedicated to the saint.[10] The indulgences given for attending masses in specific chapels naturally raised the prestige of those spaces; that in turn encouraged private individuals to purchase and decorate such chapels. Thus, church officials showed their skill at playing what we now call game theory.

Through their patronage of private chapels, Renaissance bankers and merchants paid for the vast majority of church decorations and, by purchasing the right of patronage, made substantial contributions for constructing the churches themselves. Florence equaled any Italian city in the number of churches built or remodeled to accommodate private chapels, a phenomenon that reflects both an abundance of liquid wealth and the desire to display status, but not an increase in population. Wealthy Florentines used chapels to convey information, and their fellow citizens provided an important and savvy audience. In addition, ecclesiastical officials and laymen on church building committees understood the signaling process sufficiently well to capitalize on the publicity needs of the rich in order to get their churches built. (Reflecting a similar strategy, American universities today secure funds for buildings by inscribing donors' names over the door.) Thus, the construction and decoration of chapels involved important roles as both principals and agents for donors, churchmen, and building committees. All citizens benefited because the impressive churches—the product of this elaborate game—brought beauty and honor to their city.

Virtually all the patrons discussed in this chapter were extremely affluent, with a personal wealth declared in financial records at between 5,000 and

10,000 florins. To put these figures in context, higher government officials in this period earned about 100 to 150 florins a year, and managers in merchant-banking houses earned 100 to 200 florins.[11] Hence, the typical patron of a chapel had a net worth at least twenty-five times a manager's annual salary; some were much wealthier. If we consider specific years, we can measure wealth in relation to the wages of full-time laborers. Cosimo de' Medici's stated worth of 100,000 florins in 1427 equaled 3,192 man-years. Other financial records reveal that the personal assets of some prominent donors were considerably higher: Niccolò di Jacopo Alberti was worth 340,000 florins (9,481 man-years) in 1377, and Filippo Strozzi was worth 116,000 florins (5,800 man-years) in 1491.[12] Unusually magnificent chapels helped these fabulously rich Florentines distinguish themselves from the merely affluent. Moreover, among all three families, members from different generations obtained and decorated prominent chapels within the same church. Such patterns of generational patronage also served to identify those born into the most important lineages.

Expenditures for the Purchase and Decoration of Chapels

The high financial outlays required for prestigious chapels made these expenditures effective signals. In his study of nearly 3,400 wills drawn up from 1276 to 1425 in six central Italian cities, Samuel Cohn discovered that "the average price for a chapel over this long period was 208.9 florins—more than most of the testators' total assets."[13] Though very few people who drew up wills could allot 200 florins to a private chapel, such a sum would have barely dented the finances of the truly wealthy and powerful. In the signaling game of chapel purchases, each group sought to distinguish itself from those below. To differentiate themselves, the lofty rich purchased the most expensive and generally the most prestigious chapels available in leading churches. In the late 1400s, the Florentine Pietro del Tovaglia reasoned, "If I spend 2,000 florins on my townhouse, my dwelling on earth, then 500 devoted to my residence in the next life [presumably, a tomb within a private chapel] seems to me money well spent."[14]

The purchase price of a private chapel constituted only a part of the total financial cost, often less than half. The related expenses included furnishing the chapel with an altar and the required liturgical instruments, decorating the space, and providing funds for priests to say masses within it. In 1486, Filippo Strozzi spent 300 florins (over 14 man-years) on a chapel in Santa Maria Novella—the standard price for a private chapel in one of the principal Florentine churches—and by 1502 he and his heirs had disbursed three times that amount on the decorations and the tomb within it.[15] Similarly, in his will of 1463, Gherardo Gianfigliazzi left 500 florins for rights to the high chapel in Santa Trinita but expected to spend over six times that amount for additional items that he conveniently itemized: 1,200 for frescoes; 600 to 700 for the

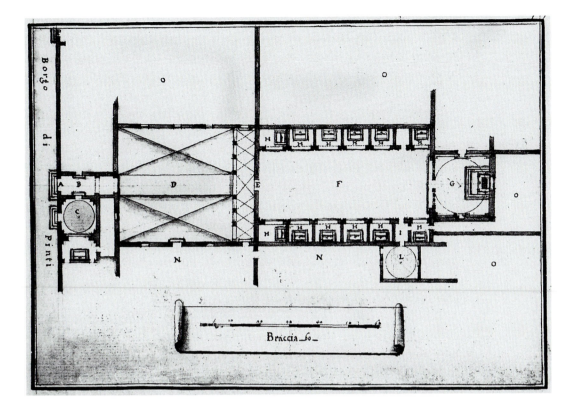

Braccia 60

stained glass window; 500 for masses; 300 for the choir stalls and altarpiece; 300 for the marble altar and tomb; and 200 for the altar furnishings. The expected costs thus totaled 3,600 to 3,700 florins (144–148 man-years.)[16]

Surviving documents do not make it possible to establish the actual cost to churches of building the chapels they put up for sale, but they were certainly much lower than the amounts patrons regularly paid for rights to them. Though the wealthy, with papal permission, might have a chapel built in their palace or villa, churches had considerable market power in chapel sales. Such power permitted the price to exceed the cost, sometimes vastly so. One valuable source for assessing such economic matters is the detailed account book for the relatively modest church of Cestello, which provides a benchmark for identifying costs and prices at larger and more prestigious churches. (fig. 5.5)[17] In the early 1480s, Cestello was built with uninterrupted nave walls; these led to the only chapel, which housed the high altar. In 1488, plans were made to add eight new chapels in the nave, four on each side. To build them entailed a major effort; the side walls had to be pierced and new spatial box chapels added. This process of retrofitting was much more costly than building chapels in a new church, as was the norm in fifteenth- and sixteenth-century Florence. Despite such additional costs, most of Cestello's chapels cost between 50 and 60 florins to build (for the walls only, excluding the window, altar table, and decorations).[18] Interestingly, the Cestello patrons only paid 50 to 70 florins for these

FIG. 5.5. Eighteenth century, drawing of plan of the church of Cestello (now Santa Maria Maddalena de' Pazzi), Florence (Kunsthistorisches Institut, Florence)

chapels, roughly their construction costs. What was the advantage for the friars at Cestello? In addition to raising funds to create a grander church, they received monies for the masses they would conduct for the chapels' patrons. Moreover, patrons were obliged to decorate their chapels, thus adorning the church as a whole.

During the same years as the Cestello reconstruction, patrons paid three to six times more for much smaller chapels in the much more prestigious church of Santo Spirito, built to Brunelleschi's plans between 1477 and 1491.[19] At Santo Spirito, each private chapel consists of two steps and a shallow niche framed in local limestone; the flanking columns outside the chapels can be considered part of the side aisle. The additional cost of constructing each chapel, in comparison to building a straight wall, would have been well below 50 florins, the costs at Cestello. Nevertheless, in the 1480s and 1490s, Santo Spirito's less prestigious chapels in the nave went for 150 florins, and at least six of the transept chapels—no larger than those in the nave—were sold for 300 florins apiece, many times their cost.[20]

These figures, and those for chapels in most other churches, were set by members of the *opera*, or building committee. Since all chapels at Santo Spirito have identical dimensions, as in many churches designed in the Renaissance, we would expect the highest prices to be paid for those closest to the high altar or to a major relic, the most prestigious locations. At Santo Spirito, however, we find a negative relationship between price and desirable location in several instances. Something else was at play: each member of the *opera* obtained a chapel, and some secured them at highly discounted rates—only 50 to 100 florins for chapels in the prestigious transept. One *opera* member did better still: Luca Pitti was given one of the chapels in the most desirable location, behind the high altar, at no cost whatsoever. At this church, and presumably many others, placement signaled status, not merely wealth. Board membership had its privileges. This remarkable situation reflects either self-dealing by members of the *opera* or, more likely, a system of rewards for past and anticipated future contributions to the church.[21]

Since money alone could not allow benefactors to obtain a chapel with a choice location within Santo Spirito or most other churches, a chapel's position constituted a constraint. Thus, location provided a particularly important signal for those who knew how to read the code. If patrons were unable to obtain chapels near the high altar, however, they had other means to secure high-visibility property. In the early 1300s, as discussed in chapter 6, the Alberti found a highly creative way to signal their status in Santa Croce: one member established an altar in the crypt chapel directly below the high altar and advertised this by placing a giant coat of arms on the arch between the nave and apse. The desire of patrons to acquire significant spaces in churches led to a category that Marvin Trachtenberg described as "exceptional" chapels. Examples appear at the end of the transepts in both Santa Croce and Santa Maria

Novella, and similar works are found in churches across Italy. These "exceptional" chapels possess three key features: size, often double that of "standard" transept chapels; location at the end of the transepts; and elevation, atop a flight of stairs.[22] The construction history and unusual shape of these chapels indicate that they were not part of the original plans for the churches, and were built as additions to the transept. According to a convincing hypothesis advanced by Ena Giurescu, wealthy private individuals left substantial funds to build these new spaces after the standard chapels were completed. Donors thus commissioned the exceptional chapels, supplied their construction costs and presumably much more, and thereby altered the shape and enhanced the magnificence of the churches.[23]

Chapel owners were expected to outfit and adorn their spaces handsomely at their own expense. These additional responsibilities constituted one significant difference between chapels and traditional private property. Moreover, patrons could lose the right to their chapels if they failed to furnish them adequately, as happened repeatedly in various churches during our period. This represented a very severe penalty, but even decorations considered merely adequate could lead to dishonor. Each chapel required an altar table and crucifix, as well as the objects used during the mass.[24] The precious materials used for liturgical instruments in prestigious chapels often made them more costly than paintings and sculptures. For his chapel in Santa Maria Novella, for example, Filippo Strozzi spent 135 florins (over six man-years) between 1488 and 1490 merely on priestly vestments. For the altar table, tomb, and marble relief sculpture of the Madonna and Child, Strozzi and his heirs paid 437 florins (twenty-two man-years) to the sculptor Benedetto da Maiano.

Virtually all chapels had painted altarpieces, though they were not required for the celebration of a mass. During our period, the cost for a typical altarpiece by a respected artist was about 100 florins, but some works naturally cost far more, and most were placed in expensive gilded frames.[25] Many chapels also had frescoes and stained glass windows, and the more prominent ones often had several of these decorations. For the fresco decorations alone in the Strozzi Chapel, Filippino was paid 373 florins (nineteen man-years). We can compare these figures with those that Cohn found in wills made by Tuscans of widely different social classes, from humble shopkeepers to wealthy bankers. He found that among those who left funds for the construction of chapels, 27 florins was a typical amount designated for commissions of sacred paintings; a fine altarpiece in Florence cost at least four times this amount.[26] Many Renaissance viewers, like modern ones, could appreciate the differences between a painting or sculpture of average cost and one by a prestigious artist. The use of rare and expensive materials in works of art provided a further signal. Five hundred years ago, churchgoers had a much easier time than would their counterparts today in recognizing which materials, such as porphyry and lapis lazuli, were difficult to obtain, and thus expensive.

The high costs of outfitting, decorating, and staffing a chapel help explain why Ludovico Gonzaga, the reluctant patron of the new tribune in the Florentine church of the SS. Annunziata, did not claim for himself the new chapels there. The Marquis of Mantua was virtually forced to spend 2,000 florins on the project and had no desire to spend another *soldo*. Instead, he gave Pietro del Tovaglia, his agent in Florence, permission to dispose of the new chapels as he wanted, but Pietro had to make sure that they displayed the Gonzaga arms. Thus, the marquis could signal the status of his family without additional cost. His agent exercised financial acumen to his own benefit. He kept one chapel for himself and gave four to the Servite friars at the church on the condition that they conduct a daily mass for him at his chapel and a yearly procession to his house.[27]

Expenditures for the Hereafter

Though Pietro made no cash outlay for these masses, churches typically also sold chapel-related services to donors; that is, they made what economists call tie-in sales. An example of tie-ins today would be the replacement parts specific to each type of automobile. For Renaissance churches, private masses constituted the most notable tie-in sale.[28] These were often purchased as part of a bequest, sometimes after the original chapel sale. These masses typically celebrated the patron saint of the chapel or donor, as well as the anniversary of the latter's death. These commemorations often included a meal, which could range from a simple repast for the priest to banquets for a large number of invited guests. A study of one community of friars shows that during eight months of 1528, the friars ate commemorative meals more than one day in three. Grand feasts naturally entailed serious financial costs, and thus provided patrons with an excellent, albeit expensive, opportunity to signal. The signal reached a highly appropriate audience, since churchmen and nuns at prestigious churches often belonged to leading local families; all Florence must have known about these magnificent events. Similarly, the number of masses and of participating ecclesiastics also signaled the wealth of the donor, even to those who could not enter the chapel itself.

The mere purchase of a mass was not a major distinguishing action, since less wealthy citizens who did not own chapels also bought masses. At the low end, short-term anniversary masses—to be performed annually for five, ten, or twenty-five years after death—were one arrangement developed in the late 1400s for shopkeepers and small tradesmen. Among the most popular funeral formulas at the time was the Gregorian mass series, which consisted of one mass daily for thirty days after death. In 1490, this option cost about one florin (14.3 man-days). The elite were prayed for on a grander scale. In 1411, the testament by the widow of Andrea Cavalcanti left provisions for an

extremely busy schedule: one thousand masses were to be held within the first two months after her death in a chapel in Santa Maria Novella. As discussed in chapter 7, the sculptor Leone Leoni left funds for three daily masses in his chapel, setting himself above not only fellow artists but also most chapel patrons in Milan.

Individuals with sufficient financial resources could also set up anniversary masses in perpetuity, which were usually officiated on the date of the donor's death and on the feast day of the saint to whom the chapel was dedicated. Donors typically endowed future activities at their chapels by giving the church a building or parcel of property; the rental of this bequest would pay for the masses. The very wealthy could also create "chaplaincies," endowed positions designed to guarantee the singing of mass for the souls of specified persons.[29] A substantial endowment was required to support a chaplain; in 1433, for example, Luca di Marco left 1,000 florins (thirty-one man-years) to construct his chapel in the church of San Lorenzo and to support an associated chaplaincy. (Interestingly, Luca was one of the very few patrons of a significant private chapel who lacked a last name, a name being a key indicator of membership in a prestigious clan.) By offering a range of options, from short-term anniversary masses to chaplaincies, churches made remembrances available for a variety of budgets. The higher-priced options brought greater profits to the church and provided commensurately more powerful signals for those remembered. Patrons also hoped these options would secure swifter passage into Heaven.[30]

The late medieval period witnessed an explosion in the purchase of private chapels and associated tie-in services. In the period before the plague of 1362–63, patrons in central Italy made a large number of small, unrestricted grants in their wills to churches or other institutions, such as hospitals, and rarely asked the institutions for anything in return. After the plague, however, private benefits—including status conveyance—came to the fore. Testators made a smaller number of far larger gifts, and these grants were usually restricted to purposes that more directly identified and benefited the donors. Such bequests were arranged to obtain private chapels, burial rights, and commemorative masses. Cohn convincingly portrays this as part of the growing "cult of remembrance."

In addition to the opportunity to signal status, private chapels brought benefits that had great significance for most patrons. Two crucial developments in the late Middle Ages linked the hope of salvation to the sale of chapels. First, the Church developed the doctrine of Purgatory, a place for temporal punishment for those who had not fully paid the price of their venial faults.[31] Second, the sale of indulgences allowed for the remission of some or even all of these punishments in recognition of good works.[32] Many wealthy Christians used pious donations to reduce their period of punishment after death. This goal naturally spurred donors to purchase private chapels, thus greasing

the skids out of Purgatory and on to Heaven. Funerary masses also offered the possibility of alleviating the pains of those in Purgatory. Only the Church had such balm to sell.

For wealthy Florentines, one prime motivation for acquiring a personal or family chapel was to have a burial site. Starting in the mid-1200s, a series of papal bulls gave Franciscan and Dominican friars permission to bury the faithful inside their churches. That honor had previously been reserved for the clergy and members of religious orders. According to Cohn's analysis of Tuscan testaments, only 20 percent of wills made before 1363 indicate a specific burial location, but of those made in the early 1400s, two-thirds are specific.[33] By that date, religious figures had publicly announced that a church burial would help directly with one's afterlife.

Antonio Pierozzi, the influential archbishop of Florence in the mid-1400s, who was later canonized as Saint Antoninus, spelled out three highly significant advantages of burials within a church: the saints honored by the church would intercede on behalf of the deceased; the faithful, coming to church, would see the tomb and pray for the deceased; and the dead would be assured of rest undisturbed by demons.[34] Significantly, Pierozzi did not indicate any reward for burial within the confines of a private chapel, as opposed to a permanent resting place in the nave pavement or crypts below. Hence, the need for church burial hardly explains the proliferation of expensive memorial chapels. Moreover, most families who had chapels in the transepts of Santa Maria Novella, Santa Croce, Santo Spirito, and Cestello also had at least one other chapel in a different church. For a patron, a second burial space was redundant. But burial in an exclusive, private chapel brought something else: patrons and their family members enjoyed final rest in an area reserved for privileged people, and the world would know.

Many church patrons surely shared the views of Filippo Strozzi, who, in a letter of 1477, wrote that "God having granted us His grace, there is no harm in our recognizing it in some way." This extremely wealthy patron then announced why he contributed funds to the renovation of three churches: "God having conceded temporal goods to me, I want to be grateful to Him for them."[35] Nevertheless, an unrestricted donation to a church could have served the same function of gratitude, and it would have purchased as many indulgences as payment for a specific chapel. Nor did masses conducted in a private chapel carry more weight. In short, piety and a concern for one's afterlife provide satisfying explanations for church donations and church burials, but something more is needed to explain the proliferation and decoration of *private* chapels.

Not only were these chapels unnecessary for salvation; the conspicuous display of private and family symbols also brought negative reception costs from some church authorities. The archbishop of Florence before Pierozzi, Giovanni Dominici, criticized the practice of self-aggrandizement, whereby vainglori-

ous patrons financed the construction of unnecessary buildings. They should instead renovate broken-down churches, said the archbishop, and "thus the name of the patron will remain with the first [benefactors]." Donations should be hidden from others, he explained; they would be seen by the omniscient God and rewarded in heaven.[36] At the end of the 1400s, Fra Girolamo Savonarola passionately took up this theme: "If I say to you, 'give me ten ducats to give to a poor man,' you would not do it, but if I say 'spend a hundred for a chapel here in San Marco,' you would do it in order to put up your arms; you would do if for your honor, not the honor of God."[37]

Chapels as Effective Signals

Despite their several drawbacks, chapels were purchased on a wide-scale because of the distinctive signaling benefits they offered. The prestige of owning a chapel was surely boosted because it separated donors so effectively: virtually every prominent clan had a chapel in a leading church, many families and several elite individuals had several of these spaces, but few undistinguished families had even one. This disparity in an observable characteristic created a convincing distinguishing signal.

A brief tabulation of chapels' patrons in Renaissance Florence makes clear the high status that their ownership conveyed. Our point of reference is Anthony Molho's important analysis of the group he identifies as the "ruling class" in Florence from the late Middle Ages until the establishment of the Medici duchy. During this period, the top third of these households dominated the economic and political life of the city. Molho identified the ruling class with 417 lineages (each containing numerous nuclear families), which he subdivided into groups we label high, higher, and highest status.[38] We compared these lineages with the family names of the 204 individuals who purchased the private chapels in nine major Florentine churches in the fourteenth and fifteenth centuries.[39] The comparison shows that these private patrons constituted the crème de la crème of the Florentine ruling class. Not only did the vast majority (81 percent) belong to lineages that made up the ruling class, as expected, but a very high percentage belonged to the most exclusive group. By Molho's calculations, 26 percent of the ruling class had the highest status in 1480, 31 percent had higher status, and 43 percent had high status. Of the 204 private chapel patrons, however, 57 percent were drawn from the highest strata, 18 percent had higher status, and 6 percent had "merely" high status. The remaining 19 percent of chapel patrons did not belong to the ruling class lineages; most likely, these individuals were powerful at the time they purchased their chapels, even if their families did not dominate Florence over the centuries. In some sense, they were nouveaux riches who never established themselves as major players in the city.

High wealth, high status, and chapel ownership went hand in hand. In 1480, the members of Molho's highest-status group controlled over a third of the total taxable wealth in Florence. Nevertheless, their riches make up only part of the story, because many rich Florentines did not own chapels. Those without surnames, for example, constituted a full 14 percent of the top 1,502 fiscal households in the fifteenth century, according to Molho's analysis, but only two of the chapel patrons were without surnames.[40]

That so few of the nameless top households owned chapels might seem counterintuitive, since those without a last name would have had more incentive than others to establish their status. The fulminations of Savonarola against self-glorification, noted above, help to explain this puzzle. Perhaps someone who lacked a family name or coat of arms for display and identification would gain little from spending his riches on a chapel. Most viewers would not know who he was. For those who did know, the patron would publicly display his embarrassing lack of a distinguished lineage. Moreover, the nameless probably would have found ownership more difficult to obtain. The *opere* probably operated as some nonprofit boards do today, and might have denied him "membership," as someone who was merely wealthy.

As we saw in the first chapter, one of the motivations for art patronage given by Giovanni Rucellai was to commemorate himself; and Giovanni Tornabuoni even stated, in his contract for the fresco decoration of the high chapel in Santa Maria Novella, that this work served, in part, as an "exaltation of his house and family." A chapel purchase represented a stride toward status on the drive for distinction. We can apply Mancur Olson's observation about modern America to Renaissance Italy: individuals donate to charity "because of a desire for respectability or praise."[41] So it was in Florence.

The substantial expense entailed in owning a chapel in a city church enhanced its signaling value. One could easily purchase half a dozen chapels, say in country churches, for the price of a single chapel in Santo Spirito. For the intercessor saints, the first audience for tombs mentioned by Antonio Pierozzi, this solution would have been ideal. But for the second audience, the faithful who attended church, the rural chapels had a distinct disadvantage. These spaces would rarely have been seen by the very people that most patrons wanted to impress, the city elite. In signaling, quality trumps quantity.

Naturally there were some patrons who focused their attention on different audiences. Giovanni Chellino, a prominent doctor, was one of the wealthiest men in Florence in the late 1400s, but he chose to be buried in his native San Miniato, the Tuscany town where he had already supported many ecclesiastical projects. "Rather than be a minor figure in a Florentine pantheon," Rubin observed, "maestro Giovanni promoted his memory in San Miniato. There he could be a dominant figure and impress the townspeople with his costly tomb and pious largesse."[42]

The financial costs of Chellino's commission enhanced its social value. For

patrons commissioning works in the city of Florence, having a chapel at Santo Spirito was prestigious and sought after primarily because the church was prominent and its chapels expensive. And they could be expensive precisely because their ability to convey status was highly sought. Throughout Italy, a prestigious chapel and its price created a virtuous signaling circle.

Notes

1. For recent studies in English on private chapels, with extensive bibliography, see Jill Burke, *Changing Patrons: Social Identity and the Visual Arts in Renaissance Florence* (University Park: Pennsylvania State University Press, 2004), and Jonathan K. Nelson, "Memorial Chapels in Churches: The Privatization and Transformation of Sacred Spaces," in *Renaissance Florence: A Social History*, ed. Roger J. Crum and John T. Paoletti (Cambridge and New York: Cambridge University Press, 2006), 353–75, 582–84. An earlier version of some the material in this chapter appeared in Jonathan K. Nelson and Richard J. Zeckhauser, "A Renaissance Instrument to Support Non-profits: The Sale of Private Chapels in Florentine Churches," in *The Governance of Not-for-Profit Organizations*, ed. Edward L. Glaeser (Chicago and London: University of Chicago Press, 2003), 143–80.

2. The discussion of these churches in the fourteenth century derives from Ena Giurescu, "Family Chapels in Santa Maria Novella and Santa Croce: Architecture, Patronage, and Competition" (Ph.D. dissertation, New York University, 1997). For the sixteenth century, see Marcia B. Hall, *Renovation and Counter-Reformation: Vasari and Duke Cosimo in Sta. Maria Novella and Sta. Croce, 1565–1577* (Oxford: Clarendon, 1979).

3. On the desire for intramural burials, and the ecclesiastical regulations that permitted it, see Samuel K. Cohn, Jr., *The Cult of Remembrance and the Black Death: Six Renaissance Cities in Central Italy* (Baltimore and London: Johns Hopkins University Press, 1992), and Robert Gaston, "Liturgy and Patronage in San Lorenzo, Florence, 1350–1650," in *Patronage, Art, and Society in Renaissance Italy*, ed. F. W. Kent and Patricia Simons (Oxford: Clarendon, 1987), 111–34.

4. For the church history and decorations, see Cristina Acidini Luchinat and Elena Capretti, eds., *La chiesa e il convento di Santo Spirito a Firenze* (Florence: Giunti, 1996).

5. For San Lorenzo, see Gaston, "Liturgy."

6. See Christa Gardner von Teuffel, "Clerics and Contracts: Fra Angelico, Neroccio, Ghirlandaio and Others: Legal Procedures and the Renaissance High Altarpiece in Central Italy," *Zeitschrift für Kunstgeschichte* 62, no. 2 (1999): 190–208.

7. On *ius patronatus*, see ibid., and Burke, *Changing Patrons*. Though the purchasers of chapels received private property in return, they were regularly described in Renaissance Italy as benefactors, and we refer to them by that term, and alternatively as donors or patrons.

8. On rood screens and chapel gates see Hall, *Renovation*.

9. For northern Italy see Alessandro Nova, "Hangings, Curtains and Shutters of

Sixteenth-Century Lombard Altarpieces," in *Italian Altarpieces: Function and Design, 1250–1550*, ed. Eve Borsook and Fiorella Superbi Giofredi (Oxford: Clarendon, 1994), 177–89.

10. Giurescu, "Family Chapels," 207.

11. Richard A. Goldthwaite, *The Building of Renaissance Florence: An Economic and Social History* (Baltimore and London: Johns Hopkins University Press, 1980), 349.

12. We estimate a man-year of unskilled labor at about 130 lire; see discussion in the introduction. For the declared worth of many prominent Florentines, see Anthony Molho, *Marriage Alliance in Late Medieval Florence* (Cambridge, MA: Harvard University Press, 1994). For Niccolò Alberti, see Sharon T. Strocchia, *Death and Ritual in Renaissance Florence* (Baltimore and London: Johns Hopkins University Press, 1992), 77, and chapter 6 below; for Filippo Strozzi, see Richard A. Goldthwaite, *Private Wealth in Renaissance Florence* (Princeton: Princeton University Press, 1968), 60, 63.

13. Cohn, *Cult*, 214. These figures, which exclude the costs of masses and decorations, apply to several cities and the surrounding countryside. The prices for chapels in the city of Florence were far higher, especially for major sites.

14. F. W. Kent, "Individuals and Families as Patrons of Culture in Quattrocento Florence," in *Language and Images in Renaissance Italy*, ed. Alison Brown (Oxford: Clarendon, 1995), 183. For Tovaglia's expenditures on his chapel, see Strocchia, *Death*, 196.

15. J. R. Sale, *The Strozzi Chapel by Filippino Lippi in Santa Maria Novella* (Ann Arbor and London: Garland, 1976), 100–147.

16. Patricia Lee Rubin, *Images and Identity in Fifteenth-Century Florence* (New Haven and London: Yale University Press, 2007), 6, 273–74 notes 7–8.

17. Alison Luchs, *Cestello: A Cistercian Church of the Florentine Renaissance* (New York and London: Garland, 1977).

18. No explanation is given for the considerable differences in construction costs for chapels.

19. Goldthwaite, *Building*, 100, states that the construction was "largely financed by the sale of its many chapels."

20. Andrew C. Blume, "Giovanni de' Bardi and Sandro Botticelli in Santo Spirito," *Jahrbuch der Berliner Museen* 73 (1995): 172, note 33, records the price of 300 florins for the Biliotti, Ridolfi, Lanfredini, and Dei Chapels. In 1493 the Nerli Chapel cost 300 florins, and in 1495 the Segni Chapel cost the unusually high price of 500 florins (31 man-years); see Luchs, *Cestello*, 159, note 5. The Luti Chapel cost 300 florins; see Jill Burke, "Form and Power: Patronage and the Visual Arts in Florence c. 1478–1512" (Ph.D. dissertation, Courtauld Institute, University of London, 1999).

21. Nelson and Zeckhauser, "Renaissance Instrument," 170.

22. Marvin Trachtenberg, "On Brunelleschi's Old Sacristy as Model for Early Church Architecture," in *L'Église dans l'Architecture de la Renaissance*, ed. Jean Guillaume (Paris: Picard, 1996), 9–40.

23. Giurescu, "Family Chapels." Unfortunately, surviving records do not itemize the payments made by donors, nor do they indicate the true costs of chapels.

24. Julian Gardner, "Altars, Altarpieces, and Art History: Legislation and Usage," in *Italian Altarpieces*, ed. Borsook and Superbi Giofredi, 5–39.

25. Michelle O'Malley, *The Business of Art: Contracts and the Commissioning Process in Renaissance Italy* (New Haven and London: Yale University Press, 2005), 133.

26. Cohn, *Cult*, 245.

27. Rubin, *Images and Identity*, 6–9.

28. For masses and related feasts, see Strocchia, *Death*.

29. Howard Colvin, *Architecture and the After-life* (New Haven and London: Yale University Press, 1991), 152–89. For San Lorenzo, see Gaston, "Liturgy," 112–13. For prices for chaplaincies, often combined with those for transept chapels, see Caroline Elam, "Cosimo de' Medici and San Lorenzo," in *Cosimo 'il Vecchio' de' Medici: Essays in Commemoration of the 600th Anniversary of Cosimo de' Medici's Birth*, ed. Francis Ames-Lewis (Oxford: Claredon Press, 1992), 157–80.

30. In the world of academia, these arrangements might be compared to the distinction between endowing an annual lecture and a professorship. Since the incremental cost of conducting a mass was extremely low to the church, the profits from the sale of masses were great.

31. Jacques Le Goff, *The Birth of Purgatory*, trans. Arthur Goldhammer (Chicago: University of Chicago Press, 1984).

32. On indulgences, see Evelyn Welch, *Shopping in the Renaissance: Consumer Cultures in Italy, 1400–1600* (New Haven and London: Yale University Press, 2005), 295–301.

33. Cohn, *Cult*, 143.

34. Gaston, "Liturgy," 131.

35. Sale, *Strozzi Chapel*, 18.

36. A. D. Fraser Jenkins, "Cosimo de' Medici's Patronage and the Theory of Magnificence," *Journal of the Warburg and Courtauld Institutes* 33 (1970): 163, our translation.

37. Girolamo Savonarola, *Prediche sopra Amos e Zaccaria*, ed. Paolo Ghiglieri (Rome: Belardetti, 1971), 2:22.

38. Molho uses the terms high status, status, and low status for the lineages that made up the ruling class. His lists draw primarily on the *catasti* (tax reports) of 1427, 1457/8, and 1480.

39. The churches, selected because information was readily available, were Badia Fiesolana, Cestello, San Lorenzo, Santa Croce, Santa Felicita, Santa Trinita, Santo Spirito, Santa Maria Novella, and SS. Annunziata. We excluded from our list "corporate" chapels, such as those owned by a brotherhood or religious order.

40. As Richard Goldthwaite kindly pointed out to us, the number of chapel owners without surnames at the time of purchase may well be higher than those indicated in the secondary literature we consulted.

41. Mancur Olson, *The Logic of Collective Action: Public Goods and the Theory of Groups* (Cambridge, MA: Harvard University Press, 1965), 160 note 91.

42. Rubin, *Images and Identity*, 80–81. For an analysis of similar decisions made in modern society, see Robert H. Frank, *Choosing the Right Pond: Human Behavior and the Quest for Status* (New York and Oxford: Oxford University Press, 1985), esp. 58–79 on "How much is local status worth?"

CHAPTER SIX ❧ Commissioning Familial Remembrance in Fourteenth-Century Florence

SIGNALING ALBERTI PATRONAGE AT THE CHURCH OF SANTA CROCE

Thomas J. Loughman

Introduction

THOUGH most studies of art patronage in Florence focus on the fifteenth and sixteenth centuries—the period of the city's republican rule under the *Signoria* and then under the Medici—public self-fashioning of individual and familial identity within the mercantile oligarchy began much earlier.[1] In the fourteenth century, we find highly aggressive and indelible assertions of family might and private wealth as merchant families systematically sponsored religious institutions and the expansion of churches, monasteries, and almshouses. Starting early in the century, elite families began to undertake ambitious architectural and artistic campaigns to enhance fellow citizens' perceptions of their status and wealth. These projects etched into Florence a lattice of neighborhoods dominated by family enclaves that have defined the urban fabric ever since.

The Alberti del Guidice—the ancestors of the famed humanist Leon Battista—provide an exemplary case of such self-promoting urban stewardship. In the course of the Trecento, they helped pay to renovate their parish churches, served on newly founded government committees to redevelop and regularize the main thoroughfares that passed by their homes, and built residential palaces on a grand scale within their neighborhood. They also began a systematic and sustained relationship as major donors to the large Franciscan community in Florence at Santa Croce, the church and monastic complex that bordered their familial enclave.

This chapter examines the savvy patronage strategy of the Alberti at Santa Croce in three distinct interventions during the fourteenth century.[2] Massive and highly prestigious, the Franciscan basilica of Santa Croce offered patrons exceptional opportunities to signal both their wealth and their accomplishments, while establishing monuments to their familial legacy. Family-based support of the artistic elaboration of the interior of Santa Croce, together with that of the contemporary basilica of Santa Maria Novella, represents the apex of self-fashioning in Trecento art patronage in Florence.[3] Elite banking families

from the Santa Croce neighborhood—the Alberti along with their contemporaries, the Peruzzi and the Bardi—systematically filled the church's interior with signs of their success, including lavish private chapels. They jockeyed for the right to do so from the very beginning of the church's construction at the outset of the century.

By that time, Florence's elite had come to recognize the limitations of mere opulent display as the prime means to communicate the honor, glory, and fame of their pedigree.[4] The proliferation of luxury goods decorating family chapels within Florentine churches saturated the visual environment and undermined patrons' abilities to distinguish themselves effectively through individual, even if grandiose, initiatives. This was particularly true at Santa Croce, a church evidently designed to maximize the number of private chapels.[5] The shrewdest families recognized that expenditure alone would be insufficient to signal their status as superior entities, perched at the pinnacle of Florentine society. They developed new ways to herald their primacy, portray their political clout, display their piety, and parade their civic leadership within the city's republican (i.e., ostensibly egalitarian, but obviously hierarchical) social system. Through the careful selection of their chapels and placement of their tombs—and by sustained attention to both over many decades—they were able to distinguish their benefactions, to instill them with an added sense of gravity, and to identify themselves as pious Christian burghers within the city's controlled social climate. Such a multigeneration strategy is hard to mimic, and impossible to implement quickly.

Major commissions at Santa Croce were not the only public benefactions of the Alberti clan. Successive members of the family signaled their prosperity and social status by expanding their adjacent familial enclave along the thoroughfares leading to Santa Croce, and by funding a series of projects at their parish churches (fig. 6.1).[6] In this careful campaign to demonstrate their benevolent dynasty in the neighborhood, each project displayed the family's wealth, civic leadership, and heraldry. The Albertis' initiative was strikingly ambitious, and more sustained than the efforts of their fellow competitors for status.[7] The family's goal was to employ an inimitable signal so as to ensure its position in contemporary republican politics and, ultimately, through history.

The Foundation for Effective Signaling

The primary benefaction of the Alberti family was its support of the Franciscan community at Santa Croce, known as the Friars Minor. Alberti family members were major supporters of the reconstruction, decoration, and endowment of the church. Historians traditionally date the family's entry into the church's affairs to a well-known bequest in 1348, and overlook its important and much earlier initiatives.[8] But the family's interventions were critically

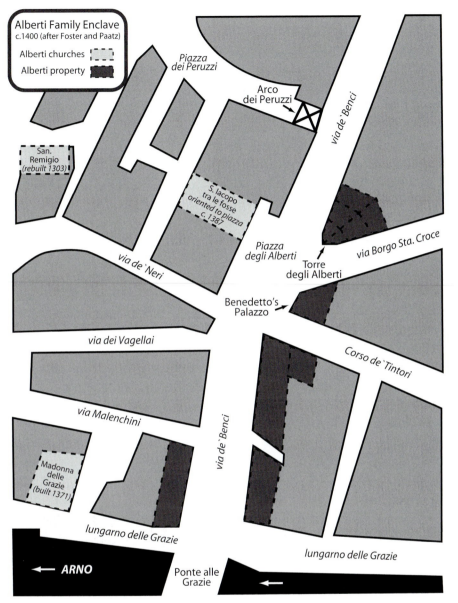

Alberti Family Enclave
c.1400 (after Foster and Paatz)

Alberti churches
Alberti property

Piazza
dei Peruzzi

Arco
dei Peruzzi

via de 'Benci

San.
Remigio
(rebuilt 1303)

S. Iacopo
tra le fosse
oriented to piazza
c. 1387

Piazza
degli Alberti

via Borgo Sta. Croce

via de 'Neri

Torre
degli Alberti

Benedetto's
Palazzo

via dei Vagellai

Corso de 'Tintori

via Malenchini

via de 'Benci

Madonna
delle
Grazie
(built 1371)

lungarno delle Grazie

lungarno delle Grazie

ARNO

Ponte alle
Grazie

FIG. 6.1.
Alberti family
enclave, ca.
1400, one
block south-
west of the
Church of
Santa Croce,
Florence (Au-
thor)

linked to the Franciscans from at least the turn of the fourteenth century, when
the reconstruction of Santa Croce began. These sustained, corporate, and in-
tergenerational benefactions at the church may even date from the time of the
Franciscans' arrival in Florence a century earlier. This chapter, which focuses
on the earliest recorded instances of the Alberti family's patronage at Santa
Croce, demonstrates how later interventions by the family at the church sys-
tematically built upon the first. (In much the same way, educational and cul-
tural institutions today capitalize on long-established reputations.) The sus-
tained generosity and active participation of the Alberti at Santa Croce over

many generations created a record that no other family could imitate. This program was a well-conceived and highly conclusive signal of both the wealth and prominence of the Alberti family.

The Friars Minor began to build a new, larger Santa Croce in the 1290s and sold patronage rights to chapels near the high altar—the holiest location—in the early years of the fourteenth century. Though surviving documents do not record these transactions, we can determine that each of the premier families from the east side of town sought the privilege to decorate the most central spaces and build their burial crypts within these chapels.[9] The families associated with the east-end chapels at Santa Croce comprise a "who's who" of Trecento gentry in the neighborhood, including the Bardi, Benci, and Peruzzi families. Within churches, as anywhere else, the prime determinant of real estate value is location. A space near the high altar was desirable for its proximity to both religious services and holy relics. Having communal prayer and the consecrated Eucharist near their chapels (and above their graves) helped ensure the salvation of the family's deceased.[10] The Alberti family was able also to secure a major space for burial, the subterranean chapel below the high altar itself.

Opposite page:
Fig. 6.2.
Crossing, with Alberti arms on north pier, church of Santa Croce, Florence (Rabatti & Domingie Photography, Florence)

A pair of polychromed reliefs emblazoned with the Alberti family arms, titanic in size, adorns the arched opening that connects the church's nave to the apse (fig. 6.2); they are seen on the uppermost course of masonry of the two flanking piers.[11] They appear to be cut upon the face of structural members of the archway, which suggests that the family secured the privilege of placing its arms in about 1300, when the east end was constructed. Within one of the massive piers is a hidden stairway leading down to the *confessio*, the crypt chapel directly below the high altar. The *confessio* would have been the least conspicuous chapel in the church, tucked below the daily view of virtually all visitors and friars. Yet both structurally and figuratively the space is the very foundation of the largest and most august part of the church, the high altar. As in most Franciscan churches built in the Trecento, the friars evidently did not cede familial patronage rights or burial rights to the high altar itself. Rather, the Franciscans decorated the high altar with some stained glass and vault frescoes with their own means for their daily use as their choir.[12]

In the *confessio*, a now-ruined fresco fragment once bore the dedication, "Alberto degli Alberti had this chapel made in honor of the Blessed Virgin Mary and Saint Nicholas [in] the year of our Lord 1304," below depictions of the two holy figures.[13] The source documenting the inscription also tells us that deceased family members were placed in the pavement of this chapel, but little is known about the space, its decoration, or regular use.[14]

In addition to honoring the saints and securing a burial place for family members, Alberto may have had an additional motive for choosing the *confessio*: to herald a connection between his familial lineage and the great apostolic age of Saint Francis himself. Michele degli Alberti—an early Franciscan

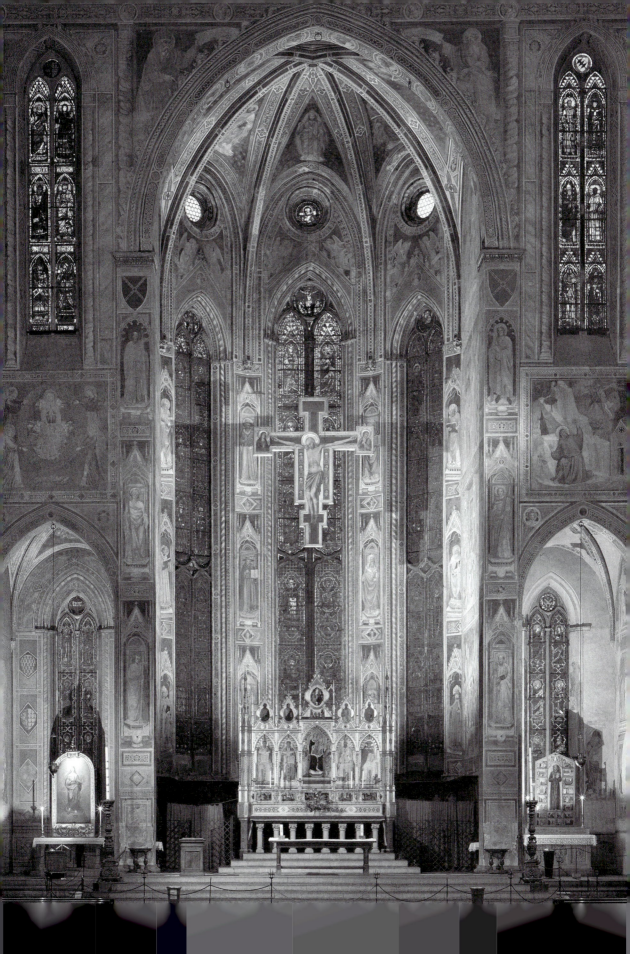

at Santa Croce, confessor to the Blessed Umiliana de'Cerchi, and one of the "first holy disciples, or Children of Francis"—died in 1246 and was buried in the crypt of the old Santa Croce, along with other members of the early Franciscan community in Florence.[15] Upon completion of the new church in the early Trecento, his remains and those of numerous Franciscan holy personages were transferred to the new *confessio*. Both the family and the friars might well have felt that the *confessio* was an appropriate focus of lay patronage by the Alberti family. This family connection may help explain the intense relationship between the Alberti family and Santa Croce.

Alberto's sponsorship of this small, underground chapel was hardly a hidden gesture. Neither did the chapel's position out of public view impair its effectiveness as a social signal. No other chapel was set on the vertical axis of the high altar, and none other than the *confessio* contained the sanctified remains of the earliest Florentine followers of Saint Francis. The *confessio* thus occupied the holiest space in the church among those made available for patronage by private individuals. At the high altar above, members of the Franciscan community focused their spiritual energies heavenward several times a day while standing on the floor above the tombs of Alberti men and those early Franciscan "holies," including Michele. No other family was able to secure such proximity to the community's constant supplications to God and to commingle with sainted remains. Alberto's neighbors knew this; many visitors to the church did as well.

The donation bore highly public signs. Elite families were reminded of the Alberti family's contribution each time they saw the huge coats of arms flanking the high altar chapel. From time to time, visitors to the church would have seen the friars and Alberti men emerge from those concealed stairways in the piers upon their return from visiting the tombs of their deceased forefathers—lay and religious—in the subterranean chapel.

The Alberti project was consonant with contemporary attitudes about the moral role of spending lavishly on church building, namely adhering to the Aristotelian theory of magnificence. While usually applied to the princely courts of Italy—where the theory found a great apologist in the Milanese cleric Galvano Fiamma—there is evidence that the concept had currency in republican Florence.[16] Certainly, it was familiar to Leon Battista Alberti—living six generations after his ancestor Alberto—who urged patrons "to strive to make magnificent with pomp" in public works, such as new additions to church buildings.[17]

Amplifying the Signal

Five decades after Alberto's *confessio* donation, a second clan member—named Alberto di Lapo degli Alberti, nicknamed Albertaccio—made an even larger

bequest. Of the many institutions remembered in Albertaccio's pious bequests, the gifts to the Friars Minor at Santa Croce stand out as his most generous, and his planning for the family graves at the church most extensive. In 1348, Albertaccio left 500 gold florins for the construction of the tombs in the pavement at the east and west openings to a new monastic choir, and left 1,000 florins for the construction of a second family chapel.[18] These are enormous sums, equivalent to roughly fifteen and thirty years of wages for an unskilled worker.[19] Perhaps previous studies have fallen short of revealing the mechanics of the bequest, and also of understanding its relationship to the earlier *confessio* donation, because the will itself makes no mention of the preexisting Alberti chapels or graves. Neither does it provide a timetable for the execution of each phase of the project, and it leaves little indication of how the gift might fit into the family's broader strategy of sponsorship at Santa Croce. Logic suggests the conscious accrual of Alberti influence as part of their intergenerational campaign to signal elite status.

The leverage exercised by Albertaccio's generosity to Santa Croce can now be measured, thanks to recently published documentation of the family's business accounts.[20] These substantiate the expenditure of funds on the friars' choir, a project executed remarkably swiftly. Family members participated both as donors and as administrators of the project.[21] Over a period of fifteen months during 1350 and 1351, 125 florins were raised from eight family members for the choir. In 1353, another series of payments followed, each for 13 florins, bringing their individual contributions up to about 62 florins. Thus the sum raised for the choir and tombs totaled nearly 900 florins—500 from Albertaccio's bequest and 390 raised from his kinsmen. Surviving evidence strongly suggests that there was a broad plan, perhaps designed in the weeks before Albertaccio's death, for the entire family to partake in these projects. This demonstrates his appreciation of intergenerational participation as a critical edge in successful status signaling.

As stipulated in Alberto's will, a greatly expanded and highly decorated structure for the friars' choir was built at the family's expense within five years of his death. The choir was a massive wooden enclosure that occupied virtually all the nave bays east of the rood screen (*tramezzo*), which effectively divided the nave of the church into two zones: the eastern one for the monks and their male guests and the western one for the public. The choir consisted of parallel banks of stalls aligned to the longitudinal axis of the church, running from the rood screen to the foot of the high altar. Two openings, at the center of the short ends, gave the friars access to the choir. Funds were dispersed from 1355 to 1356 in several payments to the workmen. More than fifty florins went to Pietro di Lando, the general contractor, for his work including the *intarsia*, paint, and other supplies, and more than twenty-five florins each went to the wood workers for their labor.[22] The choir was the only structure visible to those who approached the opening in the *tramezzo*. Its swift construction

Fig. 6.3.
Alberti family
impresa
(Author)

and great expense show the priority given to the project. A decorative marble stripe corresponding to the footprint of the now-lost choir, emblazoned with the family's *impresa* in inlaid black and white marble, remains a permanent marker of the Alberti family's bond to the Franciscan community (fig. 6.3). The symbiotic relationship between the family and the friars no doubt took visual form in the choir structure itself. The choir was completely destroyed at the behest of Cosimo I in the 1560s as part of his campaign to renovate Santa Croce. This constituted a particularly clear instance of Cosimo's attempt to eradicate all traces of the former republican oligarchy from the church.[23]

From Albertaccio's bequest onward, Alberti men were buried beneath eleven marble tomb slabs, each with black and white geometric decorations, at the foot of the high altar, in the area precisely between the choir and the broad staircase that connects the body of the church to the sanctuary of the high altar. The ladies' tomb of two similar marble slabs was installed between the choir's west end and the opening in the rood screen. Both locations were visible to the public and the friars, making them effective social signals, and both

were near where the liturgy was celebrated, enhancing their sanctity. Their segregation was functional: men were likely allowed beyond the rood screen to visit the tombs of their dead fathers and brothers buried up against the stairs to the high altar, while women enjoyed ready access to the highly visible ladies' tombs at the opening in the rood screen. These tomb sites were crossed incessantly by the friars, and the thresholds likely served as stations for the distribution of the Eucharist. This constant traffic and proximity of ritual ensured that the need of the deceased for visitation, remembrance, and sanctification was fulfilled. Thus, the placement of the family's graves indicates the family's intimate connection to the friars and demonstrates the family's unflagging desire to honor its dead, just as Alberto di Iacopo had honored them in the *confessio* project forty-four years earlier.

Alberti men of later generations recognized the elite status such a burial arrangement offered. While in exile during the 1410s, Benedetto's son Lorenzo (d. 1421; father of Leon Battista) created a parallel situation for his burial in an equally august Franciscan epicenter: the Church of Saint Antony in Padua.[24] There, as at Santa Croce, a modest floor slab marked the Alberti graves, situated precisely at the threshold dividing the choir from the altar sanctuary.

Sustaining the Legacy

After 1350, the family continued its vibrant and generous participation in the life of Santa Croce. For decades, each Alberti will included at least one special bequest to Santa Croce and its hospital.[25] The friars or laity could hardly ask the Alberti what they had done lately for the church. Yet following the choir project, the relationship between the Alberti family and Franciscans at Santa Croce showed signs of strain. Albertaccio's will called for the creation of a second family chapel (presumably since the family's burial needs had outgrown the *confessio*), a project that had not progressed by 1374. In the will drafted that year by Iacopo di Caroccio Alberti, the testator protested the inaction of the friars in producing such a chapel and ordered his executors to secure a refund for his contributions to the tomb and choir project, and to the chapel project.[26] Iacopo blasted the friars for denying him use of the family vault for the burial of his son, who died in 1371 and was interred alternatively at San Remigio, his parish church. Despite his frustrations, Iacopo bequeathed money for the hospital at Santa Croce; his son Paolo (1356–1438) later joined the Franciscan order there and went on to become bishop of Ascoli, where he died.[27] The Alberti were well established and the bequests were expensive, but the alternative—abandoning an established family tradition—might have proved more so.

Despite these tensions, relations with the Santa Croce friars remained sufficiently amicable to allow for one of the most lavish funerals ever recorded

in the history of the Florentine Republic. The August 9, 1377, funeral staged there for Niccolò Alberti, a man of extraordinary wealth who occupied a central role in Florentine civic life, matched his social stature. The obsequies were highly theatrical.[28] Five hundred poor men of Florence were each paid the large sum of two florins apiece to weep at his casket. A procession led by eight war horses and illuminated by seventy-two tapers traveled from the family loggia up the Borgo Santa Croce to the church, and Niccolò was laid to rest in the family vault at the foot of the high altar. The contemporary Monaldi diarist estimated the funeral expenses alone at three thousand florins—far more than the sums spent by the family on artistic and architectural patronage at the church through the fourteenth century—and described the events in great detail, noting that they were unparalleled in pomp and luxury.[29] Although the family's expenditures on artistic commissions cost less, they were perpetual signals whose efficacy was only magnified by spectacles such as Niccolò's funeral.

In terms of size and chronology, the ultimate act of Alberti patronage in Santa Croce in the Trecento was the monumental fresco cycle the *Legend of the True Cross*, painted around 1390 by Agnolo Gaddi in the high altar chapel (fig. 6.4). The friars appear to have conceded to the family the patronage rights necessary to undertake such a decorative project, and the family must have spent vast sums, though records documenting both these actions do not seem to survive.[30] Such a grand and centrally located redecoration project was truly unprecedented at Santa Croce, as was the grant of a patronage right to the high altar.

Two public events, separated by a mere two weeks, indicate the favorable atmosphere that allowed the Alberti family to acquire those rights and provided the Franciscans the impetus to renovate Santa Croce. First, Fra Bartolommeo Ulari was installed as the new bishop of Florence—the first Franciscan in this position—with great fanfare, including a parade on Sunday, January 28, 1386.[31] On February 8, word reached the city that Florence's ally Charles III Durazzo had been crowned king of Hungary, and three days of feasting followed.[32] A massive pageant of two rival brigades was organized: one financed personally by Benedetto Alberti (presumably drawn from his political circle, the so-called Ricci faction) and the other representing the rival political group in town, the Parte Guelfa. On an ostentatious scale, Benedetto and his partisans were celebrating personal position and expressing joy for Florence's improved security. These public feasts mark the apogee of Franciscan and Alberti power in Florence and the climate in which the Santa Croce commission was undertaken.

The narrative fresco cycle is a grand exposition of the True Cross legend in a succession of scenes centered on the themes of loss and recovery of the relic in the Holy Land. Agnolo Gaddi depicted over two dozen monumental figures on the framing pilasters, which border the three massive zones (each over ten

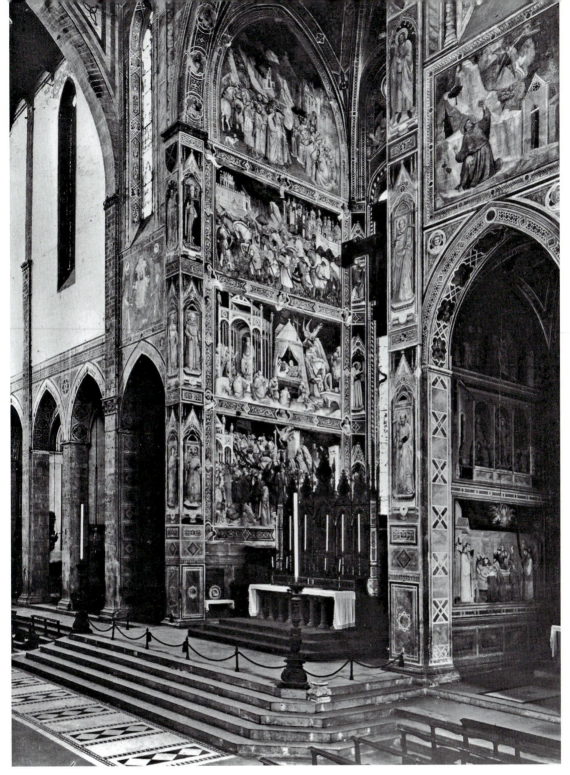

FIG. 6.4. High altar chapel, with Agnolo Gaddi's *Legend of the True Cross*, church of Santa Croce, Florence (Soprintendenza per il Patrimonio Storico, Artistico ed Etnoantropologico delle province di Firenze, Prato e Pistoia)

feet high) on the chapel's side walls. The choice of subject was highly appropriate for both the Friars Minor and the Alberti family. The True Cross was the dedication of Santa Croce specifically, and the Holy Land sites had been placed under the authority of the Franciscans earlier in the century. The Alberti paterfamilias, Benedetto di Nerozzo degli Alberti, had just died of plague, along with his nephew and wife, at Rhodes in January of 1388, while returning from pilgrimage in the Middle East during his exile from Florence.[33] A civic leader and captain of the family business for more than a decade (he had assumed this status upon the death of his uncle Niccolò in 1377), Benedetto was forced from the city in May 1387 by his political rivals in the Parte Guelfa. With Benedetto's banishment, pilgrimage, and death, the time had come to memorialize his role in the family's success and to reassert the family's reputation. Thus various projects were funded, including the decoration of the high altar and the outfitting of a memorial chapel at San Miniato al Monte, just outside the city walls of Florence.

Beyond alluding to the pilgrimage of Benedetto through the True Cross cycle, the Alberti signaled their status by having murals of their patron saints painted on the back wall of the chapel; these appear on the pilasters that separate the soaring lancets of stained glass. Foremost among the non-Franciscan saints are Bernard and Benedict. Benedetto's eldest son and primary heir was Bernardo. Thus, these frescoed saints symbolically represented the family within the sanctuary of Santa Croce. We can imagine the patrons' intention: these symbols of themselves were to stand in constant devotion to the liturgy offered in the high altar. Possibly, the patrons set up trustees for their legacy at Santa Croce, much as Benedetto and Bernardo Alberti did in wills executed in connection with their memorial chapel at San Miniato al Monte. Under such arrangements, selected individuals—likely Alberti kinsmen—would make annual payments for memorial masses to be sung.[34]

An Enduring Signal

By century's end, the family legacy was writ large in both the architectural fabric and the decorations of Santa Croce through an extensive trail of patronage stretching back to the foundation of the new church structure. This was a historical and physical record that no other family could come close to duplicating. The Alberti family's conscious monopolization of the visual and spiritual center of Santa Croce stands as a great accomplishment and ingenious stratagem by this clan, carried out in the uncertain atmosphere of the Florentine Trecento. The Alberti capitalized on their long-term commitment to the friars at Santa Croce by building a sequence of spaces to memorialize their esteemed status at the apex of Florentine society. That these acts were self-conscious may be inferred from the repetition of such patronage tech-

niques in other cities during the multiple Alberti exiles in the early Quattrocento.[35] The Alberti's physical dominance of Santa Croce boldly imposed their indelible presence at the very heart of the thriving spiritual center of their neighborhood, and their prominence within the entire city.

The Alberti campaign at Santa Croce entailed exceptional expenditures in the service of their public reputations and personal salvation. It employed parades, expensive commissions, monumental works of art, prominent burial places, and the endowment of the Franciscan community. The Alberti's spectacular display of familial clout at Santa Croce served the complementary goals of providing good works and memorializing their pedigree as the unrivaled patrons of their fashionable quarter of Renaissance Florence. As the Alberti recognized, creating what no others can imitate is the most effective signal of all.

Notes

1. See *Art, Memory, and the Family in Renaissance Florence*, ed. Giovanni Ciappelli and Patricia Rubin (New York: Cambridge University Press, 2000), and Richard Goldthwaite, *Building of Renaissance Florence: An Economic and Social History* (Baltimore: Johns Hopkins University Press, 1980).

2. There are few published sources on the patronage of the Alberti family; see Luigi Passerini, *Gli Alberti di Firenze: Geneologia, storia e documenti*, 2 vols. (Florence: M. Cellini, 1869/70).

3. For these churches, also see chapter 5.

4. On the ecclesiastical code controlling burial within churches, and on Santa Croce in particular, see the summary by Doralynn Schlossman Pines, "The Tomb Slabs of Santa Croce: A New Sepoltuario" (Ph.D. diss., Columbia University, 1985), 9–27. Ena Giurescu, "Family Chapels in Santa Maria Novella and Santa Croce: Architecture, Patronage, and Competition" (Ph.D. diss., New York University, 1997), 241–43, confronts the issue of patrons' motivations in the early Trecento. Jane Collins Long, "Salvation through Meditation: The Tomb Frescoes in the Chapel of the Holy Confessors at Santa Croce in Florence," *Gesta* 34, no. 1 (1995): 77–88, posits that lay patrons in churches always tempered ambition with humility in their commissions.

5. See Giurescu, "Family Chapels," as well as Long, "Salvation"; Julian Gardner, "The Early Decoration of Santa Croce in Florence," *Burlington Magazine* 113 (1971): 391–95; and Julian Gardner, "The Decoration of the Baroncelli Chapel in Santa Croce," *Zeitschrift für Kunstgeschichte* 34, no. 2 (1971): 89–114. On the high altar décor, see Andrew Ladis, "The Velluti Chapel at Santa Croce, Florence," *Apollo* 120 (1984): 238–43; Ulrich Middeldorf and Bruce Cole, "Some Discoveries in the Cappella Maggiore in Santa Croce, Florence," *Antichità viva* 5 (1975): 8–12; and Nancy MacKay Thompson, "Saint Francis, the Apocalypse, and the True Cross: The Decoration of the *Cappella Maggiore* of Santa Croce in Florence," *Gesta* 43, no. 1 (2004): 61–79.

6. Thomas J. Loughman, "Spinello Aretino, Benedetto Alberti, and the Olivetans: Late Trecento Patronage at San Miniato al Monte, Florence" (Ph.D. diss., Rutgers Univeristy, 2003), chapter 5.

7. Each of the Benci, Salviati, Bardi, and Peruzzi families—wealthy neighborhood peers of the Alberti, also involved in the wool trade and international banking—spearheaded its own urban campaign.

8. Gardner, "Early Decoration."

9. Recent studies, especially Giurescu, "Family Chapels," indicate that, at the end of the thirteenth century, Florence's elite families divided up rights to the decoration of the church and soon thereafter adorned their chapels with at least rudimentary decoration.

10. For fourteenth-century views on the relative sanctity of space within churches, see Howard Saalman in "Strozzi Tombs in the Sacristy of Santa Trinita," *Münchner Jahrbuch der bildenden Kunst* 38 (1987): 149–60.

11. The arms consist of four silver chains bound by a central ring, crossing to the corners of an azure field.

12. For the sequence of decorative campaigns in the high altar, Thompson, "Saint Francis," 61–64.

13. "Hanc Capella Fecit Fieri Albertus . . . de Albertis ad honore B. Mariae Virginis et B. Niccolai AD MCCCIV." Biblioteca Nazionale Centrale, Florence [hereafter BNCF], Cirri, *Sepoltuario*, n.d. (early twentieth century), fol. 1230 annotated as entry no. 3088 and preceded by the following comment: "Fondata nel 1304 da Alberti degli Alberti del Guidice e dedicata alla Vergine e a San Niccolò a Bari. Corresponde al Coro della Cappella Maggiore del Tempio col quale è in comunicazione per mezzo di una scalette scavata nella grossezza del muro, che si apre nel pilastro a sinistra dell'altare. Le mura di questo sacello erano affrescate da pittori Giotteschi. Nelle parete a destra vedevasi un S. Niccolò da Bari ed altri santi. L'altare non è quello che vi era in antico . . . nel muro a destra dell'altare, lap[idu]m e iscr[izioni] che oggi non si vede." The donor was almost certainly Alberto di Iacopo, who died in 1324. Cirri notes the other inscriptions around the altar, all later, pertaining to gifts from the Meletis family (seventeenth century) and Leopold II (nineteenth century) in entries 3087 and 3089 respectively. A slightly conflicting and loquacious description of the space—dated 1313 in arabic numerals instead of 1304 in roman ones—is found in the *sepoltuario* prepared by Stefano Rosselli in 1675 (BNCF, Fondo Nazionale II, IV, 534), fols. 385v–386v.

14. Cirri, *Sepoltuario*, entry 3090, which reads, "nel pavimento, nicci lastroni di macigno senza segno. Erano le *Sepolture degli Alberti* [Cirri's emphasis]." All the decoration of this space has been destroyed by the compound effects of floodwaters and time; it is now a white box-style gallery accessible via the Fascist-era monument with a street entrance outside the north flank of the nave.

15. Virtually our only source on Michele and his immediate family is Giuseppe Richa, *Notizie istoriche delle chiese fiorentine* (Florence: Viviani, 1754), 1:77. For his ministry to the Beata Umiliana, see her *vita* compiled by Vito da Cortona c.1250, published in the *Acta Sanctorum* [17, 384–418 (19 May)], cross-referenced by *Acta Sanctorum* 8:502 (17 March, Michele's death date). See also Umiliana's entry in *Bibliotheca Sanctorum* (3:col. 1132–34). For her cult and early works of art: Ugo Procacci, "Una lettera del Baldinucci e antiche immagini della Beata Umiliana de' Cerchi," *Antichità viva* 15, no. 3 (1976): 3–10; Dora Liscia Bemporad, "Due busti reliquari in Santa Croce di Firenze," *Antichità viva* 26, nos. 5–6 (1987): 59–68; and James Beck,

"The Reliquary Bust of the Beata Umiliana de' Cerchi," *Antichità viva* 28, nos. 5–6 (1989): 41–44. "Michele" was probably the monastic name taken by the friar, whose given name remains unknown. Another member of the Alberti clan, a Camaldolese monk resident at Santa Maria degli Angeli in 1376, took the same name; see Passerini, *Gli Alberti*, 2:155–85.

16. Paula Spilner, "Giovanni di Lapo Ghini and a Magnificent New Addition to the Palazzo Vecchio, Florence," *Journal of the Society of Architectural Historians* 52 (1993): 453–46. For the theory of magnificence, also see chapter 3.

17. A. D. Frasier Jenkins, "Cosimo de' Medici's Patronage of Architecture and the Theory of Magnificence," *Journal of the Warburg and Courtauld Institutes* 33 (1970): 163–64.

18. Passerini, *Gli Alberti*, 2:137–43 doc. 16; the original document has not been located.

19. This estimate is based on data provided in Goldthwaite, *Building*, 429, 436.

20. See *Due Libri Mastri degli Alberti: una Grande Compagnia di Calimala, 1348–1358*, ed. Richard A. Goldthwaite, Enzo Settesoldi, and Marco Spallanzani (Florence: Cassa di Risparmio di Firenze, 1995), 2:485 (codex I, fol. cccclxxi verso).

21. Payments to the "choir fund" totaling 125 gold florins are reported in *Due Libri*, 1:162–63 (codex I, fol. cclxxxxiiii recto). The entries are a synopsis of all the accounting, recording single payments as follows: 25 gold florins each deposit on four occasions from "Iacopo di Caroccio and his brothers" (i.e., Tommaso, Bartolommeo, and Duccio) on 10 March 1348 (1349 new style), 17 April and 11 September 1350 and 12 February 1350 (1351 new style); and a single 25 gold florin deposit from "Luigi di Duccio and his brothers" (i.e., Cipriano, Doffo, and Donato) on 15 June 1351. A second group of payments totaling an additional 265 gold florins is recorded in the same publication (2:469 [codex I, fol. cccclviii verso]): one for 15 gold florins by the sons of Caroccio di Duccio on 15 March 15 1353 (1354 new style), and the other for 250 on 10 April 1353.

22. *Due Libri*, 2:485 (codex I, fol. cccclxxi verso) and 2:570 (codex I, fol. dxiii verso).

23. Marcia Hall, *Renovation and Counter-Reformation: Vasari and Duke Cosimo in Santa Maria Novella and Santa Croce, 1565–1577* (Oxford: Oxford University Press, 1979).

24. Andrea Calore, "Il coro e il presbiterio della Basilica del Santo. Vicende storiche e artistiche nel sec. XV," *Il Santo* 38 (1998): 69–98. Lorenzo's tomb marker appears on the schematic plate 1, the plot labeled 168.

25. Major charitable bequests were part of the wills written by each succeeding generation. They also specified burial requests marking their connection to the Franciscans. Niccolò di Iacopo (d. 10 August 1377); Benedetto di Nerozzo (d. 8 January 1388), and Bernardo di Benedetto (d. 15 March 1389), and Gherardo di Benedetto (†1405) each ask for burial in the family vault in a Franciscan habit.

26. For the will, Passerini, *Gli Alberti*, 2:144–54, esp. 146 (regarding Iacopo's displeasure with the Franciscans).

27. Passerini, *Gli Alberti*, 2:39.

28. Sharon T. Strocchia, *Death and Ritual in Renaissance Florence* (Baltimore and London: Johns Hopkins University Press, 1992), 93.

29. *Istorie pistoiesi . . . e Diario del Monaldi*, ed. Antonio Maria Biscioni (Milan: G. Silvestri, 1845), 443–44.

30. The precise date the rights were ceded is a matter of speculation. See Bruce Cole, *Agnolo Gaddi* (Oxford: Oxford University Press, 1977), who suggests a mid-1380s dating, and Andrew Ladis, "Un'ordinazione per disegni dal ciclo della vera croce di Agnolo Gaddi a Firenze," *Rivista d'arte* 4 (ser. 5), no. 41 (1989): 153–58, who advocates circa 1390.

31. *Alle bocche della piazza: diario di anonimo fiorentino (1382–1401): BNF, Panciatichiano 158*, ed. Anthony Molho and Franek Sznura (Florence: L. Olschki, 1986), 61, under rubric 21: "[he] bestowed great honor by all the citizenry. . . . And on Monday morning he entered into the episcopate with greatest honor."

32. *Alle bocche*, 61.

33. On Benedetto's career and pilgrimage, see Loughman "Spinello Aretino," 186–204.

34. Benedetto's will (Florence, Archivio di Stato, Diplomatico, Santa Maria degli Angeli, 11 July 1387) was published in Passerini, *Gli Alberti*, 2:186–94. For Bernardo's deathbed will (drafted in Florence at Santa Maria degli Angeli on 16 March 1389), see Florence, Archivio di Stato, Notarile antecosimiano 13626, fols. 19r–23v. The payments are recorded throughout the San Miniato *entrate*—see Loughman, "Spinello Aretino."

35. For example, the tomb created by Lorenzo di Benedetto (son of Benedetto and father of Leon Battista) in Padua mentioned above (note 24). Benedetto's son Gerardo subvented the construction of a new sacristy at the ancient church of San Michele in Bosco in Bologna in the first decade of the 1400s.

LEONE LEONI'S SIGNPOSTING IN

SIXTEENTH-CENTURY MILAN

Kelley Helmstutler Di Dio

Introduction

WHEN GIORGIO VASARI visited the sculptor Leone Leoni's house in Milan (fig. 7.1), he had good reason to be impressed by the sculptor's lifestyle. Indeed, he wrote to the Florentine humanist Vincenzo Borghini, Leoni "has done and continues to do such things that were Michelangelo to return to life and see how [Leoni] lives, he would say that the art that caused him to be considered exceptional had become another thing, because in truth these masters are no longer philosophers, but princes."[1] As Vasari recognized, Leoni's home proclaimed the hard-won elevation from the artisan class for which previous artists had struggled. Such upward mobility is an important motif throughout both editions of Vasari's *Lives of the Artists*, in 1550 and 1568. In his chapter on Leoni, Vasari enthusiastically praised Leoni's house for its beauty, spaciousness, prestigious art collection, and ideal location. He noted that Leoni formulated its unusual, inventive design "in order to display the greatness of his mind, the beautiful genius that he has received from Nature, and the favor of Fortune," and that Leone had "built at great expense and with most beautiful architecture a house in the Contrada de' Moroni, so full of fantastic inventions that there is perhaps no other like it in all Milan."[2]

This chapter explores the self-celebratory messages that Leoni expressed in the decoration of his house. It then assesses how his intended audience, his contemporaries, understood these messages. Leoni signposted certain qualities, mainly his erudition, wealth, and connections with the emperor, but did not communicate other highly relevant information, such as his profession.

Leoni's Strategy

Italian artists began their struggle for higher status as early as the fourteenth century.[3] By the fifteenth and throughout the sixteenth century, a few artists had even received honorary titles; some also accumulated significant wealth.[4]

149

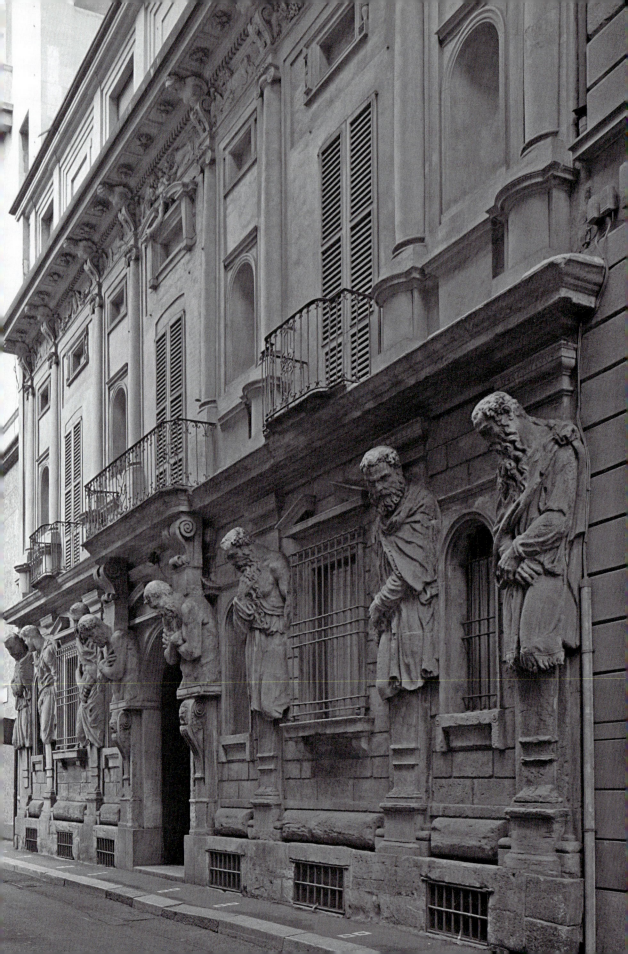

Artists gave visual form to their new status in autonomous self-portraits, which entailed little financial cost but some investment of time. The more exceptional successes sometimes went further, signaling their status by building grander homes or elaborate (and usually very expensive) funerary monuments for themselves.[5] Artist-writers such as Vasari and Gian Paolo Lomazzo lauded these artists' achievements, and emphasized the social implications of the design, decoration, and location of their homes and tombs.

Amidst those artists who strove for and demonstrated their status, Leoni (1509–90) stands out. By the mid-sixteenth century, he had surpassed all previous artists in the social standing he obtained.[6] He constructed a home finer and more expensive than that of any previous painter or sculptor. It signaled substantial wealth. Even more important, perhaps, his home allowed him to signpost honors that money could not buy. Leoni attained these honors and the status accompanying them through a combination of artistic skill, erudition, and important cultivated friendships. He worked for important patrons throughout Europe, befriended some of the most famed humanists of his day, participated actively in a scientific academy, the Accademia dei Fenici, and acted as an intermediary between various important men in Milan with Cardinal Antoine Perrenot de Granvelle, the powerful counselor of Charles V and Philip II of Spain. Charles V named Leoni his chief sculptor and granted him numerous commissions, a title of nobility, a gold chain worth 250 scudi, land and monies for his house in a prestigious area of Milan, an annuity of 100 scudi from the imperial mint, and the unusual reward of a lifetime annuity of 150 scudi. Those payments, along with the high prices that other patrons paid for his sculptures, allowed Leoni to become wealthy.[7] After Charles abdicated the Spanish crown in 1556 and his role as emperor in 1558, Leoni worked for Charles's son, Philip II of Spain, as well as for governors of Milan, several popes, and other high-ranking members of the clergy. Leoni's wealth, title, and relationships afforded him an enviable social stature. His house, and his ability to use it to signpost his accomplishments, played an equally important role. This skill in signaling and signposting brought him a stature that few artists in the centuries to follow could boast.

Opposite page: Fig. 7.1. Leone Leoni (designed by), Casa degli Omenoni, Milan (Marta Carenzi, Milan)

The Design of the Casa degli Omenoni

Leoni called his house the "Casa magna," or grand house, but it is commonly known as the Casa degli Omenoni. In the Milanese dialect, this means "the house of the big men," in reference to the large terminal figures on the façade.[8] Working as his own architect, Leoni found inspiration in the homes of Mantegna, Raphael, Giulio Romano, and Vasari.[9] Like Raphael and Giulio, he wanted his house to be an aristocratic palace and, therefore, not identifiable as

an artist's home. Like Vasari and Giulio, he employed allegories such as Virtue versus Vice, but offered multiple meanings to this image, beyond those of the artist's virtue battling against the vice of jealousy. Leoni also referred to his relationship with the Spanish court and alluded to a work he had produced for it. In a similar vein, the frescoes in Giulio's house celebrate Gonzaga rule, and the house's design refers to that of the Palazzo del Te.

Yet Leoni's house differs significantly from those of his artistic predecessors. First, the Casa degli Omenoni contains no working spaces and did not serve as his studio, which better camouflaged his artistic profession. Leoni kept his foundry and workshop separate from this property. Second, Leoni was the first artist who, because of the nobility and wealth he achieved, was able to commission an artist to execute the project, as other noblemen did.[10] Third, Leoni's house differed from those of other artists in that its architecture is dominated by expensive sculptural decoration. By contrast, the façades of most artists' homes were decorated with inexpensive frescoes, and even Giulio Romano's home had only a modest sculpted frieze and a single statue. Even in the illustrious neighborhood where it was located, the ornamentation of Casa degli Omenoni stood out dramatically, for in Milan most palace façades had little ornament.[11] Finally, the Casa was located in a very prestigious part of town, only steps away from the cathedral, the imperial church of S. Maria della Scala, and the church of S. Martino in Nosiggia.[12] Among Leoni's important neighbors were Count Francesco Secchi, the Medici of Marignano (one of whom became Pope Pius IV), the Genoese merchant Tommaso Marini, and the illustrious Moroni family.[13]

Charles V granted Leoni the property for his home in 1549; in the next few years the artist received imperial and ducal funding to cover building expenses.[14] But when these monies ended, Leoni continued work on the house until about 1565, almost exclusively at his own expense. When Leoni first received the property, he was only beginning to achieve the social stature and fame to which he aspired, and he probably did not have the economic means to pursue such an elaborate project. But while the house was under construction, Leoni became a member of an academy, was knighted, and was granted annuities for his "virtue."[15] He also obtained the rank of nobility in his native Arezzo, where he was named to two government posts, and began to function in some sort of diplomatic capacity in Milan. His artistic success flourished alongside. As a successful sculptor, he could demand very high prices for his works. By 1573, Leoni had accrued sufficient wealth to buy an additional house to serve as his workshop. As his fame, wealth, and status increased, Leoni enlarged the house and made important additions to its decoration. Leoni's prestige was reflected in the renaming of his street from the "contrada Moroni" to the "contrada Aretino," in recognition of his birth in Arezzo, and eventually to the "contrada degli Omenoni."[16] The change from a name that honored a well-established family to one that honored the house of a sculptor is remark-

able. It attests not merely to Leoni's social status but also to the public acclaim for the house he produced.

The grandeur of Leoni's home and its decoration enhanced his status in Milan. It announced his nobility, as it was designed as an aristocratic palace, and offered the traditional aristocratic signals of prestige, power, and magnificence. To reinforce his noble image, Leoni deployed his considerable wealth to create a collection of art that rivaled in size and quality even the most impressive noble collections.[17] His artistic sensibilities gave him an edge as a collector, since mere wealth could not assemble a collection of such quality, a collection that served as an integral part of the design of the house. Leoni lined the courtyard with the most impressive array of plaster casts assembled anywhere in Europe in the sixteenth century.[18] The interior corridors and highly innovative octagonal study were decorated with paintings by Parmigianino, Correggio, Tintoretto, and Titian, as well as antiquities and Leoni's own sculptures. In addition, he may have acquired the majority of Leonardo da Vinci's surviving notebooks.[19]

Signposting in the Casa degli Omenoni

Leoni's home makes repeated references to ancient and modern Rome. The octagonal study was inspired by Roman examples; its oculus and dome derived from the Pantheon, and the shape recalls the octagon in Bramante's famous Belvedere Courtyard in the Vatican.[20] The house also displayed his extensive collection of Roman sculptures. In 1549, Leoni had acquired casts of ancient sculptures, and offered to cast bronzes from them for the Gualtiera, the residence of Ferrante Gonzaga, who was then governor of Milan. Leoni suggested that "with little expense we can make a Rome at the Gualtiera."[21] However, the bronze sculptures were never made; the casts remained in Leoni's collection, and decorated the courtyard and studio along with Leoni's other casts and originals. Instead of "a Rome at the Gualtiera," Leoni created a new Rome in his personal residence in the center of Milan. Leoni's fellow academician Francesco Ciceri even wrote a fictive dialogue in which Michelangelo Buonarroti scolds Leoni for robbing Rome of all its antiquities in order to decorate his house magnificently.[22]

The "Rome" theme continues throughout the house in references to the ancient Roman emperor Marcus Aurelius. Vasari recorded that Leoni dedicated his house to Marcus Aurelius, and much of the decoration refers to this emperor. Leoni placed a full-size cast of the Marcus Aurelius equestrian statue in the center of the courtyard; thus passersby could view it through the archway portal. The statue was framed by the terminal figures on the façade, which represent tribes conquered by Marcus Aurelius, each identified by an

inscription on the column capitals. Charles V claimed to be a descendant of Marcus Aurelius, and this idea was repeatedly emphasized in both literary and visual forms produced under the emperor's aegis. Leoni embraced this connection in the design of his house through the references to Marcus Aurelius and in the frieze on the façade, where eagles from the Hapsburg heraldry and Leoni's own coat of arms (lions and wheels), which was granted to him by the emperor, are positioned side by side. With these references to Marcus Aurelius and the Hapsburgs, Leoni informed viewers that his house was a gift from Charles V, and that he enjoyed a privileged relationship with the Hapsburg family. These messages would have been well understood in Milan, then one of the Spanish crown's principal seats of government in Italy.

The equestrian monument in the courtyard particularly enhanced this theme in the house's program since it directly referred to the historical center of Roman government, the Capitoline Hill in Rome. In 1536 Michelangelo began an extensive urban renovation project of the Capitoline Hill and supervised the transport of the Marcus Aurelius monument (fig. 7.2) to that site from the front of the church of St. John the Lateran, where it had stood since at least the eighth century. Michelangelo's design for the piazza and the placement of the statue at its center has been interpreted as symbolizing the "umbilicus mundi," the center of the world.[23] In a symbolic sense, by placing the cast of the monument in the center of his courtyard, Leoni moved the "umbilicus mundi" from the Capitoline Hill to his home. This also reinforced Milan's lofty position in the dominion of the Hapsburgs, intimating that the Hapsburgs' Holy Roman Empire superseded its predecessor in the ancient world, and underscored Leoni's relationship with the imperial family and his position in Milan.

Leoni's home can be understood as part of the movement in which Italian men in the service of the Hapsburgs employed various metaphorical and allegorical allusions to advertise their relationship with the ruling family. William Eisler discussed how Federico Gonzaga in Mantua, Andrea Doria in Genoa, and Bernardo Clesio in Trent expressed their relationship with Charles in the decorations of their residences.[24] Permanent expressions of affiliations with political leaders can be dangerous when authorities have a tenuous hold on office. Because of the instability of the political situation at the time, the local leaders were somewhat reluctant to make overly explicit references to Charles V. They often chose the ephemeral (and less expensive) medium of painting for decoration laden with political meaning. Leoni had the luxury of a more stable regime, because the Spanish Hapsburg control over Milan was by then solidified. Thus, he was freer to display his relationship with the Hapsburgs through overt references to Marcus Aurelius and the imperial coat of arms in the longer-lasting (and much more expensive) medium of sculpture. Leoni's design wisely publicized his long-standing service and continued loyalty to the Hapsburgs. In fact, the Hapsburgs maintained control over Milan until the nineteenth century.

Opposite page:
Fig. 7.2.
Roman, Marcus Aurelius, Capitoline Hill, Rome (Archivi Alinari, Florence)

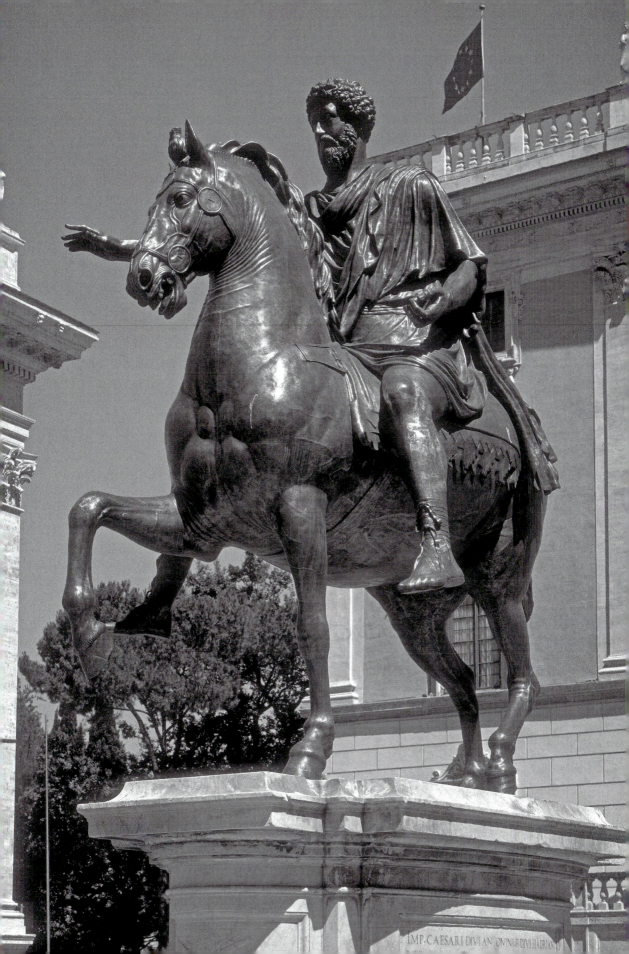

The Roman theme also effectively signaled Leoni's erudition and philosophical interests. The dedication and decorations that refer to Marcus Aurelius simultaneously allude to Stoic thought, as the Roman emperor had been its greatest proponent in the ancient world. Interest in Stoic thought was widespread throughout Europe in the sixteenth and seventeenth centuries. Erasmus of Rotterdam was its modern advocate. Charles V was well versed in Stoic thought, and Erasmus encouraged him to choose Marcus Aurelius as his model for this reason. The court historian to Charles, Fray Antonio de Guevara, published widely read texts on Marcus Aurelius and Stoic philosophy.[25] At the end of the sixteenth and beginning of the seventeenth century, Justus Lipsius's texts on Stoicism made the philosophy even more popular. The repeated references to Stoic tenets throughout Leoni's house and in his sculptures, and his friendships with scholars interested in Stoicism, suggest that he wished to make public his philosophical knowledge and connections.[26] Moreover, the Stoic desire for social order, which emphasized the importance of the aristocracy and a single sovereign, was an attractive theme given Leoni's rank of nobility. In sum, Leoni's interest in Stoicism further identified him as an erudite and important member of the court.

The terminal figures, or terms, on the façade play an integral part in the Stoic program. Their form alludes to Terminus, the god of boundaries, who refused to move from the Capitoline Hill to accommodate a temple of Jupiter.[27] The figure of Terminus came to embody the principal tenet of Stoic doctrine: a refusal to react to the passions, and immobility in the face of earthly concerns. This state of psychological fortitude went hand in hand with attainment of a superior level of virtue. Because of the meaning embodied in the figure of Terminus, Erasmus made it his personal symbol. Leoni would have been familiar with Terminus' meanings, and he designed the terminal figures on the façade so that they pushed away from the wall surface, emphasizing their lack of structural function and calling attention to their form as terms. By doing so, he made their reference to Terminus clear.[28]

Stoic themes also appear in the frieze (fig. 7.3), where lions (representing Virtue) conquer a satyr (representing Vice). The lions with their paws on wheels, which come from Leoni's coat of arms, signify Virtue controlling the whims of Fortune. Stoicism claimed that the achievement of Virtue allowed one to control and to benefit from Fortune. These concepts are continued in three of the metopes of the courtyard. One metope employs the motif of a lion with his paws on a wheel, as in the frieze on the façade. Other metopes are based on emblems found in Andrea Alciati's *Emblemata Liber* (1531) and its subsequent editions.[29] For example, one relates directly to the emblem "Fortune accompanied by Virtue."[30] There, as in Alciati's image, the caduceus is intertwined with a cornucopia (fig. 7.4, right side). However, in the metope, the figure of Pegasus replaces the image of Mercury's cap as it appears in Alciati's emblem. The accompanying text with Alciati's emblem explains that

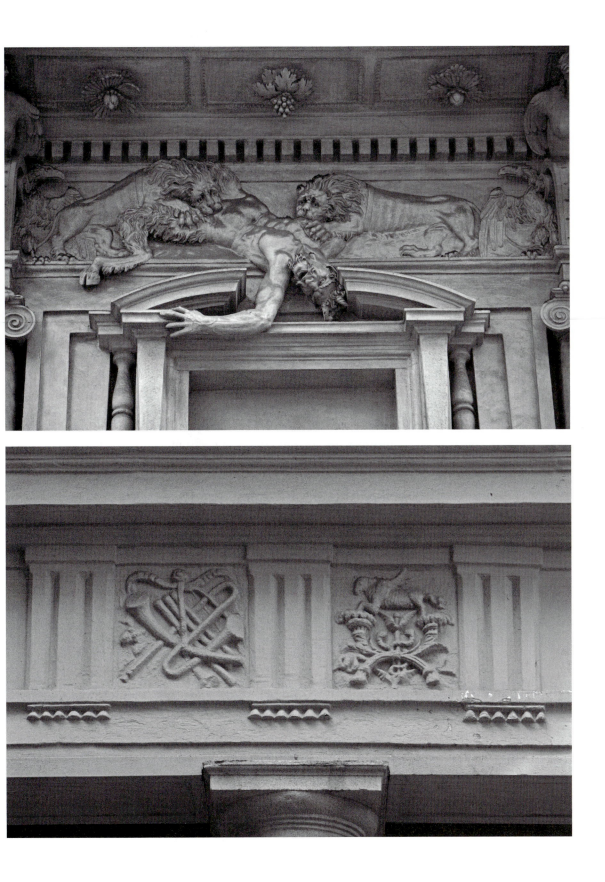

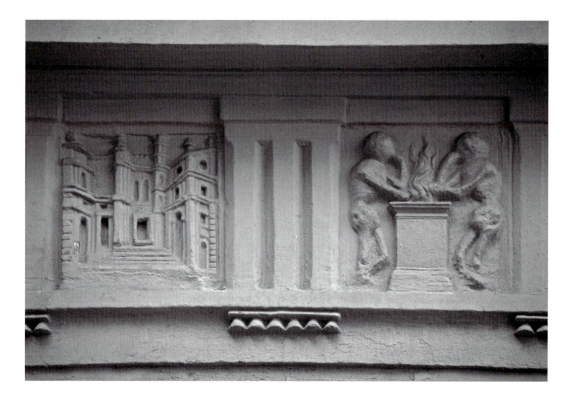

only wisdom ensures good fortune. In the metope, Pegasus symbolizes the eternal fame gained in a life guided by wisdom and good fortune.

Alciati's emblem of "Vigilance," which portrays an architectural setting with a lion in the foreground, inspired another metope. In the publication, the inscription explains that the lion is the most diligent guard.[31] In Leoni's metope (fig. 7.5, left side), however, no lion appears in the foreground. The lion's presence there is elliptical: the owner of the house, Leoni, was himself a "lion." Thus the metope signposts Leoni's vigilance, and again displays his interest in Stoicism. The Stoics promoted the idea that man should always be aware of his own weaknesses, which could destroy his ideal state of temperance. Finally, in another metope (fig. 7.5, right side), two figures clasp their hands over a phoenix rising from a flaming altar. The phoenix likely alludes to Leoni's membership in the Accademia dei Fenici (the Academy of the Phoenixes). The flaming altar represents an oracle (symbolic of wisdom), and the two figures represent the exchange of wisdom that takes place in an academy, thereby representing the Stoic tenet that Virtue could only be obtained through wisdom.

In Leoni's façade, his imperial associations and scholarly pursuits were advertised, while in a deft act of signposting he omitted overt references to his profession.[32] It was only inside the courtyard, out of view to passersby but available to his more knowledgeable guests, that specific references to his profession were visible. Casts of his own sculptures lined the courtyard, alongside his collection of ancient and modern sculptures. Moreover, in addition to the

metopes that displayed his interest in Stoicism, there are other metopes around the courtyard that contain implements used in the work of goldsmiths, sculptors, and architects, no doubt referencing the three areas of Leoni's expertise. Only in the interior of his house was Leoni forthright about how he had gained his position: through artistic prowess and erudition.

However, Leoni risked criticism from his contemporaries—that is, he risked negative reception costs—by displaying his social status and political associations so audaciously. Such boldness was especially dangerous given the divisive climate of late sixteenth-century Milan. During this period, there were disputes over who justifiably had authority over the city: the secular rule of the Hapsburgs or the rule of the Church, which was then enforced severely by Archbishop Carlo Borromeo. Moreover, some viewers might have questioned Leoni's real authority in announcing his ties to the Hapsburgs, and wondered if he was exaggerating or "stretching" his claims.

Leoni's design must have been well known to members of the Hapsburg courts, even as the house was being built. In 1561, his friend and fellow academician Luca Contile sent a letter to Cardinal Granvelle, Philip II's counselor, in which he included an engraving of Leoni's plan for the house.[33] Leoni clearly wished to make public his plans for the house and may have circulated the engraving elsewhere. In this way the design could be seen and admired by others and, consequently, convey the messages Leoni wished to communicate to a broader public. By sending the print to Granvelle, Leoni was also able to test whether or not his design would be acceptable to the court. There is no indication that anyone objected to the messages conveyed by the façade's design.[34]

Leoni, perhaps blessed with keen political judgment, accepted a risk by shooting high, and he got away with it. The Hapsburgs continued to commission sculptures from him, and he was given yet another honor: the right to be buried in the imperial church in Milan, Santa Maria della Scala. Charles V officially named this his imperial chapel in 1545; the restructuring and redecorating lasted from 1546 to 1560. A document dated March 1622 records that right to burial there was granted only to the "most worthy families."[35] In his will, Leoni instructed that his children and heirs make a tomb monument for him in Sta. Maria della Scala. He left 150 gold scudi for its execution and for the perpetual celebration of mass in his chapel three times a day. Though previous scholars have doubted whether Leoni's tomb was ever completed, documents in the Archivio Diocesano in Milan confirm its existence. Leoni's chapel gives further testament to his remarkable career and social position.

As Leoni intended, his house sent a strong signal: it proved his social status. Vasari's and Lomazzo's descriptions of the house make this clear. A letter from the agent of the Duke of Mantua in Milan to Guglielmo Gonzaga's secretary provides an unusually clear example of how signposting can lead not only to an increase in status but even to financial gain. The agent responded to con-

cerns about whether Leoni could be trusted with the large amount of silver required for a commission. He wrote, "Sir Leoni . . . is doing very well and you can, in my humble opinion, believe that he will not defraud us because he has a very beautiful house that he built a few years ago. It is a very richly decorated house, with horses and servants and other things that one cannot maintain without money."[36]

The Casa degli Omenoni immediately became a landmark in Milan. When the first Japanese delegation visited Italy in 1585, they visited Leoni's house and foundry.[37] Andrea Palladio, who saw the Casa degli Omenoni in 1566, praised the design in his *Four Books on Architecture* (1570); this established the canon of major buildings in Italy, and described Leoni as an architect who followed Bramante's lead in designing beautiful buildings.[38] Carlo Torre's guide of 1674 provides a rather detailed description of the façade, and of the courtyard and its sculptures. He wrote, "this Leoni, truly like a lion, I mean to say King of the Virtuosi, in his day, did not plan to build a house but a royal palace."[39] Thus, even a century after Leoni built his house, the meanings of the messages he wished to send through its design and decoration were still successfully conveyed.

To sum up, the Casa degli Omenoni superseded all previous artists' homes. It was recognized as the palace of an important member of the court of Charles V. Its expensive architectural sculpture and large and prestigious art collection were without equal among artists' homes or, for that matter, among most aristocratic palaces until at least the mid-seventeenth century. This glorious house conveyed much more than the owner's wealth. The complex iconographical program of the Casa degli Omenoni manifested Leoni's erudition and interest in Stoic thought; it displayed his diplomatic role in Milan; and, like the houses of other important men in the imperial court, it served to reiterate the power of the Hapsburg dominion. Leoni planned the design of his house to effectively announce his social status, and correctly anticipated that it would be a long-lasting monument to his fame, erudition, and importance.

Notes

1. "Messer Leone . . . ci ha fatto e fa cose che se Michelangelo resuscitassi e vedessi come si vive diria che l'arte che l'ha fatto tenersi raro fussi diventata un'altra, perché nel vero questi maestri non sono più filosofi ma principi." Letter dated May 9, 1566, in Karl Frey and Herman-Walther Frey, *Der literarische Nachlass Giorgio Vasaris* (Munich: Georg Müller, 1930), 2:239.

2. Giorgio Vasari, *Lives of the Painters, Sculptors and Architects*, trans. Gaston du C. de Vere, ed. David Ekserdijan (London: Everyman's Library, 1996), 2:840.

3. For the struggle for higher social status in Italy see, among others, Martin Wackernagel, *The World of the Florentine Renaissance Artist*, ed. and trans. Alison

Luchs (Princeton: Princeton University Press, 1981); Janet Woods-Marsden, *Renaissance Self-Portraiture: The Visual Construction of Identity and the Social Status of the Artist* (New Haven and London: Yale University Press, 1998); and Francis Ames-Lewis, *The Intellectual Life of the Early Renaissance Artist* (New Haven and London: Yale University Press, 2000).

4. In addition to Leoni, Michelangelo and Titian were among the very few artists to accumulate wealth. For the financial position of artists during this period, see Rab Hatfield, *The Wealth of Michelangelo* (Rome: Edizioni di storia e letteratura, 2002), with bibliography. For artists knighted during the sixteenth century, including Baccio Bandinelli, Benvenuto Cellini, Titian, Vasari, and Federico Zuccari, see Martin Warnke, *The Court Artist: On the Ancestry of the Modern Artist,* trans. David McLintock (Cambridge: Cambridge University Press, 1993).

5. For artists' houses in the sixteenth century see *Case d'artista. Dal rinascimento ad oggi*, ed. Eduard Hüttinger (Turin: Bollati Beringhieri, 1992); Nikia Leopold, "Artists' Homes in the Sixteenth Century" (Ph.D. diss., Johns Hopkins University, 1980); and *Case di artisti in Toscana*, ed. Roberto Paolo Ciardi (Florence: Banca Toscana, 1998). For fifteenth- and sixteenth-century artists' tombs see Gesa Schütz-Rautenberg, *Künstlergrabmäler des 15. und 16. Jahrhunderts in Italien: ein Beitrag zur Sozialgeschichte der Künstler* (Cologne: Böhlau, 1978).

6. For Leone Leoni see Eugene Plon, *Les maîtres italiens au service de la maison d'Autriche: Leone Leoni sculpteur de Charles Quint et Pompeo Leoni sculpteur de Philippe II* (Paris: E. Plon, Nourrit, 1887); Michael Mezzatesta, "Imperial Themes in the Sculpture of Leone Leoni" (Ph.D. diss., New York University, 1980); *Leone Leoni tra Lombardia e Spagna. Atti del convegno internazionale. Menaggio 25–26 settembre 1993,* ed. Maria Luisa Gatti Perer (Milan: Istituto per la storia dell'arte lombarda, 1995); *Los Leoni (1509–1608): Escultores del rinacimiento italiano al servicio de la corte de España*, ed. Jesús Urrea (Madrid: Museo del Prado, 1994); Kelley Helmstutler, "'To Demonstrate the Greatness of His Spirit': Leone Leoni and the Casa degli Omenoni" (Ph.D. diss., Rutgers University, 2000); and Kelley Helmstutler Di Dio, *Leone Leoni and the Status of the Artist at the End of the Renaissance* (Aldershot, UK: Ashgate, forthcoming).

7. In 1556 250 scudi were worth 271.4 florins. Leoni received 250 scudi while Titian was granted 200 scudi, their yearly stipends as Charles V's artists. Around this time in Milan, with 250 scudi an aristocratic residence could be rented for five years, a small house in one of the working-class neighborhoods could be purchased, or around twelve *pertiche* (1 *pertica* was equal to 654.51 square meters) of good land in the countryside could be bought. In terms of wages, 250 scudi was the annual income of a prosperous master craftsman or a small merchant or five years of wages for a simple journeyman in the urban crafts. My thanks to Susanne Kubersky Piredda and Stefano D'Amico for this information.

8. For Leoni's house, see Ugo Nebbia, *La Casa degli Omenoni in Milano* (Milan, Ceschina, 1963); Mezzatesta, "Imperial Themes"; Michael Mezzatesta, "The Facade of Leone Leoni's House in Milan, the Casa degli Omenoni: The Artist and the Public," *Journal of the Society of Architectural Historians* 44, no. 44 (October 1985): 233–49; Marco Rossi, "La casa di Leone Leoni a Milano," in *Leone Leoni tra Lombardia e Spagna*, 21–30; and Helmstutler, "To Demonstrate," 107–77.

9. For Mantegna's house, which Ludovico Gonzaga gave to him in 1476, see Earl E. Rosenthal, "The House of Andrea Mantegna in Mantua," *Gazette des Beaux-Arts* 60, no. 6 (September 1962): 327–48, and Ronald Lightbown, *Mantegna* (Oxford: Phaidon, 1986), 121–22. Raphael's house was designed by Bramante, possibly for himself, around 1512. For Giulio Romano's house, which he bought and designed for himself, see Kurt Forster and Richard Tuttle, "The Casa Pippi," *Architectura* 3, no. 2 (1973): 104–30; Leopold, "Artists' Homes," 89–108; and Liselotte Wirth, "Le case di Raffaello a Roma e di Giulio Romano a Roma e a Mantova," in *Case d'artista*, 49–60. For Vasari's house in Arezzo (1540–48), see Leopold, "Artists' Homes," 125–57; Antonio Paolucci and Anna Maria Maetzke, *La casa del Vasari in Arezzo* (Florence: Casa di Risparmio di Firenze, 1988).

10. Gian Paolo Lomazzo identified Antonio Ascona as the sculptor of Leoni's façade; see Gian Paolo Lomazzo, *Scritti sulle arti*, ed. Roberto Paolo Ciardi (Florence: Marchi e Bertolli, 1973), 2:361. Carlo Torre, *Il ritratto di Milano* (Milan: Agnelli, 1674), 292, reported that "all of the talented people who worked in Milan in [Leoni's] time, whether excellent in painting or sculpture, competed with each other to serve such an esteemed virtuoso . . . Antonio Abbondio called 'Ascona,' the famous carver dear to King Francis of France . . . made the eight colossi [on the façade of Leoni's house]." Antonio Abbondio was primarily a medalist but also the sculptor to the Holy Roman Emperors Ferdinand II (1565–66), Maximilian I (1566–c. 1574), and Rudolf II (c. 1577).

11. A few other buildings begun during this period are more decorative than what had been commonplace in Milan. In particular, the architecture of Galeazzo Alessi (especially the courtyard of Palazzo Marino, c. 1553–58, which Leoni may have helped decorate) and of Vincenzo Seregni (especially the Palazzo Giureconsulti, 1561, and his designs for the Palazzo Medici, c. 1565) are ornate.

12. The church of San Felice was built while Leoni was constructing his home. Leoni's house, San Felice, and Palazzo Marino were part of Milan's urban renewal initiated in 1541 by Charles V's Nuove Costituzioni. The Nuove Costituzioni aided residents financially in the reconstruction of their homes and the overall beautification of the city. See Rossi, "La casa di Leone Leoni a Milano," 21.

13. They are listed in Milan, Archivio Diocesano (henceforth MAD), "Entrate di S. Martino in Nosiggia, 1567."

14. In 1550, Leoni was given 393 lire imperiali "for the expenditures in the houses adjoining the one that formerly belonged to Messer Jacopo Antonio da Prato." Four months later, Leoni was given 530 lire imperiali to construct a small house beside the piazza of S. Martino in Nosiggia. Five months later, he received forty-five scudi for costs associated with his house and foundry. For these documents see Paola Barbara Conti, "Vita milanese di Leone Leoni da documenti inediti," in *Leone Leoni tra Lombardia e Spagna*, 43–44 docs. 2, 3, and 4.

15. Warnke, *Court Artist*, 135.

16. The "contrada Moroni" may refer to the Moroni family, which included Giovanni Moroni (1509–80), who was a cardinal and friend of Gian Giacomo de' Medici and of Pope Pius IV. He was the last president of the Council of Trent and an effective diplomat. His father, Count Girolamo Moroni, was chancellor of Milan during the last years of the Sforza dukedom. He was disgraced after attempting to form an

alliance between the forces of the Marquis of Pescara, France, and Milan against the forces of Charles V. Torre explained that the change of the street name indicated that the citizens wished to "announce the Aretine's fame . . . by calling the street the contrada Aretina." Torre, *Il ritratto di Milano*, 292. The exact date of this name change (or whether it was ever made official) is unknown. Vasari stated that the house was located on the "contrada de' Moroni" in his second edition (1568) of the *Lives*, 2:840. The street name was changed by 1738 to the Contrada degli Omenoni, in reference to the figures on Leoni's façade, according to Lattuada, *Descrizione di Milano* (1738), 443–44.

17. For Leoni's collection see Mezzatesta, "Imperial Themes"; Leopold, "Artists' Homes"; Maria Tronca, "La collezione di Leone Leoni e le sue implicazioni culturali," in *Leone Leoni tra Lombardia e Spagna*, 31–38; Kelley Helmstutler Di Dio, "Leone Leoni's Collection in the Casa degli Omenoni, Milan: The Inventory of 1609," *Burlington Magazine* 145, no. 1205 (2003): 572–78.

18. See Francis Haskell and Nicolas Penny, *Taste and the Antique: The Lure of Classical Sculpture, 1500-1900* (New Haven: Yale University Press, 1981), 5–6, 16–17, and Bruce Boucher, "Leone Leoni and Primaticcio's Moulds of Antique Sculpture," *Burlington Magazine* 122, no. 934 (January 1981): 23–26.

19. Leoni may have owned the Codex Atlanticus (Biblioteca Ambrosiana, Milan), the Windsor Codex (Windsor Castle), the libretti in the Institut de France, Paris, and the Leonardo manuscripts now in the Biblioteca Nacional, Madrid. They appear in the subsequent inventories of his son Pompeo's collection in Madrid and later inventories and other documents related to the collection at the Casa degli Omenoni. It is not possible to ascertain whether it was Leone or his son who acquired them. For Pompeo's collection, including inventories and sales documents, see Kelley Helmstutler Di Dio, "The Chief and Perhaps Only Antiquarian in Spain: Pompeo Leoni and His Collection in Madrid," *Journal of the History of Collections* 18, no. 2 (2006), 137–67.

20. Another source for his design was the studio in the villa of Marcus Terentius Varro (c. 116–27 BC) at Cassino. See Helmstutler Di Dio, "Leoni's Collection," 574.

21. Amadio Ronchini, "Leone Leoni d'Arezzo," *Atti e memorie della R.R. Deputazione di storia patria per le provincie modenesi e parmensi* 3 (1865): 26–27, vi.

22. It reads, in part, "Tu eniem Roman ipsam in tuam ipsius patriam anelis: significans opera summorum artificum quamplurima quibus Roman spoliavit Arretinus, et aedes suas exornavit, Mediolani magnifice extructas, doctissimo atque elegantissimo cuique patentas." The text was published in Emilio Motta, "Giacomo Jonghelinck e Leone Leoni in Milano," *Rivista italiana di numismatica* 1, no. 21 (1908): 79–82.

23. James Ackerman, *The Architecture of Michelangelo*, 2nd rev. ed. (Chicago: University of Chicago Press, 1986), 166–70. When Paul III decided to renovate the Capitoline Hill, after Charles V's entry into the city in 1536, he had Michelangelo move the Marcus Aurelius equestrian statue there from the Lateran.

24. See William Eisler, "The Impact of the Emperor Charles V upon the Visual Arts" (Ph.D. diss., Pennsylvania State University, 1983), and William Eisler, "Patronage and Diplomacy: The North Italian Residences of the Emperor Charles V," in *Patronage, Art and Society in Renaissance Italy*, ed. F. W. Kent and Patricia Simons (Canberra: Oxford University Press, 1987), 269–82.

25. See Michael Mezzatesta, "Marcus Aurelius, Fray Antonio de Guevara, and the Ideal of the Perfect Prince in the Sixteenth Century," *Art Bulletin* 66, no. 4 (1984): 620–33.

26. Leoni was friends with Agnolo Doni and Cardinal Granvelle, and probably knew Justus Lipsius personally. His son Pompeo's book collection in Madrid (much of which was formed from Leoni's collection) included numerous texts by Erasmus, Justus Lipsius, Cicero, and Plutarch, as well as Ovid's *Fasti* and the writings of Dionysius of Halicarnassus, where the significance of the god Terminus is explained. Natividad Sánchez Esteban, "El legado de Pompeo Leoni," in *Leone Leoni tra Lombardia e Spagna*, 108–12.

27. Thus the terminal figures make another allusion to the Capitoline Hill, as the Marcus Aurelius monument did. For Terminus, terminal figures, and Erasmus see Edgar Wind, "Aenigma Termini," *Journal of the Warburg and Courtauld Institutes* 1, no. 1 (1937–38): 66–69; Erwin Panofsky, "Erasmus and the Visual Arts," *Journal of the Warburg and Courtauld Institutes* 32 (1969): 200–227; James McConica, "The Riddle of Terminus," *Erasmus in English* 2 (1971): 2–7; and John Rowlands, "Terminus: The Device of Erasmus of Rotterdam; A Painting by Holbein," *Bulletin of the Cleveland Museum of Art* 67, no. 2 (February 1980): 50–54.

28. In this regard, they resemble more closely Terminus in Holbein's 1535 portrait of Erasmus and Alciati's Terminus emblem than the figures of Vitruvius' Persian Portico, which has previously been cited as Leoni's source. See Mezzatesta, "Imperial Themes"; and Mezzatesta, "The Facade," 233–49.

29. Andrea Alciati (1492–1550) was a Milanese jurist who was famed for his legal texts and his entertaining and instructive emblem books. The emblems were combinations of text and image that usually had a moral lesson as the subtext. Alciati's emblems became internationally renowned after the publication of his *Emblemata Liber* in 1531. There were 171 editions between 1531 and the end of the seventeenth century.

30. *Diverse imprese accommodate a diuerse moralità: con versi che i loro significati dichiarano insieme con molte altre nella lingua Italiana non piu tradotte. Tratte dagli Emblemi dell'Alciato* (Lyon: Guglielmo Rovillio, 1551), emblem 119. The inscription reads: "Here between two entwined snakes, is the caduceus with wings, on either side of which there is a horn taken from the goat that was once Jupiter's, each one adorned with fruit. Thus the wise man inclined to eloquence has wealth that stays with him and where poverty surrounds many, he always enjoys [wealth] and is always well off." Peter Daly et al., *Andreas Alciatus: Emblems in Translation* (Toronto: University of Toronto Press, 1985), II, no. 119. Leopold, "Artists' Homes," 205, first recognized the emblem as Leoni's source for the metope. She deduced that the metope signified "the abundance (symbolized by the cornucopias) of Mercury's attributes—knowledge and skill, [which] results in the highest spiritual and artistic attainment [...] [and that] immortal fame (signified by Perseus) is the reward of one amply skilled in the arts."

31. The inscription reads: "In front of the entrance of the adorned temple there lies a lion so that thieves do not go in and attempt to steal. For it alone among the herd of animals sleeps with its eyes open." Daly, *Andreas Alciatus*, II, no. 15.

32. The position of the satyr in the center of the frieze recalls the position of two

conquered figures in Leoni's sculptures, *Charles V and Fury* (Madrid, Museo del Prado) and *Ferrante Gonzaga Conquering Vice* (Piazza Gonzaga, Guastalla). Leoni employed the same motif for himself on the façade with the satyr figure attacked by lions, which were an obvious reference to the artist's own name. However, *Charles V and Fury* was commissioned in 1549, was shipped from Leoni's studio to Brussels in 1556, and was completed in Spain by Leoni's son Pompeo in 1564. It remained in Pompeo's studio in Madrid until after his death in 1608 and would thus have had a very limited audience before that date. *Ferrante Gonzaga Conquering Vice* was commissioned after 1557 and was ready to be cast in 1565. The Gonzaga heirs' lack of financial support for the project resulted in long delays, and Pompeo completed the group only in 1594 (four years after Leoni's death). Therefore, while Leoni may have intended an allusion to these two sculptures in the sculpture of the frieze of his house, it is unlikely that this association would have been recognized by his contemporaries.

33. In his letter dated 18 June 1561, Luca Contile wrote, "la nuova architettura dello stesso cavaliero [Leoni] [. . .] per imprudentia degi stampatore, vi si trova qualche difetto, ne ci si può rimediare in tutto." Madrid, Biblioteca de Palacio Real, Correspondencia de Granvela, 2313, fol. 173. The engraving is lost, and its exact appearance is unknown.

34. The only recorded controversy surrounding Leoni's properties regards the parish priest of San Martino Nosiggia, who angrily complained to city and ecclesiastic officials about Leoni's foundry; see Conti, "Vita milanese," docs. 2, 3, and 4. Burgundio wished to construct a new baptistery in precisely the area where the foundry was located; see MAD, Visite pastorali e documenti aggiunti a S. Fedele, LII, 1570–76.

35. MAD, San Fedele, LXIV, f. 36. Also see a description of the church in Milan, Archivio di Stato, Fondo Religione, that notes "there are various burials of the noblest families"; Enrico Cattaneo, *Il coro ligneo di Sta. Maria della Scala in San Fedele* (Milan: Banca Lombarda di Depositi e Conti Correnti, 1980), 33.

36. Maria Giustina Grassi, "Le 'statue' di Leone Leoni per Santa Barbara a Mantova con una nota sul reliquiario di Sant'Adriano," *Arte Lombarda* 128, no. 1 (2000): 55–61.

37. Alessandro Valignano and Eduardo de Sande, *De missione legatorum Iapponensium ad Romanum curiam* (Macao: Society of Jesus, 1590).

38. Lionello Puppi, "Palladio e il 'Cavalier Lione,'" in *Leone Leoni tra Lombardia e Spagna*, 72–73.

39. "Questo Leoni veramente Leoni, cioé a dire Re di Virtuosi, ne' suoi giorni, non pensò di fabbricarsi una casa ma si bene una reggia." Torre, *Il ritratto di Milano*, 292.

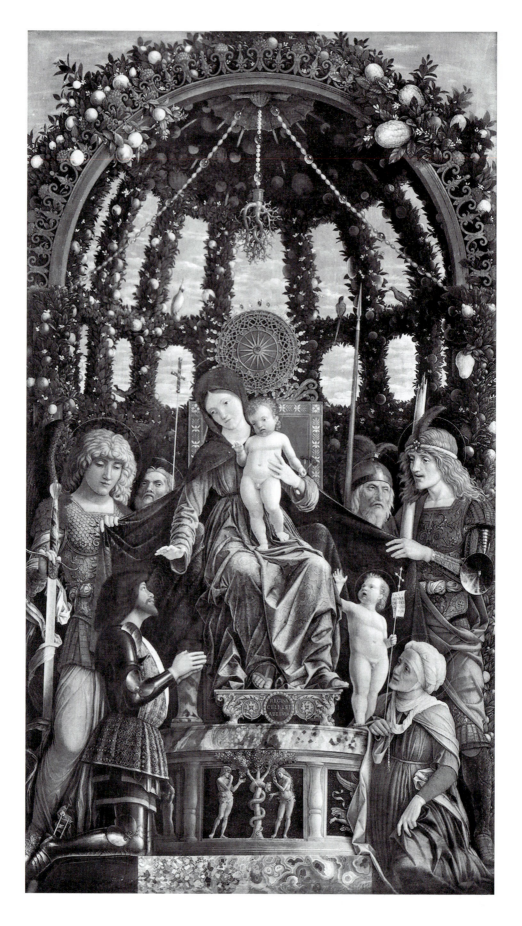

Molly Bourne

Introduction

ANDREA MANTEGNA'S famous altarpiece, the *Madonna della Vittoria* (fig. 8.1), shows Francesco Gonzaga, the Marquis of Mantua, piously kneeling in the position of a donor and giving thanks for his victory at the Battle of Fornovo in 1495. In reality, many of the marquis's contemporaries did not believe that he emerged victorious from this battle. Moreover, despite Francesco's prominence as the only portrait in the altarpiece, and the fact that he was its patron, he paid little or nothing for the work. This chapter shows how patrons can use art to transform viewers' perceptions of reality. It examines how Francesco Gonzaga employed art, architecture, and ceremony deliberately to stretch the truth in order to advance his status and authority as a ruler. The marquis's sincerity in offering gratitude to the Virgin for having spared his life should not be doubted. Likewise, although the information he provided about his "triumph" at Fornovo was exaggerated, it was plausible, and within his court few people probably knew all the facts.[1]

Descended from a long line of Gonzaga condottieri and a mercenary soldier by profession, Francesco II Gonzaga ruled Mantua as fourth marquis from 1484 until his death in 1519. His artistic patronage has long been overshadowed by that of his better-known consort Isabella d'Este, whose activities as patron and collector of paintings and antiquities have been studied extensively.[2] By contrast, Francesco is most remembered for his military accomplishments. During his career he commanded six major campaigns and was employed by European states including Venice, Milan, France, the Holy Roman Empire, and the Papal States.[3] At his death, the marquis's funerary catafalque was festooned with the battle standards of the powers he had served.[4] Paolo Giovio's 1554 treatise on military heroes has Francesco head the list of "famous warriors of our own times."[5] Such accolades were conspicuously absent during the first decade of his rule, when the inexperienced young marquis had yet to prove himself on the battlefield and his regime was plagued by political scandals and financial problems.[6]

The Battle of Fornovo in 1495 proved to be the pivotal moment in Francesco Gonzaga's early career, securing him fame and status as the self-proclaimed

Opposite page: FIG. 8.1. Mantegna, *Madonna della Vittoria*, Musée du Louvre, Paris (Archivi Alinari, Florence)

victor. Following this battle, Francesco, his consort, and his officials organized a multimedia campaign to effect a remarkable transformation in his public image, from that of a young and untested ruler to that of a valiant soldier, the "Liberator of Italy" from the French. Never before had the Gonzaga court engaged in such an elaborate display of self-glorification. Its centerpiece was the *Madonna della Vittoria* altarpiece, created by the Gonzaga's prestigious court artist, Mantegna. Most prior studies of this work have focused on its compositional innovations or on a fascinating anti-Semitic aspect of the painting's genesis.[7] What has not been noted, however, is how the altarpiece was deliberately used by Francesco Gonzaga to launch his career, even though the "victory" celebrated in this painting was, in fact, highly ambiguous. That it cost the marquis little or nothing to have the altarpiece produced was a beneficial extra. This chapter places the Mantegna altarpiece in the context of Francesco's campaign to build a reputation as an able soldier and ruler on the foundation of a victory that was ambiguous at best.

The Battle of Fornovo

In the fall of 1494, King Charles VIII of France invaded the Italian peninsula with a massive army to claim the Kingdom of Naples. As the king marched south, his troops occupied numerous cities and acquired valuable spoils of war. By the following spring, as the French began their journey homeward, the Italian forces had united to form a coalition whose primary goal was to defeat the invading armies during their northward passage. The twenty-eight-year-old Francesco Gonzaga was appointed governor-general of this coalition. (His request to receive the more lucrative and prestigious title of captain-general had been rejected given his inexperience.) A major confrontation was expected by June 11, when Francesco announced that "in the name of God and of Saint George" he was departing Mantua to fight the French.[8] Under his command the Italian forces were assembled south of Parma at Fornovo, where the battle took place along the banks of the Taro River on 6 July 1495.

According to numerous surviving accounts, the actual battle, though brief, was particularly violent and bloody. In the end, the Italians plundered much of the royal baggage train but suffered many more casualties, while the French lost their war spoils but broke through the Italian lines.[9] Who, then, was the victor? Florentine historian Francesco Guicciardini, in his *History of Italy*, states that "universal opinion awarded the palm of victory to the French."[10] The Bolognese jurist Floriano Dolfo, a close friend of the Gonzaga and thus surely not tipped against them, criticized Fornovo as "so much meat thrown to the slaughterhouse."[11] In his first private reports home to Mantua, even Francesco Gonzaga stressed the battle's great cruelty and lamented his loss of numerous men, marveling that he had been able to escape alive. Most sources, both

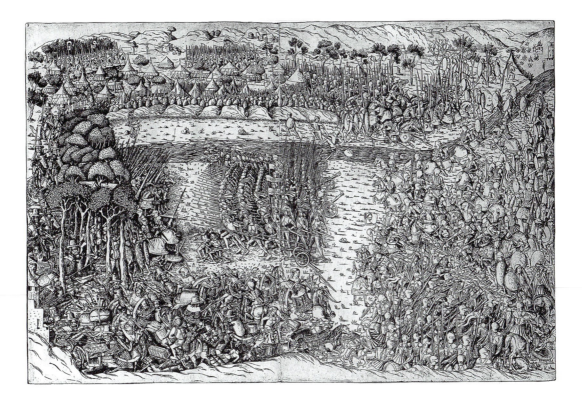

Italian and French, state clearly that the French won at Fornovo, a triumph celebrated in a rare engraving of the battle made shortly after the event by an anonymous French artist (fig. 8.2).[12] The conclusion of French victory is based on two factors: the Italians did not stop the northward march of the French, and the French sustained far fewer losses. The Italians, however, now possessed valuable French booty as proof of their victory, and sources on both sides agreed that Francesco Gonzaga had exhibited extraordinary courage on the battlefield.[13] Francesco, who stood to benefit enormously from a belief in Italian victory, quickly turned ambiguity into opportunity.

Immediately after the Battle of Fornovo, the marquis and his officials orchestrated a strategic program of commemorative medals, coins, literature, artistic monuments, and ceremonial ephemera designed to signpost his "victory" in the historical record. By selectively communicating honest and important information about the battle (such as Francesco's valor) while ignoring significant facts (such as the massive Italian casualties) and stretching others (such as Francesco's claim of victory), the marquis conveyed a convincing message with little risk that the whole truth would be revealed. Francesco and his officials evidently assessed the omission strategy as safe, since exposure was unlikely. After all, the corpse-strewn battlefield was a distant and alien concept to most Italians, especially the Mantuans, who yearned for news of victory and were receptive to a triumphal theme for their young ruler. Few would have been able to reveal what Francesco concealed, and his stretch of information.

Two bronze portrait medals were cast, one by Gonzaga court artist Sperandio (fig. 8.3) and another by Bartolomeo Talpa (fig. 8.4). Each depicts a profile bust of the marquis on the obverse, clad in armor and wearing a hat, and on the reverse one or more mounted warriors with a Latin inscription celebrating the "restored liberty of Italy."[14] True, Italy's liberty was restored, but the French army had successfully marched home. These medallic images, naturally durable, highly transportable, and produced in multiple copies, burnished Francesco's reputation as victor locally and also well beyond his dominions.

The information-stretching campaign employed both symbolism and simile. For example, when Francesco sent the broken lance he had used during the battle home to Mantua, his brother Sigismondo accorded it the importance of a religious relic. Comparing Francesco's lance to the lance of Longinus, a saint of local importance in Mantua, Sigismondo wrote that just as Longinus's lance had scattered blood for Christian redemption, so had Francesco nearly single-handedly "brought about the health and liberation of all Italy . . . freeing [her] from the siege of the barbarians."[15] Comments like this must have circulated in conversations at the Gonzaga court, as well as beyond the walls of the palace.

With local valor thus stretched to national victory, and actual defeat buried, it was time for soaring words. Rhetorical language, rich in figurative imagery but poor in hard facts, is hard to disprove. Such language appeared in reports sent by the Gonzaga chancery to other rulers, recounting how Francesco had valiantly expunged the French and restored liberty to Italy. Poetic tributes went further, and compared him to three classical heroes who drove away barbarians in order to save their people: Julius Caesar, Hector of Troy, and Alexander the Great.[16]

In addition to such words of praise, Francesco also used images to promote his own glory. To further establish his reputed triumph over the French, he dispatched court painter Francesco Bonsignori to Fornovo in October 1495 so that he could accurately depict the physical contours of the battlefield in a large-scale fresco that would celebrate the marquis's victory in the family's country palace at Gonzaga, south of the Po River.[17] Bonsignori's *Triumph at Fornovo* mural, now lost, was probably located in the "Hall of the Victories," an audience room decorated with scenes of the Gonzaga family's most important military victories.[18] Finally, at the end of July 1495 Francesco Gonzaga was triumphantly received in Venice and promoted to the coveted position of captain-general, while back in Mantua his consort Isabella ordered bells rung and bonfires lit for three evenings to recognize his newly elevated status.[19] In addition, a silver coin was struck to commemorate the marquis's new honor. Its obverse depicts Francesco in full military regalia atop a charging steed and is inscribed with his new title of captain-general, while its reverse displays an image of Mantua's most venerated relic: the Precious Blood of Christ.[20] These

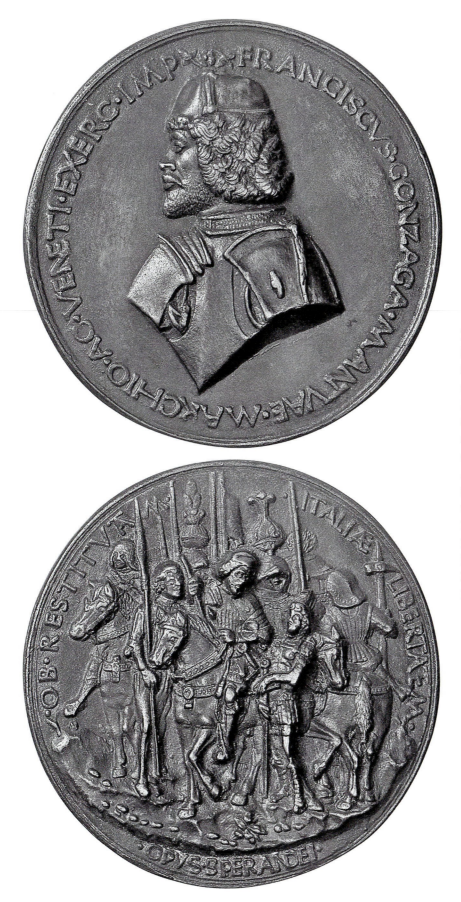

FIG. 8.3.
Sperandio
Savelli, *Medal
of Francesco
II Gonzaga*
(obverse and
reverse), Fon-
dazione Banca
Agricola Man-
tovana, Man-
tua (Museo
Numismatico
Fondazione
Banca Agrico-
la Mantovana,
Mantua)

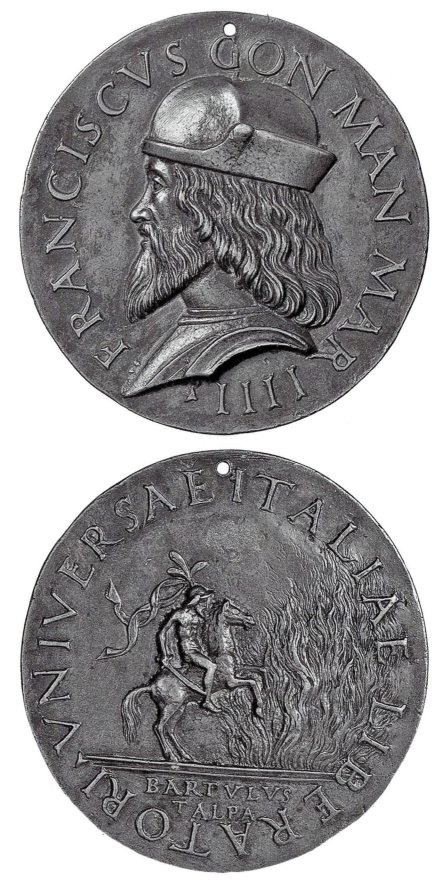

FIG. 8.4.
Bartolomeo
Talpa, *Medal
of Francesco
II Gonzaga*
(obverse and
reverse), Fon-
dazione Banca
Agricola Man-
tovana, Man-
tua (Museo
Numismatico
Fondazione
Banca Agrico-
la Mantovana,
Mantua)

two images effectively communicated Francesco's newly confirmed valor and piety on a single small coin that would carry the message across the Italian peninsula.

Thus, within one month of the battle Francesco Gonzaga had taken actions to claim victory, and a new rhetoric in praise of his triumph was on the lips of poets, courtiers, and other rulers. As we have seen, this led to one immediate and highly significant benefit: Francesco was appointed captain-general. At this point, he decided to commemorate the victory publicly in Mantua, and thus consolidate his position as head of state in the eyes of his own subjects. This objective was achieved in less than one year through the construction of the small church of Santa Maria della Vittoria, located in the center of Mantua, and the creation of its monumental altarpiece by Mantegna, now at the Louvre (fig. 8.1).[21]

Santa Maria della Vittoria and Mantegna's Altarpiece

Francesco's devotion to the Virgin was not unusual for a Renaissance prince.[22] Following his close brush with death at Fornovo, the marquis chose to display his gratitude by building Santa Maria della Vittoria in Mantua, where it would be seen by Francesco's subjects as well as by important visitors to the Gonzaga court. More than a century after the fact, the Mantuan ecclesiastical historian Ippolito Donesmondi gave an account of this church's beginnings that reads more like a chivalric fairy tale than a factual description:

> [At Fornovo, Francesco] penetrated so deeply into the enemy lines that finally [he] saw it would be humanly impossible to free himself from the barbarians. Thereupon offering himself with all his heart unto God and to the most glorious Virgin, he promised to build a temple in her honor if she freed him. No sooner had he made this promise than . . . he saw the enemy . . . turn and flee, leaving behind their tents and their baggage. . . . Returning to Mantua, and acknowledging this victory attributed to God and his Most Holy Mother, Francesco built the church of the Madonna della Vittoria . . . and Andrea Mantegna painted the altarpiece for the main altar, which is still there today and includes a portrait of the marquis, who inside the church hung up the armor he had worn on the day of the battle, as a sign of humble reverence.[23]

For Donesmondi, writing his history between 1613 and 1616, Francesco Gonzaga's creation of this monument was the direct result of his vow to the Virgin and was designed to honor her alone. The surviving documentation, however, presents a more complicated and less salutary story. The marquis capitalized on local anti-Semitic sentiments to extort financing for Mantegna's altarpiece from a wealthy Jew, hence commissioning it at virtually no cost to himself.[24]

In addition, the modestly sized brick church of Santa Maria della Vittoria was almost certainly constructed by court builders who were already on the Gonzaga payroll, thus reducing the incremental cost.[25] Francesco ensured that the monument advanced his own status as much as that of the Virgin to whom it was dedicated. Moreover, on account of continuing military obligations, he left the execution of this project almost entirely in the hands of family members and court officials back in Mantua.[26] Though he invested little of his own time in the project, he still reaped the full benefits from its resulting message.

The prominent Jewish banker Daniele Norsa was the unfortunate victim. In 1493 he purchased a house in Mantua that bore a fresco of the Virgin and saints on its exterior. Before removing this image, he was careful to obtain—and pay for—necessary permission from church authorities. Two years later, despite these precautions, local Christian zealots painted new images of saints with inflammatory inscriptions on his house, and when a religious procession passed by the site, angry participants accused the Jew of blasphemy and all but sacked his home. Norsa sought assistance from Francesco Gonzaga, who normally supported the Jews in his dominions because he benefited from their money-lending activities. In this case, however, the marquis chose, quite literally, to build on growing anti-Semitic popular opinion. Norsa's appeal had the further misfortune of coming just prior to Francesco's participation in the Battle of Fornovo, where Franceso's self-styled triumph was directly attributed to the Virgin's intervention. Consequently, Norsa's removal of her image from his home was interpreted as a direct insult to the Madonna that required immediate redress.

As the post-Fornovo propaganda campaign escalated, Norsa was forced to pay 110 gold ducats for Mantegna's altarpiece or risk punishment by death, his home was demolished, and the new Christian shrine was erected on the site.[27] By drawing an explicit parallel between the Jew and the "barbarians" that had been vanquished at Fornovo, the cash-strapped marquis was able to assert his power, make indirect and overstated claims about his assets, and reiterate his military success. Simultaneously, he was supporting a high-profile project that advanced his status as a pious and victorious ruler yet required virtually no outlay of Gonzaga cash. For the period, 110 ducats was a typical sum for a large altarpiece like the *Madonna della Vittoria*, a work executed on canvas and measuring 2.80 by 1.66 meters.[28]

Documents indicate that Norsa's 110 ducats were paid to Mantegna in two installments, the first immediately and the second as soon as Mantegna began work.[29] It should be noted that Mantegna received these monies over and above his handsome annual salary of 180 ducats, evidence of the prestige he had attained as artist to the Gonzaga court.[30] By comparison, in 1495 the less-important Gonzaga court painter Pietro Antonio da Crema received an annual salary of 72 ducats a year, while Francesco Gonzaga's chancery secretary Jacopo Probo d'Atri, who accompanied the marquis on campaign, received 84

ducats.[31] Long-term appointments such as court artist or chancery secretary were typically remunerated in both money and in kind. In addition to his salary, Mantegna, who served the Gonzaga from 1460 to his death in 1506, received regular benefits such as accommodation, grain, and firewood for himself and his family, as well as protection and privileges from the court. As a member of the prince's household, Mantegna was part of an established system of court payments, and his services were—at least in theory—always available to his employers.[32]

In Mantegna's canvas, the armor-clad marquis kneels in prayer to receive the Virgin's blessing under a garden pergola festooned with fruit, flowers, exotic birds, and strands of pearls and glass and coral beads. With the Christ Child on her lap, the Virgin sits on a magnificent throne with a base of marble and gilded bronze and a backrest of wood intarsia crowned by a ring of gleaming precious stones. Her mantle is held open by two saints in armor: Archangel Michael at left and Saint George at right. As we have seen, Francesco invoked Saint George as he set out to confront the enemy, and the broken lance held by the saint in the altarpiece serves as a visual reminder of the marquis's own weapon fragment sent home earlier from Fornovo. Standing behind these warrior saints and largely obscured by them are two saints of local importance to Mantua: on the left, Saint Andrew with his cross, and on the right, Saint Longinus with his lance. Opposite Francesco, the elderly figure of Saint Elizabeth kneels with her infant son, John the Baptist.[33] Early descriptions of the painting note that it was inscribed with the words VICTORIÆ MEMOR, probably on the now-lost original frame.[34]

The only portrait is that of Francesco Gonzaga. However, correspondence from his brother Sigismondo, who supervised Mantegna's execution of the altarpiece, discusses an earlier composition that would have pictured the marquis with his two brothers on one side of the Virgin and Isabella d'Este on the other. Significantly, Francesco discarded this idea so that the painting would emphasize his own victory and his personal relationship with the Madonna.[35] Moreover, he placed himself in the traditional pose of donor, although he did not pay for the altarpiece but rather extorted payment for it. However, in pursuit of his strategy of signposting, it is unlikely that the marquis revealed his source of financing to contemporary viewers.

Mantegna's painted image of Francesco Gonzaga in the altarpiece became the model for the marquis's portrait on all his subsequent medals and coins. Prior to 1495, Francesco was inevitably shown wearing a hat or helmet, with hair falling in bangs over his eyes and cascading in waves down to the back of his neck.[36] By contrast, the standard numismatic likeness of the marquis after the creation of the *Madonna della Vittoria*, such as the one on his silver *testone*, a coin, clearly derives from Mantegna's painted portrait, and invariably shows him with no hat and no bangs, his nearly straight hair now falling in an even length to his shoulders (fig. 8.5).[37]

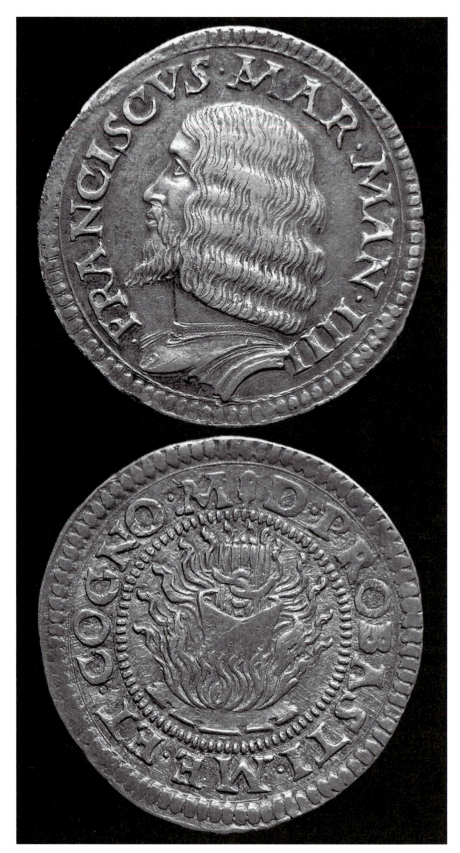

FIG. 8.5.
Silver *testone*
of Francesco
II Gonzaga
(obverse and
reverse), Fon-
dazione Banca
Agricola Man-
tovana, Man-
tua (Museo
Numismatico
Fondazione
Banca Agrico-
la Mantovana,
Mantua)

By the summer of 1496, Mantegna's altarpiece and the church that housed it were complete.[38] But a visual message must be seen to be effective. To maximize the public impact of this new monument, the Gonzaga court sponsored an elaborate pageant on 6 July 1496, the first anniversary of the Fornovo battle. During this procession the *Madonna della Vittoria* was carried through the streets of Mantua from Mantegna's house (located across the street from Alberti's church of San Sebastiano), along Borgo Pradella (now corso Vittorio Emanuele), the long boulevard traditionally used by the Gonzaga for horse races and important entries, and finally to the new shrine of Santa Maria della Vittoria. The same day, Francesco's brother Sigismondo sent the following description of the spectacle to the marquis:

> All of the religious orders and priests, together with the majority of the city's population, gathered at San Sebastiano to praise the image of the Glorious Virgin created by *messer* Andrea Mantegna. [The painting] was placed on a large, solemnly decorated platform, with a boy dressed as God the Father and flanked by two pairs of prophets. On each side there were three little angels who sang *laudi*, and on the ground stood the twelve apostles. When the signal was given, the entire platform was lifted by twenty porters and solemnly carried to [Santa Maria della Vittoria] in a procession of more men and women than had ever been seen in Mantua.[39]

In sum, the city was transformed into an open-air theater to praise the Madonna and the victory she had granted Francesco Gonzaga one year earlier at Fornovo. Moreover, as this elaborate spectacle unfolded in Mantua, subject towns throughout the Gonzaga marquisate held similar, smaller-scale processions to celebrate the salvation of their ruler one year ago at Fornovo, making the celebrations a truly statewide phenomenon.[40]

The 1496 ceremony culminated in a fiery sermon delivered outside the church by Isabella's confessor, Fra Pietro da Canneto. The gathered populace offered thanks to the Virgin for having spared the life of their brave ruler one year earlier, and prayed in unison for his continued protection. Inside the church, Mantegna's *Madonna della Vittoria* was the only altarpiece, located directly opposite the façade entrance. Within hours, vast quantities of candles and votive figurines of wax and silver began to accumulate at the site as offerings from devoted citizens. Gonzaga secretaries and close relatives told Francesco that this new shrine had brought to Mantua promise of a great future devotion of which "Your Lordship will have been the cause."[41] Santa Maria della Vittoria and its altarpiece, ostensibly commissioned in gratitude to the Virgin, served as the nexus of a thinly veiled program of adulation for the marquis himself. By prominently including his portrait in this highly visible monument, Francesco Gonzaga conflated religious and political devotion, inviting his subjects' reverence in a manner befitting a religious figure.

The following summer, in 1497, Francesco Gonzaga ordered that the anniversary celebrations be held four days earlier, on July 2, the feast day of Mary

and Elizabeth, the two female saints featured in Mantegna's altarpiece.[42] By consolidating the Fornovo commemoration with the popular Feast of the Visitation, the marquis ensured that he would receive continued homage by figuratively inserting himself as an object of veneration into an established, annually observed religious feast. In fact, for the rest of Francesco's reign and well into the seventeenth century, anniversary pageants were held annually in Mantua on July 2 to remind citizens of the piety, authority, and status that he had earned—or was believed to have earned—at Fornovo. The audience for these staged celebrations consisted of Francesco's own subjects, commoners and courtiers alike, as well as important visitors to the Gonzaga court. Because there was no risk that viewers would either misunderstand or be able to refute the intended message, Santa Maria della Vittoria and its altarpiece incurred no reception costs and could bring only benefits to the marquis, its patron.

Today, as in the Renaissance, viewers often accept as truth the message presented to them in prominent images such as the *Madonna della Vittoria*. This gives artists and patrons the opportunity to transform observers' perceptions of the reality behind the image. Through the use of Mantegna's altarpiece in a carefully designed campaign of art, architecture, and ceremony, Francesco Gonzaga succeeded in stretching the truth to rewrite Gonzaga history.

Notes

1. Some of the material presented here draws on Molly Bourne, *Francesco II Gonzaga: The Soldier-Prince as Patron* (Rome: Bulzoni, forthcoming), a revised version of my doctoral thesis, "Out from the Shadow of Isabella: The Artistic Patronage of Francesco II Gonzaga, Fourth Marquis of Mantua (1484–1519)" (Harvard University, 1997). All translations are my own.

2. Only recently have scholars attempted to redress this imbalance. In addition to my forthcoming book, see Clifford M. Brown, "'Concludo che non vidi mai la più bella casa in Italia': The Frescoed Decorations in Francesco II Gonzaga's Suburban Villa in the Mantuan Countryside at Gonzaga (1491–1496)," *Renaissance Quarterly* 49, no. 2 (1996): 268–302, and Clifford M. Brown, "The Palazzo di San Sebastiano (1506–12) and the Art Patronage of Francesco II Gonzaga, Fourth Marquis of Mantua," *Gazette des Beaux-Arts* 129 (1997): 131–80. For an introduction to the vast literature on Isabella d'Este's patronage, see Stephen J. Campbell, *The Cabinet of Eros: Renaissance Mythological Painting and the Studiolo of Isabella d'Este* (New Haven and London: Yale University Press, 2006), and Clifford M. Brown, *Isabella d'Este in the Ducal Palace in Mantua: An Overview of Her Rooms in the Castello di San Giorgio and the Corte Vecchia* (Rome: Bulzoni, 2005).

3. See Leonardo Mazzoldi, *Mantova: La Storia. Da Ludovico II Marchese a Francesco II Duca* (Mantua: Istituto Carlo d'Arco per la Storia di Mantova, 1961), 77–268.

4. A period drawing of the catafalque is reproduced by Rodolfo Signorini, "Gon-

zaga Tombs and Catafalques," in *Splendours of the Gonzaga*, exhibition catalog, ed. David Chambers and Jane Martineau (London: Victoria and Albert Museum, 1981), 4, fig. 7.

5. Paolo Giovio, *Gli Elogi: Vite brevemente scritte d'huomini illustri di guerra, antichi et moderni* (Florence: [Lorenzo Torrentino], 1554), chapter 5.

6. Shortly after succeeding to the marquisate in 1484 as an orphan of seventeen, Francesco had to contend with a conspiracy by three powerful uncles. See Mazzoldi, *Mantova: La Storia*, 77–108; Fermo Secco d'Aragona, "Francesco Secco, i Gonzaga e Paolo Erba," *Archivio Storico Lombardo* 83 (1956): 210–61; Giuseppe Coniglio, "La politica di Francesco Gonzaga nell'opera di un immigrato meridionale, Iacopo Probo d'Atri," *Archivio Storico Lombardo* 88 (1961): 131–67.

7. On the altarpiece's stylistic novelties, see Ronald Lightbown, *Mantegna* (Berkeley and Los Angeles: University of California Press, 1986), 177–84; on its anti-Semitic origins, see Dana Katz, "Painting and the Politics of Persecution: Representing the Jew in Fifteenth-Century Mantua," *Art History* 23 (2000): 475–95.

8. For the original text of Francesco's announcement of 11 June 1495, as well as related documents and an excellent discussion of his role in the Battle of Fornovo and its subsequent promotional importance for his image, see David Chambers, "Francesco II Gonzaga, Marquis of Mantua, 'Liberator of Italy,'" in *The French Descent into Renaissance Italy, 1494–95: Antecedents and Effects*, ed. David Abulafia (Aldershot: Ashgate, 1995), 217–29, at 223 note 24.

9. For a synopsis of the battle see Michael Mallett and J. R. Hale, *The Military Organization of a Renaissance State: Venice c. 1400 to 1617* (Cambridge: Cambridge University Press, 1984), 55–58; for the Mantuan perspective see Alessandro Luzio and Rodolfo Renier, "Francesco Gonzaga alla Battaglia di Fornovo (1495) secondo i documenti mantovani," *Archivio Storico Italiano* 6 (1890): 205–46, reprinted with same title in book format (Mantua: A. Sartori, 1976).

10. Francesco Guicciardini, *Storia d'Italia*, ed. Silvana Seidel Menchi (Turin: Einaudi, 1971), 1:197.

11. For Dolfo's letter to Francesco II, dated 19 July 1495, see Marzia Minutelli, *Floriano Dolfo, Lettere ai Gonzaga* (Rome: Edizioni di storia e letteratura, 2002), 47–49, letter XVII.

12. On the engraving (Washington, DC, National Gallery of Art, inv. 1952.8.5) see Elizabeth Mongan, "The Battle of Fornovo," in *Thirteen Illustrated Essays on the Art of the Print*, ed. Carl Zigrosser (New York: Holt, Rinehart and Winston, 1962), 253–68.

13. Important period descriptions of the battle include those by the Venetian chronicler Marin Sanudo, *La spedizione di Carlo VIII in Italia*, ed. Rinaldo Fulin (Venice: Visentini, 1883), 473–91, as well as the eyewitness accounts by the French diplomat Philippe de Commynes, *The Memoirs of Phillipe de Commynes*, ed. Samuel Kinser, trans. Isabelle Cazeaux (Columbia: University of South Carolina Press, 1973), 2:526–36, and by the Veronese physician to the Italian army, Alessandro Benedetti, *Diaria de Bello Carolino*, trans. Dorothy Schullian (New York: F. Ungar for the Renaissance Society of America, 1967), 97–109.

14. George Hill, *A Corpus of Medals of the Italian Renaissance before Cellini* (London: British Museum, 1930), cat. nos. 400 and 205.

15. Alessandro Luzio, "La *Madonna della Vittoria* del Mantegna," *Emporium* 10

(1899): 366, letter of Sigismondo Gonzaga in Mantua to Francesco II, 17 July 1495: "la lanza de Longino, che cossì como quello fu causa de sparger sangue per la redentione humana, cossì questo è stato causa de la salute e liberatione de tuta Italia; che veramente quando me ricordo che la V. Ex. cum la persona sua sola e pochi soi hanno questa gloria de haver liberata questa povera Italia da obsidione de barbari, el mè forza lacrimar di dolceza."

16. See Chambers, "Francesco II," 224–26.

17. For the letter of 21 October 1495 to Francesco II, in which court building superintendent Bernardino Ghisolfo notes that he and Bonsignori ("Francesco da Verona") traveled to the Fornovo battle site ("le Geroli") so that Bonsignori could make a sketch of the location, see Brown, "Concludo," 295–97.

18. The "Sala delle Victorie," part of a major architectural addition built and decorated under Francesco II, was destroyed in the eighteenth century; see Brown, "Concludo," 279 and 285–86; and Bourne, *Francesco II Gonzaga,* chapter 4.

19. See Isabella's orders to all local officials, dated 28 July 1495: "Per la bona et felice nova de la creatione del capitaneato generale de tutte le zente d'arme de la Ill.ma S.ria de Venetia in la persona del Ill.mo S. nostro consorte, volemo che . . . vui faciati fare festa de campane, et tre sere a la fila falò" (Archivio di Stato di Mantova, Archivio Gonzaga [hereafter AG] b. 2907, libro 154, c. 23r).

20. For an illustration of this rare silver *testone,* generally attributed to Bartolomeo Melioli, see Silvana Balbi de Caro, *I Gonzaga: Moneta Arte Storia,* exhibition catalog (Milan: Electa, 1995), 202, cat. no. Mg 82 and plate 33; for a discussion see Giulio Superti Furga, "Di alcune monete e di alcune medaglie di Francesco II Gonzaga IV Marchese di Mantova," *Rivista italiana di numismatica* 22 (1974): 233–34.

21. According to Giorgio Vasari, *Le vite d'più eccellenti pittori scultori ed architettori,* ed. Rosanna Bettarini and Paola Barocchi (Florence: Sansoni, 1971), 3:554, "among the last things that [Mantegna] made was a panel [*sic*] painting for Santa Maria della Vittoria, a church designed by Andrea and commissioned by marchese Francesco for his victory at the Taro River, where he was general of the Venetian forces against the French."

22. Early in his reign Francesco had founded a convent in the Virgin's honor called Santa Maria dei Miracoli, located near his family's ancestral hometown of Gonzaga. See Luisa Bertazzoni, "Il Convento di Santa Maria di Gonzaga," in *Chiese e conventi del contado mantovano* (Florence: Associazione Industriali di Mantova, 1968), 57–64; Franco Ferrari and Gabriele Ruffi, "Il Convento di Santa Maria e le origini della Fiera di Gonzaga," in *Gonzaga, Gonzaga,* ed. Mario Cadalora (Modena: Artioli, 1990), 67–90.

23. "e tanto inanti fra gli inimici [Francesco] si condusse, che finalmente si vidde, ove il fuggire di rimaner oppresso dal barbaro furore era humanamente impossibile. Perloché di tutto cuore rivolgendosi a Dio, & alla gloriosissima Vergine, promise di fabricarle un tempio a suo honore, se lo liberava: né appena hebbe fatto il voto, che . . . si viddero fuggir quelli . . . che lasciando adietro gli alloggiamenti, & le bagaglie, si recaro a gran ventura il salvarsi la vita. Francesco ritornato a Mantova, riconoscendo vittoria così segnalata principalmente da Dio, e della sua Santissima Madre, fabricò la Chiesa della Madonna della Vittoria . . . & Andrea Mantegna vi dipinse l'ancona dell'Altar maggiore, c'hà di presente, con l'imagine al naturale d'esso

Marchese; il quale havendo nella Chiesa appese l'arme, c'haveva intorno il giorno della battaglia, in segno d'humil riconoscimento." Ippolito Donesmondi, *Dell'istoria ecclesiastica di Mantova* (Mantua, 1613–16), 2:85.

24. See Katz, "Painting and the Politics," with earlier bibliography.

25. There are no known construction documents for Santa Maria della Vittoria. Though Vasari attributed the church's design to Andrea Mantegna, its basic Lombard Gothic form was most probably devised by Bernardino Ghisolfo, *superiore delle fabbriche* for the Gonzaga, who almost certainly oversaw its construction.

26. Salvatore Settis, "Artisti e committenti fra Quattro e Cinquecento," in *Storia d'Italia, Annali 4: Intellettuali e potere*, ed. Corrado Vivanti (Turin: Einaudi, 1981), 712–22.

27. On 18 August 1495, Francesco Gonzaga wrote from his military encampment at Novara to his brother Sigismondo (at the time protonotary, but later cardinal), ordering Daniele Norsa to "have made an image of the Glorious Virgin Mary by the hand of *messer* Andrea Mantegna, costing 110 gold ducats and worth that price; and these monies Daniele must pay within three days after being commanded; and if after eight days he has not paid, we wish him to understand that he risks death by hanging"; see Paul Kristeller, *Andrea Mantegna* (Berlin and Leipzig: Cosmos Verlag, 1902), 559, doc. 136.

28. The average price for an altarpiece of similar size in late fifteenth-century Italy was about one hundred florins or ducats, the gold coin used in most contracts to set the fee. See Michelle O'Malley, *The Business of Art: Contracts and the Commissioning Process in Renaissance Italy* (New Haven and London: Yale University Press, 2005), 131–60.

29. Sigismondo Gonzaga in Mantua to Francesco II, 30 August 1495: "at this point the Jews have disbursed one hundred and ten ducats, part of which has been given to *messer* Andrea Mantinea, who wants to create something excellent. The rest of the aforesaid monies I have in hand, and will give to the aforesaid *messer* Andrea as soon as he begins work"; see Kristeller, *Andrea Mantegna*, 560–61, doc. 139.

30. Kristeller, *Andrea Mantegna*, 203.

31. On Pietro Antonio da Crema's salary, see the letter from Bernardino Ghisolfo, Gonzaga *superiore delle fabbriche*, in Gonzaga to Francesco II, 10 February 1495: "Petro Antonio de Crema, dipinctore suo, vene de la S.V. per domandare licencia da quella, dicendo non poter starge per non esser pagato. Il che facio intendere a V.S. come lui non avancia da dì 25 de febraro 1494 sino a dì 25 del presente febraro 1495 che monta sue provisione a ducati sei el mese in dicto tempo ducati settantadui de quali n'ha habuto ducati cinquanta e restarebbe haver ducati vintidui" (AG b. 2448, c. 126). On Jacopo Probo d'Atri's salary, see the letter from Francesco II in Novara to his treasurer in Mantua, 19 September 1495: "Vogliamo et siamo contenti che voi faciati mettere el Sp.le Jacopo Probo de Hadria nostro secretario per li suoi benemeriti et integrità alla provisione de ducati septe d'oro el mese, como s'è sole dare alli secretarii cavalcanti come è lui" (AG b. 2961, libro 4, c. 110r).

32. On the compensation of court artists in this period, see Martin Warnke, *The Court Artist: On the Ancestry of the Modern Artist*, trans. D. McLintock. (Cambridge: Cambridge University Press, 1985), 124–42. Some of Warnke's ideas have been revised by Evelyn Welch, "Painting as Performance in the Italian Renaissance Court," in

Artists at Court: Image-Making and Identity, 1300–1550, ed. Stephen Campbell (Boston: Isabella Stewart Gardner Museum, 2004), 19–32.

33. The church of Sant'Andrea, rebuilt by Alberti in the fifteenth century at the behest of marquis Ludovico Gonzaga, houses Mantua's famed relic of the Precious Blood of Christ, which according to legend was brought to the city by Longinus. Saint Elizabeth was Isabella d'Este's patron saint, and her feast day was July 2, just three days before the date of the Fornovo battle, making her a particularly relevant choice.

34. Lightbown, *Mantegna*, 180 and 438–39.

35. Although the marquis delegated responsibility for much of the execution of the *Madonna della Vittoria*, a decision of this importance could have been made only with his explicit approval; this could have taken place while Francesco returned to Mantua briefly from November 1495 to February 1496. Ibid., 179.

36. The same hairstyle is found in two bronze medals of Francesco Gonzaga, both datable to before 1495 and attributed to Bartolomeo Melioli: an example of the first is conserved in Milan (Civiche Raccolte Numismatiche) and reproduced in Balbi de Caro, *I Gonzaga*, 410, cat. no. V.21a; an example of the second (sometimes attributed to Gian Marco Cavalli) is found in Bologna (Museo Civico Archeologico) and illustrated in ibid., 412, cat. no. V23a. A similar portrait formula was followed for Francesco Gonzaga's pre-1495 coinage: examples include his *mezzo testone* (illustrated in ibid., 200–201, cat. nos. Mg 59 and Mg 64) and his gold *ducato* (ibid., cat. no. Mg 63 and plate 33).

37. Gian Cristoforo Romano's terra-cotta portrait bust of Francesco II, circa 1496 (Mantua, Museo della Città, Collezioni Civiche, n. 11696), follows Mantegna's painted model so closely that for many years it was attributed to Mantegna himself.

38. Numerous disfiguring changes were made to Santa Maria della Vittoria following its deconsecration in 1797, but much of the original fresco decoration, obscured by whitewash since the nineteenth century, has been recovered as a result of a restoration campaign completed in 2006. For the initial results, and arguments that the frescoes were designed by Mantegna but executed by Domenico and Francesco Morone, see Ugo Bazzotti, "La chiesa di Santa Maria della Vittoria e la pala di Andrea Mantegna," in *A casa di Andrea Mantegna: cultura artistica a Mantova nel Quattrocento*, ed. Rodolfo Signorini, exhibition catalog (Cinisello Balsamo: Silvana Editore, 2006), 200–219.

39. Sigismondo Gonzaga in Mantua to Francesco II Gonzaga in Atella (near Potenza), 6 July 1496 (see Kristeller, *Andrea Mantegna*, 561, doc. 140). The processional route can be deduced from chancery secretary Antimaco's letter of 7 July 1496 to the marquis (ibid., 561–62, doc. 141). Descriptions of the July 1496 ceremony are given by Attilio Portioli, "La chiesa e la *Madonna della Vittoria* di Andrea Mantegna," *Atti e Memorie della Accademia Virgiliana di Mantova* 9 (1884): 72–74; Luzio, "*Madonna della Vittoria*," 369–70; Lightbown, *Mantegna*, 180.

40. Antimaco to Francesco II, 7 July 1496 (as in note 39): "Di fora per tutto il contado si è etiam facto processione cum regratiare nostro S. Dio che il tal giorno ne conservasse la persona di V. Ex.tia."

41. Sigismondo Gonzaga to Francesco II, 6 July 1496 (as in note 39): "credo che in breve tempo gli accreserà grandissima devozione, et de tuto questo bene la vostra Ex. ne serà stata causa."

42. Francesco II in Gonzaga to *massaro generale* Francesco Cambiator in Mantua, 1 July 1498: "Havendo noi l'anno passato ordinato che'l fusse facto publica grda . . . che ogni persona dovesse festare el giorno de domane che è quello de la Visitatione . . . volemo che . . . ordinati che se facia el medesimo, facendo intendere allo R.do vicario de lo episcopo che voglia ordinare la processione consueta che vada ad Madonna Santa Maria de le Victoria como fu facto l'anno passato" (AG b. 2908, libro 160, c. 17r). This letter indicates that the previous year Francesco had already issued an order to shift the date of the Madonna della Vittoria celebrations from July 6 to July 2, in order to coincide with the Feast of the Visitation.

VISUAL ART AS SELF-ADVERTISING

(EUROPE AND AMERICA)

Larry Silver

As long as there are rich people in the world, they will be

desirous of distinguishing themselves from the poor.

—JEAN JACQUES ROUSSEAU

The very rich are different from you and me.

—F. SCOTT FITZGERALD

Introduction

EVEN THE BEST theory needs testing for validity. General theories
about art's function in society still require analysis in terms of separate
situations—both in different periods and in different places—to con-
firm whether they provide a useful tool for understanding specifics. Because
most of the examples advanced in this book derive from the particular condi-
tions of the Italian Renaissance, this essay will attempt to test the same con-
cepts against a wider set of later instances. If signaling (combined with the
self-aggrandizing image creation of stretching) and signposting have lasting
value, then they need confirmation from other situations, including varia-
tions in gender. Thus the first examples to be considered will involve female
patrons: a Queen Mother of France who sponsored Peter Paul Rubens, and
a trio of society queens in late nineteenth-century America, noted for their
discerning collections of both old masters and living artists (especially John
Singer Sargent and Mary Cassatt). But another telling challenge to these
forms of artistic self-assertion can be found in numerous self-portraits by
painters (including Rubens again), particularly during the seventeenth century,
when artists (including a leading woman artist, Artemisia Gentileschi) sought
enhanced social status and made claims to learning as they transformed their
profession from a manual craft. Finally, buildings and their sites can play a
major role in the process of signaling—whether artists' own homes (such as
the celebrated house of Rubens) or those of their patrons. Each of these topics,
in turn, can return us to general theory.

185

Probably the most bombastic of all great works of art is the cycle of twenty-three canvases, now gracing an enormous room in the Louvre, prepared by Peter Paul Rubens for the dowager queen of France, Marie de' Medici (1621–25).[1] Its none-too-subtle ambition was to put the best face on what had been the rather embarrassing reign of a regent queen, who at the time of the commission had recently been ousted from power by her own son, King Louis XIII, and his chief adviser, Cardinal Richelieu. Eventually their truce did not hold, and the queen fled definitively into exile in 1631.

In effect, Rubens's pictorial cycle is a massive act of diplomacy, not surprising from a man who was not merely the greatest painter of his era but also one of its leading statesmen. During this period Europe was convulsed in the early conflicts of the Thirty Years War, and, as "prince of painters," Rubens had ready access to all the major royal heads of state, giving him the cover to serve as a shuttle diplomat, the seventeenth-century equivalent of Henry Kissinger, in his ceaseless quest for a negotiated peace.

Rubens employed all the pictorial means in his repertoire to meet this important and massive task, made all the more difficult by the tension between the male-dominated values of heroic rulership and the regent queen's sex.[2] Sometimes the results are unintentionally ludicrous, such as the scene of the queen depicted in the conventional role of king: in military helmet, mounted on a gorgeous white horse and carrying the baton of generalship before the field of battle in Juliers (or Jülich) (fig. 9.1). She is also accompanied here, as in so many of the other Rubens canvases, by classical allegories. The figure of Victory hovers over her head, extending the laurel of conquest, while beside her with pearls for distribution stands Generosity, a principal virtue of ruling princes, a figure that Rubens used to display his own learning through his use of a classical reference to the Roman figure of Flora Farnese. The queen's accessories also include an extraordinarily rich gown, adorned with the fleurs-de-lis of the French royal house.

Legitimation and glorification were the avowed goals asserted by this grand cycle. Many of its elements operated as signals of the queen's unique convergence of wealth, status, and power. The sheer scale of the commission and the eminence of its celebrated painter point together to the prestige as well as the vast means of the queen who commissioned it; moreover, the contract insists that the artist rather than his workshop is to attend personally to the production of these canvases. The fee was astronomical (60,000 livres), a tangible indicator of royal magnificence as well as the scale of the project and the status of the artist, especially for his exclusive services. The carefully controlled site of display for these paintings was a newly constructed gallery, devoted to public receptions and asserting the queen's political presence from her own royal residence in Paris, the Luxembourg Palace.

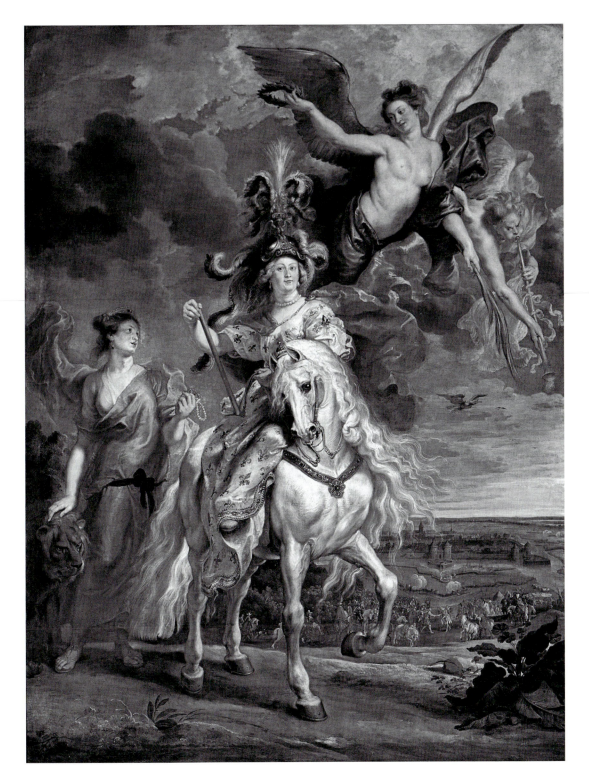

Fig. 9.1. Rubens, *Victory at Jülich*, Marie de' Medici cycle, Musée du Louvre, Paris (Bridgeman Art Library, London) © Louvre, Paris / Giraudon / The Bridgeman Art Library

In signaling the French queen's virtues, power, and glory, no work of art so richly exemplified the main theoretical processes advanced by this volume as the canvases of Rubens's Marie de' Medici cycle. Yet the artist also produced a form of visual euphemism for his subject, employing the principles of both stretching and signposting. Rubens fudged the truth in those images showing the dowager queen with her son, the king. This strategy was safe, since nobody really expected literal documentation in such a cycle from such an artist and in such a staged context of viewing, devoted to her life and achievements. Thus the allegories and personifications of virtues as well as the Olympian gods who accompany Marie de' Medici and bestow their gifts and training on her—all are part of a painted pageant, which allowed the artist and the patron to temporize about the political tensions in the kingdom, as well as to lend an air of grandeur and seriousness.[3] These pictures also play on the heritage of religious painting, of which Rubens was a master, often suggesting allusions to Marie's sacred namesake, the Virgin Mary. In short, the Marie de' Medici cycle was a powerful piece of propaganda, a best-case scenario, an expensive form of public relations. That Rubens was quite conscious of his role in stretching and signposting is patently obvious from his letters, which distinguish between reality (*sostanza*, "substance") and appearance (*apparenza*). Quite literally he fused history with myth within the cycle, to suggest how the queen exemplified nobility and incorporated all virtues. Rarely do we have documentation from the artist himself of the difficulties involved in producing such imagery, but Rubens is candid about his adjustments and necessary tact (even in describing the content of the pictures to royal visitors) as he writes to his French friend and colleague Nicolas-Claude Fabri de Pieresc about the cycle (13 May 1625):

> In this pressure of public affairs I cannot make any requests without incurring the blame of fatiguing the Queen with private matters . . . I am certain that the Queen Mother is very well satisfied with my work, as she has many times told me so with her own lips, and has also repeated it to everyone. The King also did me the honor of coming to see our Gallery; this was the first time he had ever set foot in this palace, which they had begun to build sixteen or eighteen years ago. His majesty showed complete satisfaction with our pictures, from the reports of all who were present, particularly M. de St. Ambroise. He served as interpreter of the subjects, *changing or concealing the true meaning with great skill*. I believe I've written you that a picture representing "The Departure of the Queen from Paris" has been removed, and in its place I have painted an entirely new one, representing "The Felicity of Her Regency." This shows the flowering of the Kingdom of France, with the revival of the sciences and the arts through the liberality of Her Majesty, who sits upon a shining throne and holds a scale in her hands, keeping the world in equilibrium by her prudence and equity. This subject, which does not specifically touch upon the *raison d'état* of this reign, or apply to any individual, has evoked much

pleasure, and I believe that if the other subjects had been entrusted entirely to us, they would have passed, as far as the Court is concerned, without any scandal or murmur. [in margin: The Cardinal perceived this too late, and was very much annoyed to see that the new subjects were taken amiss.] For the future I believe there will not fail to be difficulties over the subjects of the other gallery [a projected cycle for the later King Henry IV, blocked by Richelieu], which ought to be easy and *free from scruples.* . . . In short, I am tired of this Court.[4]

To complement the Marie de' Medici cycle, Rubens was initially commissioned to produce a subsequent set of canvases extolling the accomplishments of her deceased husband, King Henry IV, but Richelieu blocked its completion, taking the part of Louis XIII against his queen mother. That uncompleted Henry IV cycle, for which Rubens left behind oil sketches (1625–30), would have been easier to create because it provided a more standard set of masculine images and actions for the ruler and supreme military commander.[5] If we examine the image described in Rubens's letter, *The Felicity of the Regency of Marie de' Medici* (fig. 9.2), we can see how much generalization and tact was involved in the process of extolling the queen. Here, in the portion of her biography that should have dealt with the queen's humiliating exile (May 1617) as part of a purely chronological narrative, Rubens eliminated his original scene of *The Departure of the Queen from Paris*, as described in the letter (and preserved in an oil sketch, now in Munich, Alte Pinakothek).[6] Instead, his substitute image, *Felicity of the Regency*, offered allegorical equivocation (or as we might now say, signposting) to put a more favorable "spin" on the image of the queen. The actual circumstances of the queen's flight were frightening and embarrassing, since one of her favorites was murdered by Louis XIII, and his widow (a close friend, who had accompanied the queen to France from Florence) was subsequently executed after a show trial. The queen's fright is palpable in the oil sketch, and her future still uncertain as she descends in stealth from a portal to enter a covered wagon by night. Even here allegorical figures accompany her to convey the situation. Innocence, a figure with a lamb, leads the way, followed by Calumny, a nude hag figure who brandishes a threatening torch, as dragon-like Lies fly overhead.

In the allegory that Rubens eventually substituted, Marie de' Medici sits enthroned, one breast exposed in the standard personification of Justice as she holds the accompanying scales of balance to personify Just Rulership itself. Rather than the other traditional symbol of a sword for Justice, she bears in her left hand the French royal *main de justice* on an orb, asserting both her national monarchy and right to rule. Two buxom females, Prudence (with a serpent on her arm) and Abundance (with a cornucopia) assist the monarch and ensure her effective rule. They distribute golden chains, coins, and laurels, benefices to the arts and sciences under this apparently peaceful reign; above them, whispering in the queen's ear, Minerva offers her wisdom in support.

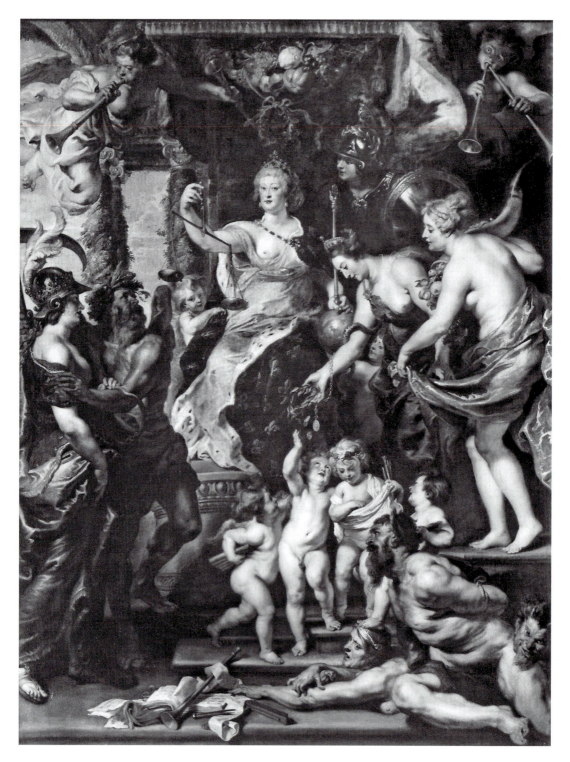

FIG. 9.2. Rubens, *Felicity of the Regency*, Marie de' Medici cycle, Musée du Louvre, Paris (Archivi Alinari, Florence)

Opposite stand the personifications of France (an armored female with fleurs-de-lis) and Time (the figure of Chronos with his scythe), and the trumpets of fame in the upper corners proclaim her accomplishments to posterity. Beneath the throne cupids, spirits of genius, display paintbrush and flute as tokens of the fine arts, among other objects of learning on the steps. These cupids have overcome larger, swarthy, muscular figures, the forces of savagery and lack of civilization, respectively Envy, Ignorance (with asses' ears), and Vice (a satyr).

This kind of inflated visual rhetoric extends throughout the cycle from its very outset, where the queen's destiny is spun by the Three Fates and her instruction as a girl is provided by the classical gods: Minerva, goddess of wisdom; Mercury, god of eloquence; Orpheus, the paragon of music's charms; and the Three Graces, handmaidens of Venus. In similar fashion, rather than follow the *Felicity of the Regency* with another canvas to make explicit the contested rulership between Queen Mother and her royal son, Rubens produced yet another allegory, *The Majority of the King*, which depicts a "ship of state" with Louis XIII taking over the tiller of the government while still seeking advice and counsel from his smiling mother beside him. No conflict here, just a peaceful transition of power, to judge by Rubens's formulation (exemplifying signposting in the service of strong distortion). Of course, history tells us that the very opposite transition occurred, an internecine struggle for power that pitted Marie de' Medici against her own son and heir, Louis XIII. Once more the female figure of France appears in Rubens's image, standing at the mast under glowering skies of storm clouds and accompanied by Prudence, who trims the sails. The oars of this vessel are pulled by hardy female personifications, identified in a preliminary drawing (and by emblems on their shields) as Force and Constancy, plus Justice and Concord, pulling together in unison. In effect, the use of allegory made such claims unassailable, since no actual stretching of the truth was involved, and a counterfactual claim cannot be disproved with the opposite account.

Even more equivocal (a paragon of allegorical stretching: changing or concealing the true meaning with great skill) is the final image of the cycle, a pure apotheosis of the queen and her son, who are shown together in a transcendent and timeless heaven (fig. 9.3). The queen holds a caduceus, symbol of peace, as she kneels on clouds. She is welcomed by her son, who supports her arm as he gazes solicitously toward her and leads her upward. Before them, Divine Justice with a thunderbolt hurls a monster earthward. Behind the queen stands a personification of Charity with two children, balanced on the other side by France, with orb and rudder, who awaits the outcome of the celestial conflict. This imagery derives from apocalyptic events, redolent of the conflict between the archangel St. Michael and the seven-headed beast, as well as the Assumption of the Virgin and her Coronation by the Trinity in heaven. Rubens continues to pull out all rhetorical stops, employing myth as well as religion alongside his allegories in the service of his commission.

In this particular political situation, neither Louis XIII nor Cardinal Richelieu was buying what Rubens, as the agent for the discredited Queen Mother, was selling. The planned cycle devoted to former King Henry IV never materialized, and the queen ended her life in exile; moreover, the political heat of European war led the artist on to the courts of Madrid and London in pursuit of his peace mission. The main difference between propaganda and information lies in audience response. Rubens certainly set out to signal both the magnificence and the accomplishment of his ruler-client on a huge scale, for a palace site, and at a cost that only a monarch could disburse (uniquely combining wealth, status, and power for the cause of an entire kingdom). Ultimately the real power lay elsewhere, as the queen's forced exile revealed. This allegorical stretching of Realpolitik and familiar recent French history was too evasive to be politically effective for long, even within the controlled setting of Luxembourg Palace. As the queen's own fortunes waned, so did the relevance of the artist's celebration of her. Indeed, the final canvas of the cycle, *Truth Unveiled by Time*, points to the queen's hopes for full reconciliation and eventual vindication in the historical record, even at a time of strained relations with her ruling son.[7] Of course the final, ironic outcome of her reputation was precisely the reverse. We are reminded of another assessment by Hamlet's queen-mother, Gertrude: "The lady doth protest too much, methinks" (*Hamlet* III.ii.236).

"Matronage" of Art in Emerging Modern America

Patronage is one of art history's favorite ways to engage with the social role of artworks. Art historians now increasingly investigate the significance of women's roles as patrons, operating within the limits of their gendered roles and opportunities in any given age.[8] Unlike the seventeenth-century dowager queen of France, who held a unique social and political prominence, later modern women—particularly in the gendered late Victorian world of America—could not so easily show their status and influence in society. Conspicuous public sponsorship in the field of art offered a significant exception. In late nineteenth-century America, for example, a group of wealthy women actively engaged in what Wanda Corn has renamed "matronage."[9] In particular, the figure of Isabella Stewart Gardner of Boston (1840–1924), "self-appointed guardian of culture" (Corn), made art patronage as well as display the hallmarks of her public self-presentation. During America's Gilded Age, the energy of "clubwomen" activated cultural institutions in almost every major city. Bertha Honoré Palmer of Chicago and Louisine Elder Havemeyer of New York occupied roles similar to Gardner's in their regions.[10]

These women played a firm leadership role in "society," the same limited social world so vividly captured in contemporary novels about New York by

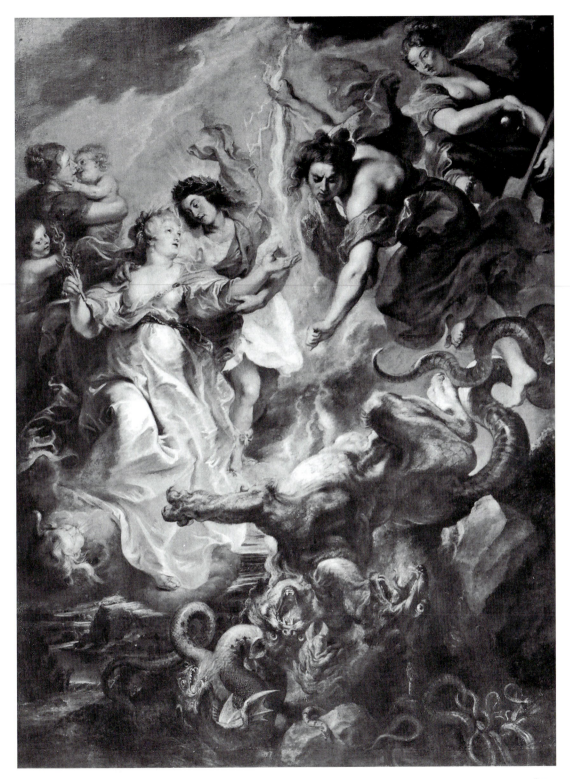

FIG. 9.3. Rubens, *Return of the Mother to Her Son*, Marie de' Medici cycle, Musée du
Louvre, Paris (Archivi Alinari, Florence)

Edith Wharton. Their impetus went toward cultural philanthropy focused on their hometowns, energetic public contributions toward civic amenities in an era still before women's suffrage, let alone membership on the gender-restricted cultural boards of museums, symphonies, or libraries.[11]

Wealth was the necessary foundation of all their activities. Their status was unquestioned and preeminent within a narrow social elite. What these women formally lacked was power, even though their husbands were often captains of industry in an era of robber barons and corporate trusts. Perhaps the most vivid self-promotion was advanced by Isabella Stewart Gardner, who created her own museum, indeed a realm of her own that she ruled with an iron fist (even after her death through her ironclad will and testament). Biographers claim that her early inspiration came from a visit to the private museum of Gian Giacomo Poldi Pezzoli (d. 1879) in Milan, who established a foundation to perpetuate his distinguished collection, placed in period rooms in his imposing house.[12] Her Fenway Court operated as an equivalent institution to the private museum collections established by her male contemporaries, the true robber barons, Huntington in Southern California and Frick in New York City. And like those other private museums, the Gardner Museum flourished as an oasis of privilege in the shadow of a major municipal museum.

Stewart Gardner more closely resembled a figure out of Henry James (whom she knew), the omnivorous American abroad in search of art treasures to take home, there to re-create a palace-home for display of these wonders for her peers as well as to celebrate the cultivated taste of the individual collector herself. Through such blatant signaling, as Anne Higonnet has argued, Mrs. Gardner managed to exert personal authority through imported European culture; by implication she also simultaneously asserted American superiority through ownership, superseding the wealth and power of Europe in a culminating present that promised a bright future in terms of culture.[13] Moreover, along with a wide range of artifacts from various centuries and regions, she also sponsored such contemporary artistic luminaries as John Singer Sargent (whose work she owned in quantity, over sixty pieces, acquired over almost four decades).[14] Sargent was also the artist of a costly, flatteringly iconic, full-length frontal portrait of Mrs. Gardner (1888) (fig. 9.4), which surely is the true heir to Rubens's flattery of his queenly patron.[15] Pictorially stretching, like all good portraitists, Sargent placed his sitter in a dark dress against an Italian velvet brocade fabric (from her own collection) in order to set off the fairness of her skin, a prized Victorian beauty trait. He also emphasized her feminine figure as a sign of both her sex and her identity while providing her with the traditional dignity and stature of a full-length solo portrait against that cloth of honor.

The highlights of the Gardner collection—in its Venetian Gothic building— are works by the Italian Renaissance masters. Most of them were acquired through the expertise of local expatriate Bernard Berenson, whom she spon-

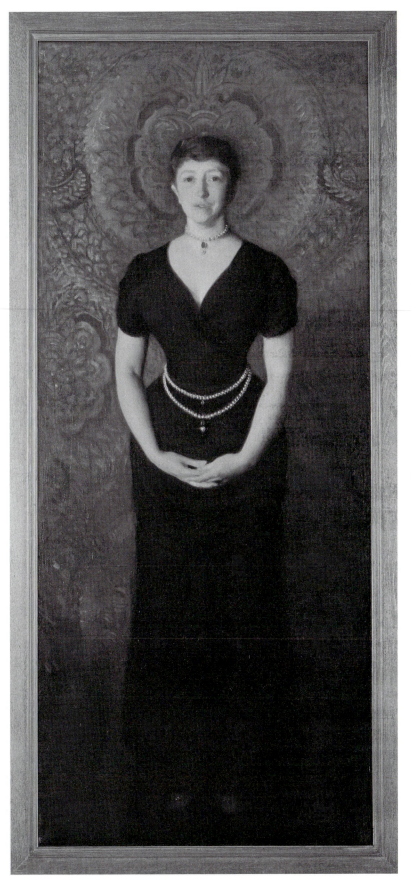

FIG. 9.4.
John Singer Sargent,
*Portrait of Isabella
Stewart Gardner*,
Isabella Stewart
Gardner Museum,
Boston (Bridge-
man Art Library,
London). © Louvre,
Paris / Giraudon /
The Bridgeman Art
Library

sored as a benefactor. Major works of Dutch masters, including Rembrandt and Vermeer, as well as other leading old masters, such as Velázquez, expand this core within an encompassing historical interest, which also includes ancient artifacts and Asian objects.[16] The past has been made present, but it is the spirit of Ruskin (another celebrated lover of Venice) and of Renaissance self-fashioning (to use the phrase of Stephen Greenblatt) that points to personal (and national) betterment as the master narrative of both Mrs. Gardner and her museum. Mrs. Gardner's personal motto was "C'est Mon Plaisir," a phrase that translates as either "it is my will" or "it is my pleasure"—an ambiguity that suited Gardner, according to Anne Higgonet. A plaque at the entrance to the museum features this motto with a phoenix rising from the ashes to achieve a form of immortality.[17]

If we pause to consider how this staging of personal taste and personality itself accords with the economic theories advanced in this volume, then we see Mrs. Jack Gardner using amassed wealth (from "trade" rather than royal revenues: her own father's linen business and mining, her husband's shipping and China trade) to produce an effect that fully removes this collector from her contemporary surroundings within her own palace construction, just as surely as Marie de' Medici created her own image through art in the Luxembourg Palace. Gardner took pride in her claimed descent from the English royal house of Stuarts, and (in a deft act of signposting) she used the ornament of Scottish thistle and white rose in the ornament of Fenway Court, echoed in the brocade of her full-length Sargent portrait. That artistically enhanced likeness (1887–88) by the greatest contemporary portraitist, Sargent, only reinforces the suggestion of her ageless beauty and grace, while ratifying her taste in the present not merely for the art of the past. Higonnet underscores Gardner's quintessentially American assertion of wealth, status, and power: "Museum founders like Gardner believed that by purchasing some of the most famous of all art objects and orchestrating sumptuous displays, they could ennoble both themselves and their nation while fostering democracy, by exhibiting at once personal power and civic service, individual taste and a collective cultural heritage."[18]

Signaling for Gardner stayed limited for the most part to her own personal prominence, but the visible activities of Palmer in Chicago and of Havemeyer in New York were channeled into wider social, even political causes during this era of the emerging "new woman." Bertha Honoré Palmer (1849–1918) remains one of the most underappreciated forces in Gilded Age American culture.[19] To be sure, she was able to utilize the enormous wealth and social standing of her husband, hotelier and financier Potter Palmer, but her own social commitments extended well beyond Chicago high society into urban social reform, through her charitable support of Jane Addams's Hull House. Mrs. Palmer, along with Mrs. Martin Ryerson and Mrs. Charles Hutchinson, the wives of early presidents of, and major donors to, the Art Institute of Chi-

cago, had official standing at the museum only through an auxiliary organization of their own, the Chicago Society of Decorative Art (CSDA), later renamed the Antiquarian Society (still extant).[20] In Chicago Mrs. Palmer's most conspicuous administrative efforts, however, were exerted in her role as president of the Board of Lady Managers of the World's Columbian Exposition (the Chicago World's Fair of 1893).[21]

For a major mural in her own personal project, the Woman's Building, Mrs. Palmer commissioned creative females in order to mark a physical and cultural presence at the Chicago World's Fair, the greatest of all tourist locations of nineteenth-century America. The Woman's Building, expressly dedicated to "the advancement of women," dramatically signaled issues of women's rights. The building itself had a woman architect, Sophia Hayden (first female graduate in her field from M.I.T.), as well as a sculpted pediment by San Francisco sculptor Alice Rideout. For the mural, Palmer chose Mary Cassatt, a leading American expatriate painter in Paris. (Cassatt was born into a prominent Philadelphia family of both social privilege and industrial eminence; her brother Alexander was president of the giant Pennsylvania Railroad).[22] Palmer proposed the theme for the mural, which in turn provided the message for the entire setting: "My idea was that perhaps we might show woman in her primitive condition as a bearer of burdens and doing drudgery, either in an Indian scene or a classic one in the manner of Puvis [de Chavannes], and as a contrast, woman in the position she occupies today." Cassatt completed the *Modern Woman* mural (fig. 9.5) (lost; the accompanying *Primitive Woman* mural commission went to Mary Fairchild MacMonnies), which drew on the concept of "feminization" of culture, already celebrated as an antithesis to industrial modernity by cultural critics.[23] In a letter reminiscent of Rubens's discussions of his planning for Marie de' Medici, Cassatt wrote to Palmer (11 October 1892) to discuss her program, focused on women picking fruit from a tree (an emphatically positive spin to the traditional condemnation of Eve as the source of the Fall):

> I took for the subject of the central and largest composition *Young Woman Plucking the Fruits of Knowledge and Science* and that enabled me to place my figures out of doors and allowed of brilliancy of color. I have tried to make the general effect as bright, as gay, as amusing as possible. The occasion is one of rejoicing, a great national fête. . . . An American friend asked me in rather a huffy tone the other day 'Then this is woman apart from her relations to man?' I told him it was. Men I have no doubt, are painted in all their vigor on the walls of the other buildings; to us the sweetness of childhood, the charms of womanhood, if I have not conveyed some sense of that charm, in one word, if I have not been absolutely feminine, then I have failed.[24]

Once more, echoing Rubens, an idealized image of fecundity as well as the flourishing of arts and sciences provides an allegory of female virtue and so-

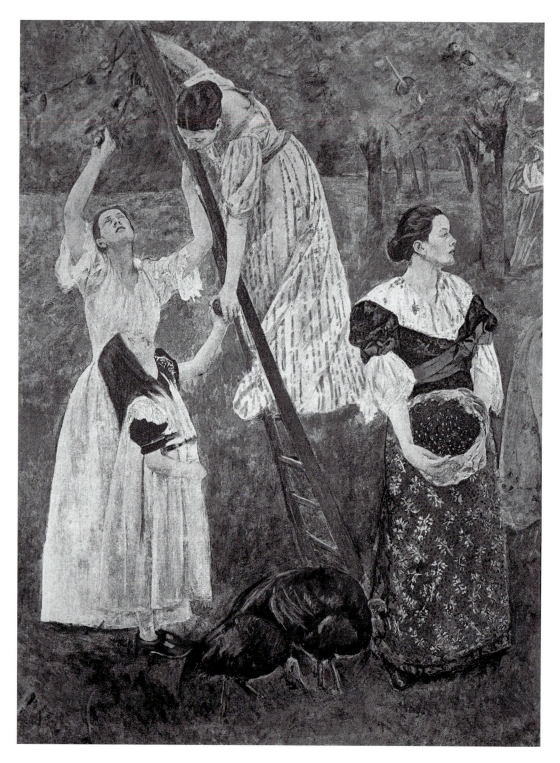

FIG. 9.5. Mary Cassatt, *Modern Woman*, Woman's Building, Columbian Exposition, Chicago (lost) (Chicago History Museum, Chicago)

cial contribution, here refashioned for a queenless democracy into a seemingly everyday setting. Female accomplishment was again the goal, made more explicit in flanking scenes, again in the words of Cassatt to Palmer: "I will still have place on the side panels for two compositions, one, which I shall begin immediately, is young girls pursuing fame. This seems to me very modern & besides will give me an opportunity for some figures in clinging draperies. The other panel will represent the Arts, Music . . . Dancing & all treated in the most modern way."[25] Paradoxically, in late Victorian society this feminine world—mixing different ages as well as both work and play in modern dress—finds fulfillment only in the depiction of a private, garden realm, yet the depiction itself is a mural on a grand scale (fourteen by fifty-eight feet) and presented in a major world exposition.

Bertha Palmer's patronage of a contemporary artist in France remained entirely consistent with her aesthetic predilections. She was one of the most ardent admirers and early purchasers of French Impressionist pictures, and her acquisitions eventually formed the nucleus of the great collection of the Art Institute of Chicago. Beyond this, she proselytized for the new art movement both with local friends and with her social peers in other cities, such as Louisine Havemeyer (see below). Her sale of some of these pictures over time (often at a real profit) made her the equivalent of an indirect art dealer, and helped her refine her collection. These activities also served her activist politics, as they raised money for her favorite causes.[26] The Woman's Building of 1893 was a brief episode to signal the cultural contributions and the social marginalization (at least from the official corridors of power, including cultural institutions) of such committed and prominent women as Bertha Palmer.

Her New York contemporary, Louisine Elder Havemeyer (1855–1929), offers a further index of the contributions, often roundabout, that these women could make. Wife of a sugar magnate, H. O. Havemeyer, Louisine Havemeyer met Mary Cassatt as a young woman in Paris in 1874 and maintained a life-long, half-century close friendship.[27] Havemeyer was the collector who most directly and constantly received the aesthetic counsel of Cassatt. Indeed, Cassatt helped build her remarkable collection of Impressionists and old masters, eventually housed permanently in the Metropolitan Museum.[28] As a fervent suffragist, Havemeyer sponsored an important fund-raising (and consciousness-raising) exhibition at Knoedler Gallery in New York in 1915, featuring the art of Cassatt as well as Degas and Dutch old masters, on behalf of the women's suffrage cause.[29] Havemeyer also wrote the introduction to the catalogue for the 1927 memorial exhibition to honor Cassatt in Philadelphia, and she had been one of the earliest collectors of the artist's works as well as a Cassatt advocate to her own circle of friends.[30] Despite all her stature and her activism, Mrs. Havemeyer, like Mrs. Palmer, never was admitted to the clubby all-male boardrooms of the Metropolitan Museum she did so much to enhance.

If, however, we consider her suffragist exhibition of 1915 as an act of perfor-

mance art, a public action, then we can again see an example of the concept of signaling. Louisine Havemeyer thereby offered a gesture that only someone with both her social prestige and her significant personal art collection could arrange: "It goes without saying that my art collection had also to take part in the suffrage campaign. The only time I ever allowed my pictures to be exhibited collectively was for the suffrage cause."[31] The original site for the exhibition was planned at the New York offices of Durand-Ruel, principal Paris gallery of Cassatt as well as Monet and a frequent purveyor to Havemeyer. Initially she chiefly planned to feature Degas pastels from her own collection, their only exhibition together. Thereafter, she called on her social connections to solicit loans of significant artworks from other major private collectors, including Cassatt, who loaned from her personal collection as well as her own creations. The event resembled celebrity charity events of today, sponsored by movie stars, popular musicians, or renowned athletes, and Havermeyer's talk on Degas and Cassatt was itself a unique event, which generated considerable public interest. "The cause" remained paramount for the sponsor, Havemeyer. More-over, the exhibition really was an argument of sorts, at once proving that Degas and his friend Cassatt both derived from and deserved comparison to the great old masters of major museums (which were now in the proud possession of American collectors). It also proved that America could be justly proud of a favorite daughter who emigrated to France and made good as an artist. Fi-nally, it underscored the important new role of women artists within the Im-pressionist movement, where Cassatt was seconded in Paris by the likes of Berthe Morisot and Eva Gonzales.[32] This exhibition was a form of salesman-ship, sponsoring the intimate, feminine figures and domestic spaces by Cassatt within an elite company of artists and before an elite audience of collectors, while also advocating the greater cause of suffrage itself within high society by associating it with the signaling displays of taste and prestige conferred by art collecting among such prominent socialites. In effect, this politically motivated event was a short-term, personal staging of art, like the Woman's Building of 1893 but also akin to the permanent museum display by Isabella Stewart Gardner.

Testimony to the success of the event was given by Cassatt herself on behalf of her lifelong friend: "Now you are destined to accomplish something and I have probably been a help, just as you and Mr. Havemeyer have been to me. The constant pre-occupation with your collection developed my critical faculty. . . . You will be [an] anchor till the last, perhaps I may too."[33] No stretch-ing here, however; the art of both Degas and Cassatt, now firmly enshrined in the pantheon of painters, was justly celebrated on this occasion, abetted by a female collector-impresario who was also a tireless champion of the suffrage movement.

Often signaling, signposting, or stretching in a work of art emerges most clearly when the painter has himself for a client—in self-portraits.[34] A primary example stems from the period of Rubens in the culminating work in the renowned career of his younger contemporary, Diego Velázquez (1599–1660). In his enormous canvas of the royal family with a self-portrait, normally known today as *Las Meninas* (fig. 9.6) ("The Ladies-in-Waiting"; Madrid, Prado, 1656), Velázquez shows himself at his easel, at ease in the presence of the princess and heiress to the royal house of Spain, Infanta Margarita, with her parents, King Philip IV and his young queen, Mariana of Austria, visible in the reflection of the mirror on the back wall of the depicted room.[35] Yet the activity of a painter, particularly as a paid profession, was considered vulgar and literally ignoble in the court of Spain. Velázquez had advanced by this point to a distinguished level of eminence as a courtier; he and his counterpart in the picture, José Nieto, silhouetted in the bright frame of the opposite rear doorway, both served in the privileged role of *aposentador mayor de palacio*, chief chamberlain to the palace for the king and queen, respectively. Velázquez had advanced from "painter to the king" (1623) to usher of the chamber (1627) to assistant in the wardrobe (1636) to assistant in the privy chamber (1643); finally his rank culminated as he became, in 1652, the master of palace decorations, *superintendente de obras particulares* and *aposentador*.[36]

Yet with all these titles and preferment and with all his privileged association with the king and the royal family, commemorated in the painting *Las Meninas*, Velázquez still held the lifelong ambitions of a social climber. He longed to be a member of the exclusive noble Order of Santiago, originally dedicated to the warrior knights of the Reconquista, the Spanish crusade against the Moors. To gain admission to this aristocratic military brotherhood, however, required purity of noble blood as well as support from previous (noble) members. The artist managed to get the first supporting letter on his behalf during a 1649–50 trip to Rome from one Cardinal Panciroli, an admirer of his skills as an artist, who wrote to the papal nuncio in Madrid.[37] The requisite royal nomination was finally provided in June 1658, followed by extensive scrutiny of his genealogy and social background, particularly in light of the proscription of anyone who had ever practiced a manual occupation (defined as including such tasks as silversmiths and painters as well as "scribe[s], except for royal secretaries"). The painter was investigated from November 1658 until mid-February 1659, as he provided 148 witnesses to his noble family stock as well as his financial independence from accepting fees for painting. Rejected by the council, the artist had to seek special dispensation from both king and pope. He finally succeeded in gaining admission to the Order of Santiago on November 28, 1659, the year before he died.

Thus *Las Meninas* provides more than a likeness and a celebration of the

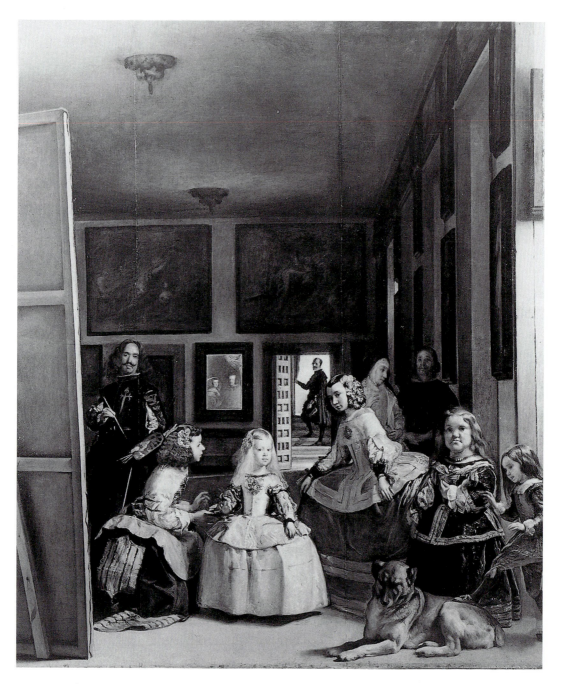

FIG. 9.6. Velázquez, *Las Meninas*, Museo del Prado, Madrid (Museo Nacional del Prado, Madrid)

courtier role of the "painter of the king." Here the artist is literally the "mirror of princes," not merely the immortalizer of his royal patron.[38] Yet he also fudges the reality of his own social status by adding to his doublet the dramatic red cross of the Order of Santiago, even though the painting itself was completed in 1656, three years before he finally was admitted! The eighteenth-century

chronicler of Spanish art Antonio Palomino describes the self-portrait of the painter in this picture in the following terms:

> On the other side is Don Diego Velázquez painting; he has a palette of colors in the left hand and the brush in his right, the double key of the Bedchamber and of Chamberlain of the Palace at his waist, and on his breast the badge of Santiago, which was painted in after his death by order of his Majesty; for when Velázquez painted this picture the King had not yet bestowed on him that honor. Some say that it was His Majesty himself who painted it for the encouragement that having such an exalted chronicler would give to the practitioners of this very noble art. I regard this portrait of Velázquez as no lesser in art than that of Phidias, famous sculptor and painter, who placed his portrait on the shield of the statue of the goddess Minerva that he had made . . . so too that of Velázquez will endure from century to century, as long as that of the lofty and precious Margarita endures, in whose shadow he immortalizes his image under the benign influence of such a sovereign mistress.[39]

Palomino, a well-informed courtier in his own right, spoke in 1725 with just as much enthusiasm and empathy for Velázquez as the artist himself could have done; his panegyric, if anything, boldly exaggerates the significance of both the painter and this master painting, which the author extols by citing the posthumous praise given to it by a fellow painter, Luca Giordano: "the Theology of Painting."

Thus Velázquez, the courtier-painter, was quite literally stretching the truth across his breast when he arrogated to himself the cross of Santiago, when he had not yet received the honor but had expectation of it.[40] His very claim to have painted without remuneration was itself patently an extreme stretch, depending on his definition of court duties, including art, intended to garner that admission to the aristocracy. The stretch was detected; the claim was rejected by the screening committee of the order. Yet his matchless role as a court painter who was given the exclusive right, like Apelles with Alexander the Great, to paint the likeness of his king was no stretch at all. Neither was his ascending sequence of court appointments—and both true accomplishments, as Palomino makes clear, are visibly signaled in this picture by the attributes he bears.

Social position often inflected the self-presentations by Rubens—very much the courtier as well as the painter of royalty—over the span of his career. Shortly after his return to Antwerp from almost a decade in Italy (where he had already occupied a position as court painter, to the Gonzaga in Mantua, and undertook a diplomatic mission for them to Spain), he took a bride from a socially prominent family and produced a double portrait of them both in a honeysuckle bower (fig. 9.7) (ca. 1609–10; Munich, Alte Pinakothek).[41] Isabella Brant, whom he married, was the daughter of Jan Brant, one of the city secretaries, a man both wealthy and cultured. By this time Rubens himself had already been designated as a court painter to the regents in Flanders,

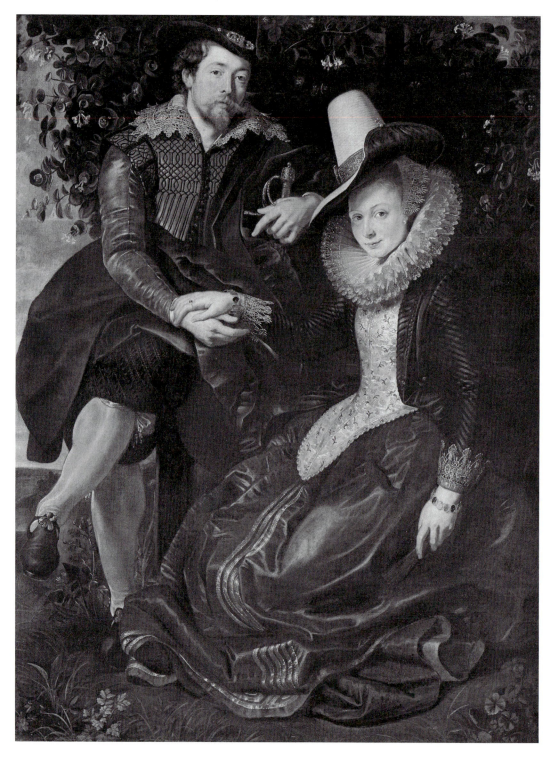

Fig. 9.7. Rubens, *Self-Portrait with Isabella Brant*, Alte Pinakothek, Munich (Bridgeman Art Library, London). © Alte Pinakothek, Munich / Giraudon / The Bridgeman Art Library

Archduke Albert and Isabella, although (unlike Velázquez with Philip IV) they did allow him to remain in Antwerp and pursue a private career instead of moving to their court in Brussels.[42]

In the large Munich painting, the rich and fashionably elegant dress of the couple bespeaks their social standing as well as the formality of the portrait occasion. Significantly the artist chose not to portray himself in professional terms, as Velázquez did in *Las Meninas*, but presents himself instead entirely as a gentleman, bearing a sword and carrying himself with noble ease in a garden precinct that implies property ownership. Even his casually crossed leg repeats a posture usually offered in medieval art either by allegorical personifications or else by princes. His learning and sophistication emerge further from his choice to depict honeysuckle, a sweet-smelling and clinging vine that symbolized true love in emblem books of the later sixteenth century (such as Andrea Alciati's book, under the category *in fidem uxoriam*, "in wedded fidelity"). Marital harmony is conveyed through an exquisitely balanced composition, in which each partner subtly inclines toward the other, outer arms like parentheses. Of course, the conjoined right hands of the couple reinforce their wedding ritual (an enduring modern practice), even as the higher seat of Rubens and his location on the heraldically superior side, on the viewer's left, point to a gendered dominance of the male in the marital bond.

Many of these same elements endure in Rubens's final self-portrait (ca. 1639; Vienna, Kunsthistorisches Museum), probably made about a year before he died.[43] He still asserts his prerogatives, now as a titled nobleman from several monarchs, instead of presenting himself as a painter. His position beside a sturdy column echoes the conventions of court portraits of kings or emperors, his own distinguished clients; the glove and sword mark him as an aristocrat.[44] The sagging flesh of his face betrays his age and declining health, but his oblique pose and forthright gaze combine to show another variant of his combined courtliness and self-possessed dignity. Again, the size of the picture and its three-quarter length further signal the importance and aloofness of this figure.

Nicholas Poussin (1594–1665), a French resident in Rome despite repeated calls from the French monarch to return to Paris, was another contemporary of Velázquez. Poussin would not normally have painted any self-portrait, but he was urged to send his likeness to his most important patron in Paris, Paul Fréart de Chantelou, and then eventually gave up trying to find any other portrait specialist to his liking. Once he broke down and finished one himself for Chantelou (1650; Paris, Louvre) (fig. 9.8), he was pressed into making a second version for another patron, Jean Pointel (now in Berlin).[45] Here, rather than presenting himself as a courtier, Poussin devised for his patron Chantelou a self-promotion that comes entirely from the dignity and learning of the artist-sitter, as well as his association with his esteemed patron and friend: "The prominence you want to give my portrait in your house greatly increases my debt

to you. It will hang there as worthily as did the picture of Virgil in the museum of Augustus. I shall be just as proud of it as if it were in the collection of the dukes of Tuscany with the Leonardos, Michelangelos, and Raphaels." The Latin inscription on an otherwise empty canvas behind the painter labels him: "Effigy of Nicolas Poussin, Painter from Andelys. Age 56. In Rome, Jubilee Year 1650." That canvas stands in for the effigy beside it; at the same time, it catches the fictive shadow of the artist and seems to underscore that a painting can only be the shadow of actual presence and of true friendship. Here courtliness reigns supreme, just as fully as in the flattering letter in which Poussin confidently compares himself to Virgil as the servant of the emperor as well as to the great Renaissance artists prized within ducal collections. Although Poussin was already appointed premier painter-in-ordinary to the king of France as well as being a member of the Roman Academy of St. Luke, none of his titles is affixed to his likeness.[46] Poussin's oblique pose with frontal gaze echoes (in reverse) the courtly composition of the older Rubens self-portrait, but now at half length and enframed by stacked canvases in golden frames. This device underscores the cool distance of the sitter (perhaps the embodiment of his physical distance from France, even as he notes his birthplace) and his placement within formal constraints. There are some subtle, coded indices of rank and status. The dark costume and book held by the artist echo a portrait of Simon Vouet, designed by another artist-courtier, Anthony van Dyck, and included in his portrait prints of fellow artists, the *Iconographie* (1641). Vouet was Poussin's Rome-based predecessor at the court of Louis XIII, and the book he held in his hand was a treatise on painting (Romano Alberti, 1585). Poussin also holds a volume in both of his self-portraits, further indicating his role as a learned painter.

The one subject that can be made out from the surface of a partly visible canvas behind the painter is a single figure: the personification of Painting, Pittura, marked with an eye on her crown. She reaches out toward the hands of a male figure in a mutual embrace, as if to suggest that the artist as producer is being reciprocated by the sophisticated judgment and mutual comprehension of his sophisticated friend and client. This background image underscores the difference between simple likeness and true presence, between mere seeing and the ability to look with deep attention, and to perceive beauty. It provides a visual commentary on the very act of presenting a self-portrait to such a discerning patron and friend as Chantelou.

When the most famous woman painter of the seventeenth century made a self-portrait (ca. 1638–39; Hampton Court, Royal Collection) (fig. 9.9), Artemisia Gentileschi (1597–ca. 1652) was able to fuse her own likeness with that same female personification of Pittura, which had remained distinct in Poussin's *Self-Portrait*.[47] Like Velázquez, this woman artist is busy with her brush and palette, and is working at a large canvas on an easel just beyond the confines of the frame. Like many court artists (e.g., Anthony van Dyck),[48]

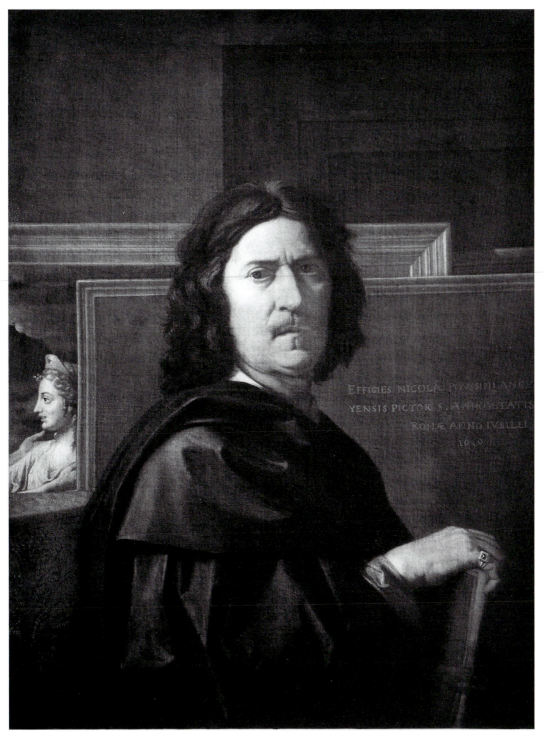

FIG. 9.8. Poussin, *Self-Portrait*, Musée du Louvre, Paris (Archivi Alinari, Florence)

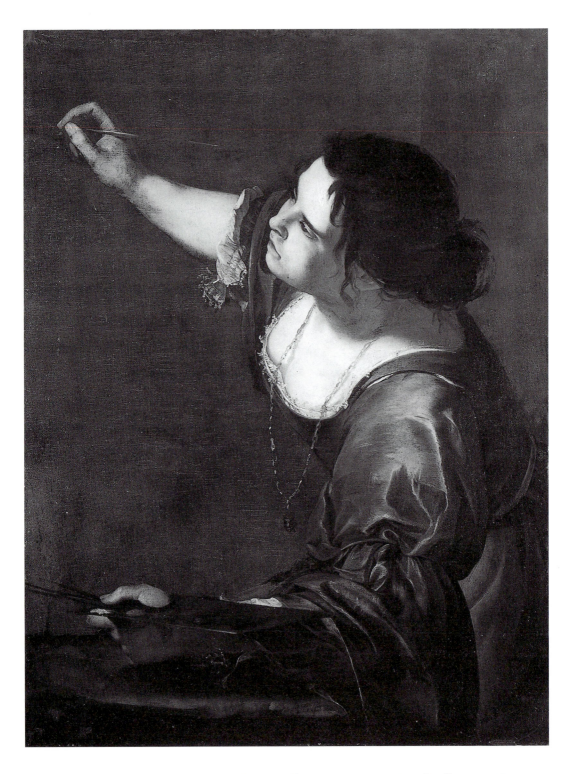

FIG. 9.9. Artemisia Gentileschi, *Self-Portrait as Pittura*, Royal Collections, Hampton Court (Royal Collection, London). The Royal Collection © 2005 Her Majesty the Queen Elizabeth II

she wears a chain of honor around her neck as the mark of her status and nobility, but this attribute might as easily refer to the emblems of Cesare Ripa, whose *Iconologia* (1603) assigns a chain to the personification of Pittura. More specifically, in Ripa's delineation, Pittura's chain bears a mask, like the chain worn by Artemisia in her self-portrait.[49] This allegory again serves to confirm the learning and the prestige of painting as a liberal art, sister of the traditional liberal arts.[50] Thus the female artist signals her own status as well as the status of her profession simultaneously, taking advantage of her sex to fuse her identity with Painting itself.[51]

Following in this European tradition, Rembrandt van Rijn (1606–69) eagerly embraced the idea of self-portraiture, almost always with a shifting vocabulary of costume and gesture to present himself in a succession of roles.[52] Here we see frequent recourse to some forms of signaling, but there is little explicit reason to imagine that the truth content of these roles should be subject to judgment about whether stretching is involved. Indeed, Berger insists that all portraits involve considerable posing in this sense of role-playing, what he calls "fictions of the pose." Rembrandt is exemplary in this regard, since he so often acts the part one would expect from a paying client, painter as patron. In general, Rembrandt seems to have wanted to be recognized for aspects of his character, such as gentility (or its opulent inverse, self-indulgence and vulgarity) or piety. Since his self-representations have been the subject of entire exhibitions and monographs, this topic is too vast and complex to be treated adequately here, but each of these poses can at least be sketched briefly in order to suggest how this most versatile, even protean, of artists shifted his persona in each new work. We do not often know the audience for these works; however, in a few cases it is clear that the fame of the artist was confirmed by the high status of the collectors of his self-portraits, which in turn added a form of prestige and luster to those collections, since the artist, increasingly regarded as a cultural celebrity, had bestowed a personal gift (like Poussin) or provided a purchase that revealed both his likeness and a sample of his virtuosity.[53]

Rembrandt-the-gentleman (and Rembrandt the fop) dominated many of the earlier self-portraits, beginning with the painting *Self-Portrait with Gold Chain* (1629; Boston, Gardner Museum) (fig. 9.10).[54] He certainly can be accused of stretching when he shows himself with gold chains as well as feathered berets, since, unlike Rubens, van Dyck, or Velázquez, he was never knighted.[55] But here the tension of ambition, negotiated successfully (eventually) by Velázquez, is being played out through role-playing, even fantasy. As Berger concisely notes about Rembrandt's painted chain: "He bestows it on himself." There are other self-portraits displaying excessive costume elements or ostentatious attributes, such as *Self Portrait with Turban and Poodle* (1631; Paris, Petit Palais).[56] Another Rembrandt image that affects the manners and privileges of landed gentry is *Self-Portrait with Bittern* (1639; Dresden), in which the artist, attired in a jaunty feathered beret and earrings but seemingly

captured in shadow during an informal, fleeting moment, holds up a large game bird, the trophy of a hunt.[57]

At the height of both his income and his self-confidence, Rembrandt produced a pair of self-portraits—an etching (1639, B. 21) and a painting (1640; London, National Gallery)—that synthetically fuse two celebrated pictorial models of courtly sitters by prestigious sixteenth-century Italian artists, works seen by Rembrandt at auction in Amsterdam: Raphael's *Castiglione* (Paris, Louvre) and Titian's *Man with a Blue Sleeve* (London, National Gallery).[58] As a further signaling element, Chapman cites Rembrandt's use of military neck armor, or gorgets, in his self-portraits, claiming that they are an index of valor and patriotism; however, these often appear in combination with chains or berets and seem instead to be self-deprecating markers of rather disreputable military libertinism.[59]

The "embarrassment of riches" (to use a phrase evoked by both Simon Schama and Harry Berger) appears in various Rembrandt self-portrait images of excess, but later works provide more of a self-parody without the berets, chains, or gorgets. In particular the large image (larger than the portrait of Jacob Trip, the richest man Rembrandt ever painted) of his 1658 *Self-Portrait* (New York, Frick Collection) (fig. 9.11) follows up on the pretense of the 1631 Petit Palais image but without the turban and poodle.[60] Redolent of an oriental potentate, his three-quarter-length, frontal, seated pose presents a commanding presence like that of a ruler enthroned, and the painter's maulstick in his left hand apes a scepter, as if to suggest that his real power comes from simulation and this kind of posing and role-playing. This work also employs bold, bright colors and lively, self-conscious brushwork in an act of painterly self-assertion, usually compared to the style of Titian and the Venetians. The picture is a manifestly theatrical stretch, even as it signals Rembrandt's assimilation of Venetian grandeur in terms of both forms and subjects (we recall that Venice is the original home of Mediterranean "orientalism," with a favorite "orientation" towards the Ottoman Turks in the Levant, a turn picked up even by the visiting Albrecht Dürer).[61]

Piety is a quality that Rembrandt very seldom signaled in his self-portraits, though one early self-portrait with his wife, Saskia, simulates the excesses of *The Prodigal Son in the Tavern* (ca. 1635; Dresden, Gemäldegalerie).[62] In later years, however, he again used his own features for the *Self-Portrait as St. Paul* (1661; Amsterdam, Rijksmuseum), the first work in which Rembrandt assumed the identity of a historical figure in a true *portrait historié*.[63] The Saint Paul role is secured by two attributes—a sword hilt, indicating the instrument of the saint's martyrdom, combined with the large open roll of papers in the hand of the evangelist. Again the millinery is a turban, fully identified here with the Near East. Recent interpretation identifies the sword with Paul's own metaphor, the "sword of the Spirit," and the dramatic light behind the sitter with the metaphor "light in the Lord" (Ephesians 6:17, 5:8). It is tempting to see

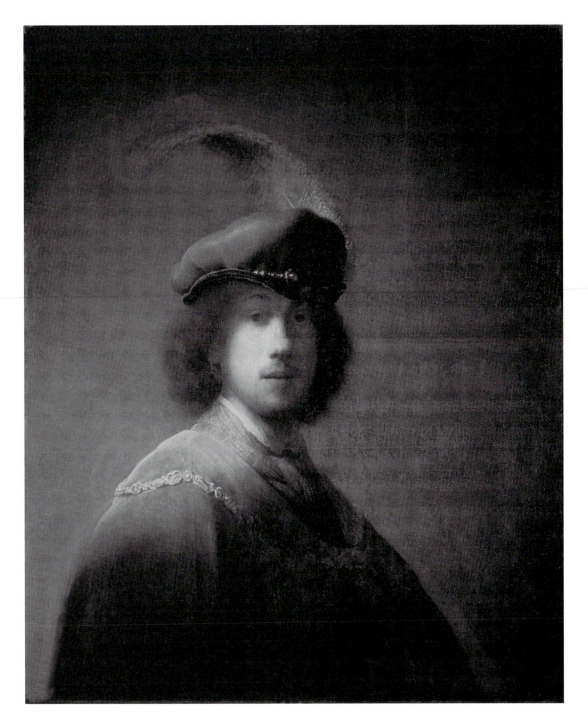

Fig. 9.10. Rembrandt, *Self-Portrait with Gold Chain*, Isabella Stewart Gardner
Museum, Boston (Bridgeman Art Library, London). © Isabella Stewart Gardner
Museum, Boston / The Bridgeman Art Library

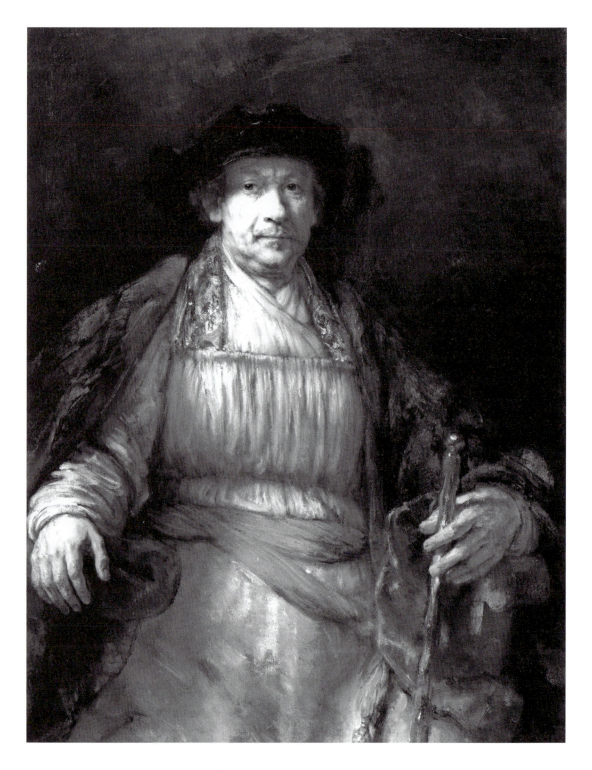

FIG. 9.11. Rembrandt, *Self-Portrait*, Frick Collection, New York (Frick Collection, New York). © The Frick Collection, New York

Rembrandt viewing himself frankly through this most inward of all followers of Christ as an aging sinner in need of grace, but we must recall that this image is as much a pose in a role as is the identification of Marie de' Medici as the enthroned allegory of Justice or as the triumphant goddess Minerva Victrix.

Sites for Sights

"The very rich are different from you and me" (Fitzgerald) seems to be precisely the point for all who wish to assert their distinctions, especially through conspicuous expenditure of wealth, but also frequently through cultural terms that signal status and power. Further, they often control the very environments in which such self-presentations are staged. Both the architecture and the ornament of those locations add an additional, framing layer that signals either the erudition or the splendor of a patron, or both.

We have already encountered one such site as a place marker of royal magnificence: the Luxembourg Palace in Paris, personal precinct of Marie de' Medici and location of the grand Rubens cycle.[64] The queen originally intended to make her Parisian residence a replica of the Pitti Palace in her native Florence, and already in 1611 she wrote to her aunt requesting measured drawings of the Pitti. She would later refer to the Luxembourg as the "Palazzo de' Medici," so she clearly identified with it and made a personal effort to tailor it to her own specifications. After construction began in 1615, however, local French palace models prevailed under the direction of a distinguished professional architect, Salomon de Brosse (1578–1626). These featured a central courtyard within two main wings and a street façade; lower-level rustication alludes to the model of the Pitti. For his gateway, de Brosse actually employed a novelty from Italy: a dome, echoing the advanced architecture of Bramante and Michelangelo. In general, however, the structural vocabulary of this French building makes informed uses of classical models to achieve the same kind of grandeur and cultural prestige as Rubens produced in paint.

The modern equivalent of such a personal palace with allusions to a glorious past is Isabella Stewart Gardner's private museum, unsubtly designated as Fenway Court.[65] As is so often the case with important buildings, "location" looms large. The Fenway itself was a major project of urban renovation, designed after 1878 by master landscape architect Frederick Law Olmsted to provide a park environment out of the Back Bay fens; the new Fenway Court was one of the earliest and most imposing of the buildings to anchor the region (the nearby Boston Museum of Fine Arts, in classical style like a "palace for the people," arrived in the neighborhood later). Just as Marie de' Medici began her palace after the death of her royal husband, Mrs. Gardner also began to realize her project shortly after her spouse's fatal stroke. Also like Marie de'

Medici, she planned the design and intensely managed the site details, assisted by architect Willard Thomas Sears. This additional intervention for a personalized structure signals personal talents well beyond the wealth and taste necessary for securing an architect.

At Fenway Court, the Venetian palazzo imagery of the building even extended to traditional structural engineering, including the driving of supporting piles deep into the soft landfill. Informed innovation led to the placement of external façades around the interior courtyard, which uses skylights to provide natural light throughout. Nostalgia and tradition further informed the technique of construction, which (on Mrs. Gardner's insistence) renounced the use of steel to conform to Renaissance building procedures. Her obsessive attention to detail extended to all aspects of layout and decoration, so much so that her restrictive will forbids any and all changes in the location of objects on display.

To complete this use of selected buildings as further instances of signaling, we can return to an artist whose self-portraits we have already examined: Peter Paul Rubens. Although restored, even reconstructed (especially 1938–46), his home speaks articulately about both the learning and the vision of its wealthy, noble, and distinguished artist-designer.[66] Constructed between 1610 and 1618, this imposing residence with an enclosed garden was modeled on Italian patrician homes and used a classical vocabulary fairly close to that of de Brosse. Along the garden Rubens added a semicircular room, based on the design of the Pantheon in Rome, to display his own private collection of ancient sculptures, chiefly busts, in niches. The open courtyard space enclosed by the house and studio was separated from the garden by a stone screen designed for the site. Divided into three arched openings, the screen featured statues of a pair of Olympian gods as protectors of the area: Minerva, goddess of wisdom and learning and patron of the arts, and Mercury, god of eloquence and reason as well as protector of commerce. These two gods had previously adorned the decoration of Cicero's villa at Tusculum, a retreat dedicated to learning, literature, and philosophy. In Rubens's garden pavilion a figure of Abundance presided, accompanied by statues of Hercules and Venus, further complemented by statues on the side of the studio opposite, Bacchus and Flora. As in the cycle for Marie de' Medici, all these classical divinities serve as presiding spirits, representing desirable qualities in the artist's creative endeavors as well as his earned leisure.

Across from the sculpture space and adjacent to the core of his house proper, the artist built his large, two-story studio space, very much in the architectural vocabulary of Italy. Documented in a pair of engravings by Jacob Harrewijn (1684, 1692; which show the renown already attained by Rubens's house), this unit featured broken pediments over the large arched windows and rich carvings on the outer walls, including ancient busts (particularly Rubens's beloved Seneca).[67] Even more striking was the inclusion across the top of this façade

of painted reliefs, probably in gray tones (grisaille), which were Rubens's own re-creations of celebrated ancient paintings, known only from classical verbal descriptions (*ekphrases*). Classical texts from Juvenal completed the elaborate façade adornment.[68] These antique references underscored Rubens's own extraordinary learning and his deep personal engagement with the heritage of ancient art, which he re-created through his remarkable familiarity with classical sculptural vocabulary, studied on site in Rome.[69] The artist was proud of his own role in translating classical art from the past to the present and from Rome to his hometown of Antwerp, and his house and courtyard formed a villa, site of contemplative virtue as well as pleasure as an earned respite (Cicero's *otium*). Rubens was one of the most learned and best-informed art historians of all time; while he had few peers, in setting up his own home environment he provided erudite references and a sophisticated ensemble for those visitors who could share his elite vision.

Rubens had ample precedent for this combination of lavish yet learned decorative signaling on the exterior of his house. In Mantua, where Rubens served as court artist for the Gonzaga dukes (1600–1605), he could have seen a statue of Mercury above the door and painted relief sculptures in the interior salon at the house of his predecessor in that role, Giulio Romano. (See also the essay by Kelley Helmstutler Di Dio on the façade of Leoni's house, chapter 7 in this volume.) In Antwerp itself, the most famous artist's house of the sixteenth century, belonging to Frans Floris (active 1547–70), was noted for its painted exterior program.[70] In this case, now lost, descriptions tell us that the figures were painted yellow, and drawn copies show represented single figures in niches below the cornice, with a gathering of allegorical figures above. These single figures have been identified as Diligence, Practice, Poetry, Architecture, Labor, Experience, and Industry. The group of allegories focuses on the principals of visual art, Pictura and Sculptura, who frame a central, crowned personification whose identity has been disputed but is probably Theoria, the precept of measure and learning, seated on a sphere and holding a large compass.

Rubens, so knowledgeable about Italian art, which he studied on site, soon went on to compose his own treatise, *The Palaces of Genoa* (1622), which clearly reveals his self-consciousness about his own personal choice of classical building vocabulary for his house (in words and references that might well apply to de Brosse as well):

We see how the architectural style called barbaric or gothic is becoming more and more obsolete and is vanishing here. We see how a few outstanding minds are introducing proper symmetry in accordance with the rules of the ancient Greeks and Romans. This does honor to and beautifies the homeland. . . . Above all, the dignity of service to God merits our devotion to better things. Yet we should not neglect private architecture, which on the whole constitutes the city's physiognomy, especially since the convenience of buildings is almost always in harmony with their

beauty and fine form. . . . Since the nobleman reigns in the republic of Genoa, his houses are very beautiful and comfortable. They are more suited to a single noble family—even though it might be large—than to the household of a ruling prince. Examples of this type are the Pitti Palace in Florence, the Farnese Palace in Rome, the Chancellery, Caprarola, and a multitude of other palaces in Italy, as well as the famous palace of the Queen Mother on the outskirts of Paris at Saint-Germain [= Luxembourg Palace]. The size, layout, and costliness of all of these exceeds the wealth of an independent nobleman. . . . I specify that the construction of a prince's palace have a central courtyard encircled by the buildings, the kind of construction which can accommodate a whole princely household.[71]

Rubens lays out the cultural significance of the choice and harmony of architectural style; he notes both the function and the conspicuousness of courtyard layout. No clearer statement of architectural signaling for a wealthy and powerful nobleman (or noblewoman) could be imagined.

This essay starts and ends with Peter Paul Rubens because no other artist ever attained the status and success that he did. What Harry Berger theorizes in *Fictions of the Pose* is the situation of an artist's self-representation, narrowly construed as the situation of his self-portrait, in which he acts as both painter and patron of a serious, if highly artificial and convention-bound, behavior. More broadly, that situation pertains just as dynamically and dialogically to the vital process of artistic signaling itself, in which an artist (or an architect) provides the proper image for his (or her, in the case of Artemisia Gentileschi or Mary Cassatt) client.

In the case of Rubens, all these roles converge: artist and portraitist, even architect, both for himself and for the most prominent and public people in Europe, including the crowned heads. Rubens was also a serious collector, whose amassed art (like Mrs. Gardner's) filled a private museum in his own palatial town house.[72] At once the most learned of art historians and versatile of artists, he understood how to use his erudition in the service of the task at hand—ever mindful of his specific situations and ultimate messages. Sometimes he stretched; often he selected and signposted in a campaign of public relations imagery (think Marie de' Medici). But always he managed to provide powerful and appropriate visual signals that showed both his prestigious patron as well as himself favorably, for the present and for posterity.

Notes

1. A good recent overview of Rubens is Kristin Belkin, *Rubens* (London: Phaidon, 1998), esp. 171–96. More comprehensive is Otto von Simson, *Peter Paul Rubens (1577–1640)* (Mainz: von Zabern, 1996), esp. 229–85. The latest monographs on the Medici cycle are Ronald Millen and Robert Wolf, *Heroic Deeds and Mystic Figures:*

A New Reading of Rubens' Life of Maria de' Medici (Princeton: Princeton University Press, 1989), and Martin Warnke, *Laudando Praecipere. Der Medicizyklus des Peter Paul Rubens* (Groningen, 1993). Also see Jacques Thuillier and Jacques Foucart, *Rubens' Life of Marie de' Medici* (New York: Abrams, 1969), and the articles by Geraldine Johnson, "Pictures Fit for a Queen: Peter Paul Rubens and the Marie de' Medici Cycle," *Art History* 16 (1993): 447–69, and Elizabeth McGrath, "Tact and Topical Reference in Rubens's 'Medici Cycle,'" *Oxford Art Journal* 3 (1980): 11–17.

2. For a penetrating analysis of Rubens's art production for male princes, see Margaret Carroll, "The Erotics of Absolutism: Rubens and the Mystification of Sexual Violence," *Representations* 25 (Winter 1989): 3–29, focusing on the *Rape of the Daughters of Leucippus* (1615–18; Munich, Alte Pinakothek). For the male-dominated court values of an earlier period and the issue of rape, see Diane Wolfthal, *Images of Rape: The 'Heroic' Tradition and Its Alternatives* (Cambridge: Cambridge University Press, 1999).

3. These mythic and abstract figures should be compared to other royal pageantry, including the staged masques, perhaps strongest in the Stuart court of Charles I and his French queen, Henrietta Maria, daughter of Marie de' Medici. See Stephen Orgel, *The Illusion of Power: Political Theater in the English Renaissance* (Berkeley: University of California Press, 1975); D. J. Gordon, *The Renaissance Imagination*, ed. Stephen Orgel (Berkeley: University of California Press, 1975). This royal wedding of Charles I with his French bride was celebrated with a feast (27 May 1625), sponsored by Richelieu in the Queen Mother's Luxembourg Palace, the same site as the painted cycle of Rubens, though whether that work was on view for the occasion has been disputed.

4. Ruth Magurn, ed., *The Letters of Peter Paul Rubens* (Cambridge, MA: Harvard University Press, 1955), 109–10 (italics added). On Pieresc and the cycle as well as Rubens as a diplomat in this period, see 81–86, and more recently Peter Miller, *Peiresc's Europe* (New Haven and London: Yale University Press, 2000).

5. For Rubens's oil sketches of the Henry IV cycle, see Ingrid Jost, "Bemerkungen zur Heinrichs-galerie des P. P. Rubens," *Nederlands Kunsthistorisch Jaarboek* 15 (1965): 175–219; Julius Held, *The Oil Sketches of Peter Paul Rubens: A Critical Catalogue* (Princeton: Princeton University Press, 1980), 123–36, for the Marie de' Medici sketches, 89–122.

6. Held, *Oil Sketches*, 119, no. 76.

7. Christiane Hertel, "*Veritas Filia Temporis,*" *Vermeer: Reception and Interpretation* (Cambridge: Cambridge University Press, 1996), 187–204, for Rubens, 191–98.

8. Cynthia Lawrence, ed., *Women and Art in Early Modern Europe: Patrons, Collectors, and Connoisseurs* (University Park: Penn State University Press, 1997): see especially Cynthia Lawrence, "Introduction," 1–20; Sheila ffolliott, "The Ideal Queenly Patron of the Renaissance: Catherine de' Medici Defining Herself or Defined by Others?" 99–110; Geraldine Johnson, "Imagining Images of Powerful Women: Maria de' Medici's Patronage of Art and Architecture," 126–53. Also, Sheryl Reiss and David Wilkins, eds., *Beyond Isabella: Secular Women Patrons of Art in Renaissance Italy* (Kirksville, Mo.: Truman State University Press, 2001).

9. This section is based on three principal studies: Kathleen McCarthy, *Women's Culture: American Philanthropy and Art, 1830–1930* (Chicago: University of Chicago Press, 1991), esp. 149–76; Wanda Corn, "Art Matronage in Post-Victorian Amer-

ica," *Cultural Leadership in America: Art Matronage and Patronage / Fenway Court* 27 (1997): 9–23; and Anne Higonnet, "Private Museums, Public Leadership: Isabella Stewart Gardner and the Art of Cultural Authority," ibid., 79–92. For a city-based study of Chicago during the same period, see Helen Horowitz, *Culture and the City: Cultural Philanthropy in Chicago from the 1880s to 1917* (Chicago: University of Chicago Press, 1976), which, however, curiously neglects Mrs. Potter Palmer (see below).

10. McCarthy, *Women's Culture*, 110–45; Christine Stansell, "Women Artists and the Problems of Metropolitan Culture: New York and Chicago, 1890–1910," *Fenway Court* 27 (1997): 25–37.

11. This is one reason why the standard study of Chicago philanthropy largely omits the significant contribution of Bertha Palmer; Horowitz, *Culture.*

12. Hilliard Goldfarb, *The Isabella Stewart Gardner Museum* (New Haven and London: Yale University Press, 1995), 6, quoting Ida Agassiz Higginson's recollection to Gardner of 1923.

13. Higonnet, "Private Museums." For the broader cultural picture, see Alan Trachtenberg, *The Incorporation of America: Culture and Society in the Gilded Age* (New York: Hill and Wang, 1982), esp. 144–47, on advocates and guardians of culture, products of the polarization of rich and poor as well as the increasing domination, or "feminization," of culture by the "beauty principle" of women: "The growing literature of domesticity must be counted along with the founding of museums and concert halls, the creation of public parks, and the spread of public schools, as part of a concerted middle-class effort to find in culture both pleasure and instruction" (146).

14. Elaine Kilmurray and Richard Ormond, *John Singer Sargent*, exhibition catalog (London: Tate Gallery Publishing, 1998).

15. Ibid., 136–39, cat. no. 47. No less an admirer than Henry James, who doubled as an art critic, described this Sargent portrait as a "Byzantine Madonna with a halo."

16. For a glorious contemporary art collection, assembled by a male robber baron of Philadelphia, Widener, see Esmée Quodbach, "'The Last of the American Versailles': The Widener Collection at Lynnewood Hall," *Simiolus* 29 (2002): 42–96, esp. 50, 73–74, for Gardner (and Havemeyer). On the taste for Velázquez, El Greco, and Spanish art, shared with the Havemeyers via Cassatt, 75–79; on the Dutch and Italians, with Mrs. Gardner, 79–90. The vogue for Dutch art in the later nineteenth century, when it was rediscovered through the eyes of Impressionism's brushwork and themes, is well discussed: Frances Jowell, "The Rediscovery of Frans Hals," in Seymour Slive, *Frans Hals*, exhibition catalog (Munich: Prestel, 1989), 61–86; Frances Jowell, *Thoré-Bürger and the Art of the Past* (New York and London: Garland, 1977); Hertel, *Vermeer*; Walter Liedtke, "Collectors and Their Ideals," in *Great Dutch Painting from America*, ed. Ben Broos, exhibition catalog (The Hague: Mauritshuis, 1990), 14–59.

17. The influence of Ruskin on American goals of self-betterment and culture as an agent of social improvement is well sketched by Horowitz, *Culture* , 5–7, 134–35. Note the response to a 1907 visit to Mrs. Gardner by Elsie de Wolfe, as quoted by David Curry, "Never Complain, Never Explain: Elsie de Wolfe and the Art of Social Change," *Fenway Court* 27 (1997): 57; Higonnet, "Private Museums," 83, notes Mrs. Gardner's personal motto, "C'est Mon Plaisir."

18. Higonnet, "Private Museums," 82. The author further notes, "Henry James called the activity of museum founders 'acquisition on the highest terms.'"

19. For a biography of Bertha Palmer, see Ishbel Ross, *Silhouette in Diamonds: The Life of Mrs. Potter Palmer* (New York: Harper, 1960).

20. McCarthy, *Women's Culture*, 131–35.

21. Jeanne Madeline Weimann, *The Fair Women: The Story of the Woman's Building, World Columbian Exposition, Chicago 1893* (Chicago: Academy Chicago, 1981).

22. Griselda Pollock, *Mary Cassatt: Painter of Modern Women* (London: Thames and Hudson, 1998), 35–67; Judith Barter, "Mary Cassatt: Themes, Sources, and the Modern Woman," in *Mary Cassatt: Modern Woman*, exhibition catalog (Chicago: Art Institute, 1998), 87–97.

23. Further to the feminization of culture, see Christine Stansell, "Women Artists and the Problems of Metropolitan Culture: New York and Chicago, 1890–1910," *Fenway Court* 27 (1997): 25–38.

24. Pollock, *Cassatt*, 41, 46; now specifically for the mural, see Sally Webster, *Eve's Daughter/ Modern Woman* (Champaign: University of Illinois Press, 2004).

25. Barter, "Mary Cassatt," 88.

26. In this respect it should be noted that Mary Cassatt advised wealthy, visiting American buyers in Paris not only on the Impressionist circle of which she was a part but also on available masterworks of the European past (such as the Art Institute's great El Greco altarpiece). In this respect she too was a tastemaker, just as fully as Bernard Berenson with Mrs. Gardner. Erica Hirshler, "Helping 'Fine Things Across the Atlantic': Mary Cassatt and Art Collecting in the United States," in *Mary Cassatt: Modern Woman*, 177–211, observed (199) that "Bertha Honoré and Potter Palmer of Chicago, . . . after the spectacular debut of their quickly assembled, private art gallery in 1893, began carefully to refine their collection," and that various Monets "had first been owned by the Palmers" (n. 62). For the Chicago El Greco, originally targeted for Philadelphia, New York, or Boston, 204–5.

27. Hirshler, "Helping," 189–91, 204–5.

28. Alice Cooney Frelinghuysen, *Splendid Legacy: The Havemeyer Collection*, exhibition catalog (New York: Metropolitan Museum, 1993), in particular Rebecca Rabinow, "The Suffrage Exhibition of 1915," 89–95, and Alice Cooney Frelinghuysen, "The Havemeyer House," 173–98, with less attention to the conventional architecture in Romanesque revival style by Charles Coolidge Haight but much more on the splendid interior ensembles, particularly with glass and mosaic by Louis Comfort Tiffany; Frances Weitzenhoffer, *The Havemeyers: Impressionism Comes to America* (New York: Abrams, 1986).

29. Kevin Sharp, "How Mary Cassatt Became an American Artist," in *Mary Cassatt: Modern Woman*, 169–70; Pollock, *Cassatt*, 210–12.

30. Sharp, "How Mary Cassatt," 158–59, 167–69.

31. Pollock, *Cassatt*, 207. Now see the important dissertation by Jennifer Criss on the women Impressionists (Mary Cassatt, Berthe Morisot, and Marie Braquemond) in relation to progressive Japoniste style and motifs (University of Pennsylvania, 2007). I am grateful to Jennifer Criss for thorough reading and criticism of this section of the chapter.

32. Whitney Chadwick, *Women, Art, and Society,* 2nd ed. (London: Thames and

Hudson, 1996), 231–42, with references; also Tamar Garb, *Women Impressionists* (New York: Rizzoli, 1986).

33. Cassatt to Havemeyer (15 April 1915), quoted by Weitzenhoffer, *Havemeyers,* 226; cited in *Mary Cassatt: Modern Woman,* 350. Louisine Havemeyer was arrested and jailed during a mass suffrage protest in Washington in February 1919.

34. Pascal Bonafoux, *Portraits of the Artist: The Self-Portrait in Painting* (Geneva: Skira, 1985); Richard Brilliant, *Portraiture* (Cambridge, MA: Harvard University Press, 1991), 141–74; for Italy, Joanna Woods-Marsden, *Renaissance Self-Portraiture: The Visual Construction of Identity and Social Status of the Artist* (New Haven and London: Yale University Press, 1998); for the Netherlands, Hans-Joachim Raupp, *Untersuchungen zu Künstlerbildnis und Künstlerdarstellung in den Niederlanden im 17. Jahrhundert* (Hildesheim: Olms, 1984).

35. On the artist, see Jonathan Brown, *Velázquez* (New Haven and London: Yale University Press, 1986), subtitled "painter and courtier," esp. 253–64; see also Brown, *Images and Ideas in Seventeenth-Century Spain* (Princeton: Princeton University Press, 1978), 87–110.

36. Brown, *Velázquez,* 187–88; Brown, *Images and Ideas,* 95, 103.

37. Brown, *Velázquez,* 208 note 40, 251–52; Brown, *Images and Ideas,* 103–10.

38. Joel Snyder, "*Las Meninas* and the Mirror of the Prince," *Critical Inquiry* 11 (1985): 539–72.

39. Antonio Palomino, *Lives of the Eminent Spanish Painters and Sculptors,* trans. Nina Ayala Mallory (Cambridge: Cambridge University Press, 1987), 165, 139–83. Brown, *Velázquez,* 257.

40. Because of the discrepancy between the date for the knighthood (1659) and the date of the painting (1656), there is still ongoing doubt about whether the artist (or someone else, though probably not the king, as Palomino claimed) added the cross later, well after his admission to the prestigious knightly order. Moreover, because of the importance of the artist's activity as a painter, his pose in *Las Meninas* assumes a key role in the interpretation of the picture. Technical study reveals an initial turn of the painter slightly away from the canvas, "the painter posing rather than the painter painting," according to Gridley McKim Smith, later altered slightly to the present, more active pose, which documents his "real pictorial activity within the approving presence of the royal family." See Gridley McKim Smith, Greta Andersen-Bergdoll, and Richard Newman, *Examining Velázquez* (New Haven and London: Yale University Press, 1988), 78–80. We must also acknowledge that the audience for this painting was reduced to a single, prestigious viewer, King Philip IV, for Brown notes that a palace inventory of 1666 places the picture in the personal office of the king (*pieza del despacho del verano*); Brown, *Velázquez,* 259, noting also, 257, about the cross: "It is impossible to test the validity of this [Palomino] statement [i.e., that the king himself added the Santiago cross] . . . because only four years had passed between the supposed date of completion and the death of the artist. Examination of the canvas after the recent cleaning (May–June 1984) seems to indicate that the brushwork of the cross is uniform with the rest of the surface. If this is so, and Palomino is correct about the subsequent addition of the cross, then this motif could have been added by Velázquez himself two or three years after the picture was painted."

41. Von Simson, *Peter Paul Rubens,* 114–17; Belkin, *Rubens,* 98–99.

42. Christopher Brown, "Rubens and the Archdukes," in *Albert and Isabella, 1598–1621: Essays,* ed. Werner Thomas and Luc Duerloo (Brussels: Royal Museums of Art and History, 1998), 121–28.

43. Von Simson, *Peter Paul Rubens,* 350–51; Belkin, *Rubens,* 153; Justus Müller Hofstede, "Peter Paul Rubens 1577–1640. Selbstbildnis und Selbstverständnis," in *Von Bruegel bis Rubens,* exhibition catalog (Cologne: Wallraf-Richartz Museum, 1992), 103–20. Another important Rubens self-portrait with a signposting assertion of the artist's affiliation with the Neostoic philosopher Justus Lipsius and two other associates, one of them the artist's deceased brother, Philip Rubens, is the *Four Philosophers* (ca. 1615; Florence, Galleria Palatina); Belkin, *Rubens,* 121–22, fig. 82.

44. Still valuable is Marianna Jenkins, *The State Portrait, Its Origins and Evolution* (New York: College Art Assn., 1947).

45. Elizabeth Cropper and Charles Dempsey, *Nicolas Poussin: Friendship and the Love of Painting* (Princeton: Princeton University Press, 1996), 145–50, 182–96, 204–5; David Carrier, *Poussin's Paintings: A Study of Art-Historical Methodology* (University Park: Penn State University Press, 1993), 2–46; Matthias Winner, "Poussins Selbstbildnis im Louvre als Kunsttheoretische Allegorie," *Römisches Jahrbuch für Kunstgeschichte* 20 (1983): 417–49; Matthias Winner, "Poussins Selbstbildnis von 1649," in *Il se rendit en Italie. Études offerts à André Chastel* (Rome: Edizioni dell'Elefante; and Paris: Flammarion, 1987), 371–401. Most recently, Todd Olson, *Poussin and France* (New Haven and London: Yale University Press, 2002), 74, compares the *Self-Portrait* sent to Chantelou in 1650 to "an epistle, constituting the personal relationship between artist and patron."

46. These very titles are explicitly included in the Berlin *Self-Portrait* for Pointel, which conspicuously omits the background canvases of the Chantelou version and instead features sculpture in the form of a tomb memorial rather than painting: "Nicolaus Poussinus Andelyensis Academicus Romanus Primus Pictor Ordinarius Ludovici Justi Regis Galliae. Anno Domini 1649. Romae. Aetatis Suae 55."

47. Mary Garrard, "The Allegory of Painting," *Artemisia Gentileschi: The Image of the Female Hero in Italian Baroque Art* (Princeton: Princeton University Press, 1989), 85–88, 337–70; R. Ward Bissell, *Artemisia Gentileschi and the Authority of Art* (University Park: Penn State University Press, 1999), 272–75, no. 42; Keith Christensen and Judith Mann, *Orazio and Artemisia Gentileschi,* exhibition catalog (New York: Metropolitan Museum, 2001), 417–21, cat. no. 81.

48. Christopher Brown and Hans Vlieghe, *Van Dyck 1599–1641,* exhibition catalog (Antwerp and London: Royal Academy, 1999), 244–45, cat. no. 66, discussing the *Self-Portrait with Sunflower* (ca. 1632–33, Duke of Westminster Coll.). Van Dyck was knighted by Charles I in 1632, at which time he was appointed "principal painter in ordinary to their majesties" and given a chain and gold medal.

49. "Painting is represented here by a beautiful young woman with black, curly hair, her mouth covered by a bandeau, and a golden chain round her neck with a mask dangling from it. In one hand she has several paintbrushes bearing the motto 'Imitatio' and in the other a picture. . . . The mask hanging from her neck on a chain signifies that Imitation and Painting are inseparable, and the links of the chain point to the close connection between the two. And through the mask one sees that Imitation is perfectly proper for painting"; see *Baroque and Rococo Pictorial Imagery: The*

1758–60 Hertel Edition of Ripa's 'Iconologia,' trans. and commentaries, Edward A. Maser (New York: Dover Publications, 1971), no. 197.

50. Rensselaer Lee, *Ut Pictura Poesis: The Humanistic Theory of Painting* (New York: W. W. Norton, 1967); Thomas DaCosta Kaufmann, "The Eloquent Artist: Towards an Understanding of the Stylistics of Painting at the Court of Rudolf II," *Leids Kunsthistorisch Jaarboek* 1 (1982): 119–48; Larry Silver, "Step-Sister of the Muses: Painting as Liberal Art and Sister Art," in *Articulate Images: The Sister Arts from Hogarth to Tennyson,* ed. Richard Wendorf (Minneapolis: University of Minnesota Press, 1983), 36–69; Clark Hulse, *The Rule of Art: Literature and Painting in the Renaissance* (Chicago: University of Chicago Press, 1990).

51. The sixteenth century also produced a leading woman artist, Sofonisba Anguissola (1532–1625), who trained in Cremona, Italy, but eventually became a leading portraitist at the Spanish court as lady-in-waiting to Queens Isabel of Valois and Anne of Austria (1559–73). There she was able to marry a member of the Spanish aristocracy, whereafter her new status permitted (or obliged) her to leave off painting. Chadwick, *Women,* 77–86; Ilya Sandra Perlingieri, *Sofonisba Anguissola: The First Great Woman Artist of the Renaissance* (New York: Rizzoli, 1992); Fredrika Jacobs, "Woman's Capacity to Create: The Unusual Case of Sofonisba Anguissola," *Renaissance Quarterly* 47 (1994): 74–101. For women artists in a male-dominated Italian Renaissance culture, see Fredrika Jacobs, *Defining the Renaissance Virtuosa: Women Artists and the Language of Art History and Criticism* (Cambridge: Cambridge University Press, 1997).

52. Perry Chapman, *Rembrandt's Self-Portraits: A Study in Seventeenth-Century Identity* (Princeton: Princeton University Press, 1990); Christopher White and Quentin Buvelot, *Rembrandt by Himself,* exhibition catalog (London: National Gallery Publications; and The Hague: Royal Cabinet of Paintings Mauritshuis, 1999); Harry Berger, Jr., *Fictions of the Pose: Rembrandt against the Italian Renaissance* (Stanford: Stanford University Press, 2000), 351–502.

53. Ernst van de Wetering, "The Multiple Functions of Rembrandt's Self-Portraits," in *Rembrandt by Himself,* 8–37, esp. 17, cites the 1639 inventory of King Charles I of England (nos. 26 and 28), cat. nos. 26, 85, which notes the two known self-portraits in royal collections during the artist's lifetime as well as those later traced in the collections of "amateurs and royalty." Charles I also acquired self-portraits by Rubens (1623), Mytens, and van Dyck, and he owned the famous 1498 Dürer self-portrait (today Madrid, Prado). Also see Volker Manuth, "Rembrandt and the Artist's Self Portrait: Tradition and Reception," ibid., 40–57, esp. 46–50 on Charles I as well as the celebrated Uffizi self-portrait collection of artists, first assembled by Cardinal Leopoldo de' Medici and his nephew, Cosimo III de' Medici. See also Karla Langedijk, *Die Selbstbildnisse der Holländischen und Flämischen Künstler in der Galleria degli Autoritratti der Uffizien in Florenz* (Florence: Edizioni Medicea, 1992). Rembrandt self-portraits were also sought by "art lovers" (*liefhebbers*) in the Low Countries and abroad; Manuth, "Rembrandt," 51–56.

54. Chapman, *Rembrandt's Self-Portraits,* 46–48. It is an accident of history, but this strong, yet fictive, assertion by the young Rembrandt hangs in Mrs. Gardner's Fenway museum.

55. Berger, *Fictions,* 377–82, 475–79, discussing two Rembrandt self-portraits in

the Louvre (1633). Further on Rembrandt and fictive chains: Julius Held, *Rembrandt's Aristotle and Other Rembrandt Studies* (Princeton: Princeton University Press, 1969), 32–41. Chapman, *Rembrandt's Self-Portraits*, 49–50, 67, 90, also claims that the beret symbolizes "the artist as *pictor doctus* or learned painter," but she considers this costume element from the viewpoint of artistic upward mobility in social terms, more than in terms of intellectual status or distance from the mechanical arts. Now see Chapman, "The Imaged Studios of Rembrandt and Vermeer," in *Inventions of the Studio, Renaissance to Romanticism,* ed. Michael Cole and Mary Pardo (Chapel Hill, 2005), 108–46, esp. 123–25.

56. At the time of this painting, the poodle was simply a dog of the rich, chiefly associated with hunting; *Rembrandt by Himself*, 137–39, cat. no. 29a.

57. Ibid., 167, cat. no. 50, denying that this visage is a self-portrait; see also the uncited article by Scott Sullivan, "Rembrandt's *Self-Portrait with a Dead Bittern*," *Art Bulletin* 62, no. 2 (1980): 236–43; the bittern is a European game bird related to the heron.

58. Chapman, *Rembrandt's Self-Portraits*, 71–76; Berger, *Fictions,* 463–73; *Rembrandt by Himself*, 170–75, cat. nos. 53–54.

59. Chapman, *Rembrandt's Self-Portraits*, 17, 40, asserting that military dress affirmed his "allegiance to the *vaderland.*" Yet Berger, *Fictions,* 258–59, 362–63, argues cogently that soldiers were actually disreputable figures in Dutch culture, and this brief assessment is well borne out by other works of art, particularly guardroom genre scenes. See also Richard Helgerson, "Soldiers and Enigmatic Girls: The Politics of Dutch Domestic Realism," *Representations* 58 (1997): 55–58; Ellen Borger, *De Hollandse kortegaard*, exhibition catalog (Naarden: Nederlands Vestingmuseum, 1996).

60. Chapman, *Rembrandt's Self-Portraits*, 90–95; Berger, *Fictions,* 479–95; *Rembrandt by Himself*, 198, cat. no. 71, which like most of its arguments from costume (including the 1639 etching and 1640 London painting) suggests derivation from sixteenth-century portraits of artists as gentlemen. Surely Rembrandt was as aware of Jan Gossaert and other sixteenth-century Netherlandish precedents as he was of Raphael and Titian.

61. Julian Raby, *Venice, Dürer, and the Oriental Mode* (London: Sotheby's, 1982); Lisa Jardine, *Worldly Goods: A New History of the Renaissance* (New York: Knopf, 1996), 379–424.

62. *Rembrandt by Himself*, 159, cat. no. 43.

63. Chapman, *Rembrandt's Self-Portraits*, 120–27; *Rembrandt by Himself*, 213–15, cat. no. 81. Arthur Wheelock, Jr., *Rembrandt's Late Religious Portraits*, exhibition catalog (Washington, DC: National Gallery, 2005), 108–10, 136, cat. no. 11. For the general phenomenon, see Peter Sutton, "Rembrandt and the *Portrait Historié*," in Wheelock, ibid., 57–67; also Rose Wishnevsky, *Studien zum 'Portrait Historié in den Niederlanden* (Ph.D. diss., Munich, 1967). The most celebrated Rembrandt *portrait historié* is his so-called *Jewish Bride,* probably a portrait couple in the guise of Isaac and Rebecca (Amsterdam, Rijksmuseum), another work of the 1660s.

64. Convenient introduction in Geraldine Johnson, "Imagining," 135–43; Anthony Blunt, *Art and Architecture in France, 1500–1700,* 2nd ed. (Harmondsworth: Pelican, 1973), 171–72. Also for a general view of the queen as patron, Deborah

Marrow, *The Art Patronage of Marie de' Medici* (Ann Arbor: UMI, 1982), esp. 11–12, 19–21 for the Luxembourg Palace.

65. This section depends on Goldfarb, *Isabella Stewart Gardner,* 14–17. The choice of a Venetian palazzo template also derives from the ideals of Ruskin's *Stones of Venice.*

66. Belkin, *Rubens,* 140–44; Elizabeth McGrath, "The Painted Decoration of Rubens's House," *Journal of the Warburg and Courtauld Institutes* 41 (1978): 245–77; Jeffrey Muller, "Rubens's Museum of Antique Sculpture: An Introduction," *Art Bulletin* 59, no. 4 (1977): 571–82; Jeffrey Muller, *Rubens: The Artist as Collector* (Princeton: Princeton University Press, 1989), 25–46; now see Jeffrey Muller, "Rubens's Collection in History," in *A House of Art: Rubens as Collector,* ed. Kristin Lohse Belkin and Fiona Healy, exhibition catalog (Antwerp: Rubenshuis, 2004), 35–40.

67. *House of Art,* 40–43, 268–69, cat. no. 65; Wolfram Prinz, "The *Four Philosophers* by Rubens and the Pseudo-Seneca in Seventeenth-Century Painting," *Art Bulletin* 55, no. 4 (1973): 410–28.

68. Muller, *Artist as Collector,* 32, using the final passage of the tenth *Satire* where Juvenal counseled: "Leave it to the gods to give us what is fit and useful to us." Muller also notes the uncited end of the text, comparing favorably the labors of Hercules to the banquets of Sardanapalus.

69. Wolfgang Stechow, *Rubens and the Classical Tradition* (Cambridge, MA: Harvard University Press, 1968).

70. Nina Serebrennikov, "'Dwelck den Mensche, aldermeest tot Consten verwect.' The Artist's Perspective," in *Rhetoric-Rhétoriqueurs-Rederijkers,* ed. Jelle Koopmans, Kees Meerhoff, Mark Meadow, and Marijke Spies (Amsterdam: North-Holland, 1995), 240–41; Catherine King, "Artes Liberales and the Mural Decoration on the House of Frans Floris, Antwerp, ca. 1565," *Zeitschrift für Kunstgeschichte* 52 (1989): 239–56; Zirka Filipczak, *Picturing Art in Antwerp, 1550–1700* (Princeton: Princeton Univeristy Press, 1987), 35–39; Carl van de Velde, "The Painted Decorations of Floris' House," in *Netherlandish Mannerism,* ed. Görel Cavalli-Björkman, exhibition catalog (Stockholm: National Museum, 1985), 127–34.

71. Rubens, foreword to *Palazzi di Genova* (1622), trans. Cornelius Gurlitt (Berlin: Der Zirkel, 1924); quoted by Martin Warnke, *Peter Paul Rubens,* trans. Donna Pedini Simpson (New York: Barron's, 1980), 173–74.

72. Muller, *Artist as Collector;* Muller, "Rubens's Collection in History," 43–56.

Molly Bourne is a faculty associate in the art history department at Syracuse University in Florence. She received her Ph.D. from Harvard University and is a former Fellow of Villa I Tatti, the Harvard University Center for Italian Renaissance Studies. A specialist in the art, architecture, and cultural history of Renaissance Mantua, she has published articles on artistic patronage, erotic correspondence, and cartography at the Gonzaga court, as well as on cultural exchange between Mantua, Florence, and Spain. Her book *Francesco II Gonzaga: The Soldier-Prince As Patron* was recently published by Bulzoni Editore.

Kelley Helmstutler Di Dio is an assistant professor of the history of early modern European art at the University of Vermont. After receiving her Ph.D. from Rutgers University, she was Kress Curatorial Fellow at the Medici Archive Project in Florence. She has lectured and published on the careers of Leone Leoni, Pompeo Leoni, on the social status of Italian artists who worked in Spain, on the intercultural exchanges between Spain and Italy in the sixteenth and seventeenth centuries, and on sculpture collections in Early Modern Spain. Her book *Leone Leoni and the Status of the Artist at the End of the Renaissance* will be published by Ashgate in 2009.

Tom Loughman is curator of European art and assistant to the director for exhibitions at Phoenix Art Museum. His dissertation, "Spinello Aretino, Benedetto Alberti, and the Olivetans: Late Trecento Patronage at San Miniato al Monte" (Rutgers University, 2003), and his subsequent work on Italian Renaissance art and architecture, reflect his particular interests in art patronage, monasticism, and the history of collecting. Loughman's current museum projects range from focused exhibitions on early Italian painting to collaborative efforts with various national collections in Europe. He conceived and organized the 2007 exhibition *Fierce Reality: Italian Masters from Seventeenth Century Naples*, which had the collections of the Museo di Capodimonte at its core.

Jonathan K. Nelson is coordinator of art history at Syracuse University in Florence. He received his Ph.D. from New York University and is a former fellow of Villa I Tatti, the Harvard University Center for Italian Renaissance Studies. His dissertation on Filippino Lippi developed into a monograph (Electa, 2004) and an exhibition (*Botticelli e Filippino*, Skira, 2004). His other main interests include Renaissance representations of women (*Leonardo e la reinvenzione della figura femminile,* Giunti, 2007; *Venus and Love. Michelangelo and the New Ideal of Beauty,* Giunti, 2002); the

relationship between art and poetry (*Michelangelo: Poesia e Scultura*, Electa, 2003); and *Plautilla Nelli* (Syracuse University Press, in press).

Larry Silver, the Farquhar Professor of Art History at the University of Pennsylvania, taught previously at Berkeley and Northwestern. He has served as president of the College Art Association and as editor in chief of its on-line journal, *caa.reviews.* His specialty is painting and graphics of Germany and the Netherlands in the Renaissance era. In 2006 he published *Peasant Scenes and Landscapes* (University of Pennsylvania Press) and *Hieronymus Bosch* (Abbeville). Silver currently has two books in press: one very much about signaling, *Marketing Maximilian: The Visual Ideology of a Holy Roman Emperor* (Princeton University Press), and another co-authored with Shelley Perlove, *Rembrandt's Faith: Church and Temple in the Dutch Golden Age* (Penn State University Press).

Richard Zeckhauser is Frank P. Ramsey Professor at the Kennedy School of Government, Harvard University. He has spent his entire academic career at Harvard, starting with his A.B. and Ph.D. degrees. Trained as an economist and decision theorist, he develops conceptual models to understand a range of real-world phenomena and then tests them empirically. Usually working with others, Zeckhauser is the author of 235 professional papers and 12 books or edited books. His most recent book is *Targeting in Social Programs: Avoiding Bad Bets, Removing Bad Apples* (Brookings Institution Press, 2006). In 2007 he won the United States Mixed Pairs Championship at contract bridge. This book is his first venture into art history.